Jeff Kieny
Vintage Folk Art Fishing
Lures and Tackle

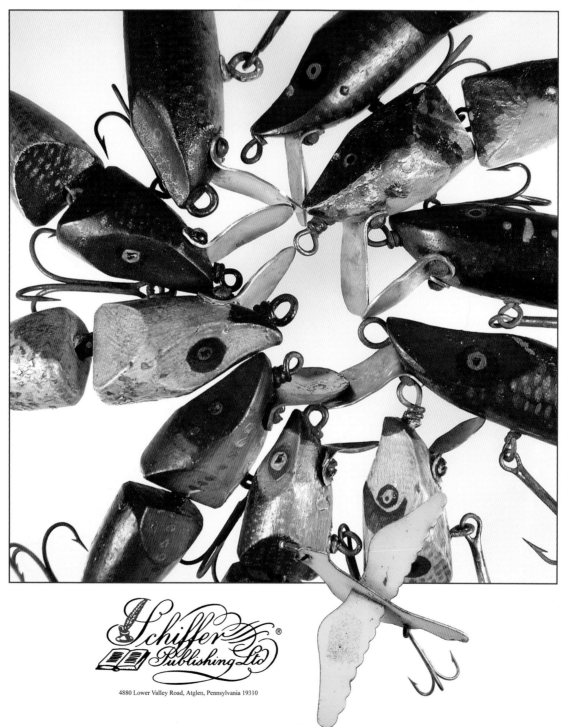

Schiffer Publishing Ltd

4880 Lower Valley Road, Atglen, Pennsylvania 19310

Library of Congress Control Number: 2011921372

Designed by "Sue"
Type set in Papyrus/Zurich BT

ISBN: 978-0-7643-3694-2
Printed in China

Schiffer Books are available at special discounts for bulk purchases for sales promotions or premiums. Special editions, including personalized covers, corporate imprints, and excerpts can be created in large quantities for special needs. For more information contact the publisher:

Published by Schiffer Publishing Ltd.
4880 Lower Valley Road
Atglen, PA 19310
Phone: (610) 593-1777; Fax: (610) 593-2002
E-mail: Info@schifferbooks.com

For the largest selection of fine reference books on this and related subjects, please visit our website at:
www.schifferbooks.com
We are always looking for people to write books on new and related subjects. If you have an idea for a book please contact us at the above address.

This book may be purchased from the publisher.
Include $5.00 for shipping.
Please try your bookstore first.
You may write for a free catalog.

In Europe, Schiffer books are distributed by
Bushwood Books
6 Marksbury Ave.
Kew Gardens
Surrey TW9 4JF England
Phone: 44 (0) 20 8392 8585; Fax: 44 (0) 20 8392 9876
E-mail: info@bushwoodbooks.co.uk
Website: www.bushwoodbooks.co.uk

Dedication

This book is dedicated to my son John and daughter Glee. I'm so very proud of you. Here's to our past and future times together — memories made and memories to be made.

Author's kids, John and Glee, at Bull Shoals Lake, Arkansas, 1987.

Acknowledgments

[Folk Art] is a varied art, influenced from diverse sources...often fresh and original, and at its best an honest and straightforward expression of the spirit of a people. —Holger Cahill, American Folk Art — The Art of the Common Man in America 1750–1900, 1970.

I thank my fellow folk art lure collecting friends and some of the many others who have graciously helped me add choice pieces to my collection or provided leads which bore fruit. Thanks one and all:

Jim Anderson, Bob Baird, Alan Bakke, Frank Baron, Gary Bergendal, Aage Bjerring, Walt Blue, Gary Bowles, Doug Brace, John Butrum, Mike Campouris, Arlan Carter, Bob Cook, Carolyn Corwin, Steve Craft, Gary Cripps, Bob Dale, Harold Dickert, Chris Diestel, Bob Drozd, Gary Fries, Ron Fritz, Don Getz, Kermit Gohring, Bob Gregory, Jeff Grootemaat, Bill Grossman, Gary Hall, Mike Hall, Gary Henderson, Mike Hines, Jason Hollerbush, Brian Hunter, Jerry Jolly, Mike Kalogridis, Ken Kerr, Jason Kleiber, John Kleiber, Ed Knight, Shane Knight, Steve Knight, Todd Larson, Tony Laws, Willis Logan, Rob Lucal, Gary Ludwig, Don Ludy, Steve Lumpkin, Allen McCord, Bill McVeigh, Max Merrill, Jason Michaels, Dan Milewski, Tim Mierzwa, Larry Moellman, Bill Muth, Dean Murphy, Joe Nelson, John Nunn, Joe Onion, Stewart Onstott, Tom Penniston, Mike Pollock, Pete Press, Joe Roesch, Carl Schaum, Tom Schofield, James Scouler, Brian Shillito, Chris Slusar, Gary Smith, Wendell Smith, Bill Sonnett, Scot Sparks, Joe Stagnitti, Dick Streater, Fred Sweeney, Gabby Talkington, Mark Taylor, Ralph Triebel, Sam Van Camp, Joe Walkowski, Bob Wallace, Greg Weaver, Allen Weiss, and Charlie Wilson.

My sincere apologies to anyone I inadvertently missed.

My additional thanks to another fine group – the well-recognized, folk art lure collectors who have inspired, enlightened, educated and befriended me in my pursuit. While folk art collectors' opinions on a particular piece will often vary based upon personal taste, its the discussion, reflection and interchange of ideas and criticisms that educate and energize each of us as we enjoy the depth and richness of the folk art tackle field. Trades, purchases and sales occur often between collectors sharing the same interest – but it's not the individual transactions that are important, it's the shared experiences and what is learned along the way:

Kerry Chatham (Alabama)
Mike Frome (Texas)
Jack Gallagher (South Carolina)
Scott Ghinazzi (Wisconsin)
C. B. "Bruce" Lewis (Pennsylvania)
David Lindsay (South Carolina)
Jack Looney (Missouri)
Ron Mahinske (Alabama)
Dudley Murphy (Missouri)
Mike Rolf (Ohio)
Bob Vermillion (Ohio)
Bob Wentz (Pennsylvania)

Jack Looney, a nationally renowned, Kansas City area tackle collector and author, graciously agreed to pen this books fine Foreword. In addition to allowing me to photograph several of his "factory" lures for illustrative purposes, Jack volunteered some helpful suggestions, which enhance and enrich the books content.

Ron Mahinske, of Birmingham, Alabama, and C.B. Lewis*, of Quakertown, Pennsylvania, deserve special thanks. Ron has been a special and constant source of encouragement and inspiration since I began collecting folk art tackle in earnest. He has helped my collection by selling me key pieces from his collection and has counseled me wisely as I have considered purchases through the years. Likewise, C. B. "Bruce" Lewis and I have spent endless hours on the phone discussing the merits of various folk art pieces. As an esteemed contemporary artist in his own right, Bruce too has been instrumental in my maturation process as a folk art collector. [1] Thanks Ron and Bruce for your wonderful support and 'good-eyes.'

Photographer *extraordinaire,* Greg Booker, volunteered to take the cover photo. I couldn't be more pleased with it. Thanks, Greg.

This book would not have been possible without the support and assistance provided by Glee, my wife, who encouraged me to write it. Finally, my sincere thanks to the people at Schiffer Publishing Ltd. who earnestly undertook the challenge of publishing it.

* Kieny, Jeff. "C. B. Lewis, Master Fish Decoy Maker," *Hunting & Fishing Collectibles Magazine*, Volume 7, Number 6, November/December, 2007.

Contents

Preface

...the folk artists' freedom from the restrictions of academic art, indeed their technical liabilities, made way for a compensating emphasis on and splendid achievement in the realm of pure design. It is certainly this bold abstraction that first gained their distinguished place in our art history. —Jean Lipman - Young America, A Folk Art History, 1986

Interest in folk art and American folk art in particular, remains high and seems to become more popular with collectors and dealers every year. While somewhat controversial in its early days, the artistic merit of folk art is now widely recognized within the art community. Specialized museums and exhibits exist to educate visitors. Hundreds of specialized folk art dealers help satisfy the thirst of thousands of collectors.

The emergence of Americas "contemporary" art scene began in the early 1900s. The artists themselves were drawn to the simple, naive styles of early American art, particularly the works of country and portrait painters who traveled the countryside and coastal areas of the Northeast in the early 1800s, prior to the advent of the camera. America's young, progressive artists were influenced by a style and certain innocence that helped them to boldly break from strict confines of classic realism (fine art) grounded in centuries-old, European tradition.

Early twentieth-century artists were an independent lot; the abstract, undisciplined style evident in early American landscapes and portraiture proved highly influential as contemporary art evolved. The increased influence and subsequent exposure to a receptive public of early Americana, much of which is now considered "folk art," was the genesis of a movement that continues to accelerate today.

Early Folk Art Collecting Period

The heightened interest in the early twentieth century for collecting American art forms (which over time became known as folk art) occurred during the Colonial Revival Movement (see Bibliography for related references), itself a resurgence of interest in the culture, art and design themes of the northeast during the American colonial period. Following America's Centennial, this movement, which started in the latter 1800s, was advanced by the patriotism surrounding World War I. Great change was underway in this era brought about by broad-based industrialization.

Harkening back to an earlier, simpler, more personal lifestyle practiced in the original American colonies provided solace and comfort in those rapidly changing times. In addition to the emergence of folk art as a unique collecting area, the re-birth of hand-painted photography, as practiced by photographer-artists such as Wallace Nutting, was popularized during the Colonial Revival Movement.

Wealthy and prominent individuals began collecting folk art in earnest in the 1910s, with the first major folk art exhibitions occurring in the mid-1920s and early 1930s. The Museum of American Folk Art was founded in 1961. Today, auction houses routinely hold specialized Americana auctions that attract worldwide attention and generate millions in revenue. Within the past few years, auction records in several categories of folk art have been set. In 2008, Edward Hicks' oil on canvas painting *The Peaceable Kingdom with the Leopard of Serenity*, painted ca. 1846–1848 in Bucks County, Pennsylvania, sold for $9,673,000, "a record for American folk art at auction." [1]

In the vintage hunting and fishing collectibles category, fish and duck decoys are most closely related to folk art fishing lures. Presently, the fish and duck decoy markets are substantially larger and more mature than the folk art fishing lure market. Outstanding fish decoys, a category of folk art that became popular in the mid-to-late 1970s, have commanded prices over $30,000. [2] In November of 2009, a ca. 1920, carved and painted fish plaque by well-known folk artist/fish decoy carver Oscar Peterson, of Cadillac, Michigan, sold privately for $100,000. [3]

Duck decoy collecting began in the 1930s and 1940s and blossomed in the 1950s and 1960s. Since then, interest and prices have exploded. In the fall of 2006, Guyette & Schmidt Inc. auctioneers sold an Elmer Crowell Plover decoy for $830,000; shortly thereafter, in January of 2007, Christies sold a Lathrop Holmes Merganser for $856,000. [4] Later, in September 2007, Stephen O'Brian Fine Arts of Boston privately sold two Elmer Crowell pieces, a pruning pintail drake and a sleeping Canada goose, for over $1,100,000 each. [5]

This is the first book of its kind to highlight and recognize the historical importance of vintage folk

art fishing lures. In addition to a growing group of collectors actively focused on acquiring folk art fishing tackle, interest in the area is increasing among veterans in the fishing lure collecting community who have grown to appreciate the creative spirit and artistic qualities inherent in these unique artifacts. Once the folk art collecting community at large becomes aware of the variety and merits of folk art fishing lures, I expect demand for quality pieces will increase substantially. Since supply is limited, the future looks bright indeed for quality folk art fishing lure values.

Whether you hold an active interest, already collect, or are considering collecting folk art lures, it should not be done in a vacuum. We are just the latest fans and participants in the realm of folk art, an expanding area of the art world now a hundred years old. The folk art field goes far beyond sporting collectibles.

Depending on your level of interest, I recommend additional education and reading that will help to provide you with heightened awareness and a broader perspective of folk art in general, a big advantage even if your focus is only vintage hand made lures and fishing tackle.

The literature of angling falls into two genres: the instructional and the devotional. The former is written by fisherman who write, the latter by writers who fish. — William Humphrey, *My Moby Dick, 1978*

My collector-friend Gary Smith once said to me, "Jeff, when I see some of these baits I think to myself, it's so neat...how could the maker ever bear to risk losing it! But then I realize that what strikes us as 'art' in the 21st century was simple utility to those folks with enough talent to make those lures back then." Georgia outdoor writer and lure collector Robbie Pavey once described folk art lures as being "unique as snowflakes" – indeed they are.

Any book of this type requires choices – many of them difficult ones. Other areas of the vintage folk art tackle market such as folk art rods, reels, gaffs, nets, and all things metal, were not emphasized here but do warrant further research and attention. Surely that will come as interest in folk art tackle expands.

Based upon the choices I made, its my sincere hope that you will enjoy the book, will find it worthwhile, and will increase your awareness of the diversity, historical significance and broad appeal of vintage folk art lures. I further hope you will feel as I do – that collecting folk art lures offers compelling opportunity and holds great promise.

Over time, I trust this area of folk art will be accorded the further exposure and study it merits. I have found collecting in this area extremely engaging and rewarding. In an ever-changing and accelerating world, it is calming and relaxing to study a lure carefully crafted by hand decades ago and brought to life by its maker for the sole purpose of catching fish. Through unconstrained vision and talent he created more than a lure; he invested part of himself and created a highly personal sculpture – an object of art to be treasured, reflected upon, enjoyed, shared and cared for beyond our lifetimes.

What is fair in men, passes away, but not so in art —Leonardo da Vinci. *Leonardo's Notebooks,* H. Anna Suh, 2005

There are untold numbers of books dedicated to the field of folk art. To help you gain a general awareness of the field and its emergence as a highly respected art form, I recommend the references listed in the Bibliography for your library; they are all part of mine.

I remain an active collector of hand crafted, fishing related items. While specializing in early folk art fishing lures and tackle, I also collect vintage handmade fish decoys and ice-fishing/spearing accessories. If you have unusual, early folk art lures or items comparable to those pictured here that you would allow me to add to my collection, please contact me and I will be pleased to respond. I welcome comments and inquiries via e-mail at jeffsfishin@sbcglobal.net, through the website www. folk-art-lures.com, or via the NFLCC Directory.

[1]*Maine Antiques Digest*, August 2008, page 33-D.
[2]*Sothebys/New York,* January 22, 2000 – Sucker, Lake Chatauqua area of New York, unidentified maker, last quarter 19th century - $32,200.
[3]*Maine Antiques Digest*, February 2010, p. 10-A.
[4]*Hunting & Fishing Collectibles Magazine*, Volume 7, Number 2, p. 65, March/April, 2007.
[5]*Maine Antiques Digest*, November 2007, p. 9A.

For related general historical references, see the Bibliography.

Foreword

The spirit and ingenuity inherent in American folk art is perhaps best represented in the works produced by talented amateurs, who were able to turn out remarkable pieces without benefit of art schooling or professional training. While many individuals led austere lives, there was still room for beauty, and even the most ordinary of homemade household accessories could become works of art in the hands of a gifted seamstress or back porch whittler. —Unattributed, *Folk Art – imaginative works from American hands,* 1990.

As a young fisherman in the late nineteen seventies, I developed an appreciation for old tackle. Three decades later, that appreciation has heightened as my knowledge of antique tackle broadened. Over the years, I have been blessed with the opportunity to open many old tackle boxes and to inspect a wide array of vintage lures. In doing so, I (like many others) developed an appreciation for the "classics." Those are the uniquely designed lures that differ from the norm. Lures such as the Wotta-Frog, Chippewa, Great Injured Minnow, Johnson Automatic Striker, Hosmer Mechanical Frog…just to mention a few.

As I searched for the classics for my collection, I found that there was another classic to add to the list. It was the quality, hand-crafted, vintage folk art lure. A unique, imaginatively conceived treasure possessing character and a surface mellowed by time; qualities that attract you to it from first encounter. Its novel form, rich thick paint and fine patina causes it to rate well above the average. Folk art lures are much more creative than the run of the mill "river plug."

As my appreciation for the classic factory lures increased, an appreciation for classic folk art artifacts increased as well. Finding a mechanical "homemade" lure that employs gadgets for fin movement or

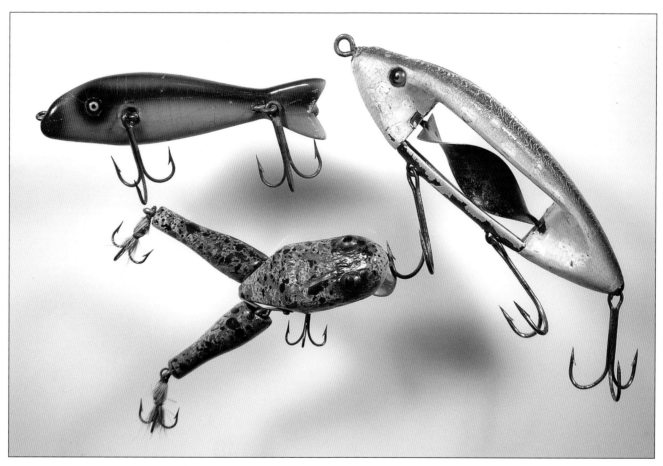

Trio of factory-made lure classics – upper left, Great Injured Minnow ca. 1920s; upper right, Musky Chippewa ca. 1910s; bottom-left, Wotta Frog ca. 1940s

articulating legs is as exciting as finding its factory equal.

I find that acquiring a superbly crafted, one-of-a-kind specimen is treasured as much (if not more) as finding a factory-made lure that is one of thousands produced.

We have all said, "If this lure could only talk." Since they don't, we use our imagination to picture its experiences…the images are endless. In the case of a classic folk art lure, it is almost a given that this imagery will be provoked as one handles it. It is possible to imagine that a basic reason for producing a hand-made lure can be rationalized and may have developed as follows:

> The sportsman of the 1880s and 1890s had a limited selection of artificial lures available. If you were willing to wait, devons, spoons and spinners could be ordered from hardware catalogs. In the years to follow, those that had an income sufficient enough to afford manufactured lures found them available through several fledgling tackle companies. Other sportsmen with modest incomes would continue to fish with live bait or would choose to fashion an innovative artificial lure from a disposable household item or tool.

At the close of the nineteenth century, American economics were improving as the nation's industrial revolution was underway. The era included a few tackle manufacturers competing for their place in a prospering market. In their infancy, they struggled to meet increasing demands for spinnered underwater minnows and surface lures. During the next two decades, increasing popularity of artificial lures inspired inventors to introduce new concepts. These included mechanical, floater divers, rubber "critter" and wiggler types. During the following years, fly rod, injured minnow and plunker types were introduced to the assemblage of tackle for outdoorsmen. Although

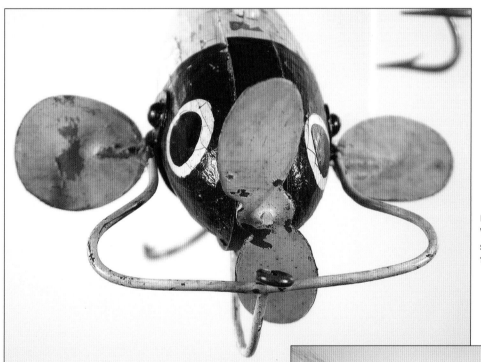

Unusual mechanical folk art lure from Wisconsin. Internal gears cause the side fins to rotate as the front prop turns.

Large Cork Bass Bug – 1-1/2" carved, painted and varnished cork body, ca. 1940s. Four rubber-band legs inserted into the cork body. Embedded, large single hook — it's hook eye forming the line tie. White hair tail is rumored to be from a polar bear.

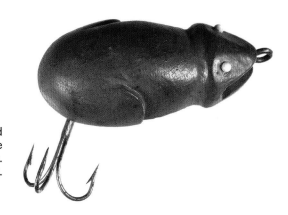

Gray Mouse – 2-1/4" carved, painted and varnished wood ca. 1930s. Screw eye line tie inserted in mouth area. White glass bead eyes. Recessed cup and screw eye belly hook rig.

economics were improving and sportsmen had more choices when buying tackle, it would still be some time before the "average guy" could afford what was at the time "expensive" fishing tackle. Most folks were just making a living; there wasn't a lot of time or money for recreation. Typically, fishermen of the era fished with live bait to contribute to the dinner table.

Since everyone couldn't afford commercially made lures, it is reasonable to imagine that, occasionally, an ingenious sportsman may have observed handsomely crafted lures in a catalog or outdoor magazine and imagined owning them. Perhaps another would see lures in a tackle box belonging to someone (boasting their effectiveness) at the local barber shop. An uncle could have had a few interesting artifacts in a tackle box and they may have caught the imagination of a nephew. In another instance, a fisherman may have observed a small animal or insect struggling to reach the shore only to be engulfed by an observant fish. It is possible that the fisherman imagined casting a hand-crafted copy of the critter along the shore line, hoping that it would fool the fish into striking again. Such events likely caused some fishermen to want to catch a fish using artificial bait. So the natural process, if it were to happen, would be to craft their own copy.

Today, I view my collection of classic, hand-crafted, folk art lures to be great examples of a special category of lure collecting. They represent another time and condition that is ever so important to a comprehensive history of American fishing tackle.

A great thing about our hobby is that new historical information is discovered and documented every day. One of *The National Fishing Lures Collectors Club's* (NFLCC) members who has made significant contributions to history is my good friend, Jeff Kieny. Through the years, Jeff and I have cultured a relationship and have become great "buds." Much

of that time he was busy building a world-class collection of hooks and harnesses. Jeff still treasures his "metal contraptions." But in recent years, Jeff has truly found his reason for collecting. Having an immeasurable passion for vintage folk art tackle, he has become one of the most recognized collectors in this field.

Due to our relationship and mutual appreciation of folk art, I am honored to have been asked to introduce this book. His many artifacts, resulting from years of searching for quality examples, and his educational findings on the topic have been brought together in this new reference. The author's knowledge of folk art is evident in the background provided in each section. As you absorb the information, you sense his enthusiasm, which genuinely inspires a reader's interest in this once-unappreciated and misunderstood aspect of historic tackle collecting.

There is little doubt that this book will cause even the most discriminating collector to appreciate hand-crafted fishing tackle. One becomes spellbound imagining the history behind each of your favorites, as you tour over 700 photographs of outstanding examples from the author's collection. Every turn of the page provides something new to be discovered or detailed information to expand knowledge of the piscatorial enthusiast.

As is the case with other quality artifacts, it was only a matter of time before these gems would be recognized for their qualities and be treasured by twenty-first century American folk art collectors. Hand-crafted fishing lures are from an era of different circumstances and influences, thus causing them to be an ever so important aspect of American fishing tackle history.

I invite you to enjoy and discover the intrigue associated with folk art tackle, as presented by this experienced collector/author, in this contribution to tackle references.

Jack Looney
Independence, Missouri

Part 1

Folk Art Defined

American folk art is difficult to define: For every definition, there is at least one contradictory example. —Helaine Fendelman and Susan Kleckner, *Collecting American Folk Art*, 2004.

If one seeks them, one will find numerous definitions, opinions and meanings for the term "folk art." Some definitions and their references are:

Art of people who have had no formal, academic training, but whose works are part of an established tradition of style and craftsmanship. www.ackland.org/tours/classes/glossary.html

Traditional representations of a folkloric character and usually made by persons without institutionalized training. www.fineartregistry.com/faqs/art_glossary.php

Art produced by people not professionally identified as artists. www.oregonstate.edu/instruct/anth370/gloss.html

Works of a culturally homogeneous people without formal training, generally according to regional traditions and involving crafts. www.members.aol.com/GRBowles/art-hist/mod-periods-def-New Yorkpl93.html

Art made by people who have had little or no formal schooling in art. Folk artists usually make works of art with traditional techniques and content, in styles handed down through many generations, and often of a particular region. www.alankritha.com/glossary.htm

Genre of art of unknown origin that reflects traditional values of a society. www.wordnet.princeton.edu/perl/webwn

The precise definition of folk art has been the subject of much scholarly debate for the better part of the last century.

The age of an object has also bred argument and debate as to whether or not it can be classified as "true" folk art. Was the first American folk art created by Native Indians? If one uses the Revolutionary War period as its commencement, is its cutoff pre-Civil War, the first Centennial of this nation (1876), pre-World War I, or even contemporary times? The fact is that throughout the 1900s, scholars, dealers and collectors debated and substantially broadened the definition of folk art. Today, most in the trade would agree that folk art is being created even now.

Since it is not my intent to plow new ground or start new debate, I begin by listing some generally recognized folk art categories:

Early, American landscapes, portraits and cut silhouettes created by untrained, itinerant traveling artists

Early, hand-made, paint-decorated furniture and boxes

Shaker furniture and accessories

Early samplers, quilts and needlework

Early scrimshaw

Early ceramics, including decorated Chalkware, Redware and Stoneware

Early painted trade signs

Early carved ship figureheads

Early shop and tobacco store figures

Tramp and 'Outsider' art

Decorative carvings and whirligigs

Canes and walking sticks

Weathervanes

Carved carousel figures

Duck decoys*

Fish decoys* and now,

Vintage, hand made fishing lures and tackle*

* limited to hand-crafted examples possessing special aesthetic and visual appeal/interest

What do the majority of these categories have in common?

In addition to being aesthetically pleasing, the objects were personal, thoughtfully created by hand and intended for actual use. Though most of these objects were not factory produced, some were—for example, certain weathervanes, carousel figures and duck decoys were catalogued and produced by specialized companies for commercial sale. Due to their hand-craftsmanship, assembly skill and overall aesthetics, certain commercially marketed examples have been elevated to objects of art.

Sometimes highly embellished or decorated, many of these objects were created to fulfill a specific need, utilitarian in function and purpose. While many who produced them had great skill, they were self-taught tradesmen, not educated in the fine or "high" art of their eras.

Early folk art was not art commissioned by the wealthy. Rather, it has aptly been said that folk art represents a remarkable body of work called "the art of the people."[1] Alice Winchester in her Introduction to *The Flowering of American Folk Art* (1974) suggests that folk art could alternatively be referred to as "unpretentious art of the folks." An influential exhibition held at the Museum of Modern Art in 1932 perhaps characterized it best. It was titled "American Folk Art – the Art of the Common Man in America."

Most folk art makers are anonymous. Folk art pieces are often simple and economically made using materials commonly available at the time of their creation. At its best, folk art is original, unconstrained, highly expressive and personal. When an untrained artisan, using his finest skills, expands the boundaries of conventional thinking to create special objects for himself, friends or family, folk art masterpieces may result.

Quality vintage folk art lures exemplify <u>all</u> the best of these generally recognized folk art characteristics. Therefore, as collectible folk art objects, high-caliber hand made fishing lures are deserving of being viewed as American folk art.

[1] *Folk Art -- imaginative works from American hands*, 1990.

For additional general historical references, see Bibliography.

Introduction

The people responsible for making potent and beautiful objects, living in the simplest state of home and hearth, utterly fascinated me. Who were these rough, proud, driven people? How did they get along? How did they raise their children, maintain friendships and marriages, express unrealized dreams and hopes? —Jane Katcher, *Expressions of Innocence and Eloquence – Selections from the Jane Katcher Collection of Americana*, 2006.

Times were tough and the challenges many in the first half of the 20th century. Travel was difficult. Until the 1920s, horses were the dominant form of travel in many rural areas. Therefore, obtaining commercially-made fishing tackle from a sporting goods or hardware store was not even an option for some. Food, clothing and shelter were the overarching priorities. In such lean times, particularly during the depression years, self-reliance became the norm. Fishing could supply the family table with food but, the common man earning common wages (assuming he had work), simply could not afford to purchase factory-made lures. It is said, "Necessity is the mother of invention." In this instance, *necessity was the mother of folk art lures*.

Historical Perspective – American Lure Development

Many readers of this book are neither fisherman nor collectors of vintage fishing tackle. Therefore, many will be far more familiar and knowledgeable of the historical context surrounding traditional categories of early folk art, than those surrounding early American fishing lure development. Unlike American painting and portraiture, samplers, quilts, earthenware, painted furniture and other categories of Americana dating back to the 1700s, the production of wooden fishing lures is a relatively recent phenomenon. Even the most ardent collector will simply not find folk art lures dating from Americas colonial period through the first half of the 19th century. Why?

Until the 1850s–1860s, most personal fishing was done with either a hook or tied fly. The utilization of live natural bait was most prevalent. Most "lures," initially developed and manufactured from the mid 19th century through the latter 1890s were glorified hooks—(sinking) decorative/flashy metal spinners or spoons intended to be trailed behind a (rowed) boat or, when used from shore, dipped/dropped/dragged into promising areas using a very long rod coupled with a short length of line. This latter technique was called "skittering."

It wasn't until around the turn of the 20th century that fishing tackle development and refinement of rods, reels and lines, had progressed sufficiently to enable lighter wooden lures to be effectively 'cast' by hand and retrieved. This process of casting an artificial lure was/is known as "bait-casting."[1]

Hand-made/folk-art lure development paralleled factory production – therefore, the earliest, wooden examples will generally date from the 1900s–1910s. Further, since few practiced bait-casting in its early days, and fewer still chose to craft lures of their own design, folk art lures of merit dating to this period are highly prized and rarely found.

Available materials and household supplies, coupled with innate ingenuity and hands seasoned through years of trade work led to the creation of an endless variety of what are now referred to by collectors as folk art lures. While typically the individuals creating such objects had no formal art or design training, they may have been expert outdoorsmen or craftsmen.

Whether wholly unique, copies, or inspired variations of popular lures of the time, they are all treasures today. A fisherman might not have been able to afford a 'Heddon slope Nose' or 'Underwater Minnow,' but he could surely make one.

Actual Heddon "Slopenose," ca. 1900s

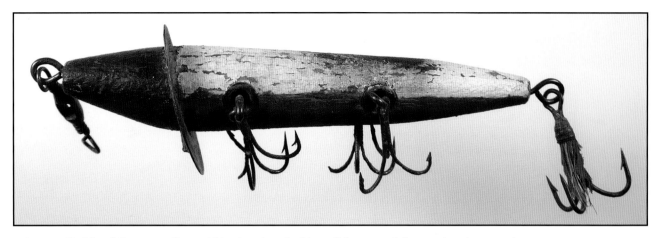

A great **Heddon "Slopenose"** ca. 1900s, hand crafted by a fisherman; it just reeks of age and use.

Some let their imaginations run wild creating unique designs and forms. Others, while remaining generally true to an original classic, sought to improve its fish-catching effectiveness by making subtle, or sometimes not so subtle changes. In Section 3, I have included examples that demonstrate this range of creative effort.

Rather than being manufactured by the thousands within strict production standards as commercial lures were, folk art lures are singular and unique. It is the resulting diversity and richness of the individual makers honest expressions that generate today's collector interest.

Unlike manufactured lures, a folk art lures thick paint, age-lines and folky rendering invoke a sense of warmth and are viewed as a badge of honor. Good folk art lures possess a character or personality that new-in-the box commercial lures lack. They provoke imagination; one senses there is a story, a certain spirit that will remain forever silent about its creation and creator.

Whether a one-of-a-kind creation or an inspired re-interpretation of a classic, every folk art lure is a miniature time capsule. They are reflections of both the era and the creative personality of the maker. A quality folk art lure speaks to you, urges reflection and solicits appreciation. Folk art lure designs are endless, and range from primitive forms in drab colors to the humorous/whimsical; unusual mechanical contraptions to highly abstract and outrageous ones.

Tackle Primer

Whether or not you are folk art savvy, if you are unfamiliar with vintage fishing lures and tackle collectibles, don't despair. Lest you not be disadvantaged by tackle savvy readers, here are some "Cliffs Notes:"

The purpose of a lure (noun) is simple – like duck decoys and fish decoys, these are designed to lure-in the quarry. Hence, the noun, "lure". However, unlike duck decoys and nearly all fish decoys, these lures are also designed to catch the quarry; thus, the need for hooks. To properly function, lures should be balanced (weighted if/as necessary) and designed to provide some type of appealing action upon retrieval. The resultant wiggling, rotation, diving, darting or splashing tempts or provokes fish to strike. Therefore, fishability is critically important – the lure, hooks and hardware should be sturdy enough to withstand the rigors of ongoing use and securely retain a fish once hooked. A lure's size, and to some extent its form and design, should be species appropriate.*

Lures attract, catch and retain fish – that is all there is to it! With that briefest of introductions, the playing field is hereby leveled. Hopefully (non-fishermen) readers can now feel more comfortable evaluating the interplay between a folk art lure's form and functionality.

* During the era most of the wooden lure examples pictured were created, the typical fisherman referred to lures as "plugs;" many of us old timers still do. Today, many collectors refer to lures as "baits." The three words can be used interchangeably.

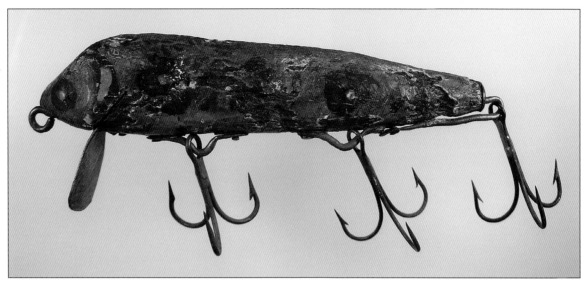

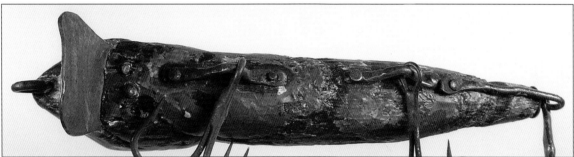

This primitive, heavily worn, ca. 1930s, hand-crafted lure has experienced untold hours of use and surely dozens of battles between fish and fisherman through the years. Though war-torn, and made by an anonymous hand, today it tells a story of its times – such historical and contextual value adds interest to folk art pieces at every level of the market.[2]

Within the world of vintage sporting collectibles, folk art lure collecting remains in its infancy. However, interest in old, folk art fishing lures has increased substantially in recent years. What once were simply utilitarian tools for the fisherman are now increasingly appreciated as miniature works of art. Growing numbers of collectors are experiencing the pleasure of finding and treasuring these unique lures, intimately hand crafted in an earlier, simpler time. Economically made solely as functional objects, handmade lures were created for only one purpose: to catch fish. Their maker's handiwork was original and pure. The mystery surrounding the time, place and circumstances of their origin simply adds to their allure.

Thankfully, for the passionate among us, vintage folk art lures remain available, and collecting them is highly enjoyable.

[1] In Mr. Kieny's article, *The Birth of Modern Bass Fishing – A Confluence of Events,* published in the December, 2004 *NFLCC Magazine*, the author examines in detail the factors leading to the emergence of "bait-casting" which, at the onset of the 20th century, would revolutionize bass fishing in America

[2] Used and Abused Folk Art Diver – 4-1/2" carved, painted and varnished wood ca. 1920s-1930s. Painted eyes, screw eye line tie. Formed heavy wire hook hangers are forged at each end, each secured to lure (on each end) by nails. A copper tail hook hanger loops around a doughnut-shaped, metal loop at the tail and is secured by a nail at the belly. An inlet, hand-cut metal diving lip is secured by two nails under the head.

Note: A portion of this introduction was partially reprinted and edited from Mr. Kieny's article "Vintage Folk Art Classics," published in the *National Fishing Lure Collector's Club Magazine*, June, 2006,

Additional Merits of Folk Art Lures

Whether born out of economic necessity or the desire to build "a better mousetrap," handmade lures can truly be classified as equal to the very finest folk art. —Dudley Murphy, *Fishing Lure Collectibles*, 2001

Folk art lures possess several other tangible and intangible benefits vs. other categories of folk art:

While supply is definitely limited, quality folk art lures can still be found.

At least presently, in contrast with many other folk art categories, collecting vintage handmade lures is a newer area which has had little exposure in the market-place. Therefore, many folk art lures can still be acquired at affordable pricing levels.

In terms of historical significance and tradition, they are the equal of any other hand crafted, sporting or tackle collectible.

Unlike duck decoys, they are generally small and much more easily transported or displayed. When displayed together in a grouping, folk art lures are traffic-stoppers; due to their inherent sculptural and aesthetic qualities, almost anyone is instantly and magically attracted to them.

When compared with fish and duck decoys, another major distinction occurs. That is, while most duck decoys look like "ducks" and most fish decoys look like "fish," a handmade fishing lure, well, can look like just about anything (fish, critters, bugs, birds, reptiles and more), or even like nothing at all on this earth.

Of course, the wide-ranging eating habits of game-fish partially explain this phenomenon. But, as you will soon observe through the photos, maybe fisherman are just more imaginative and creative at heart than hunters — or loopier — or their prey a bit denser. Any way you look at it, the depth and range of form evidenced in folk art fishing lures is far broader than that seen in either fish or duck decoys. To me, that makes for a more dynamic and interesting field.

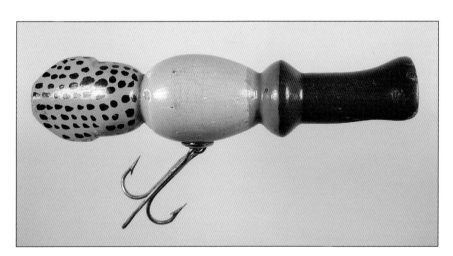

Colorful Surface Splasher – 4-1/8" turned, painted and varnished wood ca. 1920s–1930s. Belly cup and screw rig. Extended, line-tie screw anchor passes down deeply carved/cupped "throat". Design would certainly cause a major surface disturbance upon retrieve. What this abstract lure best mimics in nature is open to interpretation.

A Funny Thing Happened
While Becoming a Folk Art Collector

The impulse to make and own art knows no distinctions of gender, ethnicity, schooling, social standing, or economic necessity...The astonishing diversity of folk art reflects the life experiences, skills, ambitions and needs of those who made and acquired it. —Exhibition Catalogue, American Folk Art, Museum of Fine Arts, Boston, 2001

In the late 1980s when I began collecting lures with a passion, my primary loves were early miscellaneous lures (those made by smaller, more obscure, pre-1940 companies), and lures made by Heddon, inarguably one of the top lure manufacturers of all time. For years the opportunities were vast as I built my collection.

During a mild, "mid-life crisis" and with my amazing wife Glees urging, I decided to exit the executive rat-race and take some time off. With my family, health and peace of mind now a higher priority and income becoming less of one, I had only one problem: money! In order to raise some to help finance our major life-style transition, I decided to sell the majority of my lure collection – but, what to part-with first? Decisions were made, then, other decisions made after that; eventually, my collection was vastly reduced. Ultimately, I was down to only one 24" x 36" lure case and a bunch of "go-withs" (miscellaneous fishing tackle accessories).

What does all this have to do with my folk art collecting passion you ask? Well, hopefully you're still with me. Looking at that last case – the lures I waited until <u>last</u> to sell; well, it was like I was smacked in the head with a 4 x 4. The case contained a combination of old folk art lures I had picked up from time to time through the years (that for some reason I couldn't imagine parting with), and a bunch of factory lures that looked like folk art!

Lures like the early ABC Minnow, the North Channel minnow, an Algers, a Turners Casting Bait, a 6-hook Coldwater Finch, a Rhodes Kalamazoo Minnow, a Hansens Pull Me Slow, an early Pepper, a Browns, a Vermillion bait, a Medleys Crawdad, a Vann-Clay, a Pardee Frog, a couple of Donalys, several unusual factory wigglers with odd paint jobs and several other equally 'folky,' lower-dollar manufactured baits. Those unusual, $30 wigglers I had kept; the $1,000 Heddon Slope-Noses' I had sold. Wow.

Turning around and scanning my remaining go-withs (those I had kept), well, you guessed it – I was looking at homemade bobbers, hand-made bait tins and boxes, several unknown fish decoys, carved hand-lines, early brass winches and more of the same...

I'll never forget the feeling I got when it hit me. I WAS AND ALWAYS HAD BEEN A FOLK ART COLLECTOR! I just never realized it until that moment when lightning struck. Since stumbling into my *real* passion, I've never looked back; the rest, as they say, is history.

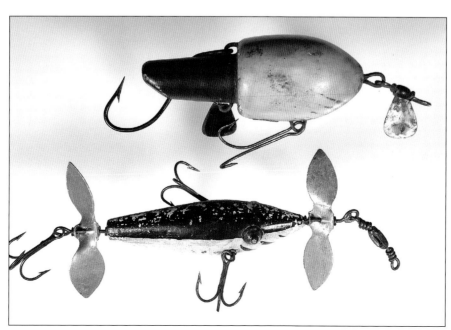

Pair of folk style, factory-made lures – Top: Donaly Redfin, Weedless, ca. 1910s. Bottom: North Channel Minnow – ca. 1900s.

Education

We have been told for years by many art historians that folk art falls outside the "mainstream" of American art and that it is secondary to the great pieces produced by highly skilled trained artists working in an academic or "school" tradition. One need only to look at the quality of the best folk art to realize this is inaccurate. Folk art has been and continues to be in the mainstream of American art. It is by and for the American people.— Dr. Robert Bishop, *American Folk Art – Expressions of a New Spirit,* 1982.

Education and the investment of time are critically important to build a base upon which one can confidently assess, value and purchase folk art. Personally, I feel the background in art, art history and design I had as part of my education in architecture benefited me. Having said that, you need not obtain advanced, related degrees to collect folk art; however, you must be willing to take and invest considerable time and effort in educating yourself in order to build an interesting, worthwhile and satisfying collection.

If you already collect primitives or folk art of any kind, I am sure you'll agree ones eye matures over time – with some instruction on the specific characteristics of folk art lures, you'll be good to go in reasonably short order. If on the other hand you avidly collect factory lures, you'll need to become a student again.

Collecting folk art lures is infinitely more complex than collecting documented (known) factory lures or color collecting. The road map to success is not linear and exacting. For example: "I need a (name your company), (name your lure number), (name your color), in (name your condition)." Documented factory lures have standard features that can be assessed with precision. With folk art, the road map is inexact and blurry – the road laden with both gold and pot-holes. Experience, good eyes, good judgment and good instincts trump precision.

If you are considering collecting folk art lures, I suggest you personally view and handle as many of them as you can. Ask questions. Talk to folk art lure collectors – if possible, view and study their collections. Carefully examine in detail individual pieces. Find out why a particular lure is in their collection; why they like it; what its strongest features are. When in the field, ask others' opinions on the relative merits of a prospective purchase. When authenticity is in question get additional professional opinions.

Using the guidelines in this book, develop and prioritize a grading/assessment system that works for you. When you see a piece that is available for sale or trade, ask yourself if you like it, if so, why and how much? If not, why not? Ask yourself if six months from now you will regret not picking it up. Of course if you pass, unlike factory lures, you will likely never see another like it. Even if you decide not to purchase an item, this review process will make it easier for you to make wise purchase or trade decisions.

The $2.00 Swimming Mouse

About seven years ago, at the huge annual lure show conducted each January in Milwaukee Wisconsin, I purchased the folk art mouse (illustrated here) for $2.00, in the first room I visited during pre-show trading.

While this 3" mouse appears as though it spent twenty years at the bottom of a lake, it nonetheless holds a certain charm and character that is difficult to put into words – through its image alone however, it amply represents and defines what a folk art lure is. Its maker hand-cut bead eyes of porcelain, then attached them with nails. Lacking a good piece of wood to carve, he chose scrap wood for his creation, forcing him to cut through 6 old nails in the process of shaping his mouse. With faded paint and in obviously rough condition, its long, hard life shows through.

I frequently include a table display at lure and sporting collectible shows, advertising for quality, early folk art lures. Always hanging from my "Wanted" sign is this little mouse. Invariably, several times a show, it attracts attention, comments and interest and I'm asked if he is for sale. Of course, my answer is always the same, "he is not." This mouse will never be valuable but will always be special. It underscores the special meaning and merits possessed by certain hand-created lures, and might be described as pure, utilitarian art.

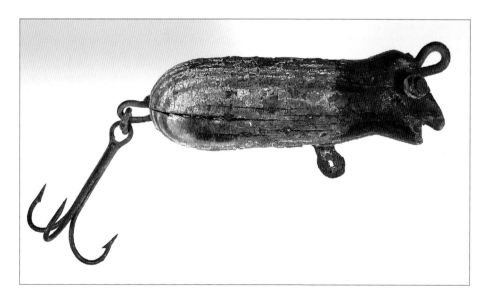

Collectibles Comparisons

Collecting taste will also continue to affect the folk art field...
Today the most important folk art is collected by art collectors who are
aggressively preserving their own rich cultural heritage. —Foreword,
American Folk Art, 1983.

A related educational topic is the likely evolution of the folk art lure arena. Duck decoy collecting has evolved and increased over the last 60+ years, and the fish decoy market over the last 30+ years. While collecting folk art lures and tackle has been going on for a while, interest and activity was fairly limited. In the last five to ten years, interest has grown substantially.

To use duck decoys as a model, initial broader interest was primarily centered among major factory-produced birds, such as those made by Dodge, Evans, Mason and Stevens. Since advertising pieces and catalogues existed, birds could be researched, identified and documented as to their makers and types. Documentation led to further collector interest. As collections matured, interests widened into lesser-known factory birds as well as individual regional carvers and styles. When quality handmade decoys became recognized as authentic folk art by the larger art community, further interest, growth and specialization occurred.

The Mystery of the Folk Art Lure Hunt

With literally millions of factory lures and duck decoys being produced since 1900, I am frequently asked why finding quality folk art fishing lures is seemingly more challenging than finding quality duck decoys. I have been told many times after a collector sees a nice grouping of folk art lures something to the affect of, "I've looked inside dozens of tackle boxes fresh from the field and I've never seen a single lure like that."

If one attends a large regional or national duck decoy show, it is hard to imagine not finding many choice examples one would readily add to their collection assuming adequate funds. Attend a regional or national fishing lure show however and the folk art lure pickings are usually slim. Why? I feel there are several reasons:

Due to the "seemingly" limitless availability of game birds in the later 1800s and early 1900s and huge demand for them by restaurants and hungry consumers, market gunners rose to prominence and had an insatiable need for duck decoys. Large, private hunting clubs were also formed – these too required hundreds upon hundreds of decoys for their customers. This demand was filled by commercial factories and independent carvers. Many of the classic early decoy makers were also guides and/or market gunners themselves and produced hundreds of decoys for the trade. Hence, while there never was large scale commercial "harvesting" of fresh water fish for the table, this was not the case for wild birds.

Therefore, lots of bird decoys from this era remain available to collectors. Scale or volume builds efficiency and enhances capability and quality. In contrast, production of a quality hand-crafted fishing lure was done locally to satisfy personal vs. commercial needs. Due to this limited need, a makers total output was minuscule, particularly when contrasted with well know decoy makers.

Duck decoy collecting started in the 1930s and has greatly expanded since, whereas folk art lure collecting is just getting legs. Knowledge, demand and increasing prices within a collectibles area draw out supply.

The first duck decoy carving competition/exhibition was held in Bellport, Long Island in 1923. It was won by Charles "Shang" Wheeler of Stratford, CT.(1) Such competitions drew both heightened interest and publicity. Importantly, these competitions also promoted the efficient production of _quality_ birds, laying the groundwork for decoys to eventually be recognized as objects of art. No such competitions ever existed for hand crafted fishing lures.

An immense library of books and base of knowledge exists in the duck decoy world. Such knowledge leads to expanding interest and results in confident buyers. Confident buyers expand a collectibles field. This is the first comprehensive book on folk art lures. Accordingly, the merits of a folk art lure already owned or being considered for trade or purchase has remained a mystery due to an information drought. Without information and benchmarking, how can one readily distinguish between the good and the exceptional?

A hunter generally needs a decoy "rig" (consisting of many decoys) in order to effectively draw birds within shooting range. Many thousands of rigs were ordered by market gunners, private hunt clubs and individual hunters. A fisherman on the other hand requires only one or two favorite lures for a successful day on the lake.

With very few exceptions, there simply was no "commercial" production of folk art lures. There were no regional "schools" of folk art lure makers employing similar styles or techniques. There were only individual fishermen with a personal, utilitarian need.

The truly limitless range and grand diversity of these individual fisherman's solutions to catching

fish is why folk art lure collecting is so interesting. Whether or not a new collecting field, or a logical extension of a folk art, duck decoy or fish decoy collection, the challenge of the hunt for quality folk art lures is very worthwhile. The elation felt by today's folk art lure collector when he turns up a one-of-a-kind golden nugget made by an unknown maker is surely the equal of a decoy collector adding another nice bird by his favorite known carver.

[1]Decoys – North Americas 100 Greatest by Loy S. Harrell Jr. © 2000 Krause Publications, page 158 and "The Decoys of Long Island – A Ward Museum Exhibition Sponsored by the Long Island Decoy Collectors Association" by Dr. Cynthia Byrd, *Hunting and Fishing Collectibles Magazine*, March-April 2010, page16.

Though lagging by more than three decades or so, fish decoys have followed a similar path. Specialized books have been published identifying regional differences in form, style and assembly as well as works documenting individual carvers and carvers from specific states. Once again, as a by-product of published reference works and increased recognition within the folk art community of the many merits of fish decoys, interest and prices have increased.

I suspect folk art fishing lures and tackle will follow the same path. This book is the first of its kind focusing on folk art fishing lures. Quality folk art fishing lures possess all the elements necessary to be recognized as fine folk art objects. In the duck and fish decoy fields, the earliest collectors who intelligently acquired worthwhile examples, while investing the time and effort to study, research, and document the area have enjoyed great success.

A Confirming Revelation

I read with great interest the article "Joel Barber and Adele Earnest – Visionaries Who Defined Decoys as Folk Art" by noted authors, influential duck decoy collectors and internationally known folk art collectors, Gene and Linda Kangas. The Kangases posited that the pioneering decoy collecting efforts of Joel Barber (1876–1952) and Adele Earnest (1901–1993) and their subsequent study and publication of ground-breaking books on the subject, were largely responsible for deserving examples being accepted by the art community as fine examples of American folk art.*

The Kangas' superb article—about the subtle elements and messages communicated by the maker to a viewer through an object of art serves to re-confirm my belief

that, on a number of levels, there are many commonalities between folk art duck decoys (fish decoys) and folk art fishing lures. More than a half-century ago, authors Joel Barber and Adele Earnest advanced that certain decoys, some quite simple in form—primitive even, many showing decades of hard use and wear— possess intangible qualities that rise far above a carved and painted piece of wood - I believe that same type of spirit, presence and character are evoked by certain folk art fishing lures.

*Published in the January/February 2009 *Hunting & Fishing Collectibles Magazine*, pages 8-16. I encourage readers to obtain a copy of this Magazine, which can be ordered through H&FCs website at www.HFcollectibles.com

Today the folk art lure area is fertile and ripe for research and study. For example, because the majority of all folk art is anonymous, there are few known lure-makers – and fewer yet who have been researched in detail. Several new names are presented here.

With this overview, I hope I've positioned the folk art lure collectibles area as being both a challenge and an opportunity. For the collector willing to invest the time to learn about the folk art field, and who is excited by the prospects of plowing new ground in a growing folk art category, great opportunities await.

Judging Quality and Establishing Values

The style of the typical American Primitive is at every point based upon…what the artist knew rather than what he saw, and so the facts of physical reality were largely sifted through the mind and personality of the painter. The degree of excellence in one of these primitive paintings depends upon the clarity, energy and coherence of the artists mental picture rather than upon the beauty or interest actual inherent in the subject matter…—Jean Lipman, American Primitive Painting, 1942

First and foremost, just because a particular fishing lure or tackle item is made by hand *does not* mean it is folk art. The folk art designation is not appropriate for all things homemade – far from it. Unfortunately, in the vintage fishing tackle realm, the term "folk art" is tossed about with wild abandon. However, the key word in folk art is "art." To transcend the norm and "qualify" as a legitimate folk art object, a hand crafted lure must attract and hold ones interest through aesthetic and visual appeal. Objectively judged, I would estimate that less than 5% of all vintage handmade lures found fall into this category.

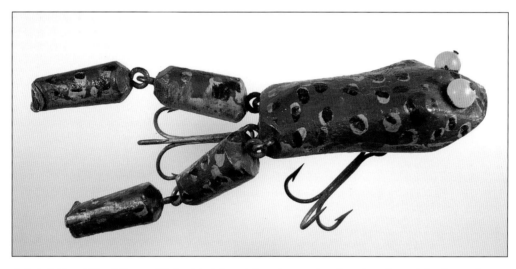

Jointed, Bead-Eyed Frog – 5" double jointed, hand carved, painted and varnished wood ca. 1930s (found in a tackle box from Dundee, Michigan). Large, opaque glass bead eyes secured by nails. Screw eye, (under-nose) line tie, hook hanger and joint hardware. Remnants of nailed-on rubber feet once attached to base of legs.

Many people would argue that assessing the quality of folk art lies in the eye of the beholder. While that is partially true, I would argue that most could agree what a crude, unappealing lure looks like when they are staring at it – and conversely, what a creative or superbly rendered one looks like (even if quite simple or primitive). Lures that cannot meet the aesthetic hurdle should more appropriately be presented as made by hand, homemade, hand carved, hand painted or similar. That being said, as with all categories of art, even educated eyes will often disagree on the merits or strength of a particular example. That's not a problem, it's a benefit. Debating art objects is provocative, educational and worthwhile. The opportunity to personally reflect upon, intimate and interpret folk art is why the area is so exciting and addicting to its many fans.

A good piece of folk art of any kind will stand on its own merits and put ones imagination to work. However, there are certain benchmark characteristics that can help measure quality. Even though subjective judgments enter into play, the following attributes are helpful in evaluating the quality of a folk art lure. In some combination and priority, depending on an individuals own preferences, some key attributes are:

Your first impression upon seeing and handling it – remember, as mentioned above, the key word in folk art is "art"

Age. In folk art, older is usually better

Uniqueness

Strong visual appeal; quality of form (scale, line, contour, proportion)

Paint type, appeal and quality

Surface finish and patina

Known maker or provenance

Assembly and build quality

Overall condition

'Fish-ability.' Is the lure properly designed, weighted and balanced, the hooks properly sized and presented? Will the lure work as intended and catch/hold fish?

Type and nature of rigging, hardware and any attachments employed

Type, mix and quality of materials used

Joints, moving parts or other mechanical attributes

Bottom-line? Some folk art lures are aesthetically pleasing, others are not; some folk art lures will stimulate the imagination and speak to you, others won't. If a lure doesn't speak to you, pass it by. If it does, and your gut instincts remain favorable after careful inspection using the above criteria, you should seriously consider acquiring it assuming it's within your budget – or, as many of us know from experience, you might regret it. After all, unlike manufactured lures, you will NEVER find another.

The best way to buy American folk art is with your heart and your eye, not your investment funds. —Helaine Fendelman and Susan Kleckner – *Collecting American Folk Art,* 2004

Values

Valuing folk art lures is difficult and fairly subjective due to the nature of an emerging, untested market, and the lack of data on past sales. Unfortunately, today there are no real 'rules' for pricing folk art lures either as a seller or buyer. It's a given that in the realm of folk art lures every piece is unique. After evaluating a particular piece using the quality attributes above, valuation basically becomes what the seller feels he should get layered against what a buyer feels its worth to him. For these reasons I have chosen not to quote prices on lures featured in this book.

Having said that, my *general* view of current valuations in today's market are:

Desirable, vintage folk art lures may still be had around $50, often less

Very good folk art lures remain attainable between $100 and $250

Great folk art lure examples may range between $250 and $500

Exceptional pieces may be priced from $1,000 up

Values and Possible Trends

Since one of my objectives for this book was to provide some historical context and comparison of folk art lure collecting to fish decoy and duck decoy collecting, the following valuation trends should be considered.

In both the duck decoy and fish decoy categories, quality pieces created by individual carvers/folk artists (whether or not created for personal use or sold into the trade), are generally valued significantly higher than its factory produced "equivalent." With the eventual classification of certain fish decoys and duck decoys as authentic folk art objects, coupled with the ever-expanding interest in quality American folk art, this valuation trend has accelerated.

This is NOT the case for folk art lures. The valuation of quality, classic manufactured lures has generally been significantly higher than its folk art "equivalent." Because quality folk art lures have yet to be "discovered" and recognized by the broader sporting collectibles and folk art communities, the author believes this trend may change over time.

Condition and Legitimacy

In collecting American folk art, condition refers to...the degree to which the object retains the original elements or decoration of its maker without any alteration, restoration, or 'help' from a later hand. Those objects that survive entirely unaltered from their original state are called 'pristine.' Though these may appear faded and abused, that's because they are untouched from the day they were made!—Helaine Fendelman and Susan Kleckner, *Collecting American Folk Art,* 2004

The assessment of condition on an old folk art lure is quite different than on a mass-produced factory lure.

On factory lures, condition-conscious collectors strive for absolute perfection. Any minor ding, scratch, chip, dent, hook drag, age line, age crack, smudge, mark, varnish or paint wear is a demerit and affects value – often precipitously.

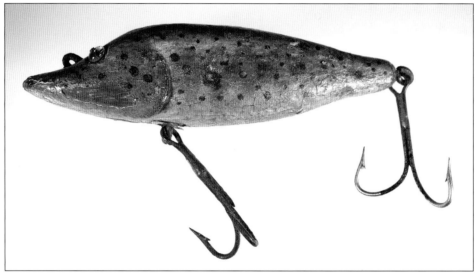

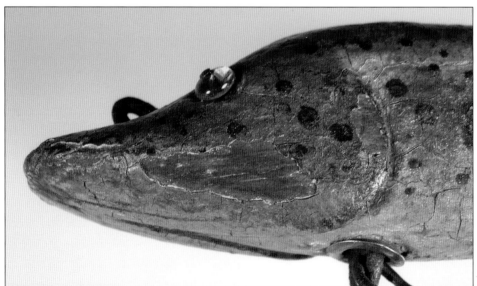

Fatty "Rainbow" Pike – 4-1/2" hand carved, painted and varnished wood ca. 1910s–1920s. Exceptional form and paint – rich surface patina. Glass bead eyes, nail applied. Very heavy fixed through-wire in both directions form the line tie and hook hangers. Metal cup at belly hook hanger. Deeply carved gills. Treble hooks cut and converted to doubles by the maker.

This is not true for folk art lures. In folk art, while overall condition certainly affects value, collectors look for form, as–made originality, completeness, and the look and feel of the surface/paint finish. When evaluating folk art, most collectors prefer an object show character and signs of legitimate age. A rich as-found surface patina and signs of authentic use are not demerits and are often pluses. Consequently, with folk art lures, some flaws of most types can usually be overlooked and in general, do not measurably affect value, assuming they are legitimate.

In the art world, professional restoration is commonplace and frequently recommended, especially in certain instances. Duck decoys are frequently enhanced/restored to varying degrees – depending upon the specific restoration, this can add to or detract from value. Often, when done prudently and professionally, documented restoration will not adversely affect and may enhance the value of a duck decoy (vs its un-restored state).

Today, modification and restoration of factory (manufactured) lures and, to only a somewhat lesser extent, fish decoys is generally discouraged. Any restoration may affect value, and most certainly must be documented at time of sale. If folk art fish decoys follow the duck decoy market, current attitudes may change over time. Since folk art fishing lures are (or will be) viewed both as 'art' and as 'lures,' the jury is out on restoration. Since we are viewing such lures as art, if the defect is highly objectionable, correction may be warranted so the lure can be properly displayed and enjoyed. Having said that, since many collectors of folk art fishing lures may previously have collected factory lures, any restoration will be unacceptable to many. Either way, restoration must be documented and openly disclosed. Time will tell whether or not prudent, documented restoration adversely affects folk art lure values.

Moving out of the deep water, just as with collectible factory lures, tightening hardware or adding age-appropriate missing hooks, swivels, screws, etc. is usually acceptable. While minor cleaning may be appropriate in some cases, washing, polishing or waxing folk art lures is a definite no-no. A word to the wise – if in doubt, doing nothing can't hurt you and is nearly always best.

How do you know your latest find is legitimate?

...for example, the best folk portraits achieve a marvelous vigor and economy of line. The artist was obviously inspired and dashed off a very strong and forceful likeness of a real person. Look at the fakes and you see eyes, mouths, and nose- all in their proper places but hardly representing real people. It is as if the police sketch artist was turned loose with assorted features and told to make folky portraits.—Samuel Pennington, April Fool – Folk Art Fakes and Forgeries, 1988

Fortunately, because collecting vintage folk art lures is at an early stage, misrepresentation and fraud is not common *yet*. However it *does* exist. Let the buyer beware. Educate yourself and exercise caution. Know who you are buying from. Learn how to recognize the signs of genuine age. Learn to recognize an authentic *old* surface. If in doubt get a second or third opinion. I do.

Following are some considerations to determine if a lure is authentic or contrived:

Does the surface finish show (genuine) age and wear? Age cracking/crazing/checkering or age lines will often be present and should appear natural. Is the surface dirty? The affects of aging, wear and/or damage should never be consistent over the entire lure. For example do the sides and contact surfaces show wear that would have occurred in a tackle box or through normal handling, while protected or recessed surfaces show less wear?

Materials, hardware, hooks and paint should all be age appropriate. Any metallic or painted wood surface should have an appropriate 'patina.'

All aspects and components of a lure, including 'found' products, should be age appropriate. For example, plastic bead eyes were not used on lures from the 1910s or 1920s. Generally, bright shiny enamel paints weren't available for common household use in the early part of the 20th century.

Unless special paint layering techniques have been used, the painted surface (after decades of handling and use) should be smooth to the touch.

Any cut-metal parts should have smooth, not rough or sharp edges.

Question surfaces showing wear where it would not naturally occur through use, surfaces with uniform scratches/dents or surfaces that appear sanded.

Interior hardware not exposed to light and wear will appear different than hardware which was exposed to light and wear. Tips of wire should not be 'bright;' fresh surface scratches should not exist. While a rare exception does exist, poured lead belly weights will be dark grey, not shiny silver.

Are there legitimate signs of use – i.e. are minor bumps and bruisers, paint peeling or flaking, hook pointers or hook drags where they should

be, etc? Original, bare wood surfaces exposed decades ago by paint dings or flakes should have oxidized to a darker color.

Study any lure that looks "too good to be true" very carefully.

Dirt, dust and grime collects in pockets and crevices over time – look for the "grunge." It should be there.

Ask or determine what the circumstances were when the lure was found. If it was found in a box containing 1930s and 1940s factory lures and accessories dated to the same period and it passes on the criteria above, chances are you have an authentic 1930s-1940s folk art lure.

Expanding this discussion, I will offer an example:

You inspect a lure with a fine warm patina with uneven wear evident. There are signs of heavier wear in areas that came in contact with the tackle box. Cracking, crazing and checkering of the paint is uneven. Hardware is wire-through. The diving lip and rear prop are smooth to the touch. The solder has discolored over time. The eyes are hand-formed glass beads, secured by old nails. The screws are hand cut. The hooks are hand assembled. There is dirt and grunge in the crevices. There is a good chance you are holding a lure from the 1920s (+/-).

There are several excellent references to help you avoid mistakes in the folk art market. Some of the best follow – each is well worth reading.

Hirschl & Adler Folk Exhibition Catalogue "April Fool – Folk Art Fakes and Forgeries," presented by The Museum of American Folk Art, *Maine Antique Digest*, Samuel Pennington, Guest Curator, 1988.

Relative to the fish decoy market, some readers will undoubtedly be aware of "Mikko" type fish which have been artificially aged. Introduced more than 20 years ago and still being made for the decorator and collectibles markets, these unmarked fish decoys have been purchased and resold into the collector market for years as authentic fish with genuine age. Many of the cautions related to legitimacy in the folk art fish decoy market ring true when considering folk art fishing lures for purchase. The Dakota Trading Post contains an excellent section on how to recognize these fish. Different "aging" techniques are examined – it is very educational. To reach it go to: www.spearingdecoy.com/fishdecoys/mikkoprimer.htm

A second article on Mikkos and other contrived fish decoys was authored by John A. Gabriel © 2007. It too is quite informative and may by found at the website *Fish Decoys Net*™ — the particular link to locate Gabriel's article is www.fishdecoys.net/pages/Story/MikkoDecoys.htm

Related to collecting antique fishing lures, Gabby Talkington maintains a super website Antique Lure Collectibles. It can be accessed via this address: www.antiquelurecollectibles.com. There are many areas of interest on this great site, but two are most pertinent to this discussion. First is the section "Protect Yourself From Lure Fakes" (a part of "Lure Collecting Knowledge Part II"). The address for this section is: www.antiquelurecollectibles.com/Articles/Lure_Knowledge2.htm#fakes. Second is the web address to read an excellent summary of how to properly use a black light: www.antiquelurecollectibles.com/Articles/Detecting_Fakes_and_Repaints.htm.

Phil White's popular website, *old fishing stuff*, contains a section on fakes and forgeries. It can be accessed at the following address: http://oldfishingstuff.com/fakes.htm

Finally, Stefan Duma's fine website, Antique Tackle Observer, contains a section on forgeries: http://www.antiquetackleobserver.com/forgeries.htm

General Notes

Is the object put together in the way it should be for its time and place of manufacture? Knowing what materials, tools and techniques were available at what time will tell you approximately when an object was made or when it was repaired.— Helaine Fendelman and Susan Kleckner – *Collecting American Folk Art,* 2004

Dimensions provided (unless noted otherwise) represent the length in inches of the lure body itself and does NOT include attached hooks, hardware or other appurtenances.

Recall that for lures, 'fish-ability' is critical – is the lure properly designed, weighted and balanced, the hooks properly sized and presented? Will the lure work as intended and catch/hold fish? The way in which the makers solved the design and fish-ability challenge varies substantially between makers. There is also a wide range of raw materials used to construct folk art lures. With the exception of the Vintage Folk Art Classics Section, I have therefore added detailed descriptions to most featured lures to highlight the materials and assembly techniques employed.

Having said that, in many cases its nearly impossible to figure out just how those guys did it. They are that good! In many cases x-rays would help. In the spirit of full disclosure, I can also say I'm no craftsman or mechanic. However, I have handled thousands of individual lures. With that disclaimer, its my hope that describing the "how" adds interest and will add further dimension to what I'm sure you'll agree is a remarkable range of ways individual fisherman approached building a fishing lure.

Unless the exact date of a lures creation is fixed in time through a verifiable provenance, please consider the date/date-ranges provided for each lure to be "educated estimates" based upon the authors experience given an objects surface characteristics, the materials used and the construction techniques employed by the maker. To lessen the debate, just assume I've inserted the word "probably" (or "perhaps") before each date provided.

Part 2
Folk Art Themes

What is the particular appeal of folk art? ...the answer might be found in an elemental beauty and sense of charm that makes this unpretentious art a pleasure to live with. — Anonymous, *Folk Art,* Time-Life Books, 1990

Through the sections and photos that follow, readers will gain an appreciation of the merits of vintage folk art lures; some may even be inspired to collect them. To best demonstrate the scope of the folk art lure field, the sections are organized by major themes: (1) Primitives, (2) Folk Art Lures, (3) Vintage Folk Art Classics, (4) Siblings and Collections, (5) Good Things Come in Small Packages, (6) Folk Artists, (7) Fisherman-modified Factory Lures, (8) Folk Art Tackle Collectibles, and (9) Contemporary Artists. Each section is introduced by a brief narrative.

This organization can provide insight into how a folk art lure collection or grouping can be arranged and presented for maximum appeal. Finally, after observing the full array of vintage folk art lure themes and hundreds of individual examples, many readers will have their favorites. Should they decide to collect folk art lures, this experience will prove invaluable.

Primitives

The Primitives are often fascinating in their technical artlessness which is probably one cause for their appearing so genuine and so winning...Fortunately, they had no academic training. Because of this they sometimes lacked the ability to describe, but it certainly did not hinder their ability to express. —Maxim Karolik

Just as debate surrounds the true definition of folk art and its expansion throughout the 20th century, so do the words 'primitive' or 'primitives' suggest different meanings to different people. Once again I do not intend to extend this debate -- just clarify it as it relates to vintage folk art fishing lures. Primitive folk art lures are seen as an important sub-category in the following example.

A nicely made, unfinished, wire-through English walnut has been fashioned into a lure, and a second walnut painted and functioning as a bobber. Both are pure, simple, economical forms that show great creativity. Essentially unadorned, they are nonetheless well crafted and executed. Each is functional and intended to be used. All the foregoing characteristics are attributes of traditional folk art. But part of the basic appeal of these two pieces is that they are quite unsophisticated and unrefined when contrasted with other lures and bobbers, even hand-made ones. These have a certain unschooled or child-like innocence about them. Yet, while being simple primitive pieces, they have artistic merit and are most certainly not 'crude.'

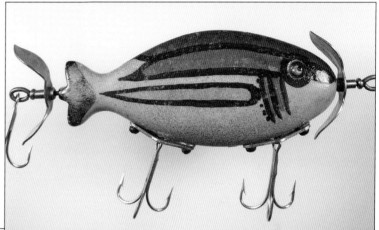

Colorful Sunny – 3-3/4" shaped, painted and varnished wood ca. 1930s. Inset glass eyes. Screw-eye line tie and tail hook hardware secure thrusted front and rear props. Lead belly weight. Well made, aluminum 2-piece type belly hook hardware. Internal wire hook hanger passes through hook hanger plate, the ends of which are turned and secured by screws at each end of the belly plate pieces.

In contrast to the walnut lure and bobber, this old sunfish lure has a simple, economical form, shows great creativity, is well crafted and is intended for use. Yet it has recessed glass eyes, bold, exuberant paint, lots of fine detailing, a nice varnish finish and exquisitely made aluminum hook hardware. This lure is anything but primitive.

A primitive piece may be colorful or striking but is more elemental and simplistic than the lures illustrated in Section 2. There are no absolute rules as to what precisely a primitive is, and what it isn't, within the folk art field. Judgments are applied. Hopefully readers will find many pieces they appreciate and enjoy in both the Primitives and Folk Art Lure Sections.

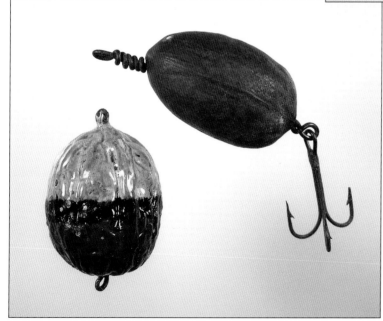

Walnut Duo – This pair speaks to the simple possibilities available to the creative mind through the use of everyday objects. Upper Right: English Walnut Lure – 1-1/2" natural English Walnut ca. 1930s. Wire-through rigging serves as the line tie and tail hook hanger.
Lower Left: Paint decorated Walnut made into a float (bobber) by Burt Errett, Ohio. ca. 1930s. (For more on Burt Errett, see page 195).

Make-do Lures

The term "make-do" refers to a lure that is made utilizing some "found" object(s) commonly available at the time the lure was produced. Due to their nature, many make-do pieces are primitives, thus I include them here. Common objects that come to mind in this category are lures made from old silverware (i.e. spoons) and those made from old clothespins. Some of these are pictured. But the imagination of old-time fisherman goes way beyond that. As you will see throughout the book, for some reason just about anything imaginable could be utilized as raw material for lures.

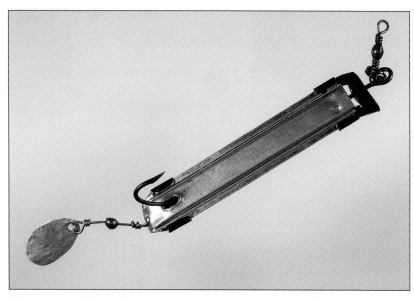

This vintage, "File Folder Clasp" spoon incorporates a handmade drop-spinner assembly. Hook Positioning is secured by the file tab's sliding clips. Creatively made by Burt Errett, Ohio.

Bottle Opener Lure by Burt Errett, Ohio – Body is fashioned from a hand-cut and hammered Schmidt's beer bottle opener; it uses a hand-tied, rivet attached hook and hand-fashioned weed-guard.

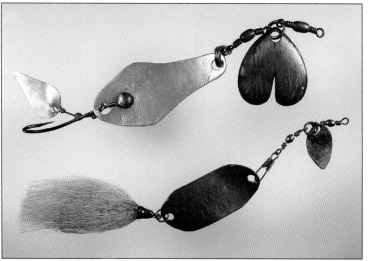

Pair Handmade Spinners by Burt Errett, Ohio – Top: Swivel-mounted, brass, heart-shaped fore-spinner attached to a hand-cut aluminum spoon holding a rivet-attached single hook and hand-cut drop spinner assembly at tail. Bottom: Brass, hand-formed Logan County dog license tag stamped 1951. As Errett passed away in 1952 this may have been the last lure he made. Attached at the rear is a hand-tied bucktail single hook; at the front is a hand cut fore-spinner assembly.

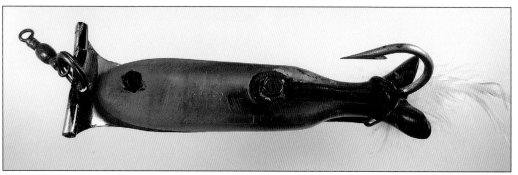

Door Hinge Fish-Spoon by Burt Errett, Ohio – 4-1/2" carved plastic fish mounted through-body with screw and nut assemblies to an etched, stamped, hand re-formed aluminum door hinge ca. 1940s. Hook is set in a carved groove and anchored by a nut and bolt at the hook eye and double-wire wrapped at the tail.

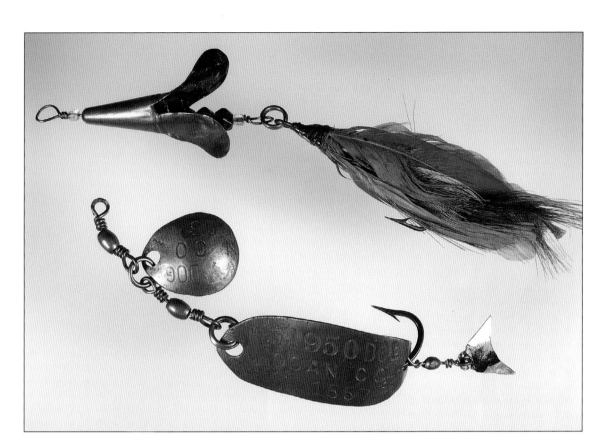

Make-Do Spinner and Spoon Pair by Burt Errett, Ohio – Top: ca. 1930s South Bend style spinner fashioned from an old "Faber" pen tip receptacle. It is mounted to a wire-tied shaft with glass beads and bearings. Hand tied rear feathered, single hook. Bottom: Spinnered spoon fashioned from an old pair of (dated) 1950 Logan Co., Ohio copper dog collar tags. Single hook is secured via holes at the front and rear of the spoon using a split ring (front) and formed wire (rear). This wire houses a homemade drop-spinner rig. Tail spinner is fashioned using a hand-cut, aluminum flasher with paint accents.

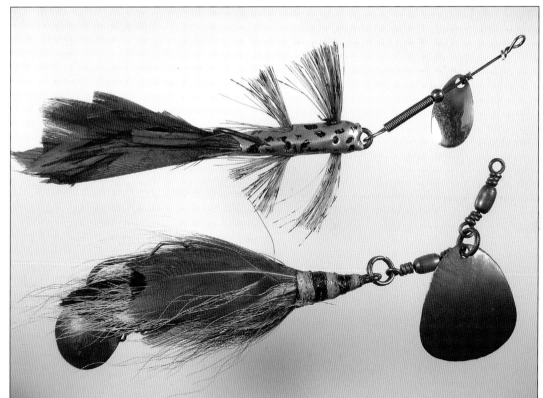

Make-Do Spinner Pair by Burt Errett, Ohio – ca. 1930s. Top: Feathered, fly lure made from a vintage, paint decorated, lady's aluminum hair roller that shrouds a nicely tied, feathered, single hook. Side holes house through-bristle attractors. Unmarked, factory fore-spinner. Bottom: Bing's weighted weedless hook tied with feathers and hair to simulate a bee or bug. Painted and varnished line wrapping secures these materials. Has hand cut and formed, copper fore and tail spinner assemblies.

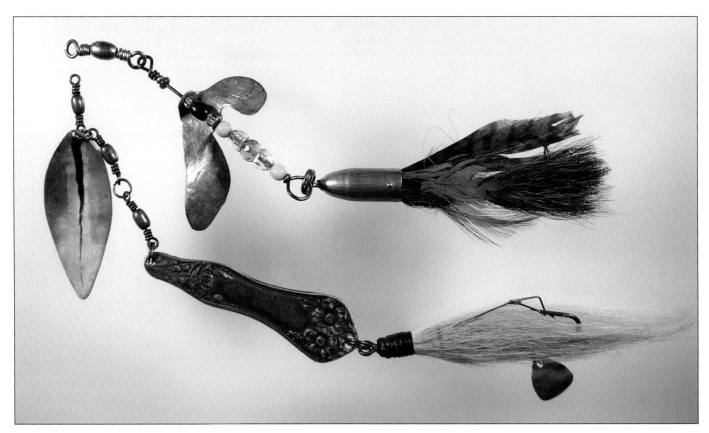

Metal Spinner/Lure pair by Burt Errett, – Ohio ca. 1930s. Top: Arrowhead Spinner – Body fashioned from a vintage arrowhead around a core wood body. Between these, feather and squirrel tail is tied and secured. Hand-cut and formed eccentric steel fore-spinner revolves around a formed wire shaft strung with 10 glass beads/bearings. Bottom: 3" sterling spoon-handle body with modified, weighted, weedless Bing's hook attached. Bing's hook has been hand-tied with animal hair and contains a hand-made steel drop flasher attachment. Handmade willow leaf fore-spinner has tasteful paint and varnish accents.

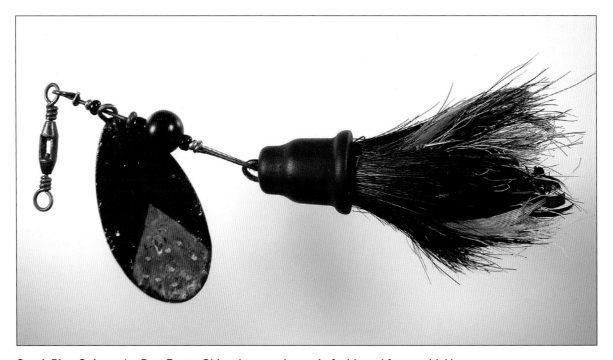

Spark Plug Spinner by Burt Errett, Ohio – Large spinner rig fashioned from a thickly painted and varnished 2-1/8" fluted spinner-blade mounted on a handmade, twisted wire shaft with various colored beads and metal bearings. Attached is a vintage rubber spark plug cap housing a combination bristle brush/feathered tail.

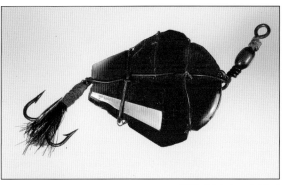

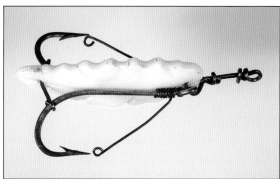

Ribbed Pearl Flasher – 2″ carved (curved) mother of pearl body in wire frame ca. 1930s. Elaborate turned wire, steel and brass frame secure the pearl body to the flush mounted hooks front and rear. This wire additionally forms the line tie and weed guards.

Ruby Glass Lure – 1-1/2″ cut-glass lure ca. 1930s. Simulating an injured (bloody) sunfish, a piece of re-carved, salvaged glass is fitted with a hand woven and soldered brass and steel wire cage.

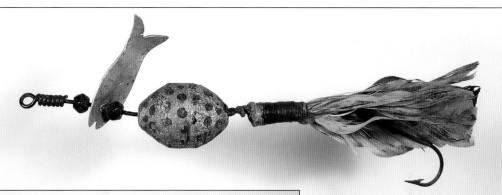

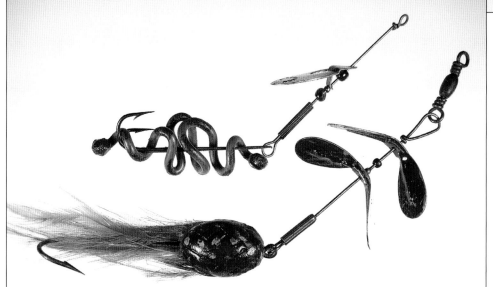

Spotted Cork Spinner – 5″ overall with 1″ painted cork ball ca. 1930s. Two piece, twisted, fixed through-wire. Tail festooned with red, white and blue painted feathers secured by colored thread, over-wrapped with painted and varnished cording. Faceted red glass beads accentuate fish-shaped cut tin spinner.

Teaspoon Bait – 2-1/8″ modified silver teaspoon, ca. 1930s. Three drilled holes used to attach box swivel, line-tie and pair of double hooks mounted to brass rings. Rear hook is formed by two single hooks soldered to the spoon.

Pair, Burt Errett Fly Spinners
ca. 1940s – Top: Factory insect (double) hook harness rig wrapped with vintage, coated, electrical wiring with paint accents in the shape of a worm. Each end of the wire terminates by being inserted into a paint-accented, glass bead. Employs a Marathon factory spinner.
Bottom: Unusual hand-split glass bead with paint accents is sandwiched around hook and tail feather decorations. Employs a tandem Pflueger fore-spinner.

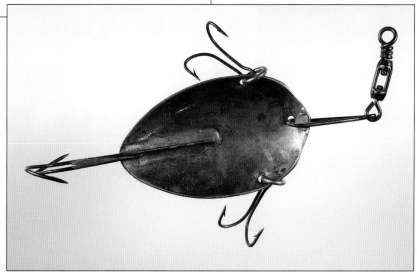

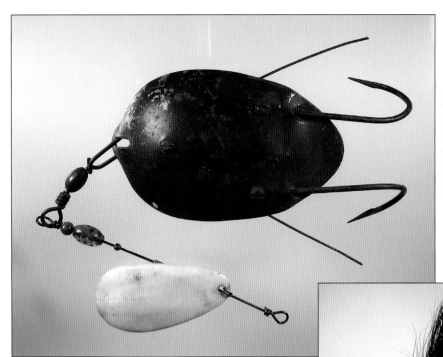

Giant Musky 'Spoon' Bait (Michigan) – 4",
12" overall; painted, reformed, vintage metal
ladle ca. 1920s. Heavy swivel with attached
brass leader containing 2-1/2" pearl spinner
and blue glass beads, one dimpled. Two large,
early black japanned hooks and formed, black
painted wire weed guard, each secured with
hand-cut screws and old square bolts.

Black Spotted Bird – 3" carved, painted and
varnished wood, ca. 1930s. Unusual form. Painted
eyes. Screw eye line tie and rear hook hanger.
Through-body, human hair wings.

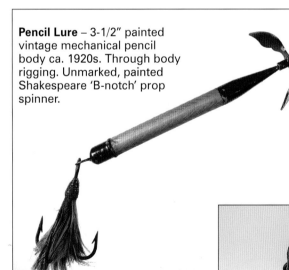

Pencil Lure – 3-1/2" painted
vintage mechanical pencil
body ca. 1920s. Through body
rigging. Unmarked, painted
Shakespeare 'B-notch' prop
spinner.

Deep Cut Gill Diver – 4-1/2" turned
and carved varnished wood with
red paint accents ca. 1940s. Internal
fixed wire hook hangers. Screw eye
line tie.

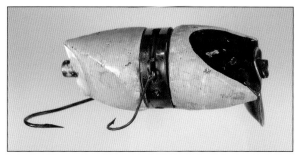

Crazy Arrow Diver – 2-1/2" shaped, painted and varnished wood ca. 1940s. Brass end caps and brass through-tube which anchors metal diving lip. Recessed, fitted metal collar holds two hooks of different sizes.

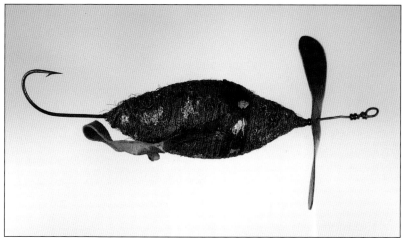

Primitive Spinnered Mouse – 3" painted and varnished cording wrapped around a weighted, wood body, ca. 1920s-1930s. Wire leader with hand-cut copper spinner and tiny glass bead bearings. Embedded single hook – leather 'strip' legs.

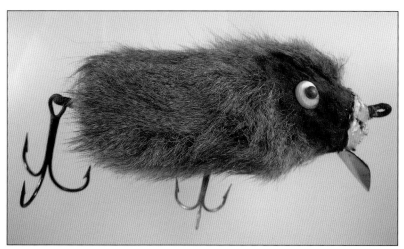

Furry Mouse – 4" carved wood body wrapped in fur. Pearl button eyes secured by round metal tacks. Screw-secured, hand cut and formed steel diving lip. Fixed, through-wire line tie and hook hanger hardware. Quite a few by the same maker have turned up. I would estimate age as 1950s though some feel they are much earlier.

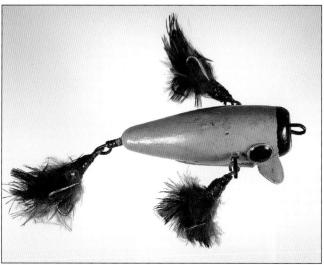

Feathered 3-Hooker – 2-1/8" turned, painted and varnished wood body ca. 1950s. Painted tack eyes. Fixed, through-wire hook and line tie rigging in both directions. Hand tied chicken-feather on hand-made side and rear treble hooks. Cut and formed aluminum diving lip secured by screws.

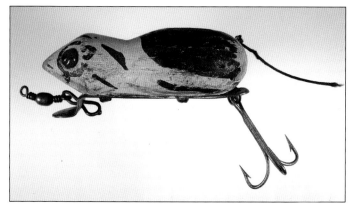

Red-Eyed Mouse – 2-3/4" carved, painted and varnished wood, ca. 1930s. Full length brass plate and combination reinforcing/ diving lip is secured by two brass screws, through which, at the front, a formed brass wire passes. This wire secures the barrel swivel line tie. A split ring attached to the rear end of the plate holds rear hook. Corded tail is held in place by a screw. Red glass bead eyes are secured by nails.

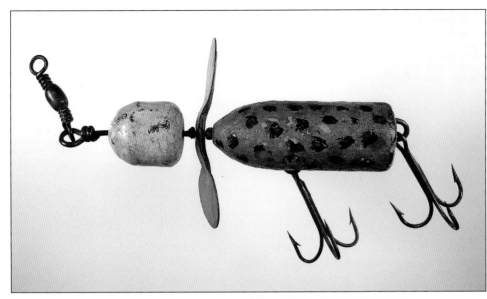

Early Surface Spinner – 3-3/8" two-piece, painted wood body mounted on heavy brass through-wire ca. 1910s. Cut-down, early Pflueger reinforced spinner with "R" (right turning) stamp. Metal bearing at rear and solder 'keeper' behind front section. Wire belly hook hanger.

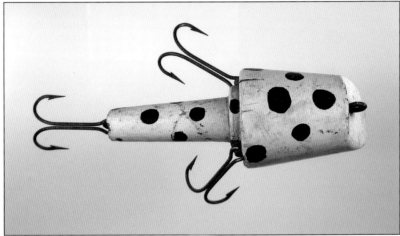

Spotted Diving Wiggler – 3" turned, painted and varnished wood ca. 1930s-1940s. Screw eye line tie and hook hanger hardware all around, recessed at the side and tail hook locations.

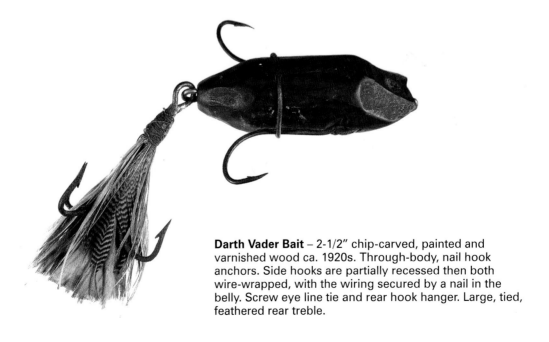

Darth Vader Bait – 2-1/2" chip-carved, painted and varnished wood ca. 1920s. Through-body, nail hook anchors. Side hooks are partially recessed then both wire-wrapped, with the wiring secured by a nail in the belly. Screw eye line tie and rear hook hanger. Large, tied, feathered rear treble.

Early Brassy Deep Diver – 3-5/8" carved, painted and varnished wood ca. 1920s. Flat-iron through-wire in both directions forms the line-tie and rear hook hanger – belly hook wire hanger which passes through the back, is hammered flush and anchored by an iron, flat-wire staple. Hammered tack eyes, painted. Wide, formed brass diving lip (which is inset into the body and follows the lower lip) is secured by a nail.

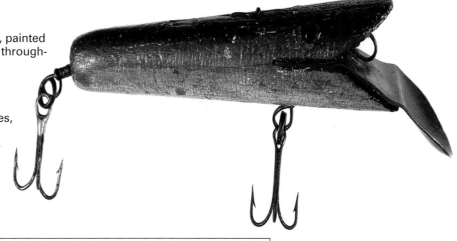

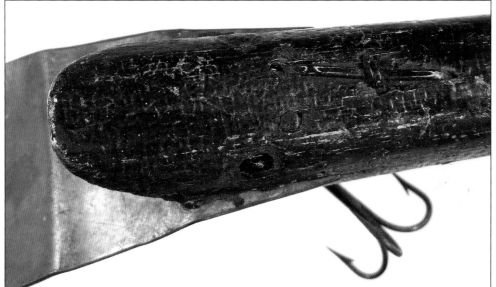

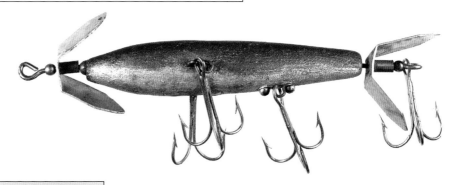

Early 4-Hook Underwater Minnow – 3-3/8" carved, painted and varnished wood ca. 1920s. Mounted on the through-body steel wire are hand-cut and formed aluminum props, soldered to brass tube washers; round, metal bead bearings. Two hand-poured, lead belly weights. Side and belly hooks secured by Stump Dodger-type wire hook rigs secured by screws.

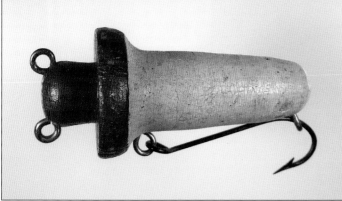

Stubby Woodpecker – 2-3/4" turned, painted and varnished wood ca. 1920s-1930s. Single black japanned belly hook, reinforced by tail screw eye. Steel screw eyes all around. Note unique double line tie.

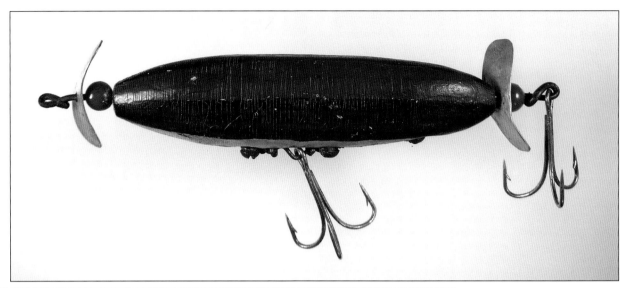

Spinnered Melon Lure –
4" wire-through, carved,
painted and varnished wood
ca. 1930s. Pair hand-cut
aluminum props with green,
glass bead bearings front
and rear. Inset rear lead belly
weight. Wire belly hook
attachment is secured by 2
brass screws.

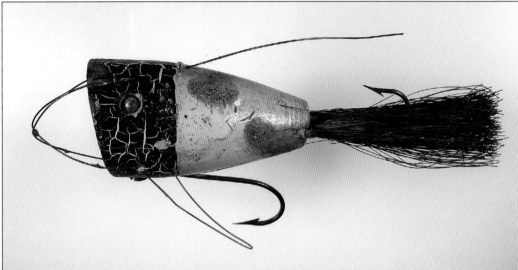

"Guarded" Red and White Popper – 2-1/4"
turned, painted and varnished wood, ca. 1930s.
Inset glass bead eyes, nail secured. Belly single
hooks anchored by brass screws with rear single
hook attached via a nail at the belly. Inlet, natural
bristle at tail; double, front wire weed guard
connected by solder at the connecting point with
4 wire staples connecting the guards to the lure
at the head. Formed belly weed guard staple
secured at 'cheeks'. Single, back-mounted weed
guard is staple secured.

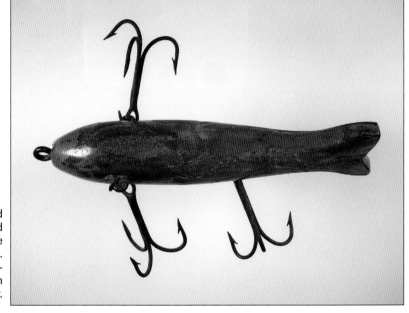

Heddon Proto Natural Fish Minnow – 3-1/2" carved
and varnished natural wood, ca. 1920s. Was acquired
in trade from the tackle box of Trig Lund by Steve
Craft in exchange for a roofing job on Trig's house.
Two lead belly weights; screw eye line tie. Wire-
through side and belly hook hardware, each with an
imbedded wire hook restrainer/limiter.

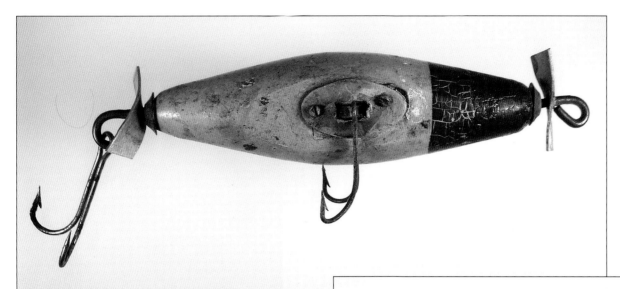

Two Piece Red & White Injured Minnow – 4" carved, painted and varnished wood ca. 1930s. Heavy brass wire line tie and hook hanger. Hand-cut Heddon type 2-piece style plate and bar belly hook hardware, screw attached. Brass nose and tail caps. Small hand cut aluminum props.

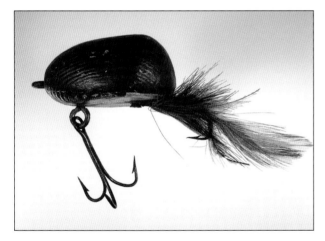

Black Feathered Chunk Bait – 1-3/4" carved, painted and varnished wood, ca. 1930s. Tied, feathered 'blued' rear single hook secured by a screw to the belly. Screw eye hook hanger and line tie.

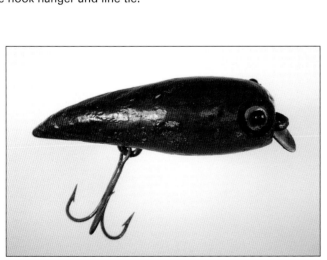

Bulbous Bluegill Bait – 2" carved, painted and varnished wood ca. 1940s-1950s. Screw eye line tie and hook hanger.

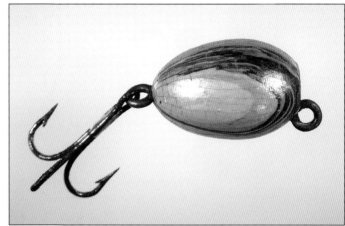

Marbleized Ball Bait – 1-3/8" carved, painted and varnished wood ca. 1920s-1930s. Screw eye hook and line tie hardware. Exceptional paint.

Tadpole Bait – 2-7/8" chip-carved, painted and varnished wood ca. 1930s-1940s. Screw eye hook and line tie hardware. Glass pin eyes. Line tie screw anchors small, dished metal diving lip.

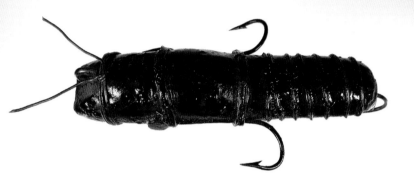

Rustic Jointed Diver – 3-3/4" carved, painted and varnished jointed wood ca. 1930s. Full through-body wire forms both line tie and segment joint. At the rear this wire extends through the tail, then returns around and along the belly where it is secured by the rear belly hook. So formed, this wire acts as the rear/tail hook hanger. Hand cut and varnished Paw-Paw style diving lip is secured by cup and wire hook hanger hardware.

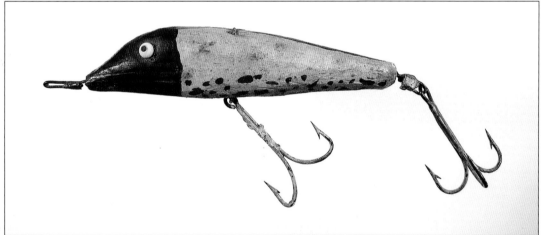

Hellgrammite – 3-1/4" carved, copper wire wrapped, painted and heavily varnished wood ca. 1940s-1950s. Side and rear single hooks mounted with nails and wire wrapped. Side hooks further secured by bent nail over wrapped wire at belly. Heavy brass line tie. Nailed on surface mounted belly weight. Copper feelers at top of head formed by wrapped wire.

Red & White Sucker – 3-1/2" chip-carved, painted and varnished wood, ca. 1920s. Nail-set glass bead eyes. Full loose through – wire (soldered at the front), forms the line tie and rear hook hanger. Painted belly double hook is formed by two soldered single hooks. Through body belly hook hanger returns at the back of the lure.

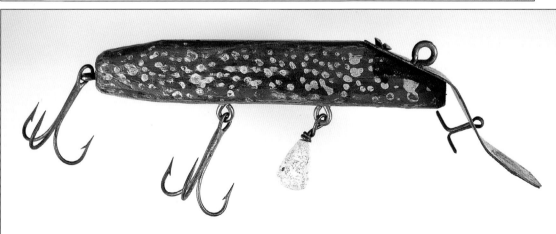

Silver Spotted Green Diver – 3-7/8" chip carved, painted and varnished wood ca. 1920s-1930s. Hand cut and formed large brass diving lip secured by screw eye line tie and screw at forehead. Cotter-pin line tie. Screw eye hook hangers, the first bearing a bell-shaped lead weight sinker.

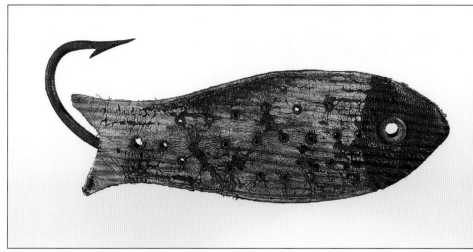

Leather Fish Lure – 4" hand cut, stitched, painted and varnished leather ca. 1920s. Large, flat-forged single hook secured by through-pin rivet at center of fish. Brass grommet doubles as both the line tie and the lure's eyes.

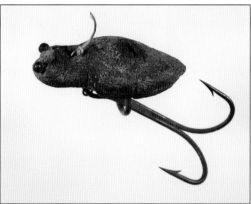

Amazing Primitive Bug – 1-5/8" hand carved wood with varnish remnants, ca. 1920s. Through-body double clip line tie connector is attached to huge double hook which is further secured and reinforced by a large screw eye. Small glass pin eyes. Creative form and rigging.

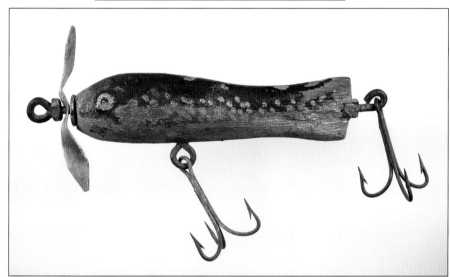

Spinnered Fish – 3-1/2" hand carved, painted and varnished fish-shaped wood ca. 1920s. Painted eyes. Heavy, fixed through-wire with screw eye belly hook hardware. Front line tie affixed to homemade metal 'keeper' behind which is a hand cut and formed aluminum blade and hand cut washer bearing. Rear hook hanger affixed to hand made rear metal keeper which is inlet to receive the carved tail.

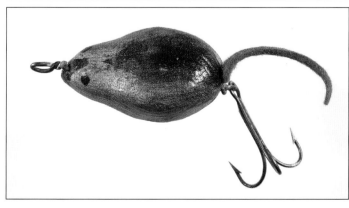

Carved Mouse Bait – 1-3/4" hand carved, painted and varnished wood ca. 1940s. Painted eyes. Felt tail attached with a nail. Full through-wire forms line tie then passes through the head to the underside of the belly, terminating as the rear hook hanger. This wire is further fixed into the belly by a heavy wire staple.

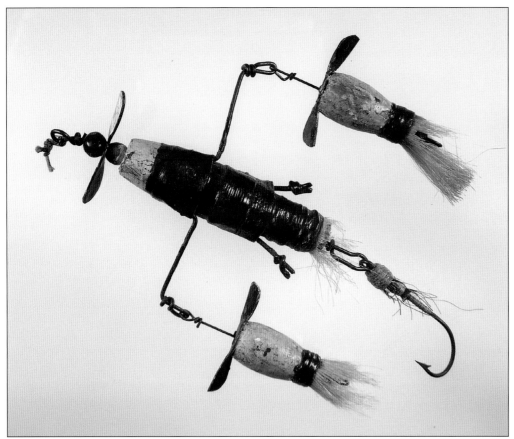

"Airplane" Lure – 2-1/2" hand carved, wrapped, painted and varnished wood ca. 1930s -1940s. Two 1" outboard spinning attractors (also carved, painted and varnished) each attached at the end of a formed wire hanger, which is secured at the main body via heavy wrapping. Full, loose through-wire construction forms the front line tie and rear hook hanger. Spinning front prop with glass bead bearings. Both the rear, stubby wire weed guards and the 1-1/4" surface mounted belly weight are secured via heavy line wrapping. Remnants of hand-tied bucktail both at the rear section of lure as well as on the trailing single hook. Outboard propellers of hand-cut metal are nail fixed, thus causing rotation upon retrieve. Wrapped bristle at tail completes the lure.

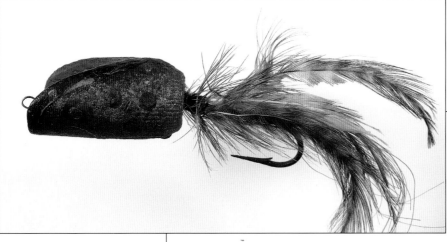

Feathered Diving Chunk Bait – 1-3/4" carved painted and varnished wood body ca. 1930s. Large, integral single hook fixed by a nail at the belly. Embedded wire line tie. Rear tail feathers inserted into the body adjacent to the hook shank.

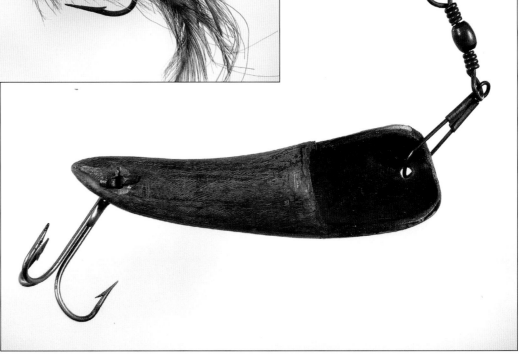

Horn Diver – 4" varnished, carved natural horn ca. 1930s. Horn is coped to fashion a diving bill (painted). Snap swivel attached to line tie located at bottom of bill. Iron cotter pin at tail turns down at the back and secures rear treble hook.

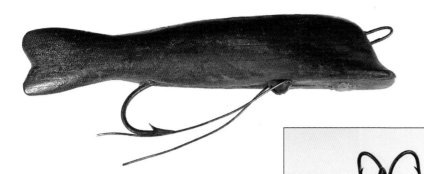

Whale-Bait – 4" carved and varnished natural wood suggesting a whale ca. 1930s. Single countersunk hook is secured at nose end by poured lead. Wire line tie passes through the belly at which point it's wrapped around a brass screw which secures it – the 'tails' of the wire then form the hook's weed guard. Very creative.

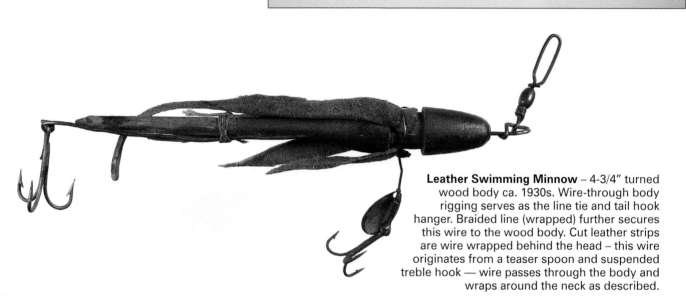

Bone 3-Hook Minnow - 2-7/8" hand carved bone minnow ca. 1910s–1920s. Through-body wire passes through minnow in both directions forming the line tie and the hook hangers.

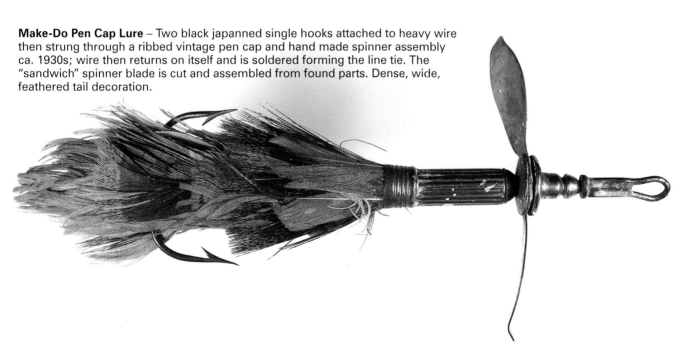

Leather Swimming Minnow – 4-3/4" turned wood body ca. 1930s. Wire-through body rigging serves as the line tie and tail hook hanger. Braided line (wrapped) further secures this wire to the wood body. Cut leather strips are wire wrapped behind the head – this wire originates from a teaser spoon and suspended treble hook — wire passes through the body and wraps around the neck as described.

Make-Do Pen Cap Lure – Two black japanned single hooks attached to heavy wire then strung through a ribbed vintage pen cap and hand made spinner assembly ca. 1930s; wire then returns on itself and is soldered forming the line tie. The "sandwich" spinner blade is cut and assembled from found parts. Dense, wide, feathered tail decoration.

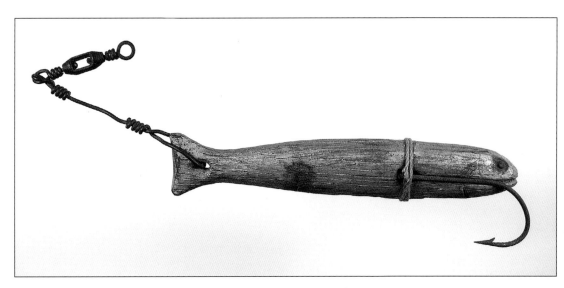

Silver Injured Fish Jig (Wisconsin) – 3-3/4" carved, painted and varnished wood, ca. 1930s. Tack eyes, carved mouth and gills. Painted, hand poured lead belly weight. Single hook is recessed along body and secured by wrapped string. Heavy brass wire leader/line tie attached via a hole in the tail.

Leg-Bone Lure – 3" varnished leg bone ca. 1940s. Leg bone from an Egret or Pelican. Through-wire likely anchored in lead, supports a tail spinner and rear double hook.

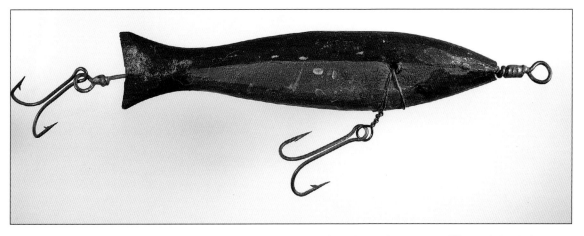

Green and Gold Minnow – 4" chip-carved, painted and varnished wood ca. 1920s. Through-body loose copper wiring (soldered at the ends), forms the line tie and tail hook hangers. Additional transformer wiring passes through a hole in the side of the lure and wraps around the belly where it is twisted to form the belly hook hanger. The copper wire 'tips' are then twisted and inlaid flush with the belly.

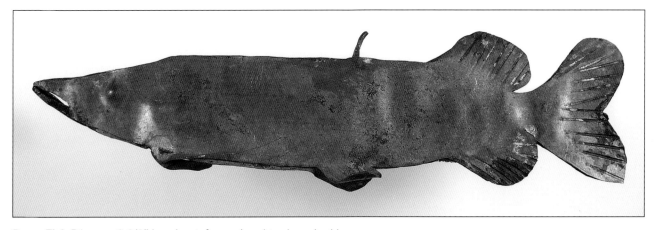

Brass Fish Decoy – 6-3/8" hand-cut, formed and tool-worked brass, 7-fin fish decoy ca. 1930s. Soldered wire loop line tie.

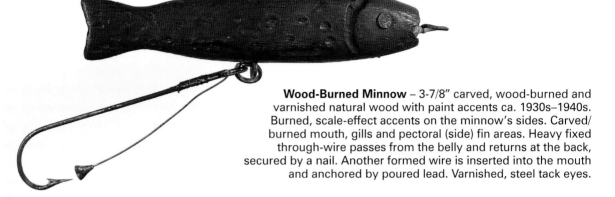

Wood-Burned Minnow – 3-7/8" carved, wood-burned and varnished natural wood with paint accents ca. 1930s–1940s. Burned, scale-effect accents on the minnow's sides. Carved/burned mouth, gills and pectoral (side) fin areas. Heavy fixed through-wire passes from the belly and returns at the back, secured by a nail. Another formed wire is inserted into the mouth and anchored by poured lead. Varnished, steel tack eyes.

Finned Bone Minnow – 3-1/8" carved bone minnow ca. 1900s. Two single hooks mounted alongside the body are riveted at the front and through-body wired near the tail. Twisted copper wire passes through the minnow's 'eye-hole' serving as the line tie/leader. Formed, twisted and painted front pectoral fins cause rotation upon retrieve. These fins are secured to the bone body near the belly by a rivet.

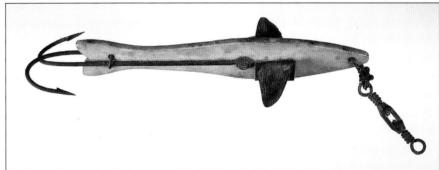

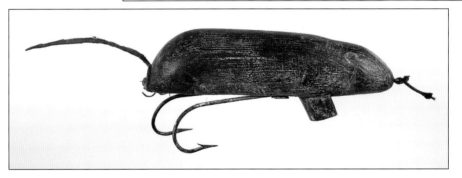

Primitive Gray Mouse – 2-3/4" carved, painted and varnished wood ca. 1920s-1930s. Hand made tin diving lip inlet into the body under the head. Subtly painted eyes. Two single hooks attached by nails at the belly. Brown cord tail secured by nail at butt.

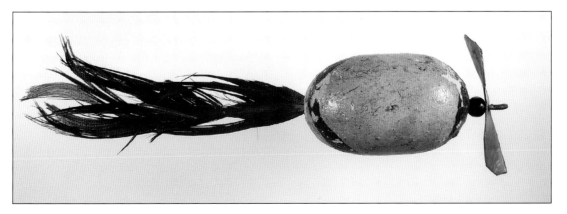

Bulb Craw – 1-3/4" carved, painted and varnished wood ca. 1930s. Large single hook tied with feathers and brass wire line tie are both recessed into the body via a belly-cut; this recess was then filled with lead and painted. A portion of the tail feathers is gathered and wire tied for leg/claw effect. Hand-cut, formed aluminum prop with glass bead bearing at 'nose' of lure.

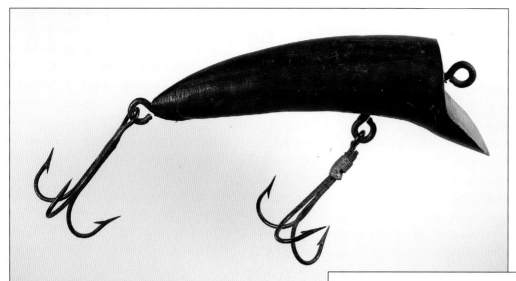

Diving Horn Lure – 3-3/4" carved black natural horn tip ca. 1930s. Screw eyes all around. Hand built and soldered belly treble hook.

Primitive Bone Frog Chunk Bait – 7/8"x1-3/8" hand carved bone body ca. 1930s-1940s. U-shaped through wire at belly and forehead forms 2 different line ties. Leather legs are inlet into the bone body and secured by nails. Opposing single hooks are sewn to the leather legs.

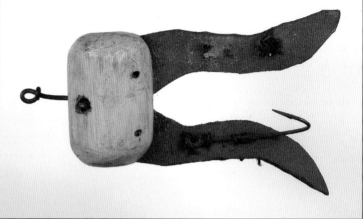

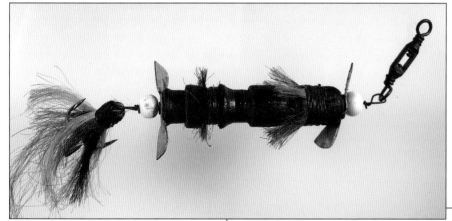

Spinning Wood Bait – 2-3/8" lathe-turned, painted, wrapped and varnished wood ca. 1930s-1940s. Through-body, loose wire rigging with glass bead attractors/bearings front and rear. Hand-tied and dressed rear treble. Two line-wrapped areas on body securing bristle simulates front and rear fins. Opposing hand cut, formed and painted metal front and rear spinners are fixed at the front and back by nails, causing the lure to spin upon retrieve.

Loon or Snake Lure – 4" chip-carved, painted and varnished wood body ca. 1930s–1940s. Fixed, through-body line tie/hook hanger hardware with twisted wire drop at tail hook. Glass eyes inset into deeply carved sockets. Thread-wrapped and varnished tail section may have originally held feathers.

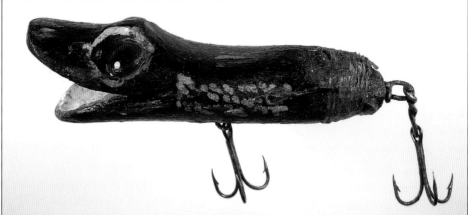

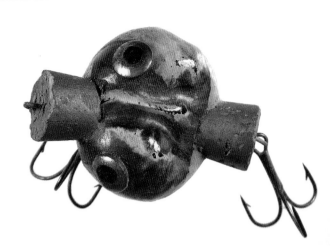

Natural Buckeye Lure – painted and varnished Buckeye ca. 1940s. Pair of corks, inlet at both the front and rear. Through-wire, fixed rigging forms the line tie and hook hangers. Painted and varnished metal tack eyes.

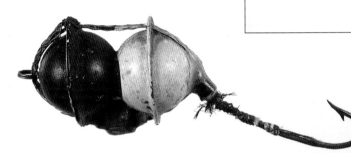

Double Chamber Lure – 1-7/8″ lure fashioned from a vintage double metal float ca. 1920s; body likely originated as a plumbing or industrial part. Entire affair is wrapped in twisted copper wire which passes through a lead belly keel. Hand forged rear single hook has remnants of once being tied.

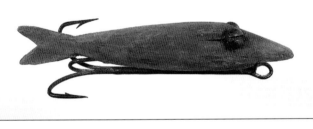

No Steal-Um Minnow – 3″ chip-carved, natural finish wood minnow ca. 1930s. Likely made by a fisherman tired of capturing his own live bait or paying for store-bought minnows. Minnow is mounted via a longitudinal hole through its body to the bait pin of an Eppinger's No-Steal Um bait harness (which ordinarily would hold a 'live' minnow). Large dome-top screws are used as eyes.

Kitchenware Diver – 2-1/4″ cut handle from vintage Bakelite tableware ca. 1930s. Through-wire line tie/hook hanger hardware secured by solder at the nose and tail. Designed utilizing original handle rivets suggesting eyes.

Foil Tube Diver – 1-3/4″ vintage glass bottle with screw-on metal cap ca. 1930s–1940s. Bottle is foil lined to represent scales. Soldered metal diving lip. Flat bar serves as line tie and belly hook retainer, both soldered to the metal cap.

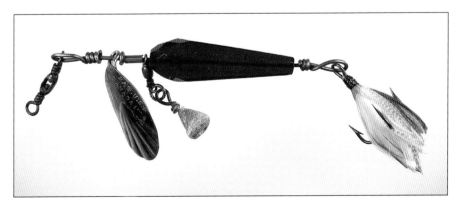

Chandelier Bait – 1-5/8″ faceted glass bead mounted on loose through-wire shaft which forms the line tie and rear hook hanger ca. 1920s. Fluted Skinner blade with tube and washer bearings mounted on the through-wire. Also includes a drop swivel, attached to which is a small lead weight.

Beaded Spinners – Bottom - 1-3/4" 3-beaded spinner ca. 1920s. Hand formed loose through-wire forms the line tie and rear hook hanger. Remnants of hand-tied rear treble. Hand cut and hammered brass blade.
Top – 1" beaded spinner-hook ca. 1930s–1940s. Series of glass tubes and beads in combination with a hand-cut metal spinner blade threaded on the shaft of a fish hook.

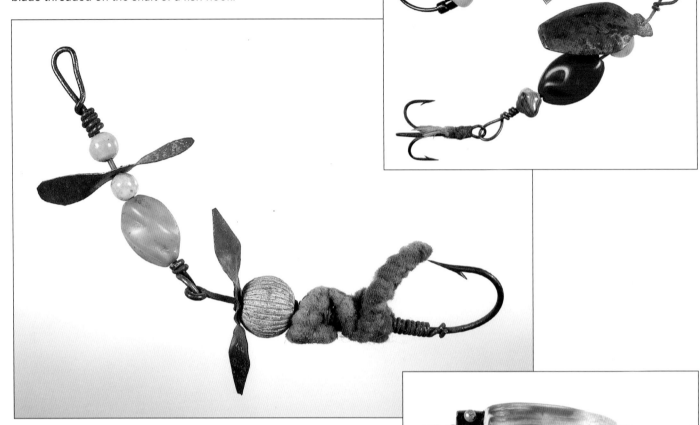

Jointed, Beaded Double Spinner – 3" knurled, painted wood and glass bead body ca. 1930s. Full wire-through line tie and joint hardware terminates by wrapping and securing rear single hook. Two hand formed and cut tin spinners. Rear weed guard fashioned from an old twisted pipe cleaner.

Cork Shell Bait – 2" natural shell 'beetle' lure with integral, painted cork head ca. 1940s-1950s. Full through-body loose wire with glass bead bearings front and rear. Glass bead eyes are wire attached to the cork head.

Knife Bolster Pike – 5-1/2" salvaged European celluloid straight razor (knife) side bolsters in the form of a Pike, ca. 1880s–1890s. Through-body tied wire hangers at the front and rear form the line tie and rear hook hanger. The side bolsters are further secured by old-wrapped gut (or waxed line) at the mid-section.

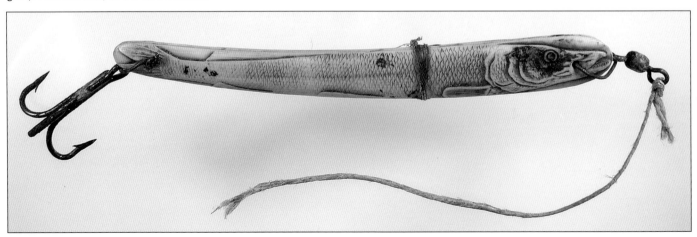

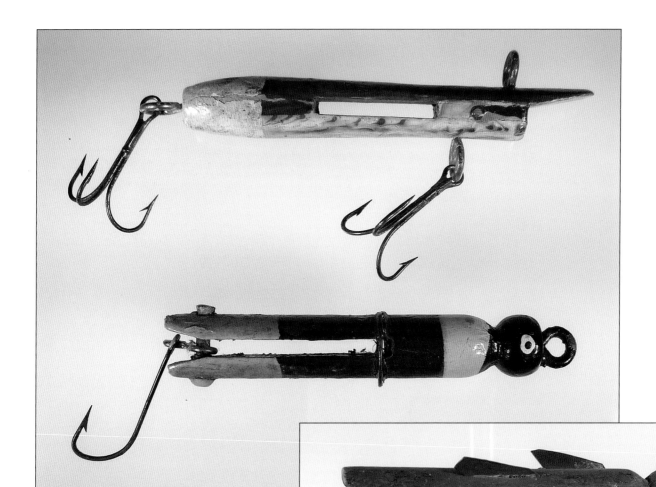

Pair Clothespin Baits – ca. 1940s. Top: 4"
re-carved painted and varnished clothespin,
partially leaded at nose. Giant screw eye line tie
and hook hangers, two of which are anchored
in the lead. Painted tack eyes also anchored in
the lead.
Bottom: 3-1/2" injured minnow style. Painted
and varnished clothespin wire wrap reinforced.
Heavy nail through-body rivet with formed wire
hook hanger, supports single rear hook.

Pair Clothespin Baits – Top: Bluebird – 3-3/4"
leaded clothespin with inlet and painted brass
pectoral and dorsal fins. Painted eyes. Formed
single hook and wire line tie anchored by lead.
Bottom: Winged Bird – 3-7/8" painted and
varnished clothespin. Painted eyes. Through-
body cotter pins secure the front line tie and
belly hook hangers. Natural bristle 'wings'
secured between the legs of the clothespin.

White Cat Toy – 5" painted rubber cat toy modified to include a through-wire, threaded leader forming the line tie and rear hook hanger ca. 1940s.

Bird Ornament – 3-1/8" turquoise painted metal tree ornament converted into a fishing lure by an enterprising fisherman ca.1950s.

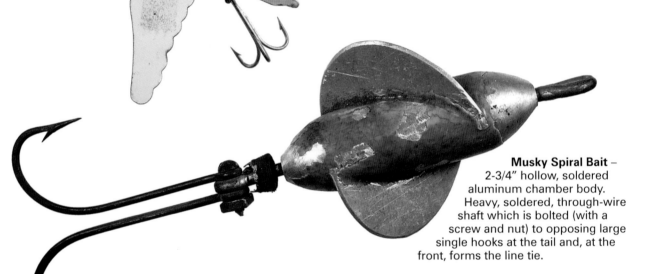

Musky Spiral Bait – 2-3/4" hollow, soldered aluminum chamber body. Heavy, soldered, through-wire shaft which is bolted (with a screw and nut) to opposing large single hooks at the tail and, at the front, forms the line tie.

'Electric' Musky Minnow – 4-1/2" metal, hammered electrical conduit body with paint accents. 8-1/2" overall length. Conduit is crimped at the head to secure a heavy wire leader which contains a marked Heddon spinner blade and a large, faceted, clear glass bead. The conduit at the rear is likewise crimped, cut into a fish-tail form and painted. 3 pairs of single opposing hooks are wired together, then through-body, rivet attached.

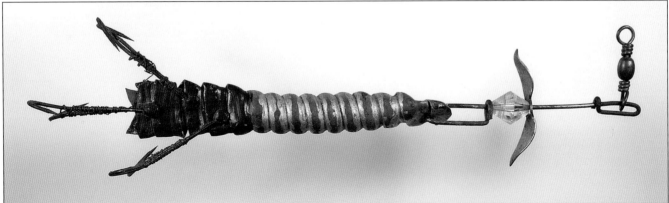

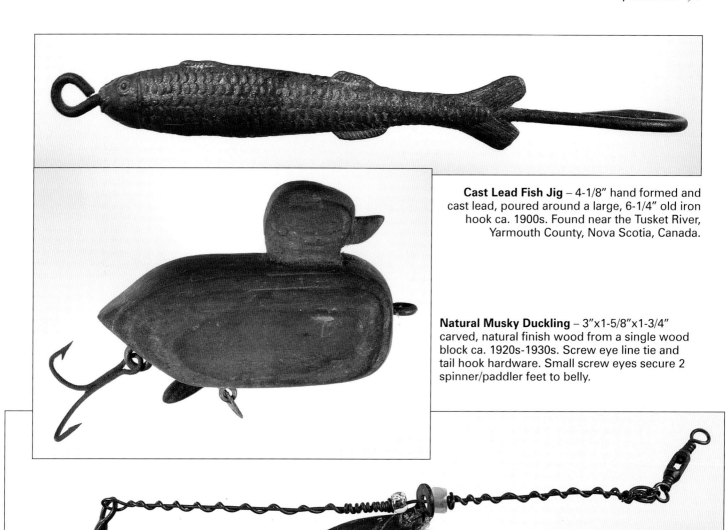

Cast Lead Fish Jig – 4-1/8" hand formed and cast lead, poured around a large, 6-1/4" old iron hook ca. 1900s. Found near the Tusket River, Yarmouth County, Nova Scotia, Canada.

Natural Musky Duckling – 3"x1-5/8"x1-3/4" carved, natural finish wood from a single wood block ca. 1920s-1930s. Screw eye line tie and tail hook hardware. Small screw eyes secure 2 spinner/paddler feet to belly.

Wood Spinner – 4" (blade 2") unusual, carved, painted and varnished wood spinner blade mounted to a twisted wire shaft that forms the line tie and rear hook hanger ca. 1910s–1920s. Formed, punched metal 'bar' clevis secured by a nail to the spinner's head and additionally by a domed nail to the wood spinner. Glass bead bearings.

Cork Ball Bait – ca. 1910s. 1-1/8" hand carved, painted cork body; 2-3/4" with bead bearings. Full, through-wire hardware forms line tie and rear hook hanger. Six multi-colored glass bead bearings, 3 each, front and rear. Two hand-cut and formed aluminum props. Loosely attached, U-shaped, hand formed aluminum keel strap. Remnants of hand tied rear treble hook.

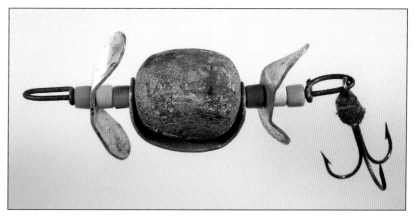

Red White and Blue Eyed Rattler – ca. 1930s. 2-3/8" two piece segmented body connected via a front and back wire, each of which are stubbed into the head (some type of pressed, industrial metal part) with a large, luminescent blue glass marble rattling around inside. Rear wire hook hanger passes through a painted cork (body). Reverse fixed, cupped washer at nose would provide minor water disturbance.

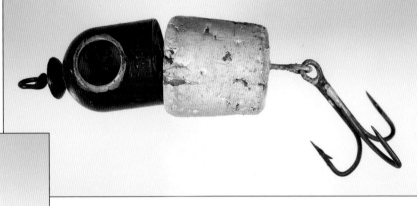

Handmade Pearl Spinner Bait – 2-1/8"x1-1/8" hand carved mother of pearl spoon rig ca. 1910s-1920s. Bait is entirely handmade using brass wire, barrel swivels and 3 hooks. Unique, large circular clevis holds carved pearl spoon. Twisted, flattened brass wire/straps wrapped around shank for added weight and/or appeal.

Bobber-Craw – 2" hand painted, multi-colored bobber mounted on a turned wire shaft with applied feathers to simulate a crawdad ca. 1930s. Hand cut and formed tin spinner. Unusual, white ceramic leading bead/attractor.

Diving Bird – 2-1/4" hand carved, painted and varnished wood with applied deerskin wing and throat accents secured using nails. Embedded wire line tie and screw-eye hook hangers. Inlet cut and painted aluminum diving lip. Painted eyes.

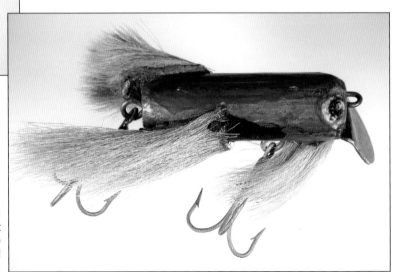

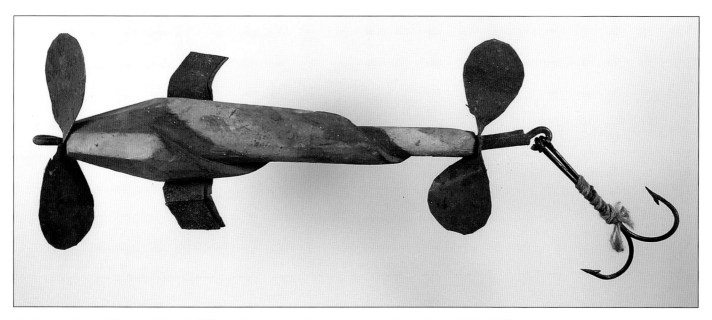

Corkscrew Spiral Musky Bait – 4-1/2" hand carved and paint decorated wood ca. 1910s–1920s. Primitive, hand cut and formed tin props. Through-wire construction. Cut and formed tin side fins wrap around belly and are secured by nails. Rear tin thruster bearing. Pair of thread-wrapped black japanned single hooks form a double hook at the tail.

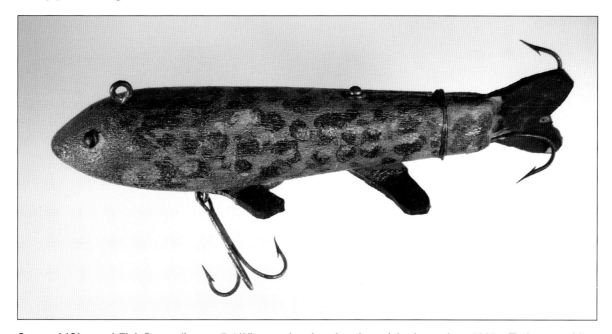

Spotted (Cheater) Fish Decoy/Lure – 5-1/2" carved, painted and varnished wood ca. 1930s. Tack eyes with paint accents. Screw eye line tie and belly hook hanger. Cut rubber pectoral and tail fins secured both by nails and the hook fasteners. Single hooks top and bottom secured by screws with additional wire wrapping near the tail. Tail is coped/inlet to receive hook shanks and rubber tail piece.

Red and White Decorated Spoon – 3" hand-hammered, paint decorated, varnished metal spoon ca. 1930s. Paint graphics appear only on one side. Rivet attached single hook.

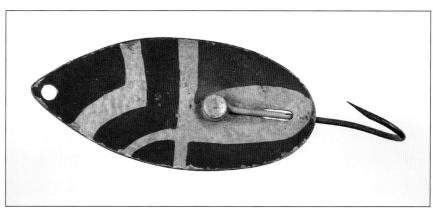

Butterfly Bait – 2"x2-1/2" hand cut aluminum, painted body ca. 1930s–1940s. Three through-body, cylindrical lead weights at rear. Tied rear treble with remnants of bucktail. Through-wire, 'U-shaped' line tie with gut leader remnants.

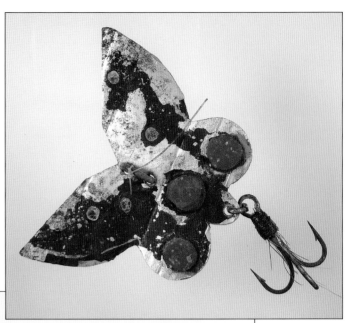

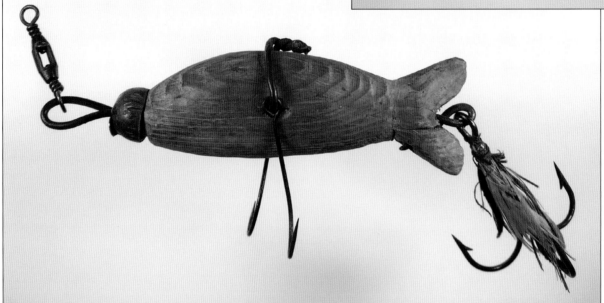

Backstrap Minnow – 3-5/8" hand-carved, natural finish wood ca. 1920s. Heavy twisted through-wire forms line tie and rear hook hanger. Heavy brass through-body wire forms the side hook hangers. These wires are twisted at the back end, hammered down along the body. Shaped, lead nose cap fixed into place by a nail. Hand tied rear treble hook.

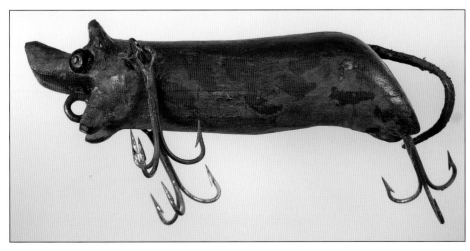

Side-Hooked Bass "Hog" – 4-1/4" hand carved, painted and varnished wood ca. 1940s. Nail-attached, glass bead eyes. Inlet, leather tail. Fixed, painted wire-through side and rear hook hangers. Separate, hand-carved, nail applied and painted ears made the carving a bit easier. Screw-eye front line tie.

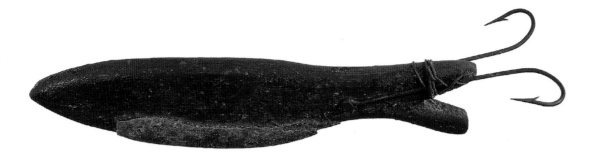

Streamlined Natural Minnow – 4-3/4" hand carved, natural finish wood with varnish remnants ca. 1920s. Hole for eyes. Remnants of a staple line tie at back. Hand formed, surface mounted, lead belly weight, molded or wrapped along the underside of the body and fixed into position by nails. Two single hooks mounted on each side at the tail are secured by a single, turned down, through-body nail and additional external, wire wrapping at mid-shank.

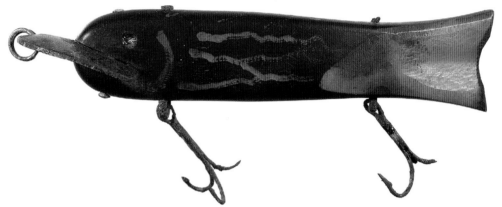

Scraper Fish – 4-1/2" re-carved Bakelite or early plastic 'handle' – possibly a vintage scraper who's iron working end has been flipped and reworked to form a bill ca. 1920s. Carved eye, gill and scale details on body. Bill is secured by two nails. Hooks secured by through-body cotter pins folded at the lure's back.

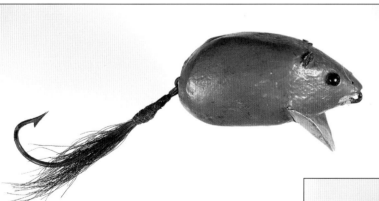

Grey Diving Mouse – 1-7/8" hand carved, painted and varnished wood ca. 1940s. Glass pin eyes. Inlet metal ear clasps show remnants of plastic or composite ears. Full fixed through-wire line tie/tail hook hanger. Remnants of applied whiskers. Inlet, hand cut and formed aluminum diving lip. Rear single hook is hand tied to suggest a tail.

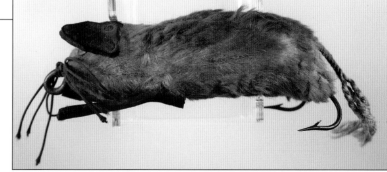

Primitive Furry Mouse – 3" skin/fur covered, carved wood body. Skin is thread-secured to the body. Each ear and fore-leg is of hand-cut rubber secured by 2 nails. Painted steel tack eyes. Braided line knotted around line tie forms the mouse's whiskers. Inlet, braided cord tail. Two single rear hooks. Heavy brass wire line tie.

Gold Tandem Minnow Rig – 9" chip-carved, painted and varnished wood fashions two individual minnows connected by box swivels and a split ring ca. 1900s (found in the village of Jeffersonville, New York). Both minnows are fully fixed through-wire in both directions. Side and belly wire rigging fixes the hooks in two places. Lead minnow has tack-applied surface belly weights. Rear minnow has a hand made and wired rear treble hook at the tail.

Artful Minnow – 3-1/2" carved, painted and varnished wood ca. 1920s–1930s. Unusual, inlet brass nose piece returns under the chin where it is secured by a cotter pin. Painted steel tack decoration on back. Unique belly mounted, wire hook hanger supports a hand-made and soldered treble hook with one leg turned up into and anchored in the body.

Primitive Bird – 3" chip-carved, painted and varnished wood ca. 1940s–1950s. Relief carved and painted eyes. Hand cut and formed tin wing side-plates, each attached with 2 screws. Screw-eye line tie and tail hook hardware. Tied feather tail secured to the back by a tiny screw eye. Hand poured lead belly weight.

Early Spotted Minnow – 3-1/2" hand carved, painted and varnished minnow-shaped wood body ca. 1910s. Loose through-wire construction in both directions - soldered line tie reinforcement. Hand cut and formed brass spinner blade and washer bearing at nose. Three single hooks wire-wrapped at belly. Remnants of 3 single hooks wire-wrapped at tail.

Turtle Lure/Gang – 2-5/8" hand carved, painted and varnished wood ca. 1920s. This floating lure may have been baited and used to capture turtles. Three single recessed hooks are secured by wire staples at the eye and fully, wire-wrapped around the body of the lure near the hook-bend. This wrapping is recessed and painted. Unseen at the angle illustrated is a carved hole at the top functioning as a line tie.

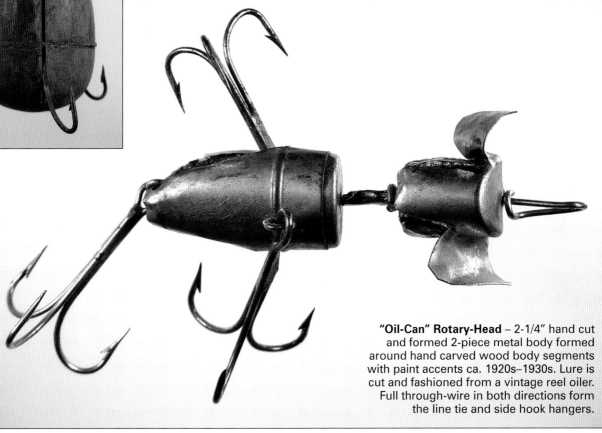

"Oil-Can" Rotary-Head – 2-1/4" hand cut and formed 2-piece metal body formed around hand carved wood body segments with paint accents ca. 1920s–1930s. Lure is cut and fashioned from a vintage reel oiler. Full through-wire in both directions form the line tie and side hook hangers.

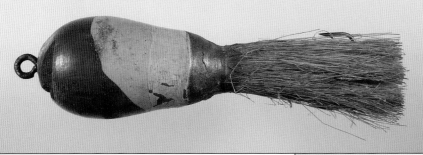

Folky Goldfish – 3-1/2" chip-carved, painted and varnished wood with fin, facial and gill detailing ca. 1920s–1930s. Subtle carving/painting suggest eyes and mouth. Heavy formed wire line tie stubs through at belly. Screw eye belly hook hanger.

Bulbous Brush-Chunker – Bearing similarities to the pre-1900 Gaide Bait, this simple, visually pleasing lure appears at first glance to have been made from a vintage man's shaving brush (but was not). 2" turned, painted and varnished wood with carving accents at head area. Screw eye line tie. Natural bristle which protects rear treble hook, is inlet, wrapped and painted at body interface. Treble is likely attached using a wire staple at the rear of lure.

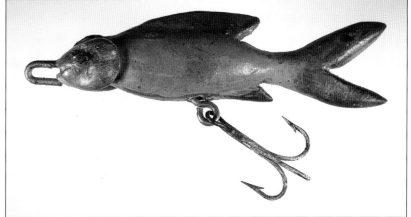

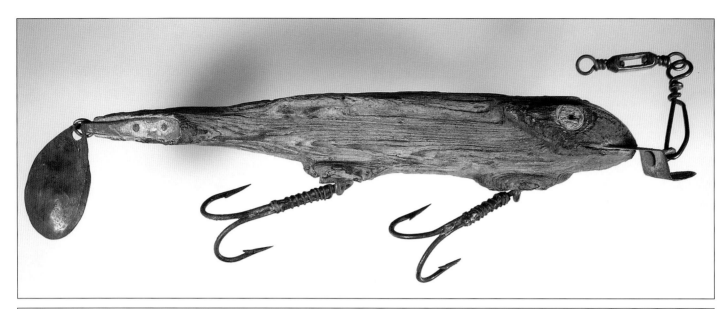

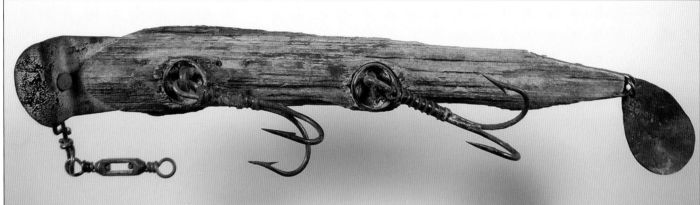

Driftwood Musky Diver – 7" re-carved, hardened, weathered wood, possibly driftwood. Carved eye detail. Inlet, formed metal diving lip secured by nail. Large, deep hand cut and hand hammered brass cups appear to be set in natural 'knot-holes'. Brass screw-eyes support heavy, hand-made and wire wrapped double hooks. A thin, formed brass plate/strap, nail secured on each side at the tail, supports a hand-hammered, brass tail-spinner.

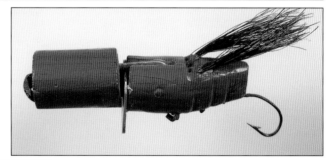

Jointed Pink Craw – 2-3/8" hand carved, painted and varnished wood. Vertical joint of cut aluminum flat stock passes through head forming line tie. A nail through the rear section acts as a pivot, allowing (the rear section) to move up and down upon retrieve. Folded, cut aluminum flat stock shrouding the notch guides the movement. A hand-cut, tacked-on aluminum lip mounts at the front of the rear section to 'catch' the water. Inlet bristle arms/claws. Remnants of four rubber legs. Hook is inlet into the joint cavity and further secured by staples at the belly.

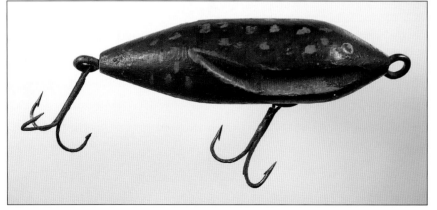

Cut Faced Wiggler (Wisconsin) – 3-1/4" carved, painted and varnished wood ca. 1920s. Painted eyes; cup and screw belly hardware. This lure was first pictured on page 280 of *The History & Collectible Fishing Tackle of Wisconsin* by Robert A. Slade, 1999. Its 'soul-mates' are not pictured here.

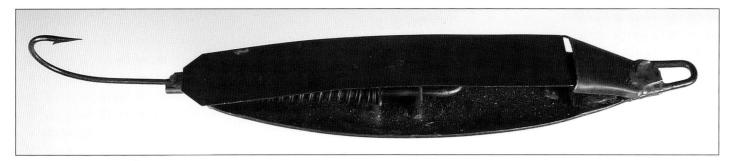

Spring-Loaded Brass Musky Wobbler – 5" hand-cut, formed and soldered brass. Brass wire trigger mechanism soldered to single striking hook. Heavy, spoon type, fish-shaped base. When set, a brass U-shaped trigger rod 'sets' on a brass stud and is anchored by two brass plates. When the top brass bar/ strap contacts (compresses) the hook, the trigger rod releases from the pin and discharges the hook to the rear.

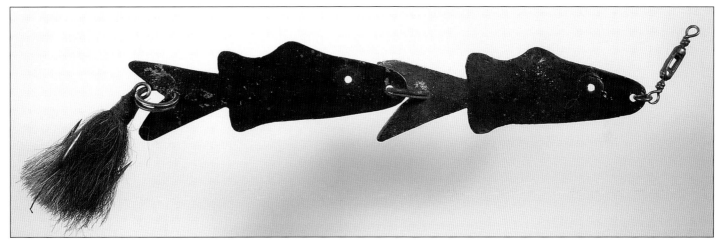

Tin Minnow-Chasers – pair of cut-tin, minnow shaped flashers (hand cut from flat sheet), each 3" in length and painted on one side, are joined together by a large split ring ca. 1920s–1930s. Hand-tied hair treble hook at rear.

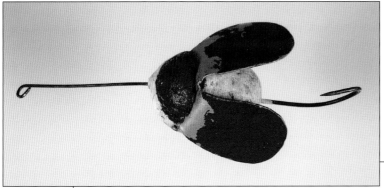

Weedless Cork Bug – 1-1/4" (1-1/2" including wings) carved, painted and varnished cork body ca. 1920s. Hand cut, painted and folded aluminum wings are inlet into the body, secured by a nail at the forehead. The location and orientation of the wings would render the lure weedless in use. The single rear hook and the separate line tie wire are inserted into the body and anchored into place by hand cast lead.

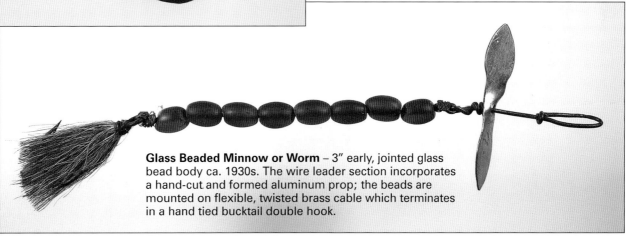

Glass Beaded Minnow or Worm – 3" early, jointed glass bead body ca. 1930s. The wire leader section incorporates a hand-cut and formed aluminum prop; the beads are mounted on flexible, twisted brass cable which terminates in a hand tied bucktail double hook.

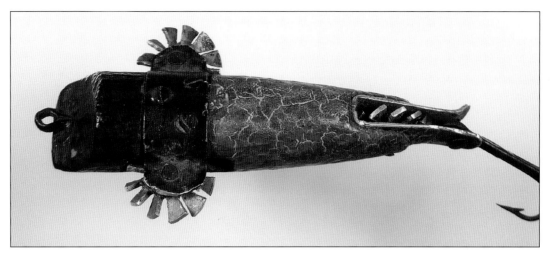

Fan-Finned Wonder (Alabama) – 4-3/8" hand carved, painted and varnished wood ca. 1920s. Pectoral and tail fins are suggested by 3 hand-cut and twisted, rivet-secured, spinning aluminum fan blades. Pectoral blades are anchored by a hand-formed, inset, painted aluminum strap set flush with the back and secured by 3 painted brass screws. A rectangular, carved, horizontal through-body cavity receives the inside edge of the pectoral fan blades. Line tie is a cotter-pin with its opposing legs bent 90 degrees to fit flush with the inside face of the body cavity. At the tail, a formed aluminum 'receiver' is inlet into the body and anchored by a through-body rivet passing through both sides of the wood body, the 'tail' fan blade and the formed aluminum receiver. At the end of the tail a through-receiver rivet acts as a pivot-point hanger for the rear hook. This rivet contains a loose, brass tube-bearing, over which the (pivoting) large tail hook is anchored through its eye.

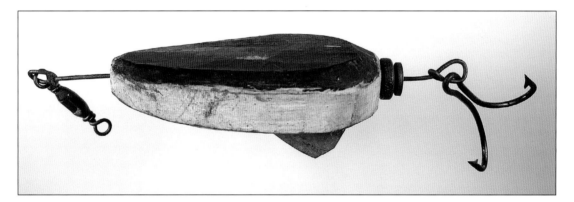

Wobbling Wood Musky Spoon (Floater) – Found in LaCross, Wisconsin. 3"x1-1/2" chip-carved, painted and varnished wood ca. 1930s. Full, loose through-wire forms line tie and rear hook hanger. Brass knurled found part functions as rear bearing. Cut and formed galvanized sheet attached eccentrically by nails at the belly, makes a 'keel' type lower fin – this would cause a surface wobbling action. Its design may suggest a swimming rodent.

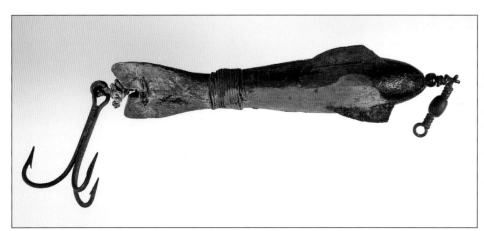

Primitive Finned Fish – 3-3/8" chip-carved, painted and varnished fish-shaped wood body ca. 1920s. Great form, paint and primitive appeal. Hand cut and inlet tin dorsal and pectoral fins show paint remnants. Full, loose through-body wire rigged with red, glass bead bearing at nose. Carved tail is inlet into the wood body and reinforced by through body wire at tail and 3/8" of full wire body wrapping at the joint. Mysteriously, the minnow is hollowed out from top to bottom immediately behind the dorsal fin.

Milkweed "Seed-Pod" Lure – 2-3/4" dried and varnished natural milkweed seed-pod body ca. 1930s. Twisted, loose, through-body wire forms line tie and rear hook hanger. Diamond-shaped, hand-cut and twisted, copper prop with glass bead bearings front and rear. Natural and appealing, the definition of economy and ingeniousness applied to a folk art lure.

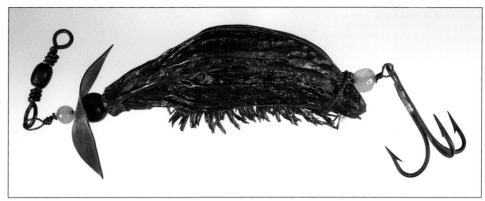

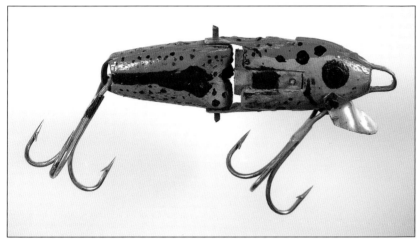

Reinforced Jointed Diver – 2-3/4" hand carved, painted and varnished wood. An incredibly complex assembly – a 1/8" recessed, tack-secured, multi-part, aluminum reinforcing strip wraps the entire lure forming the line tie, joint connections and both the front and rear hook hangers. An octagonal aluminum tube is embedded into a hollowed-out front body section. It is secured into place by coped-in aluminum strapping and a horizontal, through-body metal pin/rivet. A vertical, through-body metal pin passes through the reinforcing strips, securing the body segments at the joints. It is fixed into place by a recessed set-screw. Screw-attached, hand cut and formed aluminum diving lip.

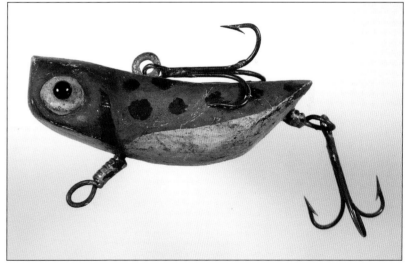

Bullfrog Chunk Bait – 3" chip-carved, painted and varnished wood, ca. 1930s. Relief carved eyes with glass pin pupils. Twisted and soldered, brass, through-body wire line tie/rear hook hanger passes from the belly through the back; it then returns down through the body at the rear of the lure. The back-mounted treble hook suggests this lure was specifically created to catch bullfrogs.

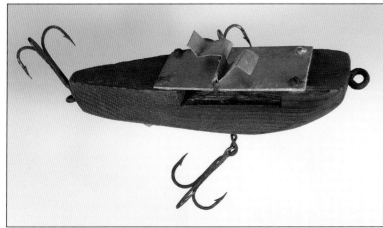

Side-Hooked, "Clacker" Lure – 4" shaped and carved, natural finished, boat-shaped lure from Florida, ca. 1930s. An aluminum plate mounted on the back with 4 screws, covers a coped-out area which spans across the lure (creating a hollow, sound reverberation chamber). A pair of shaped aluminum clackers would tap this plate creating noise as the lure is retrieved. Both clackers are retained by a single through-wire which wrap around this back-plate, each end then passing through the wood hull and terminating as hook hangers for the side hooks.

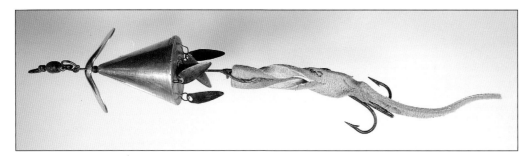

"Cone" Pork Rind Minnow,
ca. 1930s - Highly creative 4-1/4" (overall), 1-1/4" (cone only), hand twisted, through-wire lure with hand assembled, machined aluminum cone, attached to which is a twisted, cowhide strip (trailer). Reinforced fore-spinner. Four small, Hildebrandt spinner attractors are mounted on wires passing through a "plate" on the rear of the cone. Wire shaft incorporates a soldered bearing "stop" and a soldered wire clip to secure the leather trailer. The wire shaft passes through a drilled brass screw/bearing fixed to the back of the cone.

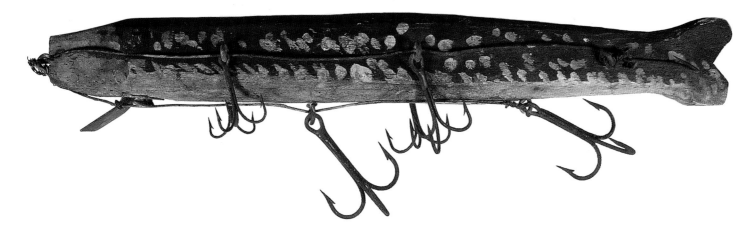

Foot-Long Pike Bait – Primitive 12" chip-carved and painted 8-hook lure. Screw eye hardware all around; hand cut metal diving lip secured by two screws. In an extreme example of hook reinforcement, *all* 8 hooks *and* the diving lip are attached to one another via twisted wire cable which passes through the lip, line tie and all of the hook hangers. In effect, the *total* strength of all hooks and hardware are brought to bear even if a fish is hooked on only one hook. Therefore, even if a large fish were to pull out one or more hooks, the lure would not fail. Folky and evoking a primal, "survivalist" appeal, this lure represents the antithesis of today's "Catch and Release" trend.

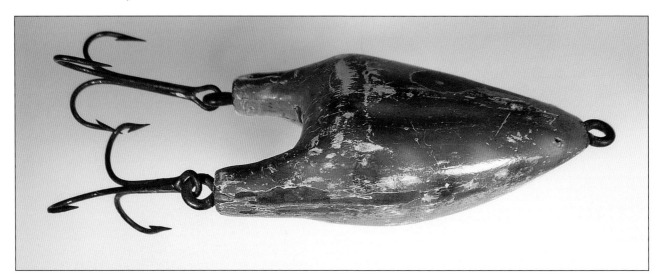

Musky Casting Frog – Reported to have been found in Wisconsin Rapids, Wisconsin, this 4" x 2" wide x 1+" thick frog ca. 1930s is a handful – quite simple in form, a casting frog of this size is rare. Heavy duty screw eye, line tie and hook hanger hardware. Lead belly weights. A "hole" in the center of the forehead suggests it may have been fished not only as a big casting lure but also as a cheater decoy in winter.

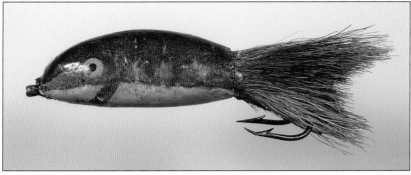

Painted Casting Minnow – 2" hand carved, painted and varnished body – 3-1/2" overall length ca. 1920s–1930s. Dyed hair tail cut to achieve a fish-tail form. Two single hooks (inlet into body) form a double hook effect at tail. Individual hook eyes are joined at the nose forming the line tie.

Musky "Egg" (Chunk) Bait – 2-3/4" x 1-3/4" x 1-3/4" egg-shaped, turned wood body, painted and varnished (with sparkles added for appeal) ca. 1950s–1960s. Two large, inlet single hooks in great striking position. The author believes this basic form was intended to suggest a swimming duckling. An odd, yet simple and effective solution conceived by a creative fisherman.

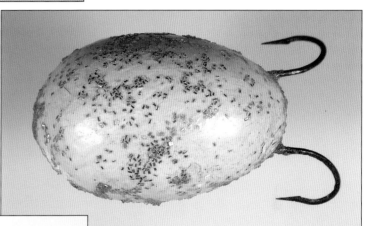

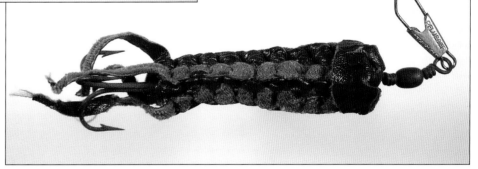

Light-Reflecting Minnow – Highly creative 3" darting surface minnow fashioned by carving a piece of early plastic/Lucite ca. 1940s. Body has a round, drilled-out chamber, into which is inserted crinkled foil from a cigarette pack. The line tie eye was then inserted into a clear epoxy "plug" sealing the chamber.

Braided Leather Crawdad – 2-1/2" leather body, ca. 1930s–1940s. Tightly braided leather strips simply yet creatively form the illusion of a segmented body, thus emulating the shell, legs and claws of a live crawdad. Full through-wire secures a single trailing treble hook. Highly original, this unique lure would certainly be a fish catcher.

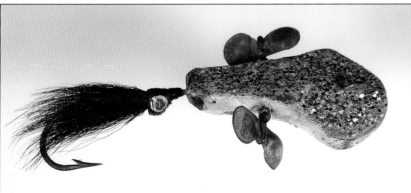

Paddle-Wheeler Lure, ca. 1940s-1950s – 2-1/8" hand carved, painted and varnished pear-shaped wood body with applied glitter. Through-body brass tube provides a channel into which a single wire is inserted. The ends of this wire are crimped and soldered to hand cut and formed, cupped, copper paddle blades. Through-body fixed wire provides line tie and deeply inset rear hook hanger. Hand tied and painted trailing single hook.

Shovel-Headed Jointed Pike – 4" carved, painted and varnished wood, ca. 1930s. Wide flared head; pin-attached, glass bead eyes. Deeply recessed, screw-eye hardware all around (including body joint).

Harmonica Lure – Creative, 3-1/2" jersey-rigged, rotating spoon constructed from a vintage top plate of a Solo Richter Harmonica. The fine old script pressed into the face plate can still be clearly read.

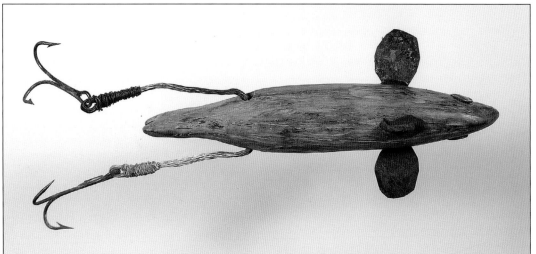

Primitive Cheater Decoy – 3-3/4" chip-carved and varnished natural wood body with carved tail and tack eyes ca. 1920s. Iron line tie and tin fins secured by poured lead belly weight. A novel, through-body brass cable "trapeze" secures the two trailing "cheater" hooks. A simple, appealing old minnow with character.

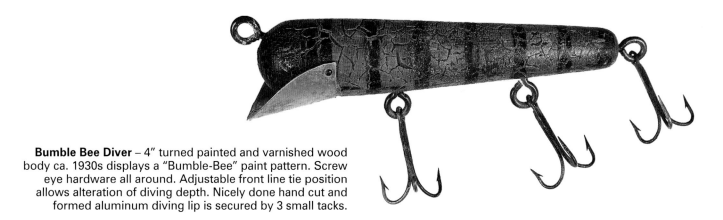

Bumble Bee Diver – 4" turned painted and varnished wood body ca. 1930s displays a "Bumble-Bee" paint pattern. Screw eye hardware all around. Adjustable front line tie position allows alteration of diving depth. Nicely done hand cut and formed aluminum diving lip is secured by 3 small tacks.

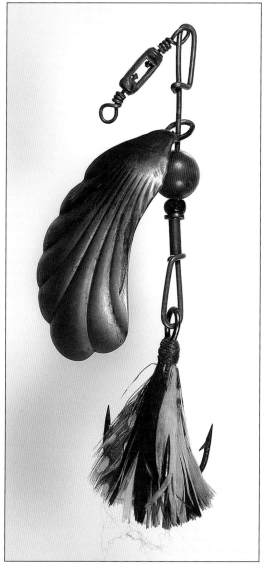

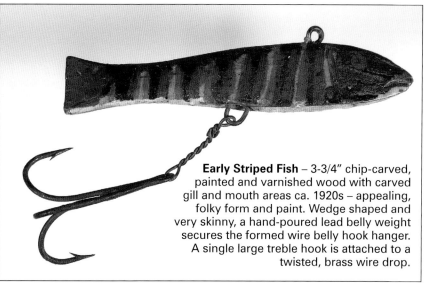

Early Striped Fish – 3-3/4" chip-carved, painted and varnished wood with carved gill and mouth areas ca. 1920s – appealing, folky form and paint. Wedge shaped and very skinny, a hand-poured lead belly weight secures the formed wire belly hook hanger. A single large treble hook is attached to a twisted, brass wire drop.

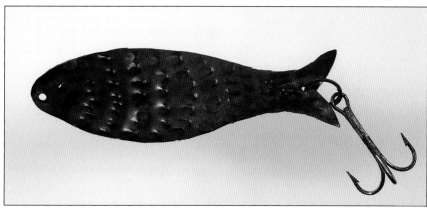

Hand-hammered Minnow, ca. 1920s – 3-1/4" hand cut and hammered metal minnow was likely highly effective. Punched eye and line tie details. What tool or instrument was used to make the small, raised scale shapes will always remain a mystery. A through-body split ring holds the rear treble hook.

Sugar Spoon Spinner, ca. 1920s – It is difficult to *classify* this unique, "make-do" spinner. With graceful form and an attractive patina, the 2-1/2," hand-cut and soldered sugar spoon, in combination with a large orange glass bead bearing, lends an air of class to this old lure.

Primitive, 5-Hook, Underwater Minnow, ca. 1910s – 5" chip carved and painted wood body with full wire-through in both directions. Protruding twisted brass wire forms line tie. Screw attached, 3" carved and painted lead weight strip surface mounted on belly. Five wire hung double hooks are formed by pairs of single hooks tied together at the shank by old braided fishing line.

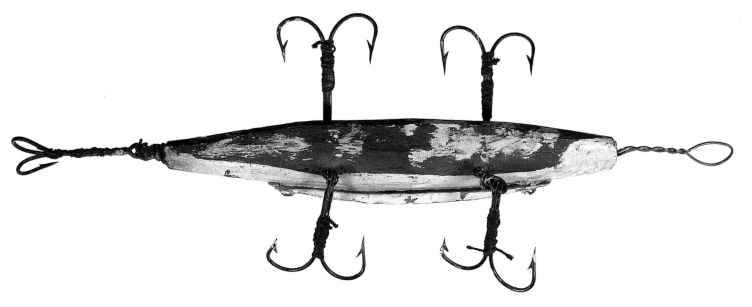

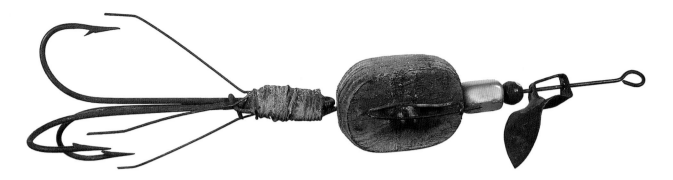

Primitive Pork Rind/Minnow Rig, ca. 1920s-1930s – Super folky 5-1/2" long piece is rigged with a hand formed wire pork rind/minnow "clip" which is secured to the wood body via a screw. Hand cut and formed metal blade and unique colorful glass beads add appeal. Fully (fixed) wire-through assembly loops on itself and fixes the horizontal positioning of the large, 3" rear treble hook. Additional, heavy soldered wire wrapping further reinforces this great primitive lure.

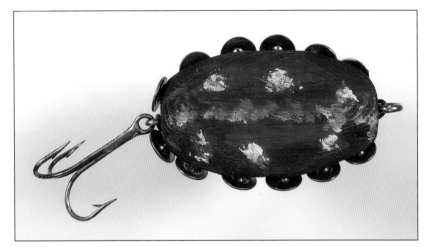

"Tacky" Turtle, ca. 1940s – 2-3/8" carved, painted and varnished wood. Unique, naïve interpretation of a baby turtle. Steel thumbtacks are inserted around the perimeter of the "shell." Screw eye line tie and tail hook hanger are reinforced by a full length, heavy formed wire running under the belly of the lure tying the front and rear screw eyes together.

Yarn-tailed ,Spinner-hook, ca. 1900s - Early, 2" painted, lead-filled, wound, heavy brass wire body formed over single hook secures the thick yarn tail. Cut and formed brass spinner mimics early Burgess pieces. Lead fixes the (bodies) position on the hook shank and anchors the nose bearing. Remnants of old braided line remain.

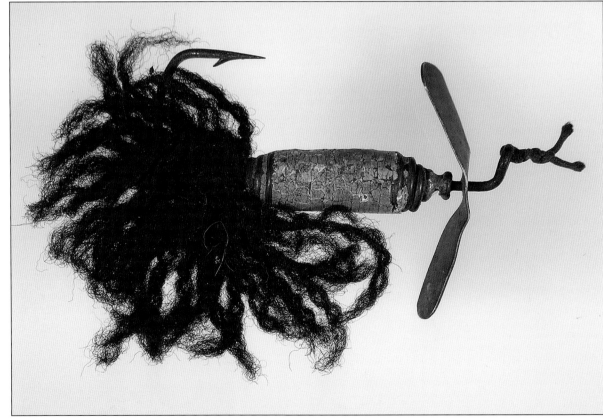

Art Deco Styled, 7" Musky Rotary-Head, ca. 1940s–1950s – Shaped, painted and varnished wood, monumental in form. Hand formed through-wire in both directions form line tie and hook hangers. Hand cut, painted aluminum prop is fixed via screws to the head section. A large fixed, painted wood dome and two different metal bearings separate the body segments. Large blue faceted glass bead bearing at tail; hand assembled, turkey-feather dressed double tail hook formed by two single hooks is wire wrapped, leaded and painted.

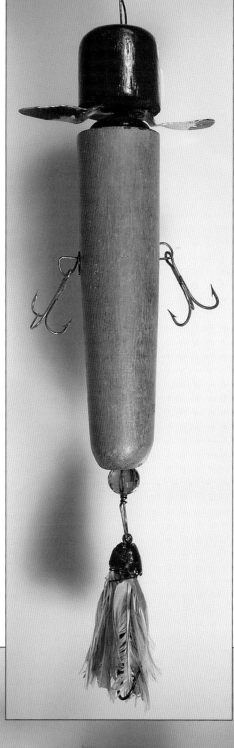

Musky "Downy" Duck – Large 7-1/4" x 3-1/4" x 2-5/8" one-piece, chip-carved, painted and varnished wood with remnants of adhered duck down. Solder and washer-reinforced, formed, through body wire rigging in both directions forms the line tie and hook hangers. Wire "ends" of belly hook hanger are turned down over reinforcing washer at top of back. Certainly imposing in the water, one can only imagine that casting this primitive duckling would be like casting a shoe; but, as its worn-torn appearance suggests, this *shoe* walked many miles and caught fish!

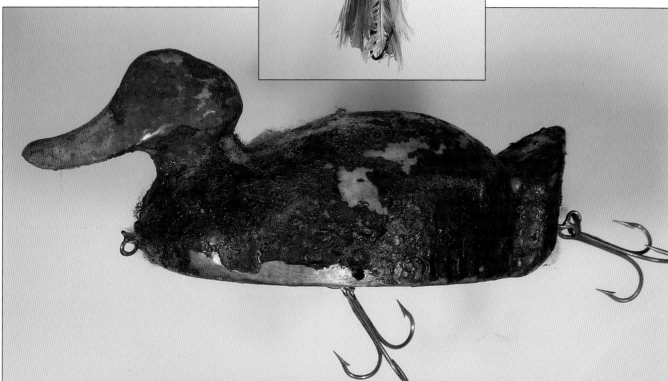

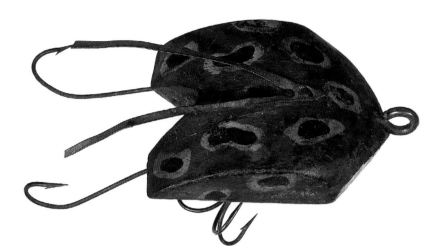

Weedless Chunk Bait Frog - Hand carved, painted and varnished wood ca. 1930s. Rich age patina on this primitive frog chunk bait measuring 2-1/2" x 1-3/4." Somewhat resembling a Creek Chub Weed Frog, its single trailing hooks are both nailed and staple secured to the belly. Screw eye line tie and belly hook hanger. The flat strip, V-shaped weed guard is hand cut from a single piece of tin and secured by two tacks at the back.

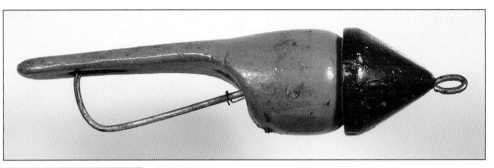

Mechanical Bird Lure – 4-1/2" turned, carved, painted and varnished wood spring loaded lure, ca. 1930s. The simple form may have been intended to simulate a wounded bird. Inside the body cavity, a "pin/nail" passing through the hook eye and containing a collapsible spring positions the hook in weedless position. When a fish strikes, the internal spring is compressed, moving it through the "tail" into striking position.

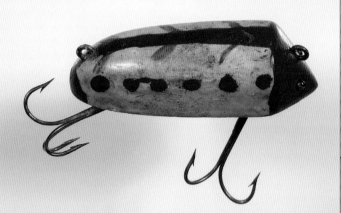

"Flat-Belly" – 2-3/4" carved, painted and varnished wood body ca. 1930s. A simple paint scheme, glass bead eyes, <u>both</u> front and rear line ties (for differing action in the water), a flat as a pancake belly and full wire through hardware make this lure highly original.

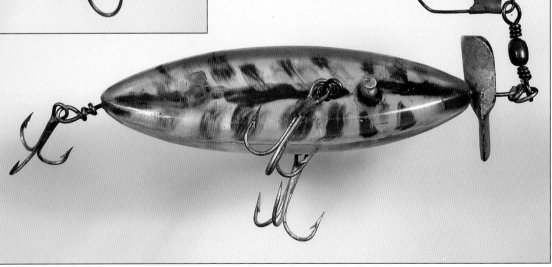

Acrylic Minnow ca. 1940s –4", two pieces of shaped acrylic sandwiched together longitudinally. Paint affects are *internal*, painted on the *inside* surfaces of the acrylic plates before attaching them. Surface ground through body rivets front and rear simulate eyes and serve to connect the two body plates. Unique hand carved and painted front prop. Wire through side hooks. Front line tie and rear hook hangers are made of formed wire that loop around the through body rivets anchoring them in place.

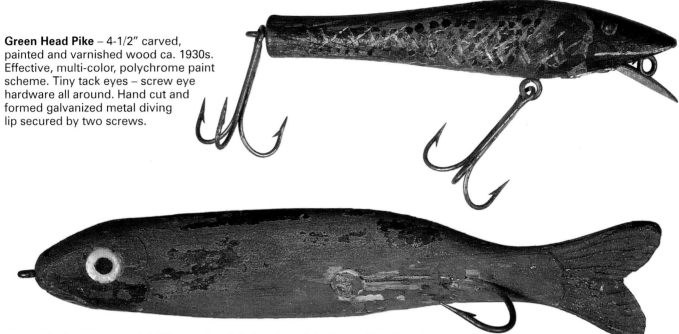

Green Head Pike – 4-1/2" carved, painted and varnished wood ca. 1930s. Effective, multi-color, polychrome paint scheme. Tiny tack eyes – screw eye hardware all around. Hand cut and formed galvanized metal diving lip secured by two screws.

Green Musky Minnow – 6-1/2" carved, painted and varnished wood. Designed as a surface darter, its graceful curved form would simulate a minnow's swimming or dying action. Simple yet elegant, and possessing fine character, this minnow features carved mouth, gill and tail-fin details. Carved mother of pearl and Bakelite disk eyes. Eye of single hook is anchored by a nail with the shank fastened by a through-body brass cotter pin.

Foil Darter – 4" carved, painted and varnished wood with adhered aluminum foil on rear body to simulate reflective fish scales, ca. 1930s. Double screw eye line ties pass through a hand cut tin face plate to reinforce and anchor them. Nail secured glass bead eyes; carved gill detail. Rigid rear single hooks (flush mounted, one per side) are secured in two places – at their hook eyes, by screws into the wood body and secondly, fixed at the tail – by a separate pair of screws (with wire wrapping passing around the screws and adjacent hook shanks).

Folk Art Hooks
Collection of early Native American hooks/lures, each utilizing
Indian trade beads – found in Byron Center, Michigan.

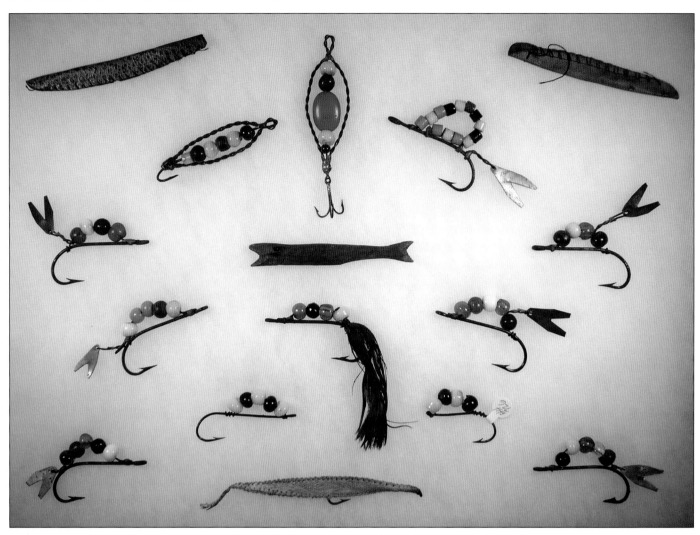

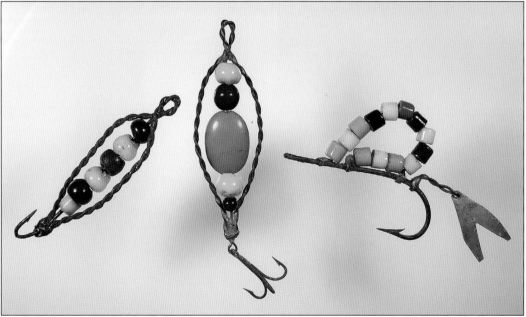

This close-up shows the elegance and appeal of the woven wire work and trade beads in these
unique artifacts.

Primitive Minis

Whether folk art or factory, miniature lure examples swim in a school of their own. For consistency, I've elected to present small primitive folk art lures within this section. Visually, the examples illustrated are very different from their fancier cousins highlighted in Section 5. Commingling primitive minis with their more refined counterparts can be visually distracting. For maximum appreciation, each lure deserves to be viewed in context with its kindred spirits. The inherent simplicity and "primitiveness" of the following examples are appealing to many. Others may prefer the more refined examples in Section 5.

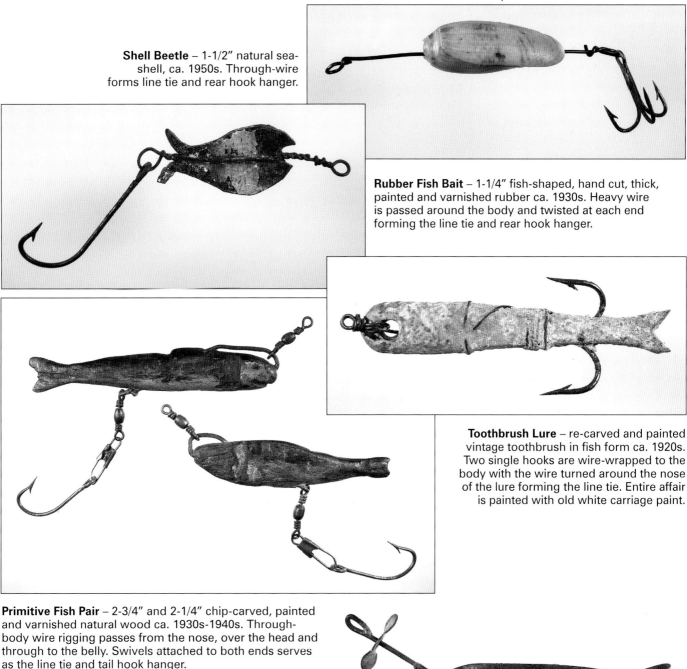

Shell Beetle – 1-1/2" natural sea-shell, ca. 1950s. Through-wire forms line tie and rear hook hanger.

Rubber Fish Bait – 1-1/4" fish-shaped, hand cut, thick, painted and varnished rubber ca. 1930s. Heavy wire is passed around the body and twisted at each end forming the line tie and rear hook hanger.

Toothbrush Lure – re-carved and painted vintage toothbrush in fish form ca. 1920s. Two single hooks are wire-wrapped to the body with the wire turned around the nose of the lure forming the line tie. Entire affair is painted with old white carriage paint.

Primitive Fish Pair – 2-3/4" and 2-1/4" chip-carved, painted and varnished natural wood ca. 1930s-1940s. Through-body wire rigging passes from the nose, over the head and through to the belly. Swivels attached to both ends serves as the line tie and tail hook hanger.

Silver Metal Minnow – 2-1/2" hand-cut metal minnow ca. 1920s. Single hook soldered to one side. Hand made and soldered front wire leader holds a tiny, hand cut and formed metal spinner.

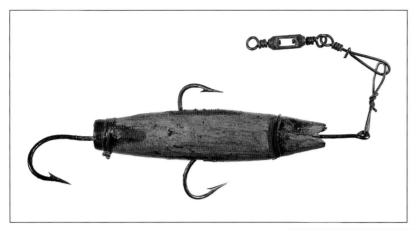

Primitive Mustard Fish – 2-1/2" chip-carved, painted and varnished wood, ca. 1920s. Paint eyes. Three early blued single hooks are inlet into the body with the recesses filled. One of these hooks (shank) passes through the mouth of the lure and becomes the line tie. Body is wire-wrapped near the tail and around the gills to further reinforce the lure.

Pair Clothespin Bugs – ca. 1940s–1950s. Top: 1-3/8" re-carved painted and varnished clothespin. Rear treble hook set in inlet tail slot, pinned in place by a copper through-nail. Two sets of red feathers are inserted on each side of the tail area. Bottom: 1-7/8" re-carved and varnished bug built around an inset single hook whose eye forms the line tie.

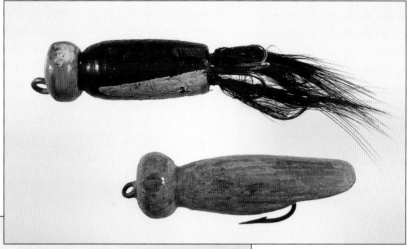

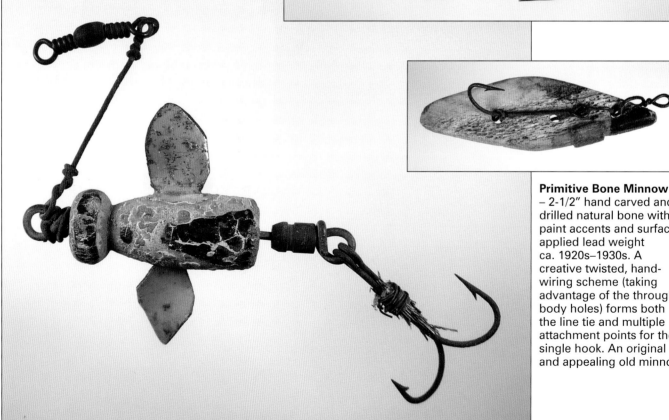

Primitive Bone Minnow – 2-1/2" hand carved and drilled natural bone with paint accents and surface applied lead weight ca. 1920s–1930s. A creative twisted, hand-wiring scheme (taking advantage of the through-body holes) forms both the line tie and multiple attachment points for the single hook. An original and appealing old minnow.

Revolving Clothespin Bait – 1-5/8" re-carved, painted and varnished clothespin body ca. 1920s. Heavy, loose, wire-through body forms line tie and rear hook hanger. Odd metal tube bearing at rear. Handmade and wire-tied rear double hook shows remnants of being feather tied. Twisted wire front leader. Inset, formed and painted tin wings cause body rotation.

Folk Art Lures

Much folk art is united by an originality of expression and a love of materials, colors, patterns, and forms; often this emphasis adds great visual appeal and a sense of joy to primarily utilitarian objects.—Gerald W. R. Ward, *American Folk*, 2001

This Section presents the stuff of dreams to most folk art collectors. The "bread and butter" of the folk art lure field if you will. Nothing here is ordinary -- often, the makers take on form, paint and finish is a refreshing twist from the conventional. At other times creativity rules all, with the makers design and execution skills offering the fish something they have never seen before – and never will again. These solutions' to every fisherman's biggest question, what will catch fish, go beyond the ubiquitous factory designs guided by efficiency and cost. An individuals unique creation was driven by vision and passion, *not* time or cost. Though made by hand using common materials, the result sometimes yielded a lure beyond anything ever conceived by any manufacturer. In these types of lures, the extraordinary was born.

It is in this section that I'll back up my earlier claim that the creations within the folk art lure field are more diverse than either the duck decoy or fish decoy realms. I am constantly asking myself just what was it that triggered these makers thoughts? Why this? Why not that?

Even in the 1930s, a fisherman had literally hundreds of factory lures he could choose to buy (assuming he could afford to), or could 'copy' (assuming he had the tools and skills). Why then invent a new solution? Of course, there is only one answer and it's obvious. Because he had a better idea! An idea that because of some mix of ego, pride and optimism compelled him to conceive, create and *use* something truly unique.

Following are some of my favorites. Some chosen hold a special appeal – perhaps its their unique form or great paint; others make an overall impact so special, they are readily appreciated as an example of the finest in American folk art. Each abstract sculpture reflects an individual fisherman/makers unique, honest and personal interpretation of natures own elements; each example also provides us with a tangible link to our past. I encourage you to take your time, meander and absorb the photos. There are untold numbers of fascinating stories here – rich history that will never be known. Imagine the maker. Imagine the setting. Imagine the feeling of spending hours creating a lure unlike any ever created before and then catching your dinner…ah, to be sure, the stuff of dreams...

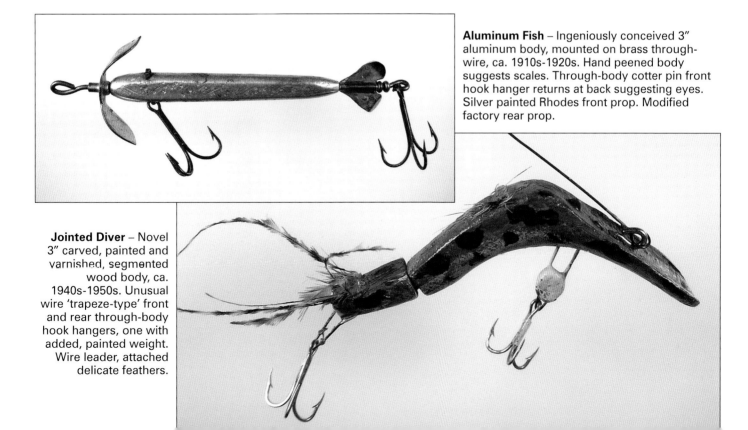

Aluminum Fish – Ingeniously conceived 3" aluminum body, mounted on brass through-wire, ca. 1910s-1920s. Hand peened body suggests scales. Through-body cotter pin front hook hanger returns at back suggesting eyes. Silver painted Rhodes front prop. Modified factory rear prop.

Jointed Diver – Novel 3" carved, painted and varnished, segmented wood body, ca. 1940s-1950s. Unusual wire 'trapeze-type' front and rear through-body hook hangers, one with added, painted weight. Wire leader, attached delicate feathers.

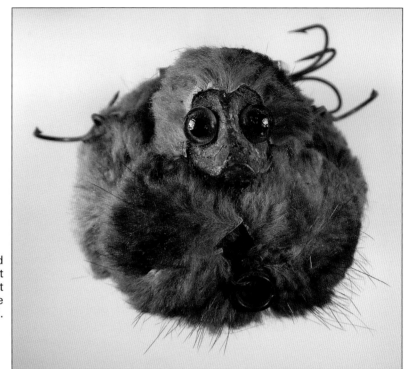

Furry Musky Duck – 5"x3-1/2"x2-3/4" carved wood body and head with attached, skin mounted Muskrat fur ca. 1920s-1930s. Glass taxidermy eyes, paint effects on face. Internally fixed wire-through line tie and hook hangers with attached split rings all around.

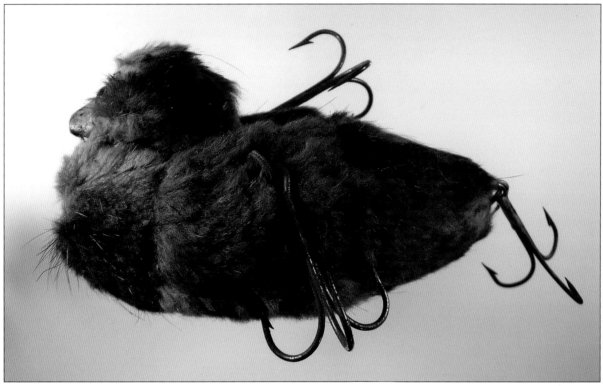

"Musky Duck – side view"

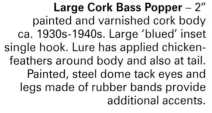

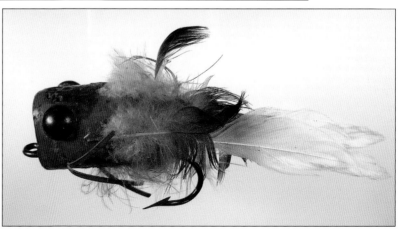

Large Cork Bass Popper – 2" painted and varnished cork body ca. 1930s-1940s. Large 'blued' inset single hook. Lure has applied chicken-feathers around body and also at tail. Painted, steel dome tack eyes and legs made of rubber bands provide additional accents.

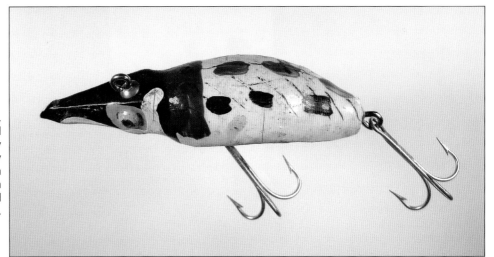

Brown's Ladybug – 3-1/2" carved, painted and varnished wood ca. 1930s. While manufactured by Brown's Co., the lure is entirely hand made and painted. Aluminum tack or brad eyes. Screw-eye with reinforcing washer hardware all around.

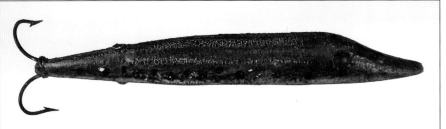

Green Pike Jig/Cheater – 4-1/8" carved, painted and varnished wood, Wisconsin, ca. 1920s. Line tie is a hole through the body. Dome metal tack eyes – belly weight. Pair of partially recessed single hooks at tail, mounted (at front) via brass tacks and wire-wrapped at rear.

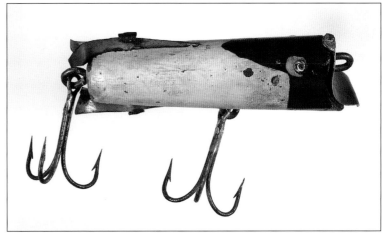

Silvery-Tailed, Red-Head Wobbler – 3" carved, painted and varnished wood ca. 1920s-1930s. Fixed steel through-body wire secures metal face plate. Inset, small glass bead eyes. Double layer of ultra-thin, tin strips inset into the body at both the top and bottom of the tail are flared into a 'double-tail' effect. The top and bottom sections are both secured by crimped tin keepers.

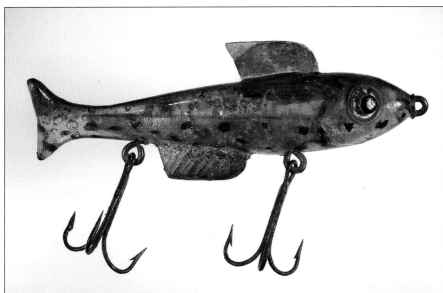

Serpentine Sinking Fish – 4" fish-shaped, hand poured celluloid or plastic body cast over a lead ½ body with integral dorsal and anal fins; varnished with paint accents, ca. 1930s. Inset glass eyes – lead surrounds brass wire line tie and hook hangers.

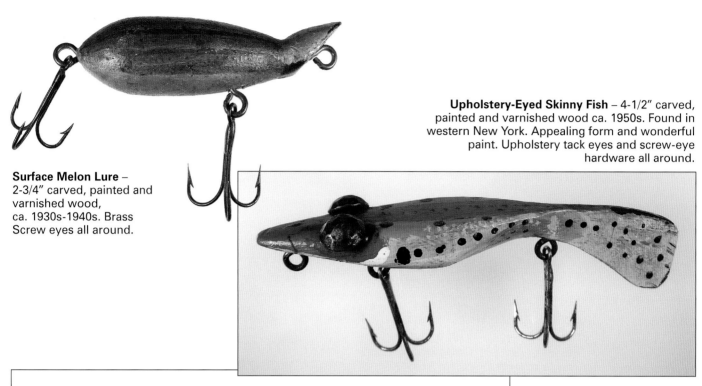

Surface Melon Lure –
2-3/4" carved, painted and
varnished wood,
ca. 1930s-1940s. Brass
Screw eyes all around.

Upholstery-Eyed Skinny Fish – 4-1/2" carved,
painted and varnished wood ca. 1950s. Found in
western New York. Appealing form and wonderful
paint. Upholstery tack eyes and screw-eye
hardware all around.

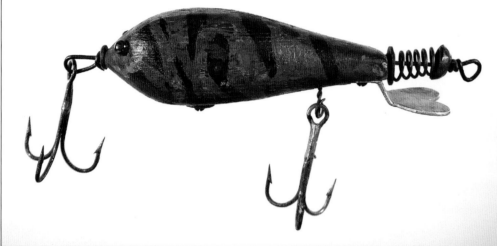

Amazing Mechanical Crawdad –
3" carved, painted and varnished
wood ca. 1930s. Wire-through
hardware in both directions.
Glass pin eyes. Aluminum diving
lip. With a removable hook, this
crawdad lure is capable of being
fished from either end – as either
a diving or surface lure. The
mechanical spring and washer
assembly was likely intended to
aid in freeing the lure if snagged.

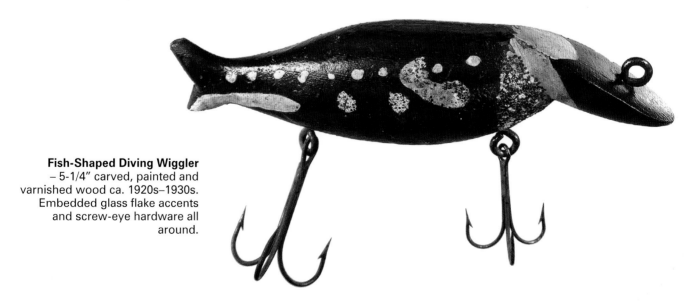

Fish-Shaped Diving Wiggler
– 5-1/4" carved, painted and
varnished wood ca. 1920s–1930s.
Embedded glass flake accents
and screw-eye hardware all
around.

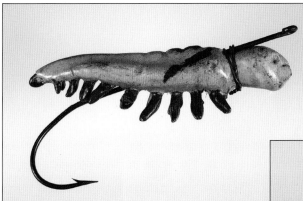

Carved Hellgrammite – 2-3/4" chip-carved, thickly painted and varnished wood ca. 1910s-1920s. Large 'blued' single hook passes through the body. Hook is further wire-wrapped at neck.

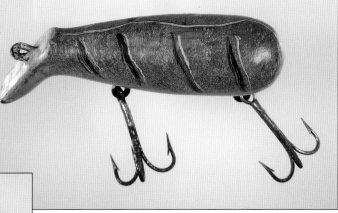

South Haven Bait or Alliance (Ohio) "Leg-Lure" – 3" painted and varnished wood ca. 1930s. Fixed, internal wire line tie and hook hanger hardware.

Fat Happy Sunny – 2-1/4" carved, painted and varnished wood ca. 1940s-1950s. Painted tack eyes. Screw eye hardware all around.

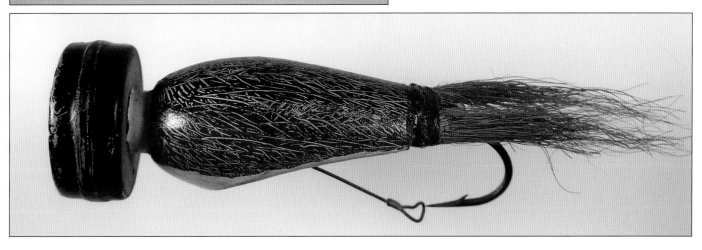

Scratch-Painted Bird Popper – 3-1/8" carved wood, painted and varnished body ca. 1920s. Wrapped, double bucktail 'tail' looped around inlet tail area. Applied round, painted aluminum head secured by heavy brass internal wire. Finely turned weed guard mounted to hook which itself is secured by formed brass plate and 3 screws.

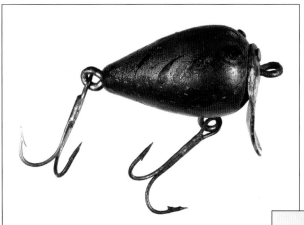

Colorful Bulbous Diver – 1-3/4" carved, painted and varnished wood, ca. 1930s-1940s. Odd varnished aluminum reverse teardrop diving lip is nail secured as well as stabilized by line tie. Nail eyes. Screw eye line tie and belly hook hanger.

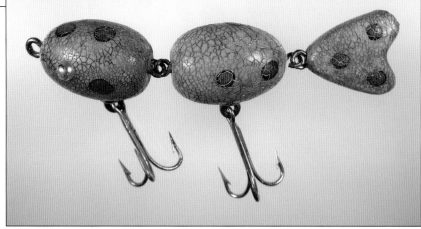

Fish-Tail, Jointed Bulb Bait – 3-7/8" double-jointed, carved, painted and varnished wood ca. 1930s-1940s. Painted pearl eyes. Cup and screw eye hook hardware.

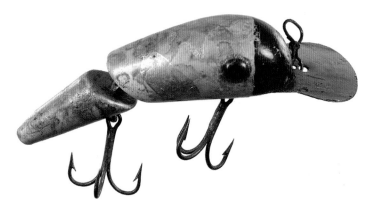

Red-Nosed Jointed Diver (Muskegon, Michigan) – 3" carved, painted and varnished wood ca. 1930s. Hand cut tin diving lip secured by two screws under the mouth as well as belly hook screw-eye. Eyes possibly painted melted glass. Formed wire line tie. Plate and screw eye joint construction with plate likely anchored by rear hook screw eye.

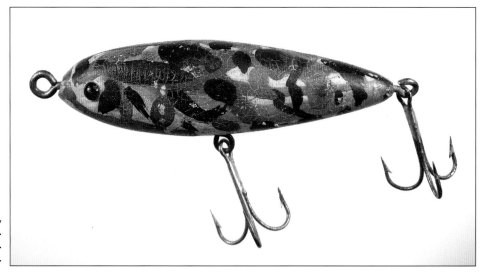

'Camo' Surface Bait – 3-5/8" carved, painted and varnished wood, ca. 1930s. Screw-eye hook and line tie hardware. Black, glass pin eyes.

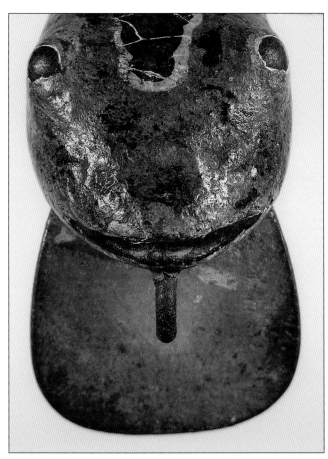

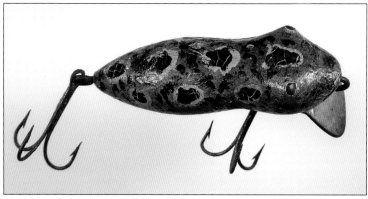

Diving Frog – 2-3/4" hand carved painted and varnished wood ca. 1920s-1930s. Steel dome tack eyes, partially painted. Screw eyes at front line tie and rear hook hanger. Thick, formed galvanized metal front diving lip secured by two screws under the head.

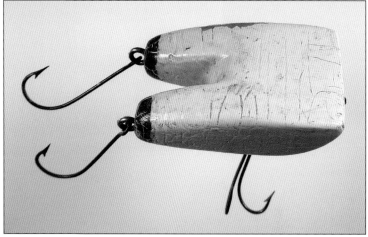

Square Pants Chunk Bait – 2-1/4" carved, painted and varnished wood, ca. 1930s. Screw eyes all around. Double hook at belly and two black japanned single hooks at rear.

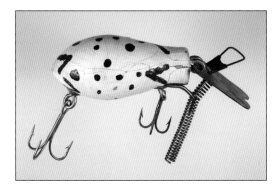

Adjustable Lipped Wobbler (Oklahoma) – 1-1/2" carved, painted and varnished wood ca. 1930s-1940s. Adjustable brass diving lip secured by two screw eyes. 'Snap' line tie. Lip adjustability provided by 1-1/2" spring which, when turned, adjusts angle of diving plane. Spring adjustment occurs via a heavy wire loop which passes around and under the front hook hanger. Washer reinforcement at rear hook hanger.

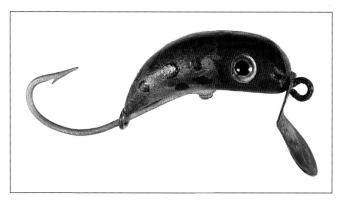

Crescent Wiggler – 1-7/8" carved, painted and varnished wood ca. 1940s. Glass eyes. Figure-8 shaped tin diving lip inserted in mouth area and secured by screw eye. Formed, galvanized single hook is curved to follow belly and is anchored both by a screw at the belly and a screw eye at the tail.

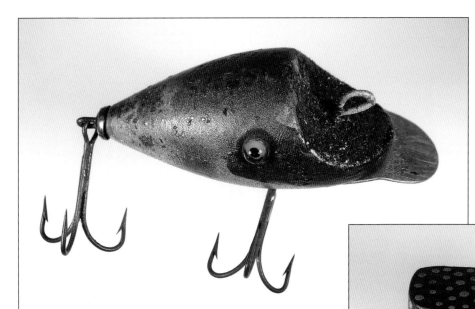

Fat and Sassy Diver – 3"x1-1/2"x1-1/2" shaped, painted and varnished wood with crushed glass glitter ca. 1940s. Glass eyes. Hand cut and formed aluminum diving lip secured at the belly by 3 screws, coped at lead end for stabilization to receive belly hanger. Internal, fixed wire, painted line tie and belly/tail hook hangers. Metal tail reinforcing cap.

Clown-Face – 2-3/4" carved, painted and varnished wood ca. 1940s–1950s. Painted line tie acts as tongue. Bulbous, painted bead eyes are nail secured, the nail painted as a pupil. Varnished pipe-cleaner dorsal fin and tail accents. Domed washer reinforced wire belly hook hangers.

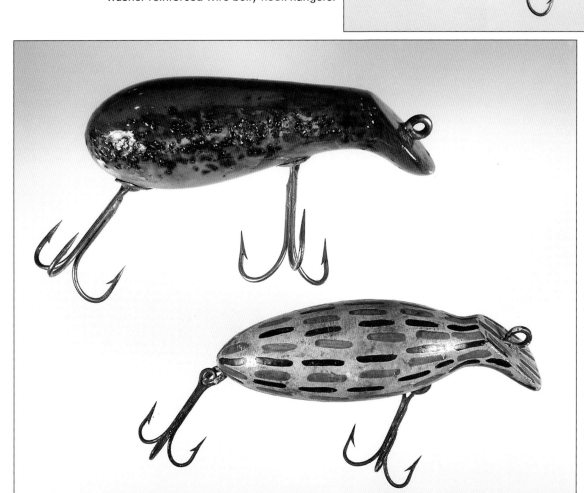

Wiggler Pair No. 1 - Top 3-3/8", Bottom 3-1/8"; each of carved, painted and varnished wood, ca. 1930s. Top employs cup and screw hook hardware, glass chip accents and a screw-eye line tie. Bottom, a "Leg-Lure" made in Alliance, Ohio, utilizes screw-eye line tie and hook hardware.

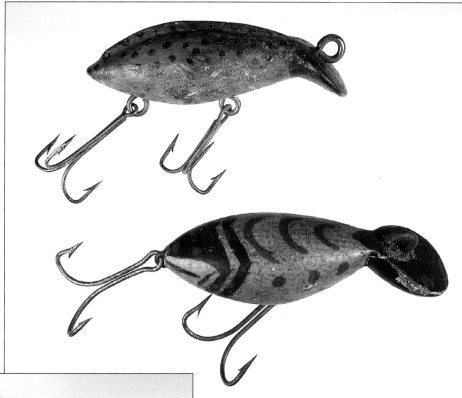

Wiggler Pair No. 2 – Top 2-3/4" ca. 1930s, Bottom 3-1/8" ca. 1920s; each made of carved, painted and varnished wood. Top features a uniquely carved, raised back 'rib' and has screw-eye hook hardware all around. Bottom (crawfish pattern) wiggler features great paint and employs internally fixed wire hook hangers and a large, screw-eye line tie.

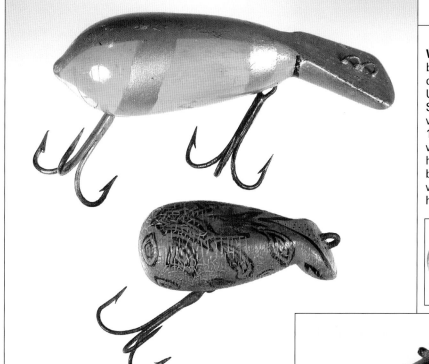

Wiggler Pair No. 3 – Top 3-5/8", Bottom 2-1/8" both of carved, painted and varnished wood ca. 1920s. Top is quite similar to an Albyler Underwater "Basgeter," (an obscure lure from Seattle, Washington); this one, also from WA, was made by an even more obscure maker ca. 1930s. This wiggler features an internal, double-wire line tie and deeply set large, cup and screw hook rigs. Bottom wiggler employs a screw eye belly hook hanger and an internal lead belly weight. Note special paint detailing under the head and belly.

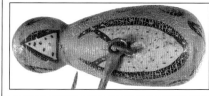

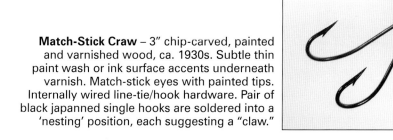

Match-Stick Craw – 3" chip-carved, painted and varnished wood, ca. 1930s. Subtle thin paint wash or ink surface accents underneath varnish. Match-stick eyes with painted tips. Internally wired line-tie/hook hardware. Pair of black japanned single hooks are soldered into a 'nesting' position, each suggesting a "claw."

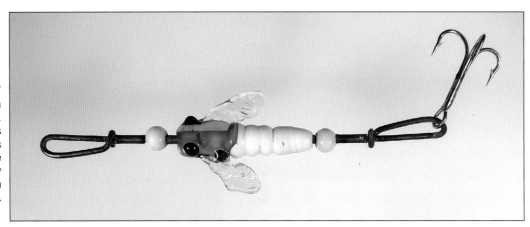

Glass Winged Bug – 1-1/2" glass bug lure mounted on a brass shank, ca. 1920s. The body slides on a brass armature "stopped" by glass beads front and rear. The beads are in turn stopped by brass armatures holding them in place.

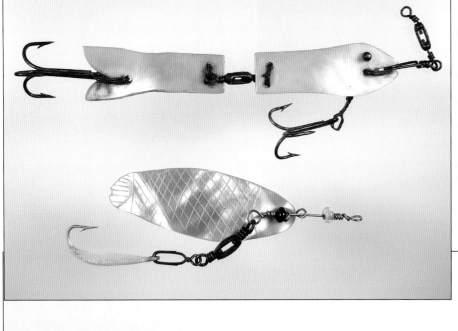

Carved Pearl Pair – Top: 3-3/8" jointed, hand carved pearl minnow, ca. 1910s. Cup-shaped, front and rear body sections. Joint is assembled using a box swivel, each end of which is wired to a body section. Through-wire attached rear hook. Line tie swivel is wired through the body forming the minnow's mouth. Eyes are formed by a rivet passing through metal beads on each side of the head. Wire front hook hanger is secured to the line tie (mouth) wire. Bottom: hand carved pearl spinner with gill/scale/tail accents attached to a beaded wire box swivel rig. An attached, pearlized single hook completes the rig.

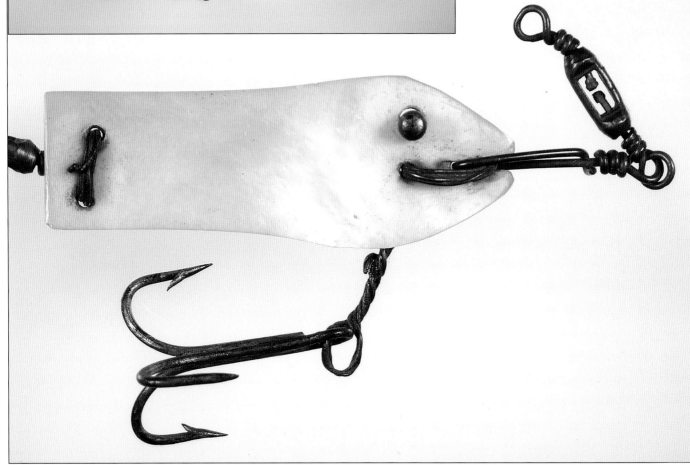

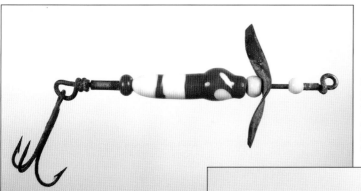

Glass Bodied Spinner – 1-1/4" glass body mounted on a metal tube or armature which in turn is fitted over a through-wire brass shaft. Another brass tube spacer bearing at rear. 3 glass beads; hand cut and formed brass prop completes the unit.

Glass Eyed Rotary-Head – 3-1/2" turned, painted and varnished wood. Glass eyes. Fully fixed wire-through line tie and rear hook hanger. Belly cup and screw eye rig. Inset rear cup rig, painted. Formed brass wing cut from sheet and nailed to nose section. Aluminum washer bearing at joint.

Scaled Pike Lure – 9-1/2" (musky-sized), carved, painted and varnished wood. Painted eyes. Hand applied, detailed scale pattern. Hand-cut metal diving lip inserted into the mouth area – the lip is secured by a screw. A modified screw passes through the lip and functions as the line tie. Two hand-poured lead belly weights. Screw eye hook hangers all around. Found in Manitoba, Canada.

Rotary-Head Musky Cork Muskrat – 7" carved and painted cork. Through-wire fixed line tie and hook hangers. Side-hook rigged. Hand-cut and formed brass rotating collar nail-secured to the head.

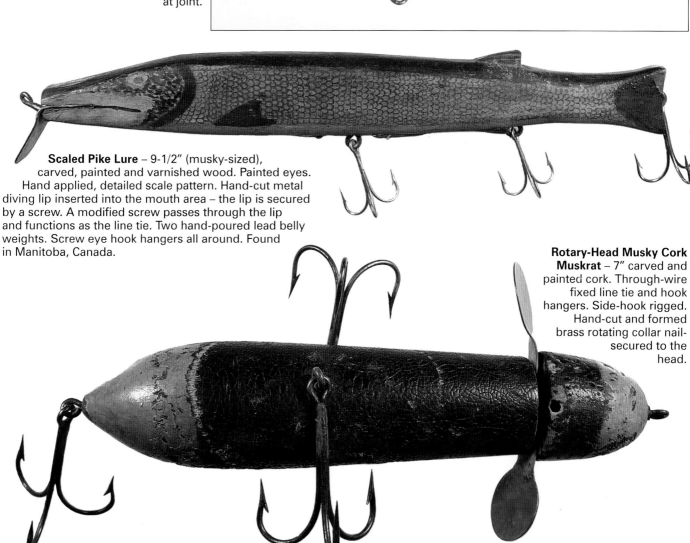

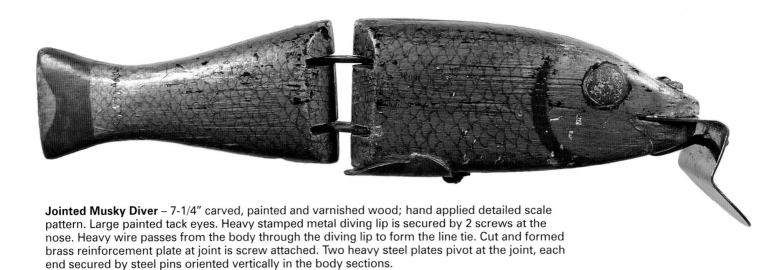

Jointed Musky Diver – 7-1/4" carved, painted and varnished wood; hand applied detailed scale pattern. Large painted tack eyes. Heavy stamped metal diving lip is secured by 2 screws at the nose. Heavy wire passes from the body through the diving lip to form the line tie. Cut and formed brass reinforcement plate at joint is screw attached. Two heavy steel plates pivot at the joint, each end secured by steel pins oriented vertically in the body sections.

Flared Gill Musky Diver – 8" carved, painted and varnished wood. Painted metal dome tack eyes. Hand-cut, formed and painted diving lip is secured by 5 screws. Embedded wire front line tie. Deeply set screw-eye hook rigs.

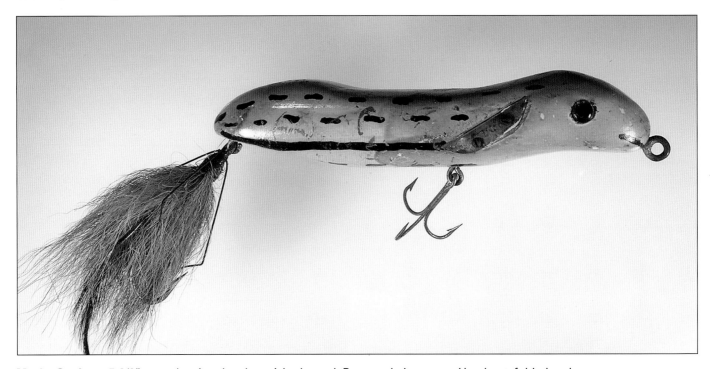

Musky Gopher – 5-3/8" carved, painted and varnished wood. Recessed glass eyes. Hand-cut, folded and screw-attached side 'splasher' wings. Through-wire line tie – hand-tied weedless bucktail treble at tail.

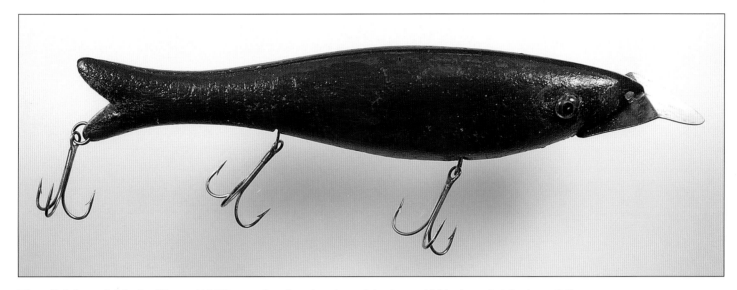

Plate-Reinforced, Musky Diver – 7-3/8" carved, painted and varnished wood 'sides' sandwiched to a full, fish-shaped brass body, through which the wire hook hangers pass. Inset glass eyes. A folded, cut brass diving lip is soldered to the brass body plate.

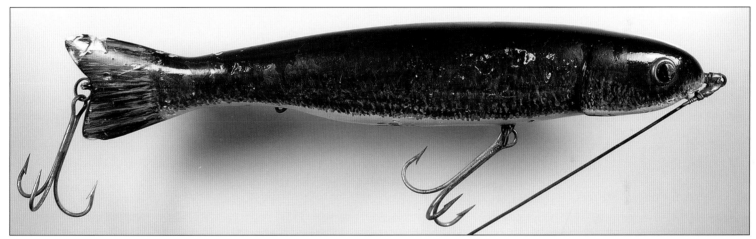

Musky Sucker – 10-3/4" shaped, carved, painted and varnished wood ca. 1940s. Found south of Madison Wisconsin. Superbly crafted and painted, this lure has detailed mouth and gill carving and sports painted tack eyes set into a metal ring or bearing. Fixed, through-body wire forms the line tie and hook hangers. The 11" heavy wire leader is wrapped and soldered on each end. Lure shows clear evidence of a Musky attack in a former life.

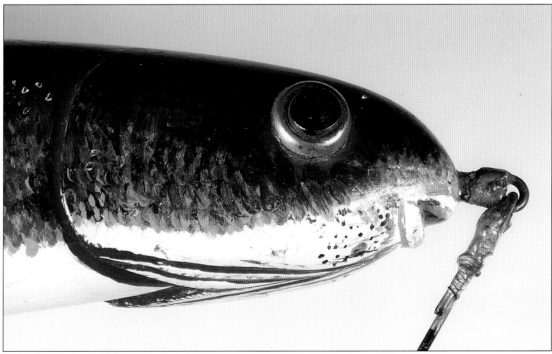

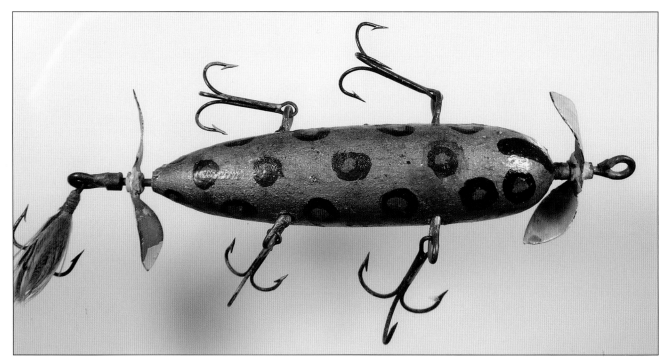

Fred D. Rhodes 5-Hook Surface "Cabin" Bait
– Acquired with documentation July 20, 2005 from collector Walt Blue who found this lure at Rhode's old cottage at Austin Lake in Portage, Michigan. This lure was discovered as part of the same find as the other Cabin Baits, several of which are featured in *Fishing Lure Collectibles* by Dudley Murphy and Rick Edmisten © 1995. This particular lure was added to Mr. Blue's folk art collection and retained by him until passed to the author. Turned, painted and varnished wood. Painted eyes. Pair handmade, thrusted and painted spinners. Full, heavy, soldered through-wire in both directions form the line tie, tail and side-hook hangers.

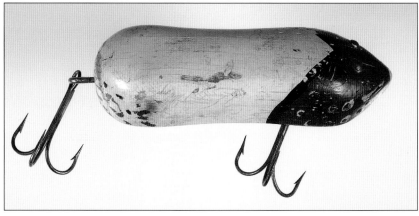

Red & White Mouse – 3-1/8" carved, painted and varnished wood ca. 1930s-1940s. Small tack eyes. Painted ears and whiskers. Under-head line tie. Screw eye hardware all around.

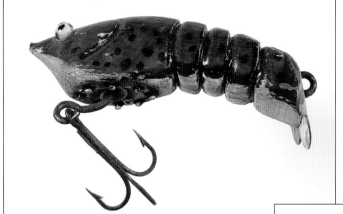

Hand Carved Wright & McGill Wood Crab – 3" earliest version, carved, painted and varnished wood ca. 1926-1929. Glass eyes. Painted, shaped aluminum diving lip is tacked on and further secured by line tie screw eye. Protruding wire belly hook hanger. 8 tacked-on legs are long gone.

Spotted Chunk Bait – 2-3/4" carved, painted and varnished wood ca. 1930s-1940s. Recessed single hook at tail secured by a screw. Formed and painted wire weed-guard also secured by a screw. Hand poured lead belly weight and painted gill marks.

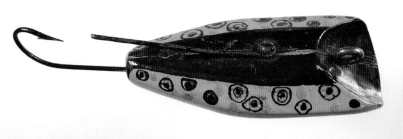

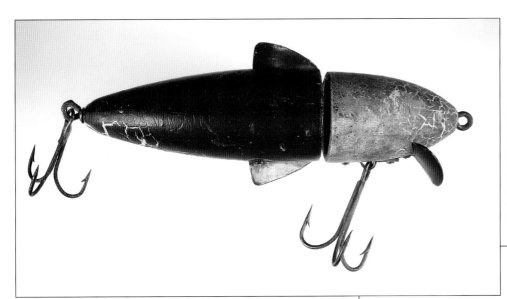

Diving – Rotating Tail Lure – 4″ turned, painted and varnished wood ca. 1920s-1930s. Formed, painted metal diving lip. Through-wire construction. Side wings on tail section are inlet into the body and further secured by a screw which penetrates a formed flange. Heddon bar rig belly hook hanger.

Gem-Eyed Geometric Diver – 2-1/4″x1-1/2″ carved, painted and varnished wood with 6 inlet gemstone 'eyes', 2 each on each side and one on each side of the canted 'face.' Wire-through hardware in both directions forms line tie and hook hangers. Hand formed, cupped metal diving lip with substantial solder added as additional weight for deeper diving.

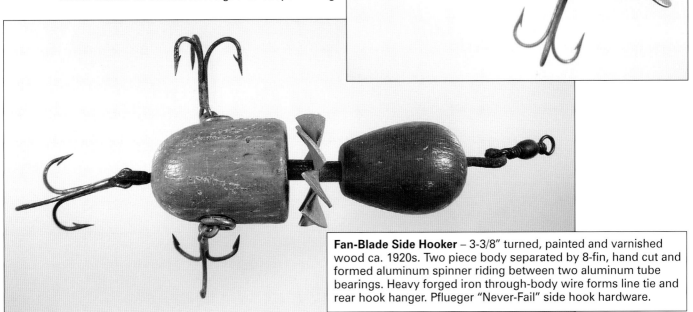

Fan-Blade Side Hooker – 3-3/8″ turned, painted and varnished wood ca. 1920s. Two piece body separated by 8-fin, hand cut and formed aluminum spinner riding between two aluminum tube bearings. Heavy forged iron through-body wire forms line tie and rear hook hanger. Pflueger "Never-Fail" side hook hardware.

Patriotic Chunk Bait – 2-1/2″x1-1/4″ carved, painted and varnished wood ca. 1930s. Nail at tail used as pork rind stud. Belly mounted single hook secured by painted metal shroud which in turn is secured by eight nails on the belly. Giant, screw-eye line tie.

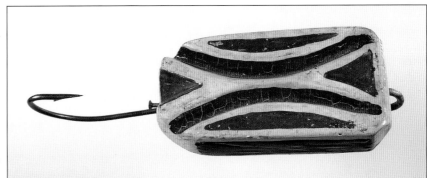

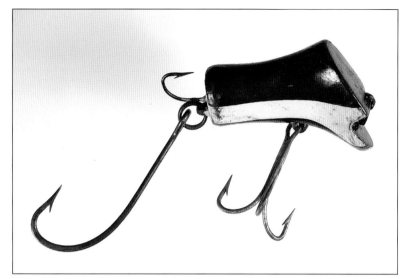

'Ghost-Fish' Diving Chunk Bait – 1-3/4" shaped, painted and varnished wood ca. 1930s. Punched, heavy through-wire bar forms line tie and rear tail hook hanger. Belly hook is wire attached. Embedded, fixed rear pork rind hook. White side paint details suggest a second fish swimming with an open mouth.

Paddle Lure – 4" shaped, painted and varnished wood with centrally located, 4-winged, (painted) steel fan blade ca. 1930s. The blade is constructed by twin folded steel straps anchored to a central tube. A through-body hammered pin supports the blade and has washer stops at the inside edges of the central opening. A few similar pieces have been found. One theory is that this device could also be positioned ahead of another lure and used without hooks as a fish attractor.

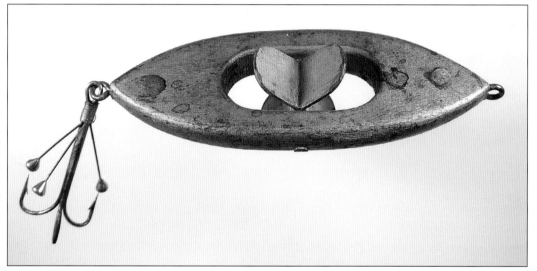

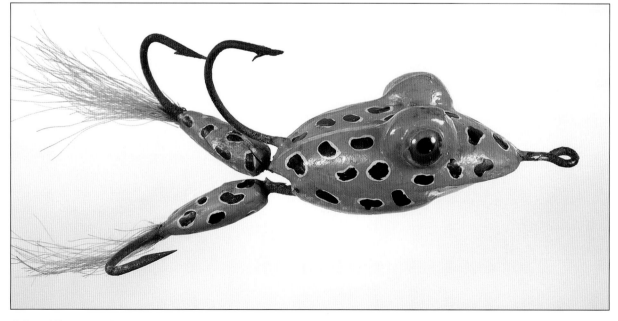

Jointed Frog – 2-3/4" carved, painted and varnished wood with integral bucktail at each leg ca. 1930s. Glass eyes. Legs are built around a formed, V-shaped, hook which passes through and is locked by a recessed heavy wire anchored to the main body. Primary body hook passes through the frog and terminates as the line tie. This frog is gorgeous and well crafted.

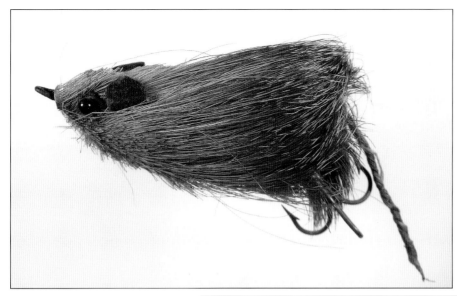

Bucktail Mouse – 3" body built over wood frame ca. 1930s. Leather ears, glass bead eyes. Twisted fiber tail.

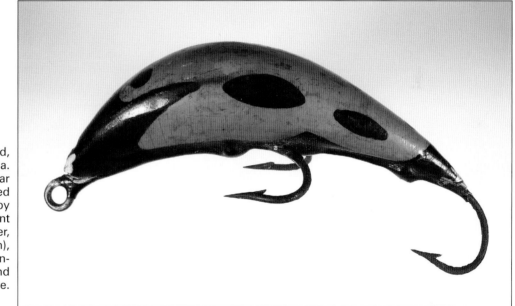

Ghost Bait – 4-1/4" carved, painted and varnished wood ca. 1910s. Front double and rear single hook are partially recessed along the body and secured by large pins. Through the paint scheme, the maker (using clever, figure-ground alternation), suggests a second, open-mouthed fish with red eyes and fins on each side of the lure.

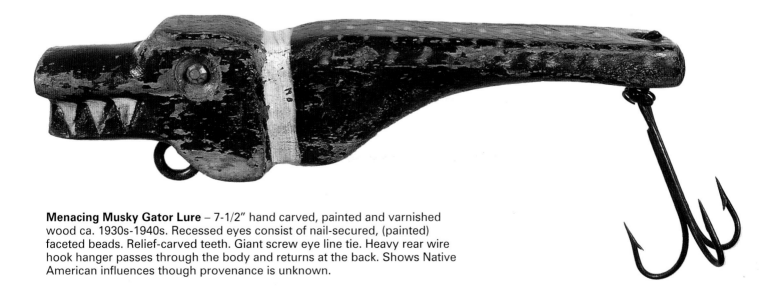

Menacing Musky Gator Lure – 7-1/2" hand carved, painted and varnished wood ca. 1930s-1940s. Recessed eyes consist of nail-secured, (painted) faceted beads. Relief-carved teeth. Giant screw eye line tie. Heavy rear wire hook hanger passes through the body and returns at the back. Shows Native American influences though provenance is unknown.

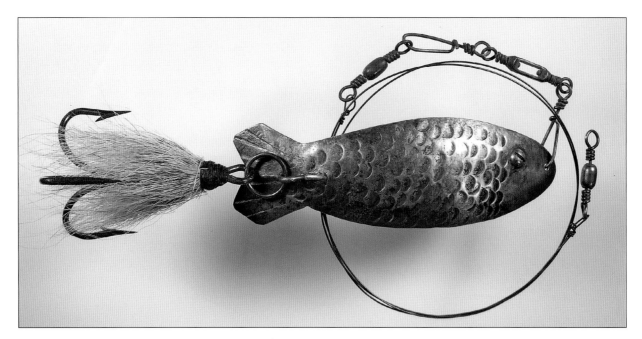

Musky Hand-Hammered Fish – 5-1/4" hand-formed, hammered and detailed sterling silver fish ca. 1920s. Screw/rivet eye detail. Heavy, soldered wire "hump" rear tail hook hanger. Large, hand-tied, rear bucktail treble. Finely detailed, hand hammered 'tail bones'. Incorporates wire leader. An amazing folk art piece in all respects.

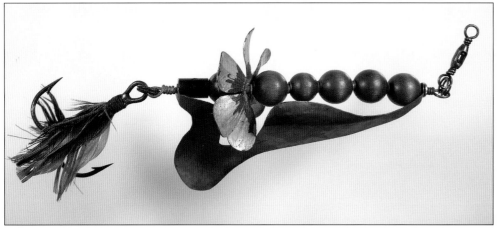

Musky Keeled Spinner ca. 1920s (Fulton, New York) – 4-1/4" through-wire shaft forms line tie and rear hook hanger. Large, hand-cut and formed brass keel attaches at front and rear. Revolving around a coped opening in the brass keel and around the shaft is a 6-bladed, hand cut and tooled, painted copper fan. A series of 6 painted wood balls with brass washers at each end, act as spacers/bearings. Steel tube bearing at rear. This wonderful piece goes way beyond the conventional.

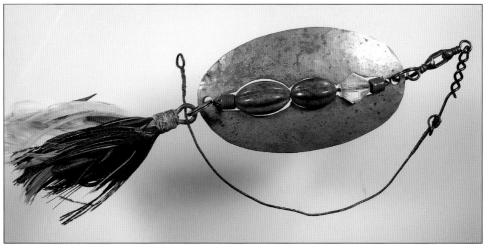

Hammered Musky Beaded Spoon ca. 1920s – 3-1/4"x2" hand cut, formed and hammered metal alloy spoon with a series of precisely cut openings along it's centerline to receive and 'seat' fancy glass beads. Attached wire leader and hand-tied, rear feathered treble hook.

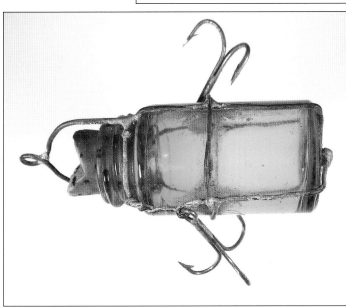

Grey Injured Minnow – 4-1/2" hand carved, painted and varnished wood ca. 1930s. Chiseled tail effect. Screw eye hardware all around with recessed cup and screw side hook hardware. Recessed glass eyes. The simple form and blended paint scheme with minimalist accents is highly effective.

Jar Bait – 2-3/4" wire wrapped, vintage glass jar with angled cork stopper which serves as diving lip ca. 1930s. Soldered wire harness wraps the jar and forms both the line tie and side hook hangers.

Propeller Bait – ca. 1920s. Shaped, painted and varnished wooden propeller type blade 2-1/2"x1-1/4" revolves around a hand-formed, through-wire shaft that serves as the line tie (soldered) and rear hook hanger. Front propeller has a metal tube passing through it which rides on the shaft. It is at least possible this is a Frank Brown's Patent Bait, patented November 25, 1924 in Patterson, New Jersey.

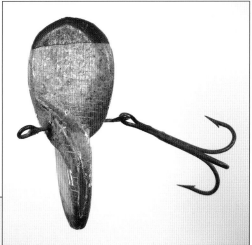

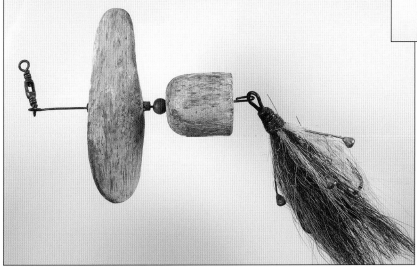

Propeller Bait 2 – ca. 1920s. 2" shaped, painted and varnished 2-piece propeller lure with full through-wire forming the line tie and rear hook hanger. Front propeller has a metal tube passing through it which rides on the shaft. Glass bead bearing at center and tied rear Bing's-type rear treble hook. Rear body section contains an inlet, cut-lead belly weight. It is at least possible this is a Frank Brown's Patent Bait, patented November 25, 1924 in Patterson, New Jersey.

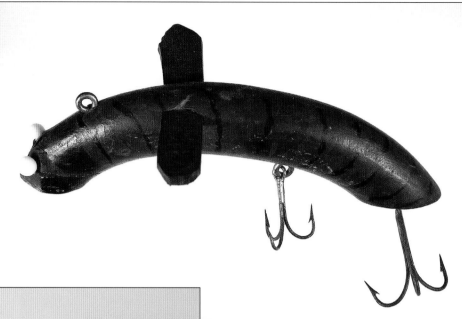

Swooping Bird (or Dragonfly) Lure – 4-1/2" shaped, painted and varnished wood ca. 1930s. Large glass pin eyes. Screw-eye line tie and belly hook hangers. Heddon bar-rig tail hook hanger. Inlet, painted rubber wings. This unique, highly creative folk art lure possibly started life as simply a wood 'handle.'

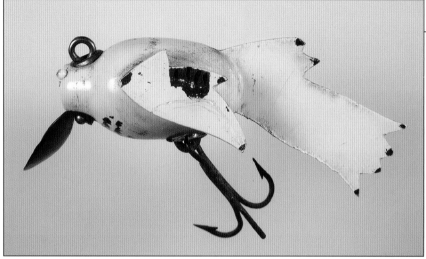

Diving Bird – 3-3/4" shaped, cut, painted and varnished wood ca. 1930s–1940s. Inlet tail and applied side wings. Hand-hammered, screw-attached, brass diving lip. Painted, glass pin eyes. Modified, deeply set (possibly hand made) metal grommets at line tie and hook locations. Screw-eye line tie and hook hardware.

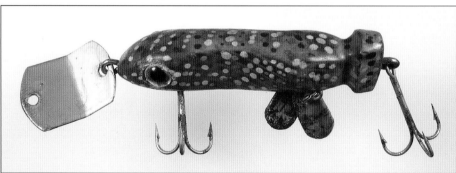

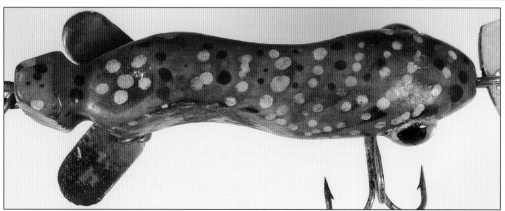

Spotted Darter – 2-3/4" carved, spot-painted and heavily varnished natural, serpentine-shaped wood ca. 1940s. Formed, loose, painted metal diving lip/attractor. Large, inset glass eyes. Screw eye hardware all around – belly hook cup rig. Hand cut/formed, painted rear flashers near tail.

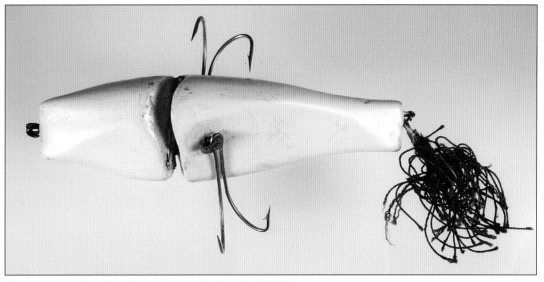

White Jointed Wiggler – 4" hollow aluminum with vertical, reticulated joint behind head allowing side-to-side movement. Hand cut and formed aluminum shell is coated with some type of dental paste/epoxy compound in solid white. Thread-tied rear treble hook. Through-wire side hook hangers. Front line tie and rear hook hanger formed from twisted wire. Unusual steel hinge assembly at joint.

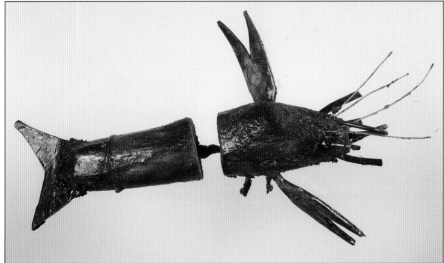

Primitive Craw – 3-3/4" segmented, hand carved, painted and varnished wood ca. 1930s–1940s. Double hooks pass through the front body segment, the eyes of which anchor a rear wire that passes through and out the rear body segment of the craw. The wire is further secured by hand cast lead and wire wrapping at the tail. Inlet, painted rubber tail and arms/claws. Additional rubber legs and gut 'feelers' are inserted into the front body segment.

Gem-Eyed Mouse – 3-1/8" hand carved, painted and varnished wood ca. 1920s–1930s. Faceted gemstone eyes. Leather tail. Screw eye hardware all around inserted through shallow painted cups at the belly. Hand-cut, formed and painted diving lip secured by screws. Inlet, leather ears.

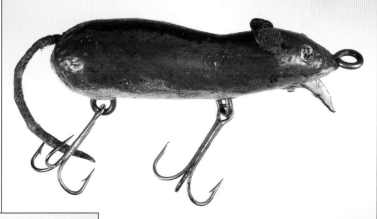

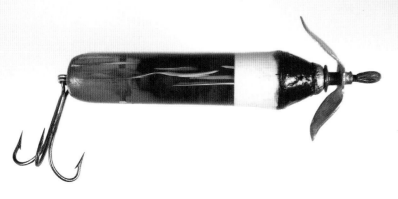

Amber Lure – 2-3/4" hollow translucent, yellow amber/Bakelite outer body with some paint accents, surrounds a carved cork/varnished underbody ca. 1920s–1930s. Hand cut and formed, thrusted, metal front prop. Brass brad bearing and metal nose cap assembly. Double wrapped, wire rear tail hook hanger is secured by a metal rivet which passes through the body.

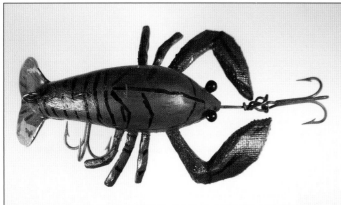

Gray Craw – 2-1/8" carved, painted and varnished wood ca. 1930s–1940s. Wire-through construction in both directions. Painted, hand-cut aluminum diving lip is secured by 2 tacks and a screw. Hand cut and painted rubber arms/claws pass into body and are secured by a recessed screw at the belly. Inlet, painted rubber legs and glass pin eyes.

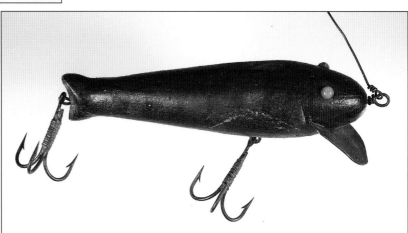

Green Eyed Diver – 3-1/4" carved, painted and varnished wood ca. 1930s. Full, fixed, through-wire construction in both directions, forms line tie and hook hangers. Hand-cut and inlet metal diving lip secured by a nail under the head. Green glass pin eyes. Integral wire leader. Handmade, wire-tied treble hooks.

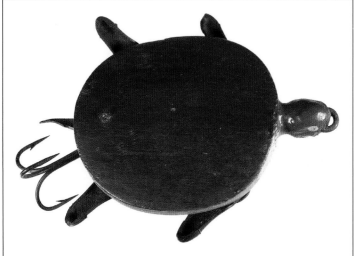

Turtle Lure – 2-3/4"x2" hand carved, painted and varnished wood, ca. 1930s-1940s. Embedded wire line tie. Screw attached metal diving bill. Steel thumbtack applied, cut rubber legs. Rubber tail secured by screw eye tail hook hanger. Only one of two authentic hand-made, vintage folk art turtle lures the author has ever seen.

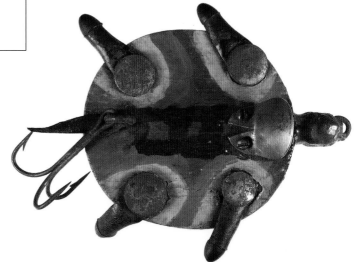

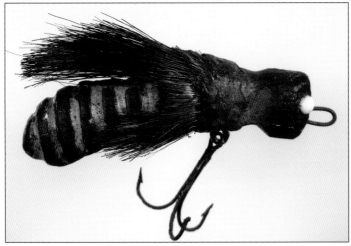

Big Bee – 3" chip-carved, painted and varnished wood ca. 1920s. Adhered, turkey-beard 'wings.' Glass pin eyes. Wire line tie passes through main body where, upon exiting the back, it is exposed and twisted above the striped tail segment, then secured to the body by a nail. Originality, character and personality abound.

Folky Fish – 4-1/2" carved and varnished wood with paint decoration ca. 1930s–1940s (found in northern Indiana). Glass eyes. Painted lead weight in the nose. Remnants of bristle accents at front pectoral and tail fins. Large, imbedded single hook provides line tie <u>at tail</u> and protrudes from the back as a spiked dorsal fin (protected by bristle or gut guards). Screw-secured double hooks are separated and re-curved along the belly and lower sides of the body, finally bending away from it in a way suggesting side fins. This maker copied no-one.

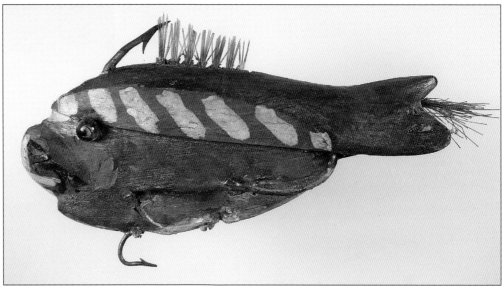

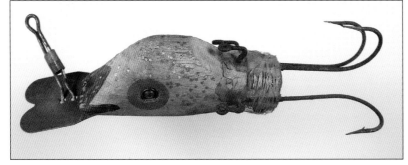

Hi-Head Pork Rind Diver – 2-3/4" carved, painted and varnished wood with glass fleck accents ca. 1930s-1940s. Screw attached, Bomber Bait Co. style lip. Screw and washer eyes. Three re-formed, recessed single hooks wrapped to the tail of the bait – the L-shaped hook line ties serve as individual pork rind studs. So rigged, I'll bet this lure was highly effective.

Nose Cone Bait – 3-5/8" turned and varnished wood with paint accents ca. 1900s-1910s. Heavy brass through-wire forms line tie and tail hook hanger. Large, folded brass nose cone and smaller brass tail cap, both seamed.

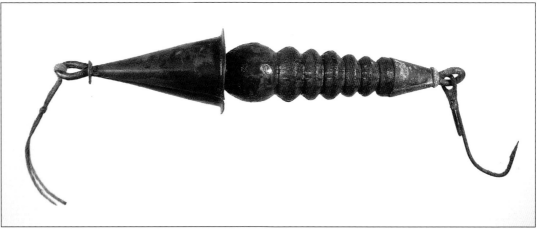

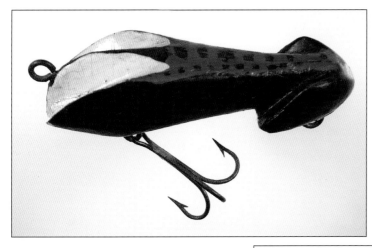

Manly Craw – 3-1/4" carved, painted and varnished wood ca. 1920s–1930s. Screw-eye line tie and hook hangers. Belly hangers are cut, diamond-shaped plates, secured by two nails to odd 'thickened' body sections.

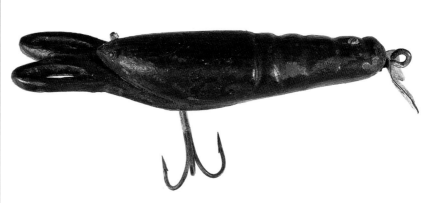

Dark Craw – 4" chip-carved, painted and varnished wood ca. 1920s. Tiny, nail-secured, glass bead eyes. Belly, cup and screw hook hardware. Inlet, hand-cut, re-formed, Heddon Crab Wiggler lip, secured by screw at tail (back). Formed wire passing through the diving lip serves as line tie. Creative form with simple oval cut-outs suggesting arms/claws.

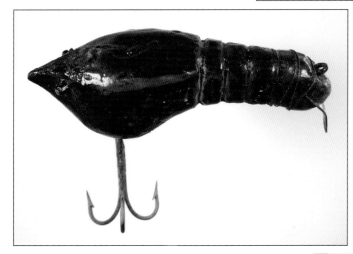

Fiery Craw – 3-1/4" chip-carved, painted and varnished wood ca. 1930s-1940s. Wire line tie passes through the body and is turned down like a staple after penetrating the back. Varnished, inlet, cut-tin diving plate further secured/reinforced by wire-wrapping. Cylindrical, nailed-on bead eyes.

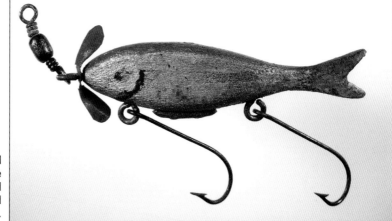

Spinnered Minnow – 3" hand carved, painted and varnished wood ca. 1920s. Painted eyes. Screw eye line tie and hook hardware. Hand cut and formed front spinner. Surface applied belly weight attached by nails. Restored tail tip.

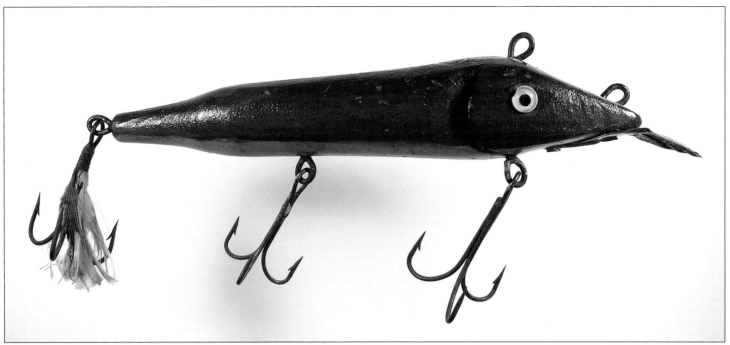

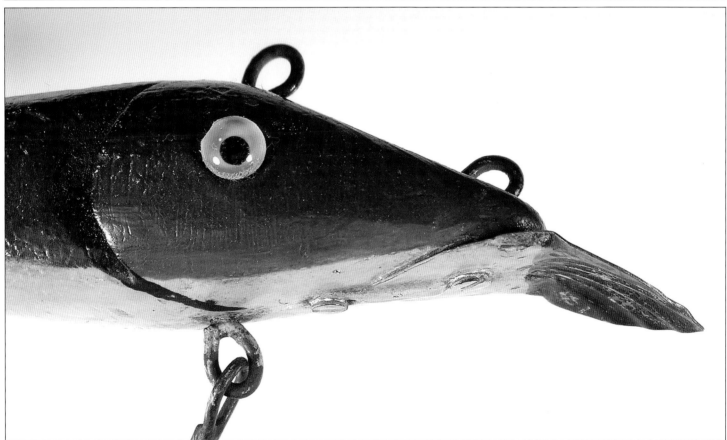

Green Musky Diver – 7-1/4" carved, painted and varnished wood ca. 1930s. Deeply carved gills, glass eyes. Heavy wire line ties and hook hangers. Tied rear feathered treble. Folded, fluted vintage spinner blade used as diving lip, painted on the underside. Lip is secured by screws and wire strapping.

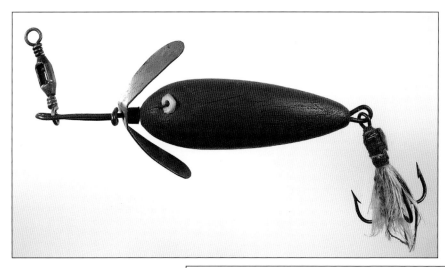

Red Spinnered Minnow – 2-1/8" turned, painted and lightly varnished wood – possible colored stain mix ca. 1900s. Full, fixed through-wire line tie and hook hanger. Hand cut and formed spinner painted on verso. Hand cut mother of pearl washer eyes attached by fine through-body wire.

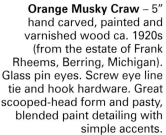

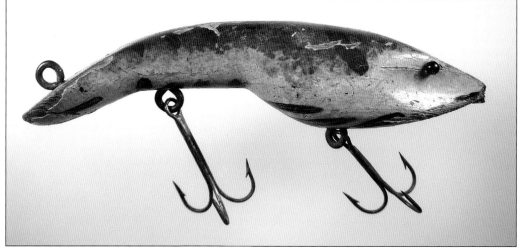

Orange Musky Craw – 5" hand carved, painted and varnished wood ca. 1920s (from the estate of Frank Rheems, Berring, Michigan). Glass pin eyes. Screw eye line tie and hook hardware. Great scooped-head form and pasty, blended paint detailing with simple accents.

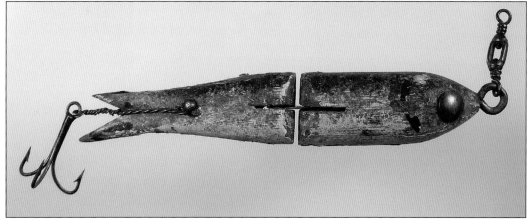

Early Segmented Swimming Minnow – 4-1/8" carved, painted and varnished wood ca. 1910s-1920s. Plate is inlet on either side of the body, hinged, and secured by pins through the back. Brass dome tacks for eyes. Twisted wire rear hook hanger runs along the sides of the rear body segment anchored by steel tacks.

Chunker Cube – 1-5/8"x1"x1" carved, painted and varnished cork ca. 1930s–1940s. Full through (fixed) wire forms rear treble hook hanger, front line tie and rear single hook hanger. It is reinforced by a screw eye at the back. Bucktail trailers are inlet into rear of cube. Glass bead eyes. Small, hand-cut lead belly weight is attached at the surface of the belly by a nail.

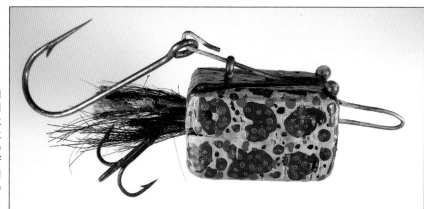

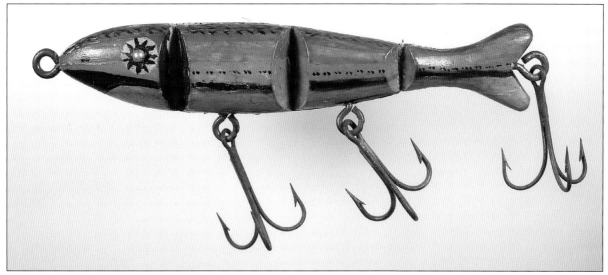

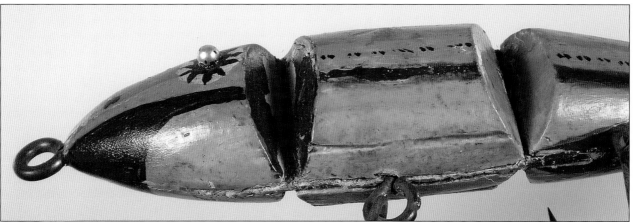

Triple Jointed Surface Darter – 5″ carved, painted and varnished wood ca. 1920s-1930s. Pearl eyes. Screw eye hardware all around. Body side segments are sandwiched around flexible canvas which does double duty as joint material. A beautifully crafted and painted lure.

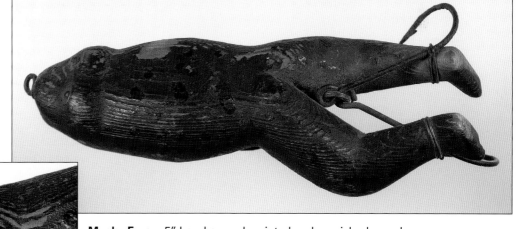

Musky Frog – 5″ hand carved, painted and varnished wood ca. 1910s-1920s. Heavy 'square' twisted brass through-wire forms line tie and rear hook hangers. Rear single hooks are further secured by brass wire wrapping to the legs. Hand cut recessed brass washers secured by tiny brass nails form the eyes. 8 individual, hand-poured, lead belly weights. Recessed, screw and staple attached belly hook.

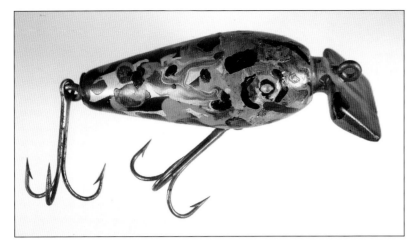

Swirl Plug – 3-1/8" hand carved, painted and varnished wood with odd, integral, wedge-shaped, carved wood diving lip ca. 1930s. Painted tack eyes. Screw eye line tie and rear hook hanger. Rear hook hanger has a painted reinforcing washer. Metal, rectangular shaped, hand cut, screw-attached belly hook hardware with integral, soldered wire loop.

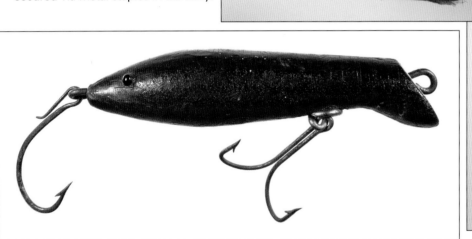

Brown Mouse – 2-1/8" hand carved, painted and varnished wood ca. 1920s. Small, hand-cut mouth bill is inlet into head and secured by tacks. Glass bead eyes, nail attached. Fixed, through-wire secures rear treble hook. Feathers suggesting a tail are secured via metal staples in the belly.

Elongated Elegant Craw – 3-3/4" hand carved and deeply varnished natural wood with painted back ca. 1920s-1930s. Brass, screw-eye line tie and tail hook hangers. Black glass pin eyes. Pflueger "Never-Fail" belly hook hanger. Scarce, South Bend removable single hook at nose adds interest.

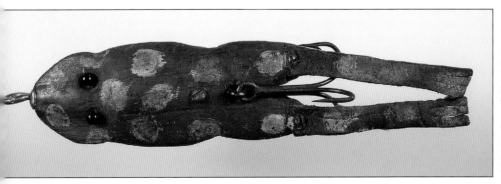

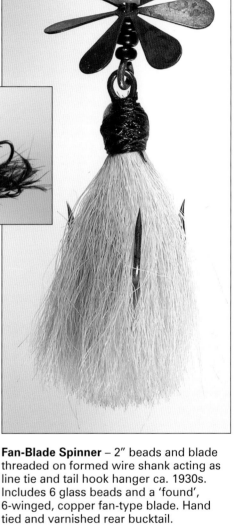

Fan-Blade Spinner – 2" beads and blade threaded on formed wire shank acting as line tie and tail hook hanger ca. 1930s. Includes 6 glass beads and a 'found', 6-winged, copper fan-type blade. Hand tied and varnished rear bucktail.

Flattie Froggie – 2-7/8" (4-3/4" overall) hand carved, painted and varnished wood ca. 1920s (purchased at auction in Kansas). Hand cut and painted leather legs are screw-attached. Embedded wire anchors the rear treble hook. Glass pin eyes. Metal, hand cut/formed line tie reinforcing washer. Recessed, screw-applied, painted lead belly weight at <u>both</u> the top and bottom of the lure – yet the frog is only 3/8" thick at its widest.

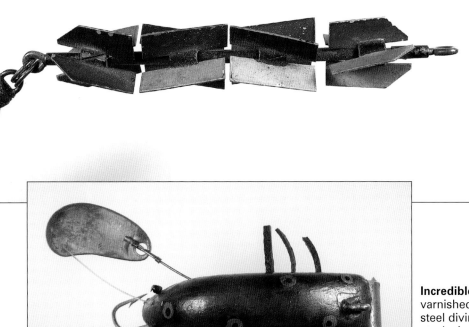

"Rubik's" Spinner – 3-5/8" four, 4-winged, multi-color, metal, fan-type blades revolve around a brass shaft separated by tube bearings ca. 1930s (originally found by Art Kimball, Boulder Junction, Wisconsin). Exceptionally crafted. Threaded, brass screw-eyes anchor into the nose and tail pieces, forming the front line tie and rear hook hangers. Hand tied rear single hook.

Incredible Craw – 2-3/8" shaped, painted and varnished wood ca. 1940s–1950s. Embedded steel diving lip is secured by a nail. Embedded steel wire arms support spinner blade 'claws' – very creative. Tiny, nail-secured glass bead eyes. Bristle feelers. Through-body, rubber strip legs. Screw-eye hook hangers.

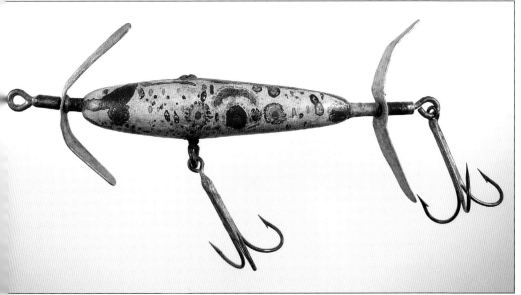

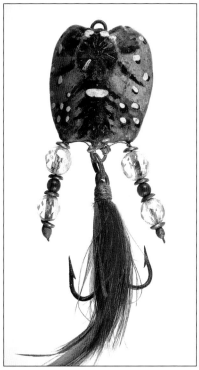

Painted Minnow – 3" carved and painted varnished wood ca. 1910s. Very folky paint detailing. Painted eyes. Through, fixed wire construction forms front line tie and rear hook hanger. Twisted wire belly hook hanger passes through the body with ends turned down on the back. Hand cut and formed, aluminum props. Bearings on each side of the spinners – the fore and aft bearings are soldered into position. Hand made twisted and soldered treble hooks.

Butterfly Lure – 1-1/4"x1-1/8" hand carved, painted and varnished wood with inset gemstone ca. 1920s–1930s. Originally thought to be made from a turtle shell, this lure is superbly painted and rendered. Full, fixed through-wire. Additional, embedded rear wire 'tendrils' tied back to rear hook hanger contain a mix of fancy glass bead and metal bearing decorations.

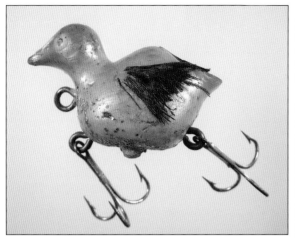

Baby Duck Lure – 2" carved, painted and varnished wood with glitter accents and adhered feathers as wings ca. 1930s– 940s. Simple, interesting 'hump-back' form. Fixed, through-body wire hook hangers. Screw-eye line tie. Lead belly weight. Painted eyes.

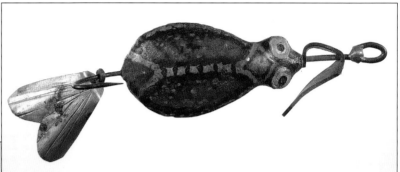

Lead Bug – 2" hand cast and painted lead poured around a wire line tie and rear single hook ca. 1930s. Hand cut '4-way' type spinner blade. Hand cut, formed and engraved rear metal tail flasher. Paint-accented, dish-formed eye detail.

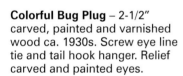

Colorful Bug Plug – 2-1/2" carved, painted and varnished wood ca. 1930s. Screw eye line tie and tail hook hanger. Relief carved and painted eyes.

Classy Lure – 4" shaped, painted and varnished wood ca. 1930s. Painted eyes. Screw-eye hardware all around. Belly cup rig. Tail reinforcing provided by a vintage 2-piece, snap part. Brush painting simply doesn't get better than this.

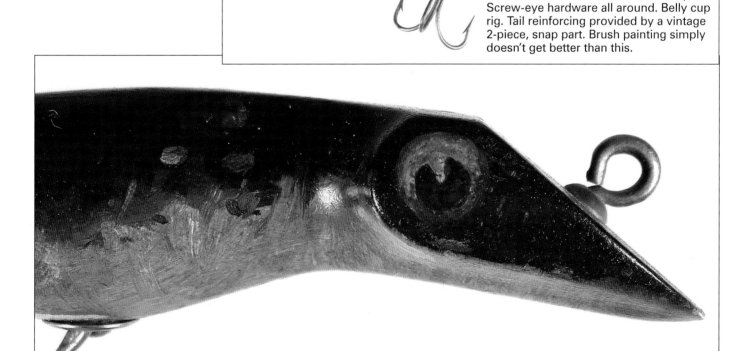

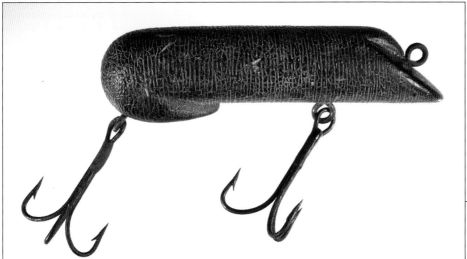

Craw Plug – 3-1/2" shaped, painted and varnished wood ca. 1920s–1930s. Screw eye line tie and tail hook hardware. Fine patina. Simple carving and paint emphasis suggests claws at front, turned down tail at rear and legs at the sides.

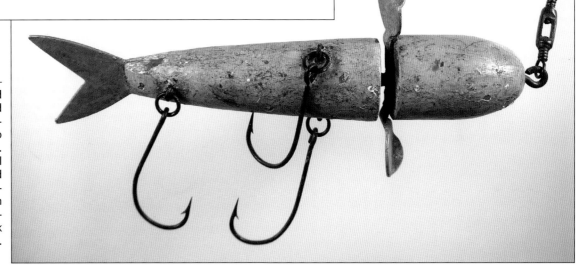

Rotary-Head Fish – 5-1/4" shaped, painted and varnished wood ca. 1900s–1910s. Aluminum fin attached to head causes rotation. A uniquely shaped tail section narrows and terminates at a nail-secured, inlet, aluminum tail fin. 3-hook "jersey-rigged" on 'staple' hook hanger rigs.

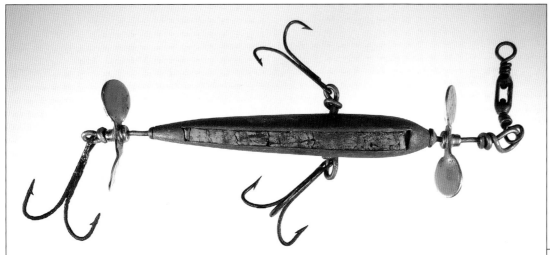

Mystery Minnow – 3" cork-filled, thin-walled, finely shaped aluminum (possibly lead) body ca. 1900s. Twisted through-wire in both directions forms line tie and tail hook hangers. Brass nose and tail caps. Plated, thrusted, Mickey Mouse type props suggest a possible early Rhodes/Shakespeare connection.

Leggy Frog Chunk – 1" body with 4-1/4" legs ca. 1930s. Shaped, painted and varnished wood body encases large single hook, the front of which serves as a line tie. Leather trailing legs are inlet into the wood body secured by two tacks through the back. <u>Horizontally</u> mounted, painted lead weight.

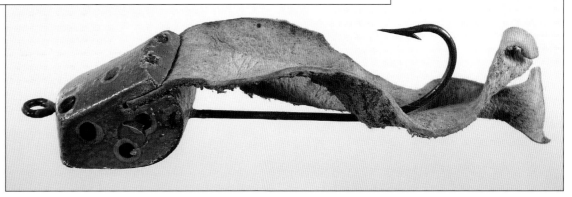

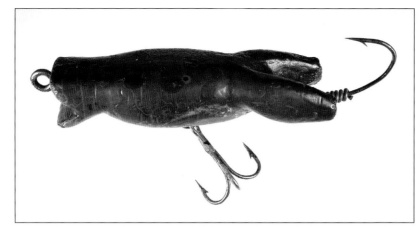

Green Frog – 3" hand-carved, painted and varnished wood ca. 1920s–1930s. Screw eye line tie and belly hook hanger. Wire-wrapped rear single hook is partially recessed and secured to the belly by a screw. Remnants of inlet, pin-secured rubber feet. Curiously, the frog bears no eye detailing.

Giant Cork Bug Bait – 2-3/4" carved, painted and varnished cork ca. 1930s–1940s. Painted, nail applied aluminum washer eyes. Full length, hand made and formed belly plate with integral diving lip is wire wrapped and screw-secured to the flat-bottomed cork body. Rear hooks are secured by both embedded metal clasps and a screw, all heavily varnished. Unusual "opposite-hand" type paint scheme.

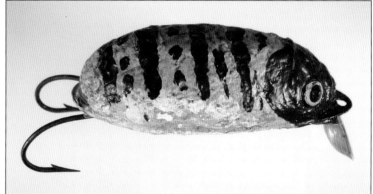

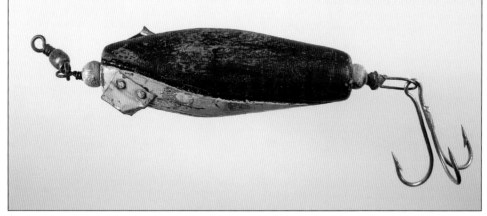

Winged Spiral Lure – (Michigan) Originates from the Kimball's collection. 2-5/8" shaped, painted and varnished wood ca. 1930s. Two recessed, painted, spiral groove decorations. Two nail-attached, hand cut and formed painted metal wings placed near nose cause rotation. Full, loose through-wire, soldered at the tail, forms the line tie and tail hook hangers. Two painted glass bead bearings, one each at front and rear.

Jointed Natural Fish – 5" triple-jointed, fish-shaped, varnished natural wood body ca. 1930s–1940s. Fully fixed, through-body wire provides line tie and joint ties. Inlet tin tail. Evidence of a (former) diving lip – given its good overall condition, it likely was removed by a fisherman for use as a surface darter/ wiggler vs. a diving lure.

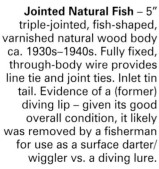

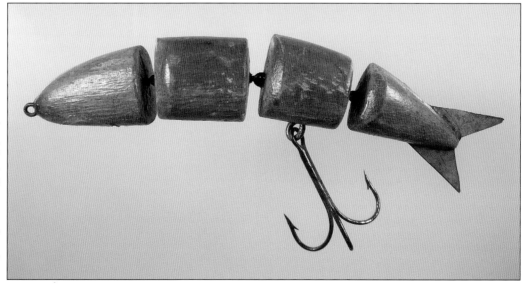

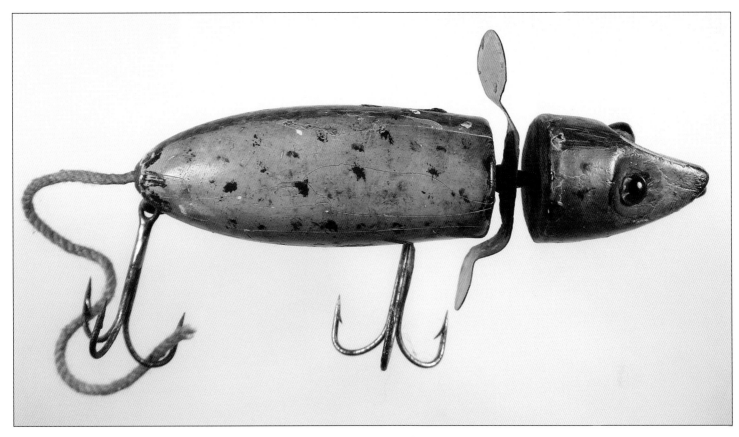

Spinnered Mouse – 4" turned, painted and varnished wood ca. 1930s. Glass eyes. Thrusted, hand-cut metal collar revolves independently of the body. Body segments are fixed relative to one another. Cord tail. Embedded wire line tie and tail hook hanger. Cup and screw belly hook hardware.

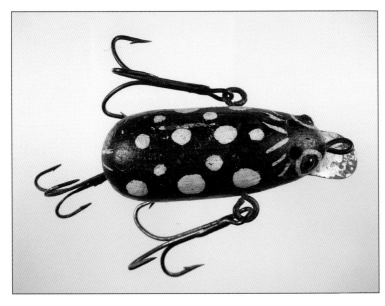

Black Spotted Mouse – 2-5/8" carved, painted and varnished wood ca. 1930s–1940s. Recessed, glass pin eyes. Hand cut and formed diving lip attached by 2 screws. 'Holes' for ears. Painted screw-eye side hook hangers.

Snakeskin Minnow – 2-1/2" hand carved wood wrapped in snake or fish-skin with paint accents ca. 1920s–1930s. Appealing and creative minnow, painted tack eyes. Wire-wrapped, inlet, feathered tail. Fully through-body, internally fixed-wire line tie, belly and rear hook hanger. Remnants of feathered dorsal fin remain.

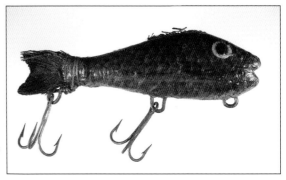

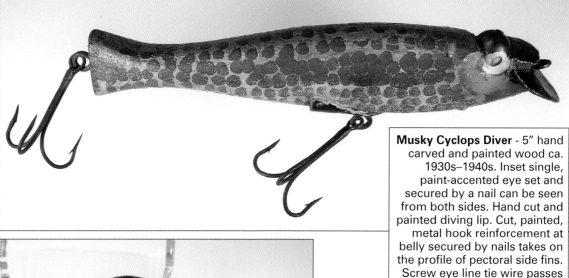

Musky Cyclops Diver - 5" hand carved and painted wood ca. 1930s–1940s. Inset single, paint-accented eye set and secured by a nail can be seen from both sides. Hand cut and painted diving lip. Cut, painted, metal hook reinforcement at belly secured by nails takes on the profile of pectoral side fins. Screw eye line tie wire passes through the body and is turned-down/anchored at the belly.

Yellow-Eyed Minnow – 4-1/8" carved, painted and varnished, fish-shaped wood body ca. 1920s. Screw eye line tie and hook hanger hardware. Recessed, nail-applied, yellow glass bead eyes. Two surface-mounted, nail-applied lead belly weights.

Green Jointed Frog – 3-1/4" hand-carved, painted, varnished and segmented wood body ca. 1920s–1930s. Tiny inlet diving lip secured by line tie wire. Relief carved and painted eyes. Fully wire-through legs/joint at rear body segment anchors hand tied, wrapped and varnished bucktail treble hooks at each leg.

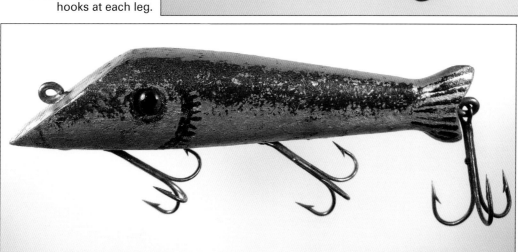

Wedge-Headed Diver – 5" shaped, painted and varnished wood ca. 1920s–1930s. Large, recessed glass eyes. Full, fixed, through-wire in both directions form line tie and hook hangers (which are recessed into the belly). Poured lead belly weight. Dome tack (painted) balance weight on chin.

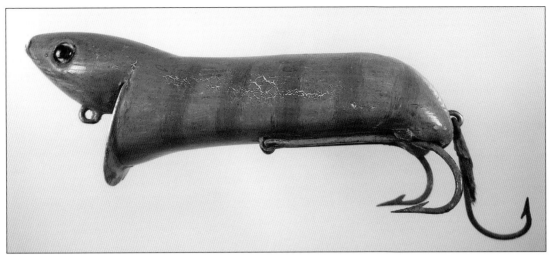

Musky Gopher Bait – 4-1/2" shaped, painted and varnished wood ca. 1940s. Inset glass eyes. Cut and shaped, painted aluminum diving bill nail-secured to the body. Remnants of tied, bucktail "tail" fashioned from the rear, trailing single hook. Internal wires and special, embedded 'clips' seat two single hooks against cut grooves in the belly; the hooks shanks would unclip and swing free upon a strike.

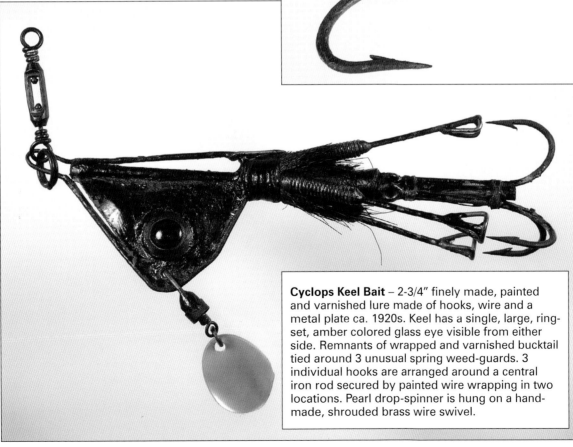

Cyclops Keel Bait – 2-3/4" finely made, painted and varnished lure made of hooks, wire and a metal plate ca. 1920s. Keel has a single, large, ring-set, amber colored glass eye visible from either side. Remnants of wrapped and varnished bucktail tied around 3 unusual spring weed-guards. 3 individual hooks are arranged around a central iron rod secured by painted wire wrapping in two locations. Pearl drop-spinner is hung on a hand-made, shrouded brass wire swivel.

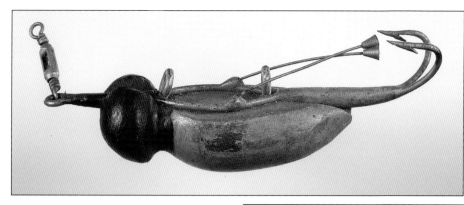

Harness Bug Bait – ca. 1910s, 2-5/8" carved, painted and varnished wood 'bug' body is mounted via two large screw-eyes to an early Herman Ladish bait harness ca. 1907. Coped head area receives the lead end of the harness rig. Perhaps the exposed screw eyes held tied string legs at one time.

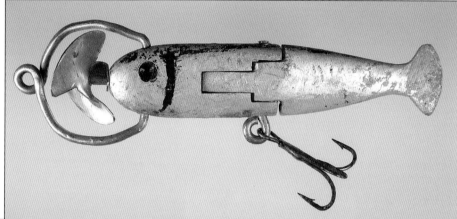

Jointed, Aluminum Swimming Minnow – 3-1/2" machined aluminum, segmented, jointed minnow with paint accents ca. 1920s. Dished eyes, painted. Wire securing the belly hook doubles as a through-body joint rod, riveted as it exits the back. Adjustable, round aluminum wire collar shrouds an unusual, flared, 2-bladed prop. As prop revolves, an internal shaft screw moves the rear body section back and forth.

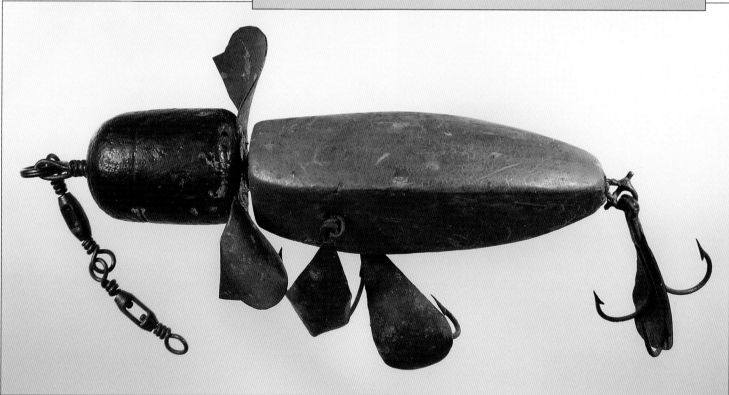

Musky Rotary-Head Paddler – 5"x1-1/2" lure simulating a paddling duck or gopher. Carved, painted and varnished cork head with shaped, painted and varnished wood body of complex form ca. 1900s. Hand cut, formed brass collar pinned to the head causes rotation. Full fixed, through-body wire forms line tie and rear hook hanger. Side hooks secured by twisted, through-wire. A separate, soldered wire keeper pin acts as a tail hook restrainer. Hand cut and shaped, brass paddle 'feet' and 'tail' painted on one side are soldered to a pair of single hooks, forming a double hook at each paddle. During use, side hook paddles would ride up into the curved, concave belly chamber on each side rendering a near-weedless lure in use.

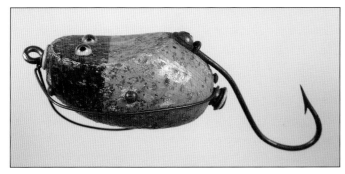

Glass-Eyed, Wiry Chunker (Cleveland, Ohio) – 1-7/8"x1-1/4" shaped, painted and varnished wood with applied glitter ca. 1930s. Glass eyes. Large rear, re-formed single hook is both staple and screw attached. A series of 5 pins that are inserted around the mid-section of the lure perhaps were intended as attractors. Odd double-grommets at nose and tail support full-length, side wires that perhaps were intended to function as weed-guards. Nose assembly is secured by a screw-eye while a nail secures the rear.

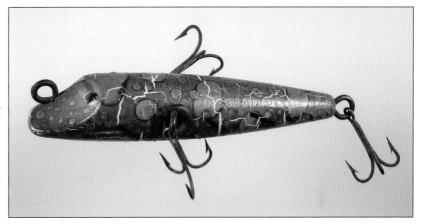

Spotted Side-Hooked, Diving Darter – 3-1/4" shaped, painted and varnished wood ca. 1920s–1930s. Highly unusual, quality spotted paint scheme with red accents. Painted eyes. Screw-eyes all around. Brass grommet cup hardware on side-hooks.

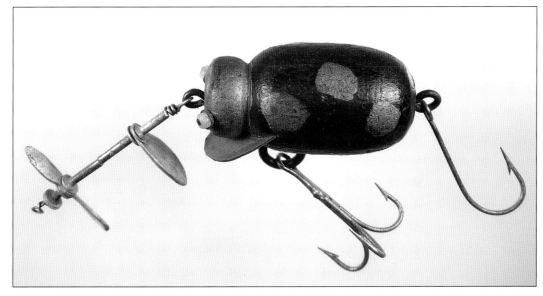

Spinnered Bug – 2-1/8" turned, painted and varnished wood. Nailed-on glass bead eyes with washer cups. Screw eyes all around. Remnants of rubber legs nailed to the belly. Inlet, hand-cut aluminum diving lip secured by belly hook screw eye. Attached, eccentrically balanced, hand-cut/ formed aluminum, multi-segmented fore-spinner.

Diving Bug – 2-1/2" carved, painted and varnished wood ca. 1930s–1940s. Screw eye line tie and (recessed) belly hook hangers. Shallow glass bead eyes. Screw attached, painted metal diving lip. Natural bristle wings, string-attached at neck with wrapping waxed and varnished.

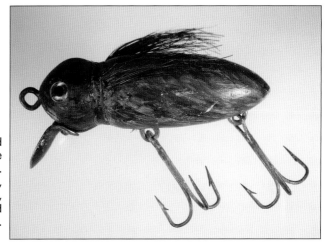

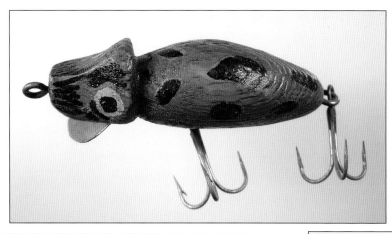

Fancy Frog – 2-7/8" hand carved, painted and varnished wood ca. 1930s–1940s. Odd head form with great paint detailing. Painted eyes. Screw-eye hardware all around. Hand cut/folded metal diving lip (painted on verso) is secured at the throat by a screw-eye.

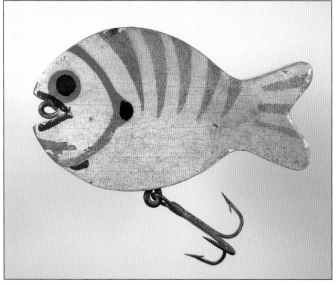

Super Sunny – 2-7/8" shaped, painted and varnished wood. Painted eyes. Through-wire line tie and belly hook hardware.

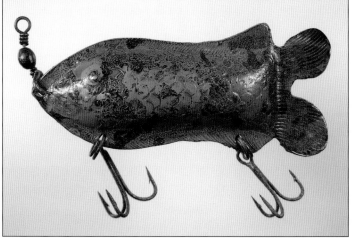

German Silver Fish – 3-1/8" hollow chambered fish-form, crafted of (painted) German silver with highly detailed, scale and fin tooling; dimpled (metal-punched) eye detail ca. 1920s–1930s. Punched holes form line tie and hook hanger attachments. This one took a lot of work.

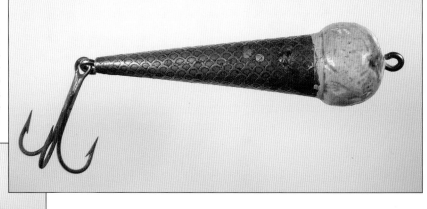

Ice Cream Cone Lure (Florida) – 3" carved, painted and varnished wood ca. 1930s–1940s. Wood head attached to hollow, stamped brass soldered "cone." Remnants of long-lost, through-wire side hooks. Rear hook hanger is attached to an internal swivel allowing it to freely rotate, thus minimizing the leverage a fish can impose once hooked.

Finned Bass Plunker – 2-5/8" carved, painted and varnished wood with possibly black sand accents sprinkled on the surface. Inset, nailed-on glass bead eyes. Through-body, dyed bristle side fins. Inset bristle dorsal fin. A single, fixed, through-wire forms the line tie and rear pork rind pin/clip assembly recessed into a carved groove on the back.

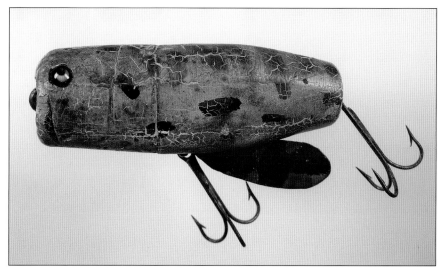

Keeled Cork Bait – 3-1/4" carved (and possibly weighted), painted and varnished cork body ca. 1920s. Photos just can't capture the "coolness factor" of this lure. A single, inset glass eye suggests that either the maker forgot the other one or possibly the lure is balanced to float on its side like Creek Chub's Injured Minnow. Large, inset, hand cut and painted brass keel. Heavy, fixed through-wire forms both the line tie and the hook hangers. The hangers are partially recessed with the heavy wire acting as a hook limiter.

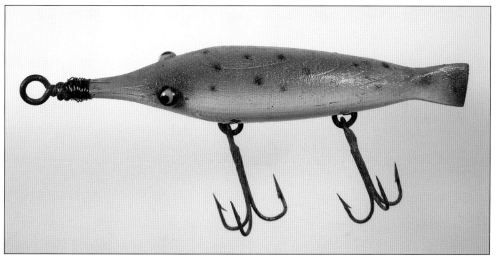

Pencil-Nose, Weighted Needlefish – A beautiful, glass eyed bait. 4-1/4" shaped, painted and varnished wood ca. 1930s. Heavy, formed, fixed wire-through line tie and hook hardware. Hooks are further secured and the lure weighted by integral, cast lead weighting. Twisted wire line tie is additionally reinforced at the thin, pointed nose by multiple turns of copper transformer wire.

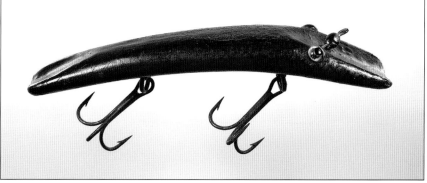

Sleek, Skinny Diver – 3-7/8" shaped, painted and varnished wood ca. 1930s–1940s. Nice form and paint, glass eyes. Full, fixed through-wire line tie and hook hangers. Unusual, integral barrel swivel functions as line tie.

Glass Eyed Shiner exhibits superb form and paint detailing – 3-3/4" thinly carved, painted and varnished fish-shaped wood ca. 1920s. Unusual, single embedded 'sneck' hook protrudes from one side of the body suggesting that it may have been balanced to fish as an "injured minnow." A single, hand-formed, spring-wire weed guard is wrapped to the line tie extension using waxed line. An unusual, single 'found' turned bearing decorates the line tie area.

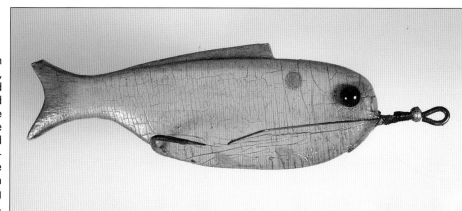

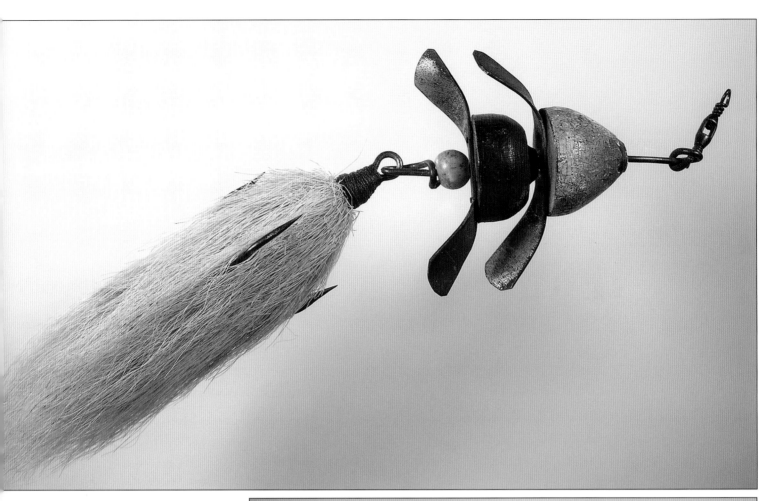

Musky Spinnered-Body Lure – 2" shaped, dual-spinnered, painted and varnished body sections, each of different form, revolve around a central, hand-formed, brass wire shaft. Large 5" hand-tied, bucktail dressed rear treble with attached, separately dressed, large trailing single, stinger hook. Large, hand-made glass bead bearing at rear and a separate, dual hat-shaped, formed metal bead and washer assembly separate the body sections. Dual painted, opposing, hand cut and painted aluminum props are fixed to the underside of each body section using two tacks.

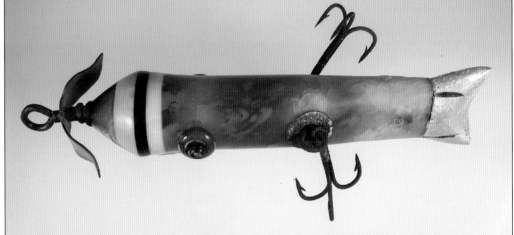

Striking, early **Tenite/Pyralin 4-1/4" Minnow**, ca. 1920s – An amazing example of lure design and hand craftsmanship, this art-deco styled minnow is fashioned using an early composite plastic formed over a wood core. Carved black and white Bakelite rings decorate the head while the tail section has a hand made and fitted aluminum "cap". Side-hook screw eye hook hangers pass through a protective, surface-mounted iron grommet cup. Painted, nail-applied glass bead eyes are set into a small plastic receiver that is itself set into a round, partially recessed T-shaped collar. The unmarked thrusted, prop assembly is likely Shakespeare. Between the prop and body section is a metal nose cone bearing. The line tie is likely a large screw eye attached to the wood body core. I have not identified the purpose for the through-body rivet just in front of the tail.

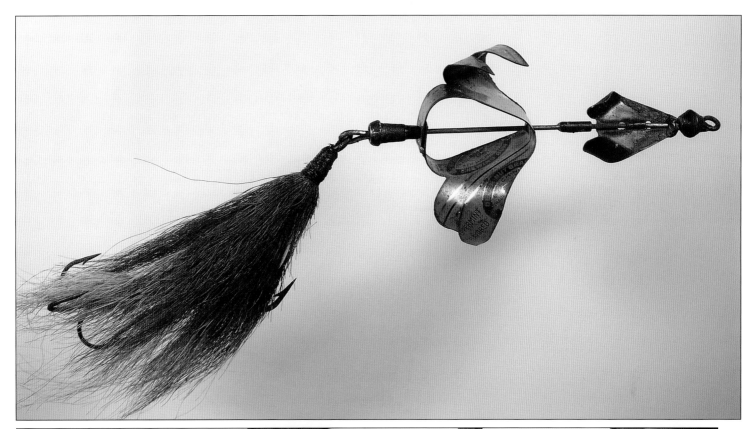

Fancy Dual Musky Spinner – 4" dual, hand cut and formed opposing metal spinners mounted in tandem on a hand-formed, soldered steel shaft, ca. 1920s. Eccentrically-shaped fancy rear spinner is cut from an early, peppermint-flavored, Beech Nut Chewing Gum tin. Soldered, painted, hand-cut, arrowhead-shaped fore-spinner evokes early blade patterns. Hollow metal 'found' turned, painted bead decorates the line tie area and is soldered to the painted, turned-wire loop that forms the line tie. The fore-spinner is 'stopped' by a painted, soldered steel tube bearing fixed at its rear. Another found, turned and painted bearing at the rear of the large spinner slides forward at the turned rear wire hanger, allowing interchangeability of hooks. Large 4-1/4" hand-tied bucktail hook rig consisting of a large, leading single hook and a trailing hand-tied treble stinger hook.

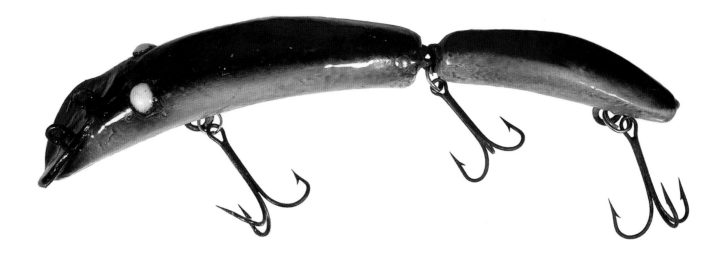

Jointed **Mo-Jo Musky** – Giant 12" jointed, carved, thickly painted and varnished wood body exhibiting a unique, fluid form and well-blended paint ca. 1930s. An impressive piece built to lure and hook wall-hangers. Large, partially recessed white glass marble eyes. 2" wide diving lip with a thin, 3/8" overhang on each side of the head is actually relief-carved wood. Very heavy fixed through-body iron wire forms double line tie, the body joint and the front/rear hook hangers.

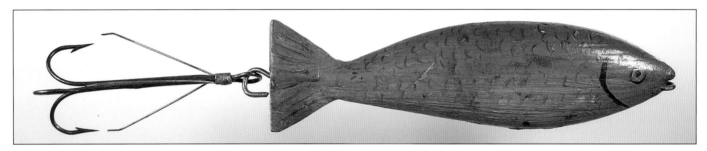

Sleek Painted Minnow – 5" carved, painted and varnished, slender, fish-shaped body ca. 1930s. Great form, paint and mellow patina. Painted eyes, gills, scales and tail-bone details. Three hand poured lead belly weights. Subtle mouth carving. Unusual, U-shaped (staple-type) brass line tie, each end entering the body on opposing sides. Rear, brass wire tail hook hanger.

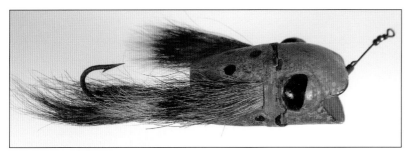

Bulging Swimming Froggie (Alabama) – 1-3/4", 4" overall including tied, squirrel-hair accents ca. 1930s. Carved, painted and varnished wood. Superb design, craftsmanship and paint quality. Painted, protruding eyes are non-metallic. Side hair legs are secured at the surface by multiple, full-body wrappings of braided line, painted. Embedded, rigid single hook is anchored within the body by unknown means. Screw-eye front line tie.

Double-jointed Snake (Ohio) – 4"carved, painted and varnished wood ca. 1930s. Well crafted. Embedded, cut and drilled bar joint hardware is anchored at each joint by nails. Deeply recessed, tiny glass bead eyes, nail secured. Inlet, cut and folded tin diving lip is anchored by unknown means. Heavy iron wire staple line tie – brass screw eye secures belly hook. Attractive 'snake-skin' paint scheme.

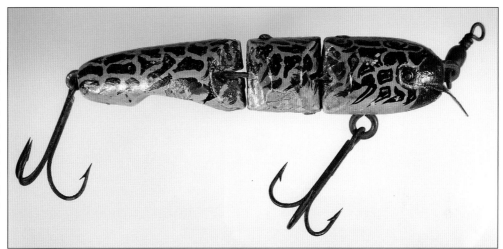

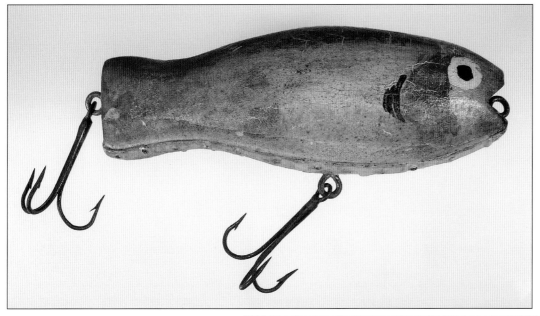

Musky Sunny – 4-3/8"x1-1/4"x3/4" carved, painted and varnished wood ca. 1930s. Painted eyes. Screw eye hook hardware all around with the line tie being secured by a return of a continuous metal belly strap/plate. Protective belly strap is secured by 24 small nails.

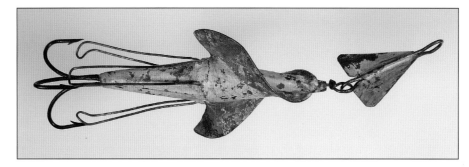

Serpentine Bait – 2-1/4" hand crafted, painted, brass-bodied, "winged" revolving bait ca. 1900s–1910s. Metal body is built around a hollow, "tooled" brass tube which somehow incorporates an internal swivel allowing separate and opposing rotation of the front spinner and body sections. Features a pair of cut, formed, soldered and painted serpentine wings. 3 single black japanned hooks are fixed at the tail by solder. 3 formed brass antique ladies hair pins soldered to the lure body act as weed guards. Integral wire-attached painted brass lead spinner.

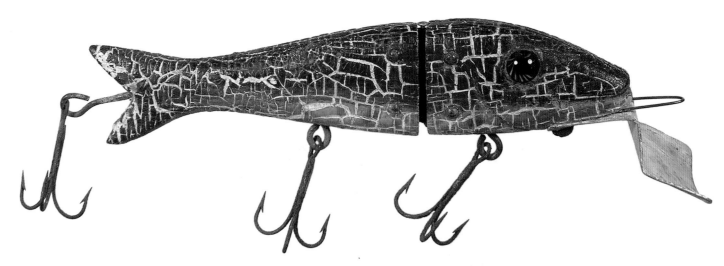

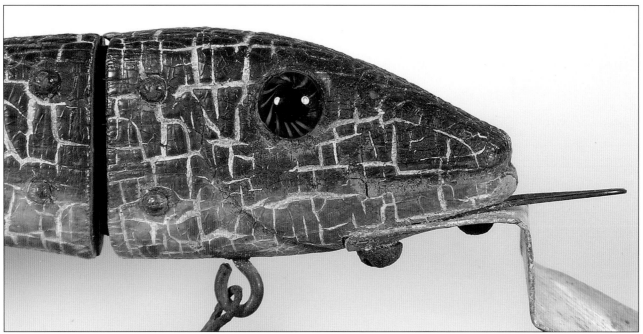

Jointed, Diving Swimming Fish – 5-3/4" carved, painted and varnished wood ca. 1920s–1930s. Fancy glass eyes – carved mouth and gill detailing. Cut and formed aluminum diving lip secured by two screws. Looped wire line tie anchored by the diving lip assembly. Embedded, heavy wire hook hangers all around. Creatively-assembled body joint consists of a box-hinge with the wings inlet vertically into each side of the lure. The hinge flanges are anchored by brass, through-body pins.

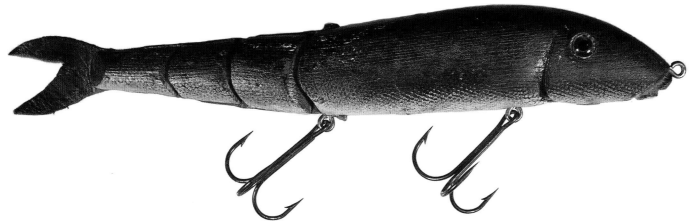

Sweet Jointed Musky Sucker – Strong form, paint and build quality exhibited by this 9-5/8," triple-jointed Sucker of painted and varnished, shaped, cut and carved wood, ca. 1930s–1940s by an anonymous maker. Lure features inset glass eyes, carved mouth and gill detail, 3 belly weights and screw eye hardware all around. A 5" cut and painted leather membrane is sandwiched between segmented body joint parts and forms the tail. Through-body tacks secure the (inlet) lead end of the leather at the rear end of the main body as well as all the individual hand cut and shaped wood joint (body) segments. Clearly, the talented craftsman of this superb lure found in northern Indiana (but likely of Wisconsin origin), must have made many others. Where are they?

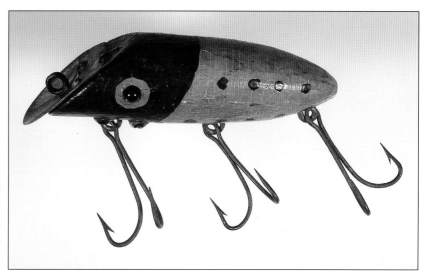

Black-Eyed Wiggler – 3-3/8" turned, painted and varnished wood ca. 1930s. Screw eye hardware all around; glass pin eyes. Hand-cut aluminum diving lip covers most of the dished face and is secured by the line tie and 3 small screws. Four larger screws at the belly were added by the maker for weight or balance/action.

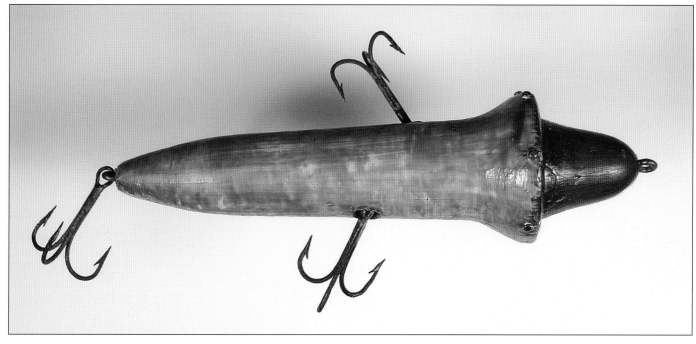

Early Studded Side-hooked Musky Woodpecker – 5-1/2" turned, painted and varnished wood with brass tack decoration around collar ca. 1910s. Deep rimless, hand-cut and formed brass cups with recessed screw eyes protect the body from hook contact. Unique variation of a popular early lure style.

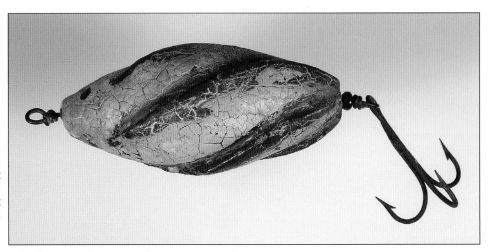

Cork Serpentine Bait – Ancient 3" hand carved, painted and varnished lure ca. 1900s. Body is relief carved employing raised, curved ridges. Since the body is mounted on loose, hand twisted through-wire, it would rotate on the surface upon retrieve, perhaps suggesting a swimming rodent. Inset glass bead bearings front and rear with an additional external bead bearing at the rear. Surely it survived intact only as a result of its very thick painted surface.

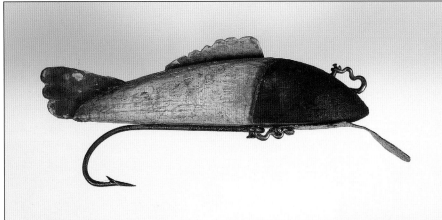

Finned Swimming Minnow – Appealing and creative 3-1/2" carved, painted and varnished wood with inlet painted brass dorsal and tail fins ca. 1930s. Fine sweeping form accented by carved gills and novel hook positioning. Hand cut, formed and varnished diving lip is secured by tack and a Heddon "L-rig" hook retainer. An additional tack nicely positions the single hook against the body. A second L-rig hanger is used as a multi-position line tie.

Red-Winged Black Bird – Attractive, well finished 2-1/2" (4-1/4" with feathers) carved, painted and varnished body ca. 1940s. Large single hook inlet into body at belly forms line tie. Wings formed of dyed bucktail and feathers are secured to body by wrapped and varnished braided line. Tail feathers inlet into the body at butt. Contrasting under-feathers at tail are tied and varnished to the main hook.

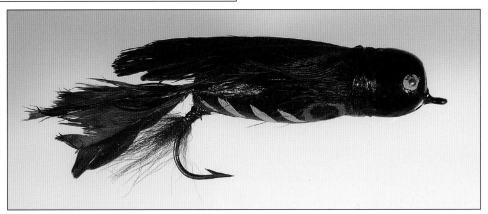

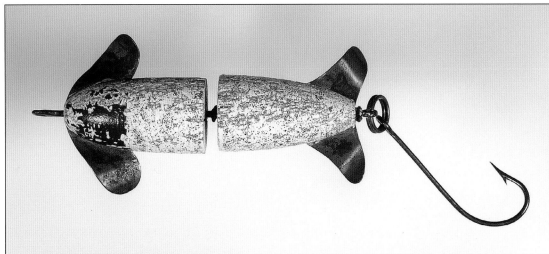

Double Revolving Surface Splasher – 3-1/4" jointed, turned, painted and varnished wood ca. 1920s. Soldered, turned (loose) through-wire forms line tie and rear hook hanger; a soldered washer at mid-section separates the body parts. Hand cut and formed, inlet copper wings mounted front and rear cause counter-rotation of the body segments upon retrieve.

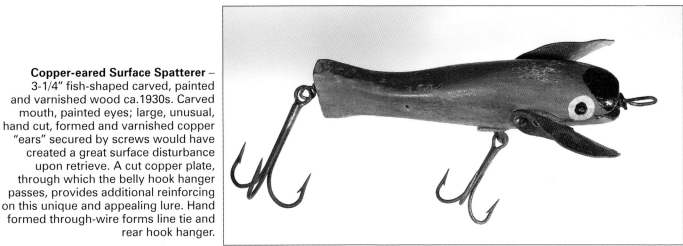

Copper-eared Surface Spatterer – 3-1/4" fish-shaped carved, painted and varnished wood ca.1930s. Carved mouth, painted eyes; large, unusual, hand cut, formed and varnished copper "ears" secured by screws would have created a great surface disturbance upon retrieve. A cut copper plate, through which the belly hook hanger passes, provides additional reinforcing on this unique and appealing lure. Hand formed through-wire forms line tie and rear hook hanger.

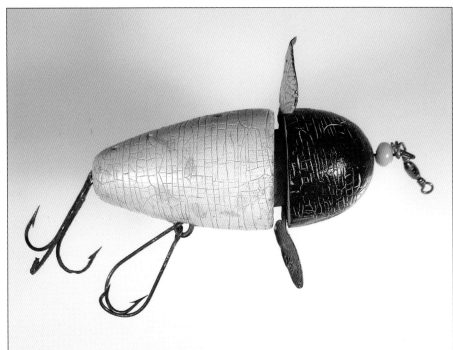

Fat "Norelco" Rotary-Head – 3" turned, re-carved, painted and varnished wood, ca. 1920s. Creatively designed, its maker provides a head extension that somehow "floats" 3-dimentionally within the dished-out rear body section; a complex arrangement likely done to ease weed removal. Metal "ear-shaped" wings are cut and formed from one piece of metal. This assembly is secured/fixed by tacks between the head extension and the head section. Loose, wire-through hardware forms the line tie and rear tail hanger. A deeply recessed belly hook hanger presents a pair of single hooks in a weedless configuration.

Painted Metal Crawdad – 3" cut, formed and painted metal ca. 1940s. This is a well made and painted lure. Belly-mounted, screw-anchored, single hook with hand tied chicken feathers suggest legs and claws. To further stabilize it, the hook shank passes through the head area. Free-hanging, hand-cut leather claws are connected to the lure via sliding clips. A through-body secondary line tie is fashioned from a small tack.

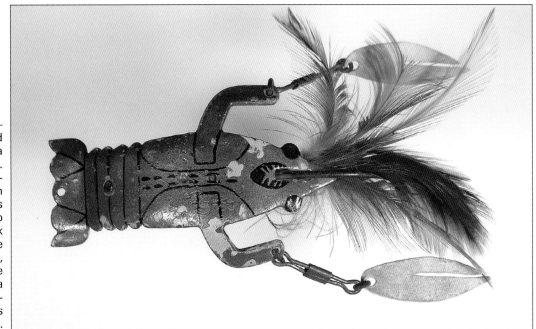

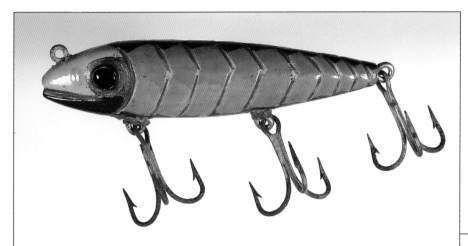

Colorful Carved Wiggler – 3-1/2" carved, painted and varnished wood ca. 1940s. Painted tack eyes – carved gill, mouth and side details. Hooks are set into unusual, hand-cut, raised iron cups. A creative paint scheme adds interest and personality.

Fabulous Shrimp, ca. 1920s-1930s – Hand carved, painted and varnished wood. Glass pin eyes; screw eye line tie and hook hangers. Metal flathead nail at belly might once have secured legs/feelers. A large screw inserted under the (folded) tail, passes into the main body reinforcing the body and preventing breakage of the rear tail section. Great patina and eye appeal.

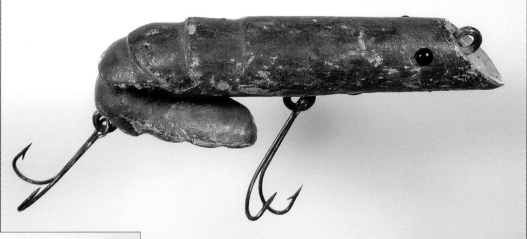

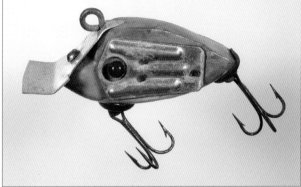

1-3/4" Robo – Lure, ca. 1950s – Hand carved, painted and varnished wood. This striking little crank-bait uses what appears to be old can "pop-tabs" as side-plates, suggesting color and scales. Into the tabs round opening, red glass pin eyes are inserted. A hand-cut aluminum diving lip is attached to the nose/head of the lure via a small slotted screw and the line tie screw eye, thus reinforcing the connection. A pair of large iron boot grommets act as surface-mounted cups at each hook hanger. A fun and creative folk art lure.

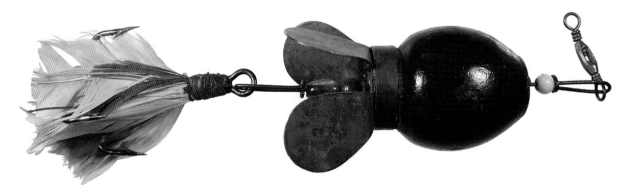

Musky "Ball & Propeller" Bait, ca. 1920s – 2-1/2" turned, painted and varnished wood. 4-bladed cut and formed, collared, brass spinner is anchored to the wood body by 4 screws. Separate round, painted brass cap at front of ball is secured by 4 brass pins. Fully (loose), wire through shank forms line tie and rear hook hanger. Colorful glass beads at nose and tail form bearings.

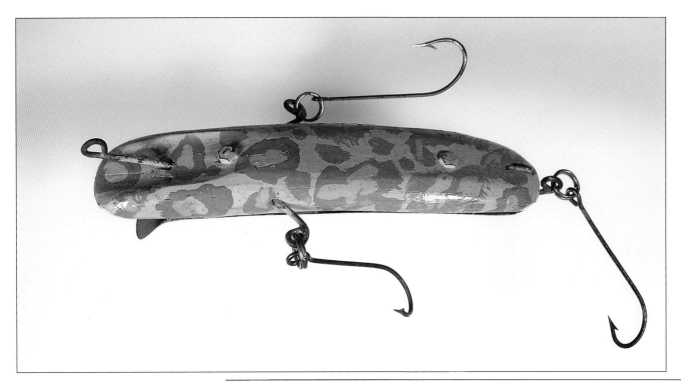

Jersey-Rigged Musky Diver, ca. 1940s–1950s – Highly creative, seemingly indestructible lure. 5" carved, painted and varnished wood body. A screw mounted aluminum plate (which is curved downward at the nose to form a diving lip) covers the entire belly. These screws pass entirely through the body and have tiny nuts attached at the back. Similarly, both the formed and soldered wire line tie and rear hook hanger pass through both the belly plate and wood body significantly reinforcing them. Formed, wire-through detailing provides a swinging, trapeze-like mounting for the side hooks.

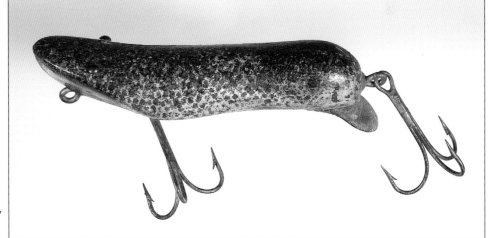

Swimming Rodent – Super form and amazing paint are found on this 3-1/2" carved, painted and varnished wood body ca. 1930s–1940s. Brass tack eyes. Probable through-wire line tie and rear hook hanger; cup and screw belly rig. Screw-attached, hand cut and formed, concave, inverted steel spoon at underside of tail would cause side to side motion.

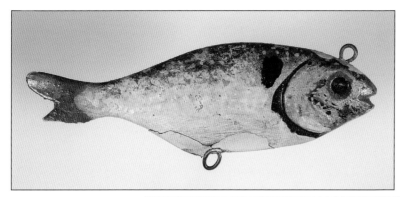

Happy Sunny – 3-1/4" hand carved, painted and varnished fish-shaped wood body sans hook. Extremely thin – due to its being less than ¼" thick, the maker embedded the hand formed through body wire (which serves as the line tie and hook hanger), in cast lead at the top of the head and belly. Carved eyes, mouth and gills and a super paint scheme complete this attractive lure.

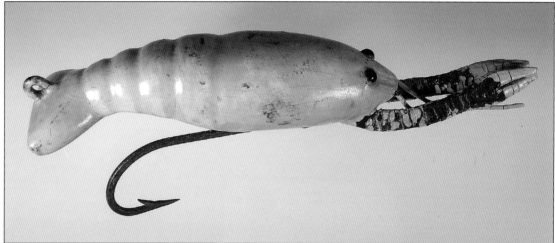

Albino Craw – Hand carved, thickly painted, carved wood body ca. 1920s-1930s. Heavy staple rigs serve as line tie and belly hook hanger. Inlet, painted, cut-leather arms/pincers. Inlet, painted leather string "feelers." Black, glass-pin eyes partially recessed in carved head grooves. A unique, finely made folk art crawdad.

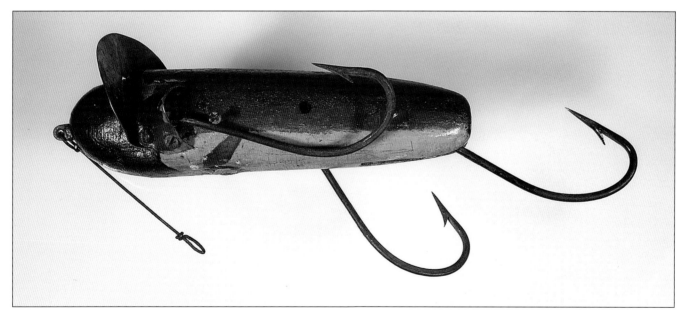

Jersey-rigged, Weedless Musky Surface Splasher - thick 4-5/8" carved, painted and varnished wood body ca. 1920s. Eccentrically positioned cut tin, varnished collar (with integral flanges) at head is screw secured along a relief-carved slot. Screw secured, painted and varnished cut tin "covers" shroud the side hook attachments to aid weed prevention. Two hand poured lead belly weights act as a keel and balance action of the lure. Large rear hook pivots in a long slit and is "stopped" in striking position by a through-body pin which is cut flush with the body and anchored at each side by a counter-sunk square nut. Staggered side hooks are also stopped by screws extending from the wood body. Integral wire leader is attached to an embedded flat bar which serves as the line tie.

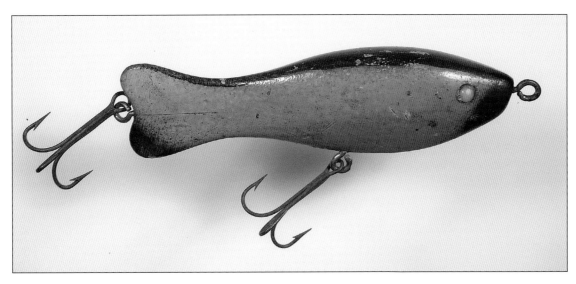

Mustard Fish – this beautifully made 4-1/4" fish shaped minnow made of carved, painted and varnished wood was originally found in Florida. Elegantly simple form and paint – the subtle red blush accents at nose and tail add interest. The width of its ultra skinny tail is less than 1/8" thick. Screw eye hardware all around – the glass bead eyes are inset *sideways*.

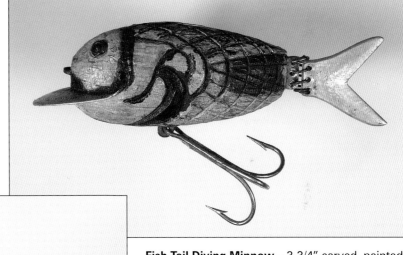

Fish Tail Diving Minnow – 3-3/4" carved, painted and varnished wood. Unique, deeply carved "checkering" to the body suggests gill plates and body scales. Tack secured washer eyes; inlet, cut and formed aluminum diving lip. Iron staple line tie – screw eye and cup rig belly hook hanger. Inlet, cut and drilled aluminum tail anchor; hand cut and drilled aluminum tail. Tail is secured to tail anchor via spiral brass wire allowing some motion upon retrieve.

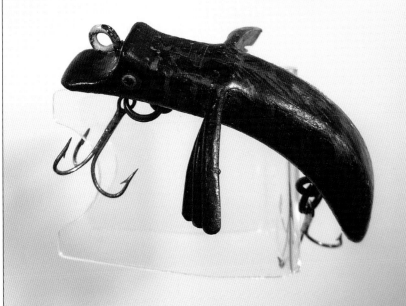

Diving Bug-O-Bird – 3-1/8" carved, painted and varnished wood body. Relief-carved eyes. Unusual, lateral "wings" suggest either the wings of a small bird or large bug. I am uncertain of wing material as well as how they were securely fastened to the body. Screw eye hardware all around.

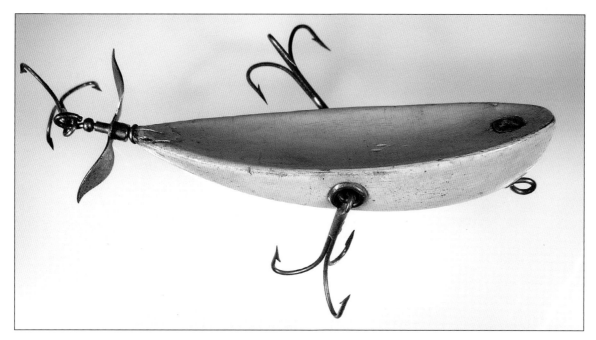

Early White Surface Skitterer – 4-1/2" finely shaped, painted and varnished wood ca. 1900s–1910s. This dished-out, attractive side-hooked lure suggests a *boat* form and surely had substantial action when fished. The streamlined, fluid shape coupled with simple paint holds ones attention. It employs ca. 1907 Heddon hardware all around. Inset cast lead at the nose anchors the line tie and likely provides optimal "balance" for use.

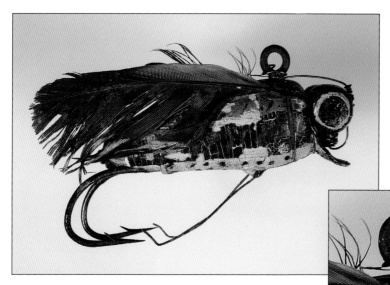

Bug 'r Bird Lure – This 2-3/4" (3-1/4") overall, ca. 1930s. Lure is either intended to portray a very large grasshopper or a small injured bird; it is made of two attached pieces of carved, painted and varnished wood. A hand cut and painted diving lip is fitted between the wood head and rear body section. The "head" likely made from the top of a re-carved clothespin, is anchored by pins through the head (and metal lip) into the rear section. Two single hooks are hand shaped and inlet into the main body – their hook eyes passing through the diving lip, further fixing it into position. To ensure the lure stays together, an exposed wire passes from the two hook eyes to the line tie at the back. Wing feathers are secured by inset wire wrapping passing around the lure body. Similar wire body wrapping secures the two hook shafts near the butt. A pin at the belly anchors the wire weedguards. Unseen at the rear of the lure is an embedded brass wire loop which may have held a stinger hook or tail flasher at one time.

Vintage Folk Art Classics

*The artisan tradition discernible in all folk art is perhaps its chief
unifying characteristic, but it is the eye of the artist directing the hand
of the craftsman that gives it aesthetic validity.*—Alice Winchester, *The
Flowering of American Folk Art 1776–1876,* 1974

For decades, most tackle collectors mistakenly attributed quality handmade versions of factory-produced lures to be prototypes of the original, hand crafted by the inventor himself. Without a supporting provenance documenting this theory as fact, collectors have amplified the truth and short-changed early fisherman—a truth that is equally interesting and far more probable.

Even inflation adjusted, until the 1950s and 60s, purchasing a bright, shiny new lure made by a major manufacturer took a big bite out of disposable income. Many factory lures were well marketed, caught lots of fish and became very popular. If a fisherman wanted to fish a certain lure and couldn't afford to purchase an original, he had to try his hand at making it. Alternatively, even if he had the money, if he had access to the necessary materials and possessed the requisite skills, why not make it himself?

One scenario: After careful consideration, an Illinois farm boy buys a CCBC Pikie Minnow – his one lure budgeted for the season. After a week of successful fishing he loses it while battling a big one. He can't afford to buy another until next year. Why not make one from scratch? He knows what it looks like and how it works…

Such dilemmas spawned lures that I have fondly coined "vintage folk art classics." The hand-created lures featured here are copies or facsimiles of popular lures of the past. To heighten the challenge and hold my interest, I choose to limit my own personal search to examples that are of the same vintage as the original classics.

This area is very popular with collectors of manufactured fishing lures. If one collects all models of a specific factory lure, as many collectors do, a homemade example or two adds variety and interest to the collection. In addition, as lure collectors educate themselves and gain field experience, they are able to identify increasing numbers of manufactured lures. Consequently, when folk art copies are displayed together, most veteran collectors relish the challenge to identify and date them all.

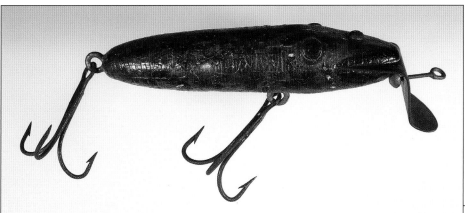

Folk Art Polychromed Pikie Minnow
– Faceted glass eyes set in metal rings
and wonderful paint highlight this
fisherman made, heavily varnished
3-1/4" baby Pikie ca. 1920s.

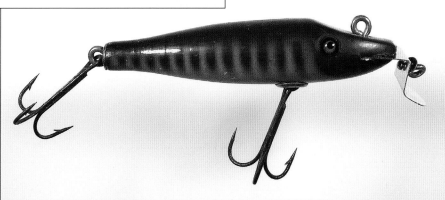

"Baby Pikie," ca. 1920s. Factory-
made, Creek Chub Bait Co.

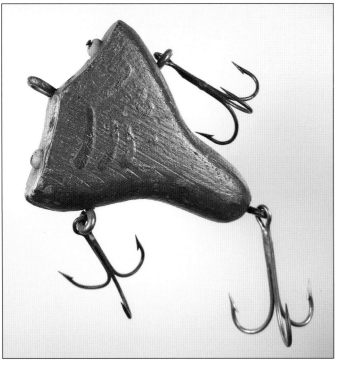

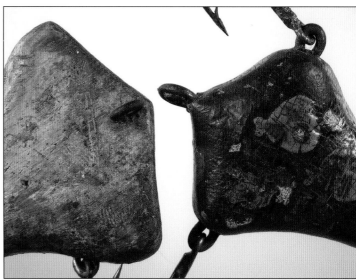

Two folk art Vacuum bait 'copycats' face-off and prepare to head-butt.

The bead eyes on this hand made version of **South Bend's "Vacuum"** bait, ca. 1920s, appear to be made of carved bone. The same maker crafted the "Tease-Oreno" shown on page 149.

South Bend Vacuum bait. Appealing carved, painted and varnished wood with glass eyes, carved "gills," wire-through hardware and hand assembled treble hooks has great personality. It is fully wired-through in both directions.

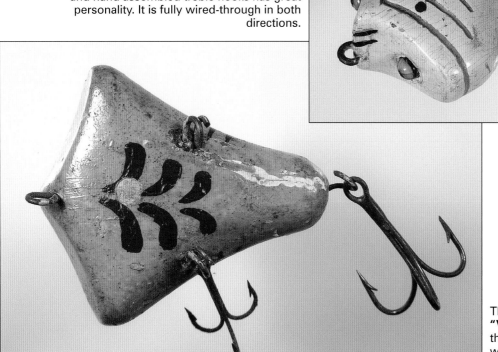

The maker of this classic **Howe's "Vacuum Bait,"** ca. 1910s, formed the ends of the pivoting, through-wire hook hangers into split rings for quick hook attachment/ replacement.

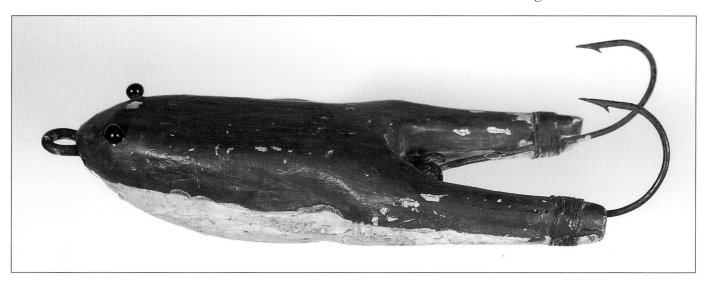

Pflueger Satin Cork/Conrad Frog – ca. 1920s. This simple, chip carved and thickly painted example sports glass pin eyes, hand wired hooks and belly weight.

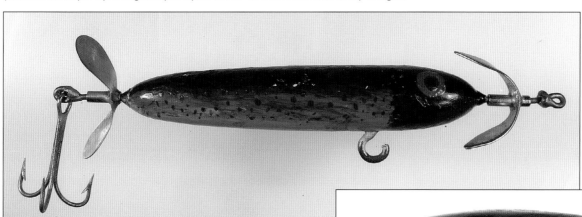

Heddon Torpedo. Even without hooks, one can readily appreciate the build, paint and metal-work quality in this 3-7/8" lure. Found in the 1960s at Slims Bait Shop, Little Rock, Arkansas.

Arbogast Jitterbug – ca. 1940s. 3"

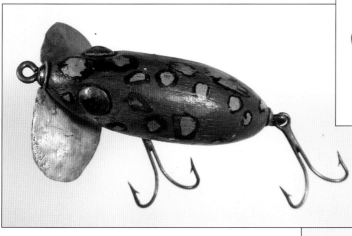

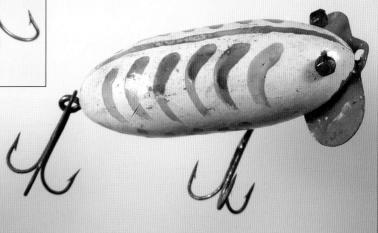

Arbogast Jitterbug – ca. 1940s. 2-1/2"

Arbogast Jitterbug – ca. 1940s. made from a broomstick handle.

Heddon "Game Fisher" ca. 1920s. Superbly crafted, it is evident in this. It also employs hand-tied hooks.

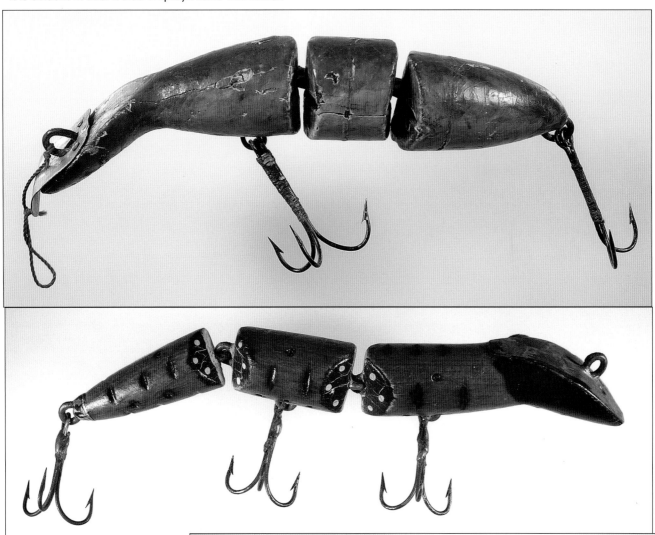

Heddon Game Fisher – I couldn't resist including this 2nd (bonus) Game Fisher. Exceptionally well made, this 5-7/8" example is both wood-burned and paint decorated.

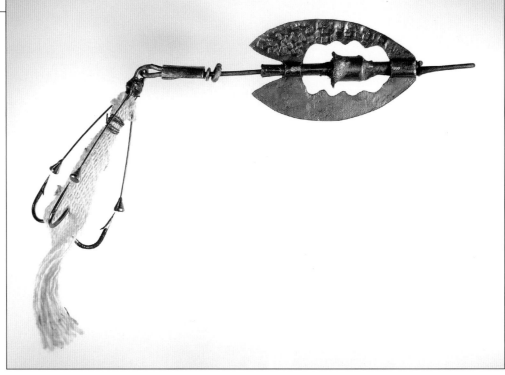

I can't imagine sitting down and attempting to make a classic **American Spinner**, first patented by McHarg in the mid-1880s. An old lantern wick is wire wrapped to the weedless treble hook and used as tail decoration.

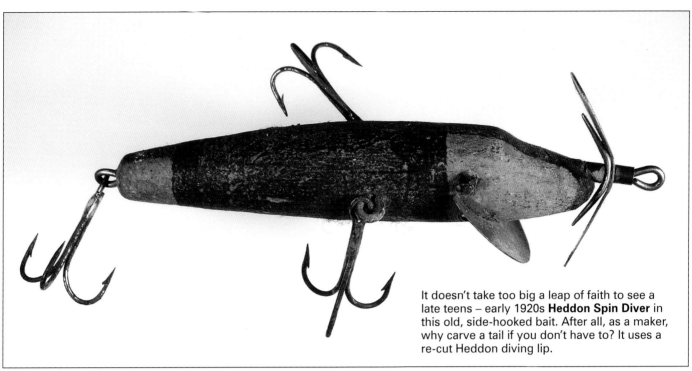

It doesn't take too big a leap of faith to see a late teens – early 1920s **Heddon Spin Diver** in this old, side-hooked bait. After all, as a maker, why carve a tail if you don't have to? It uses a re-cut Heddon diving lip.

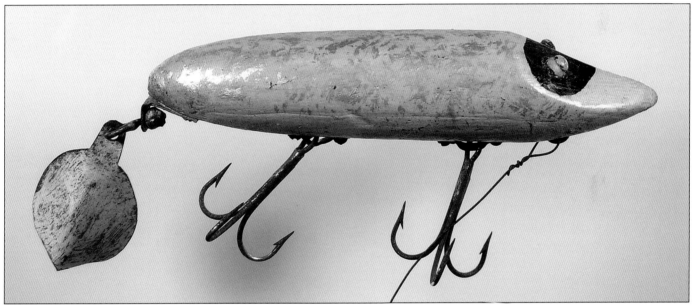

Musky Heddon Flaptail – 5-1/2" carved, painted and varnished wood ca. 1940s. Surface-mounted, heavy metal 'bar' hook hangers are screw-attached to the body. Heavy steel tail flapper mounted to a solid wire passing through the tail hanger. Painted glass bead eyes are nail-attached. Wire leader is attached via a cup and screw rig. Found in the 1960s at Slim's Bait Shop, Little Rock, Arkansas.

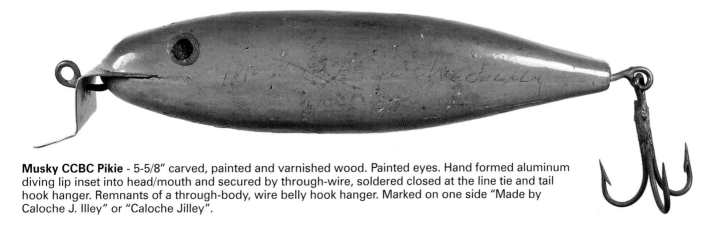

Musky CCBC Pikie - 5-5/8" carved, painted and varnished wood. Painted eyes. Hand formed aluminum diving lip inset into head/mouth and secured by through-wire, soldered closed at the line tie and tail hook hanger. Remnants of a through-body, wire belly hook hanger. Marked on one side "Made by Caloche J. Illey" or "Caloche Jilley".

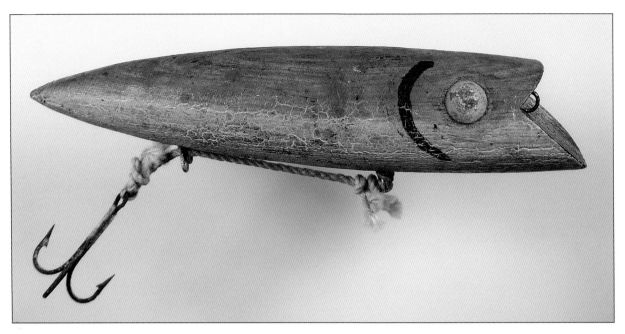

Heddon King Basser – 6" carved, painted and varnished wood. Fixed wire-through forms line tie and wrapped, belly hook attachment. Painted, dome-tack metal eyes. Cording for belly hook hanger is clipped into a hand-formed wire 'release' clamp near the tail.

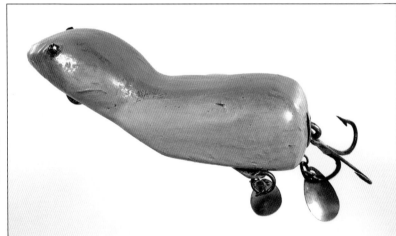

Shakespeare Baby Pad-Ler – Thick gray paint with rose accents at the head and tiny glass bead eyes enhance this smaller, 3" version of Shakespeare's famed Pad-Ler.

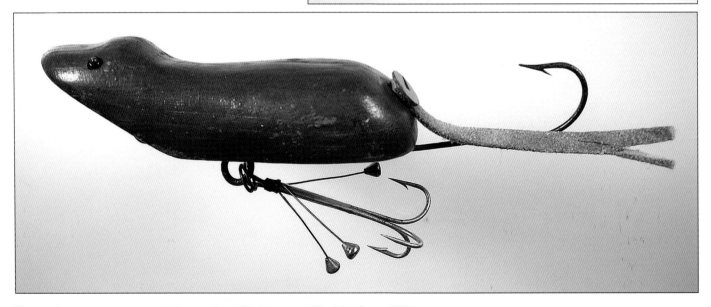

Teeny glass eyes punctuate this weedless **Shakespeare "Pad-Ler"**, ca. 1930s.

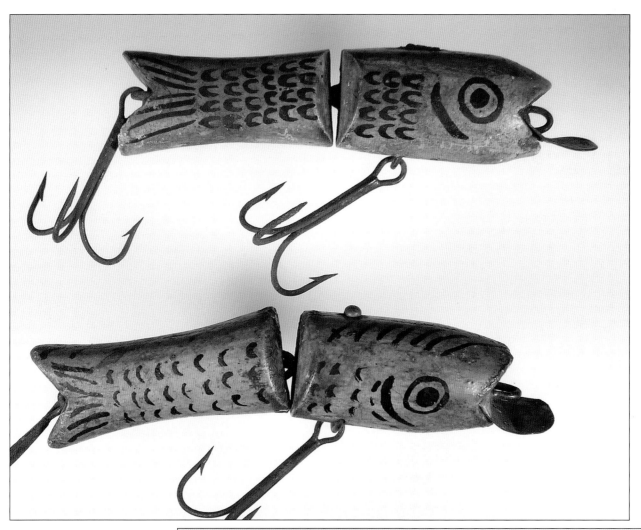

Shakespeare Musky Tantalizer Pair – If only these babies could talk — each is made of carved, painted and varnished hardwood. Heavy, full, fixed through-wire in both directions forms line tie joints and hook hangers. Soldered line tie wire secures hand-cut, formed and painted diving lip. On the bottom example a through-wire belly hook hanger is formed into a 'button-head' as it penetrates the back. On the top example, the wire, after passing through the back is twisted, bent and hammered flush with the wood surface.

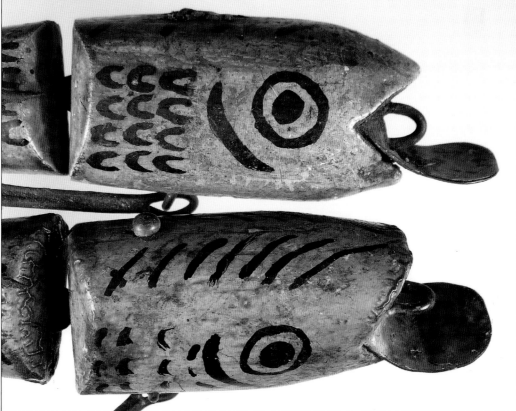

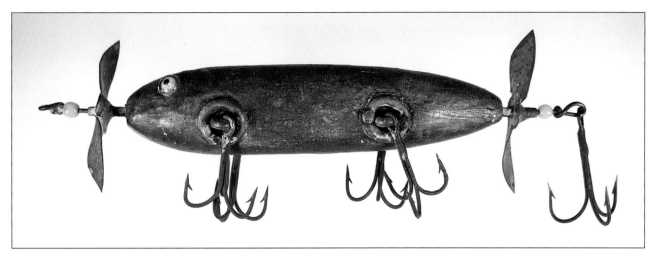

Early 5-Hook Underwater Minnow – 4" hand carved, painted and varnished wood ca. 1910s. Glass eyes. Fixed, wire-through in both directions with small, glass bead bearings added front and rear. Large, deeply set, painted grommets at the side hooks act as hook protectors. Hand cut and assembled, thrusted tin props front and rear.

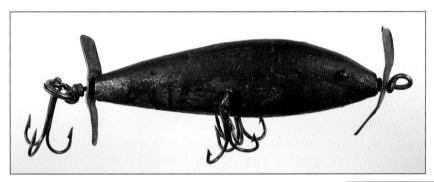

Maroon Underwater 3-Hook Minnow – 3" shaped, painted and varnished wood ca. 1910s. Teeny glass bead eyes, nail secured. Brass through-body wire in both directions. Hand cut and painted brass props. Highly unusual, long, slender, inset belly weight is secured by brass tacks.

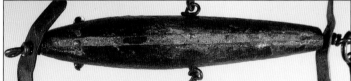

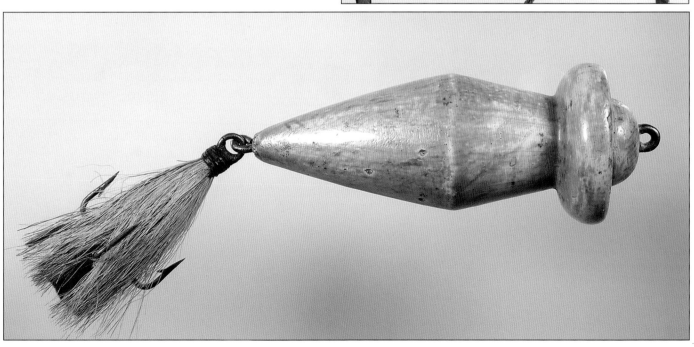

Moonlight Floating Bait ca. 1910s has a bit of a 'waist.'

CCBC Weed Frog type lure by Burt Errett, Ohio. ca. 1930s – sports painted weed-guards and pork rind clip as well as a handmade, beaded, fore-spinner assembly featuring a hand-cut, patterned, frog-shaped spinner blade.

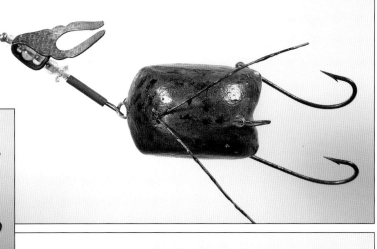

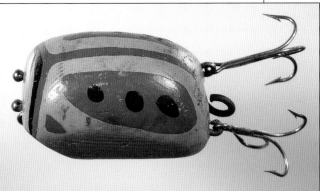

Treble vs. single hooks were used in this realistic, home-made **Creek Chub "Weed Bug"** in bug finish, ca. 1930s. Salvaged chain-pull parts used as eyes; note rear vs. back-mounted pork rind attachment.

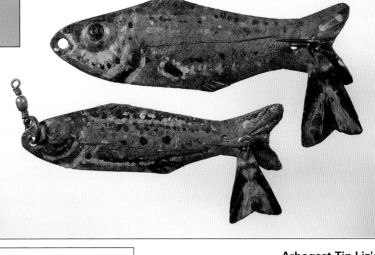

Arbogast Tin Liz's ca. 1930s. Fine detailing, form and color on these. Found in a Kentucky tackle box that also held a Kinney's "Bass Bird."

Pflueger Surprise ca. 1910s. Nail remnants still visible.

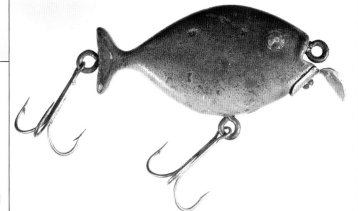

Heddon 740 Punkinseed, ca. 1940s. Faceted gemstone eyes and a carved tail distinguish this lure.

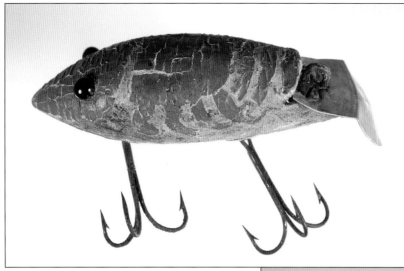

Hamilton's Medley's Wiggly "Crawfish" ca. 1920s wears its age proudly.

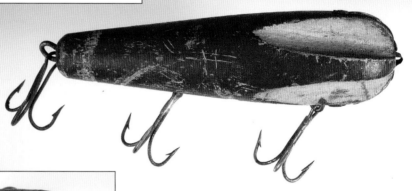

"Wilson Wobbler" ca. 1910s. This employs a unique nail-fastened, surface-mounted, metal 'strap' line tie which passes from the forehead to the throat.

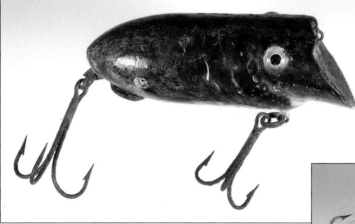

Heddon "Basser" ca. 1920s has an exposed belly weight, carved gills and glass eyes. Made by Burt Errett, Ohio. See page 195.

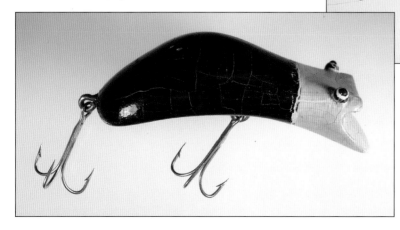

"Kimmich Mouse" ca. 1930s. Closely mimicking the original.

Wedgy, bug-eyed, **Shakespeare "Swimming Mouse"** ca. 1920s.

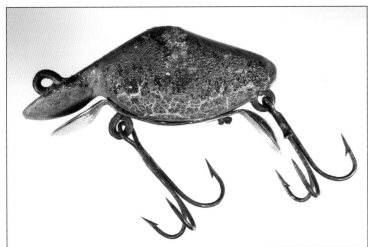

Sporting a pronounced hump-back and flattened head is this **Keeling "Little Tom"** ca. 1920s.

Keeling "Little Tom" or "Surface Tom" ca. 1920s. This is a nice hand-made reflection of this Rockford, Illinois, company's distinctive offerings.

"**Shannon Twin Spin**" ca. 1920s. A weighted **Heddon Stanley Harness** was used as the starting point for this fine lure. Note clipped-on white Bakelite flasher. Made by Burt Errett, Ohio. See page 195.

Creative paint affects and glass pin eyes punctuate this **Pflueger Pal-O-Mine** ca. 1920s.

One has to inspect closely to conclude this hand-made **Bite-Em Wiggler**, complete with quality hardware is not factory.

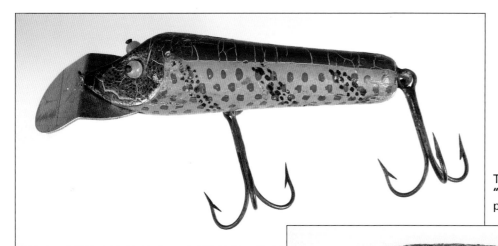

This ca. 1930s **South Bend "Baby Pike-Oreno"** is beautifully painted and constructed.

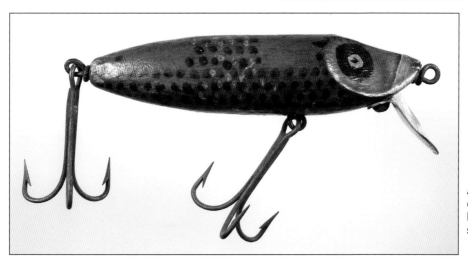

Glitter adds appeal to this wire-through, **Heddon "River Runt"** ca. 1930s. Please see Sibling and Collections Section for more nice lures made by this unknown, Pennsylvania maker.

A mustard nose and painted 'bulls-eye' eyes provide a striking effect on this **Heddon "Baby Vamp"** ca. 1920s by the same Pennsylvania maker.

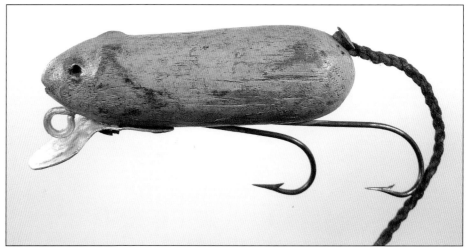

Folky Paw Paw "Mouse Bait" ca. 1930s employs a novel belly hook arrangement.

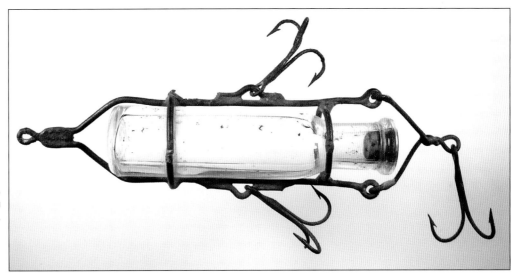

Glass minnow tube, ca. 1910s. No minnow ever escapes in this amazing lure.

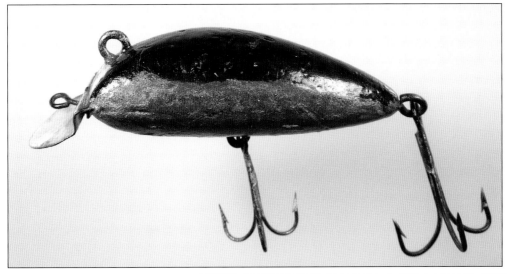

Creek Chub Bait Company's (CCBC's) famed **"100 Wiggler"** was this craftsman-fisherman's inspiration in the 1920s.

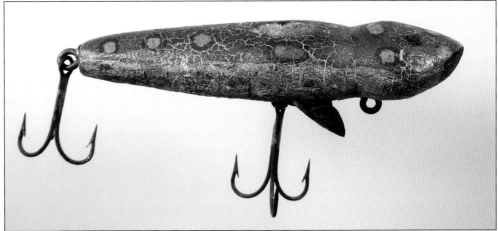

This super **CCBC "Jigger,"** ca. 1930s, has great paint and a rich patina.

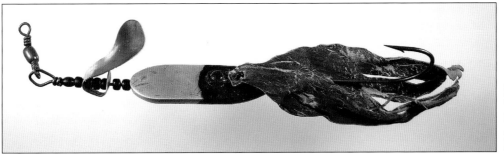

Fine wrought aluminum **Al Foss "Oriental Wiggler,"** ca. 1920s, by Ohioan Burt Errett. See Folk Artists Section for more great Errett lures.

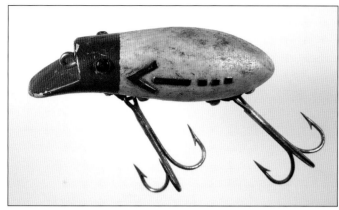

Creek Chub "Baby Bomber," 2-5/8". This well made rendition ca. 1940s from Grand Haven Michigan features painted, applied wood side accents and relief carved eyes. Made by same maker of the Carved Bone Minnows. See page 162.

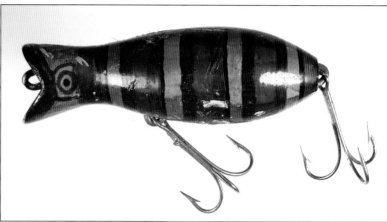

Creek Chub's **"Dive Bomber."** This colorful, larger, 3-1/8" lure is painted like a vintage bobber.

P & K "Whirl-A-Way", ca. 1930s. It took a talented maker to hand-craft this.

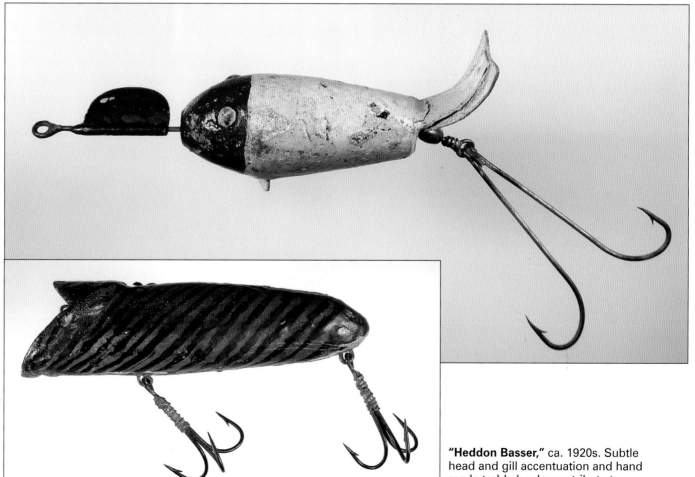

"Heddon Basser," ca. 1920s. Subtle head and gill accentuation and hand made treble hooks contribute to something special.

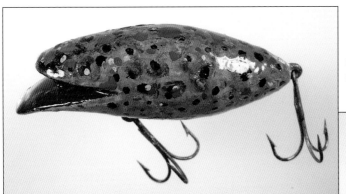

Colorful and creative **Carter-Dunks "Bestever,"** ca. 1920s, by Burt Errett (Ohio)

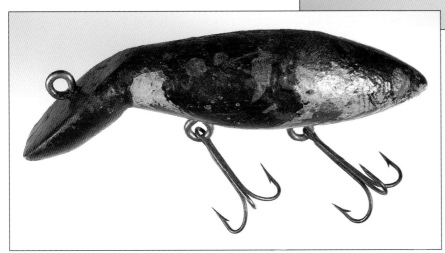

Donaly "Wow"/Heddon "Crazy Crawler" interpretation, ca. 1930s–1940s. A simple paint scheme and nice aluminum metalwork is applied to this fine lure.

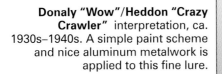

Rush Tango "Swimming Minnow," ca. 1910s–1920s. The maker used his own interpretation of Rush's unique mottled paint technique to fashion this example.

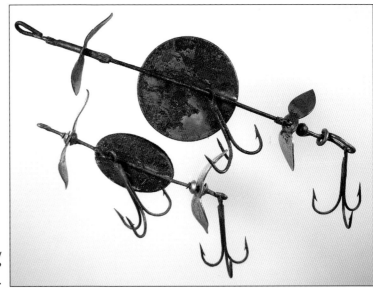

Scooterpoopers, ca. 1940s. Wow, how cool is this pair of hand-wrought lures? The smallest one uses Eger props.

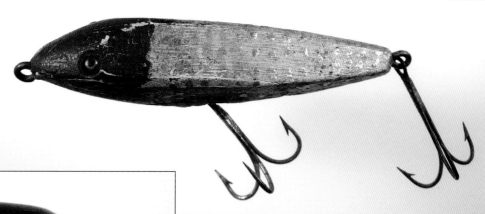

Size, form, eye-position, and cross-section all lead one to believe the maker of this early ca. 1910s lure used the rare **"Shakespeare's Favorite Floating Bait"** as his model. As one would expect, it is much harder to find fisherman-made examples of early classics that were *not* popular in their time.

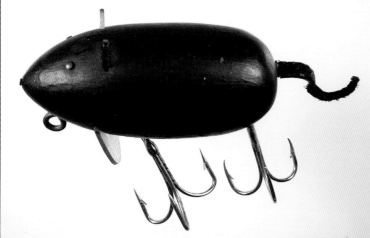

This superbly made, **CCBC "Lucky Mouse"** ca. 1930s would be great to try at night.

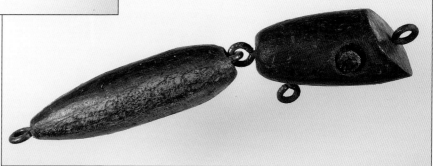

It's a big challenge to find an old folk art copy of **Jamison Co.'s "Wig-Wag",** ca. 1930s. A '3-D' effect is seen in this example's eyes, which are made from old painted nails, flush mounted in deep, carved holes.

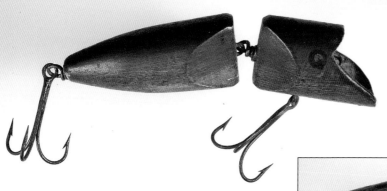

This neat, paint-eyed, scoop-mouth **Heddon "Zig-Wag,"** ca. 1920s–1930s was found in a Pittsburgh, Pennsylvania attic.

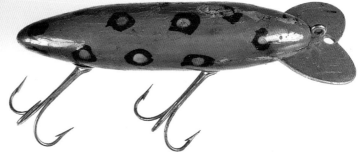

I'll bet this nifty, elongated rendition of the famed **Bomber Bait Co.'s "Bomber"** was a fish-catcher.

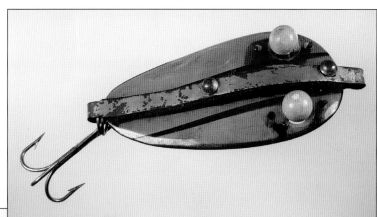

Who can doubt that **Hofschneider's "Red Eyed Wiggler,"** ca. 1940s, spawned this very creative and 'wavy' yellow-eyed iteration.

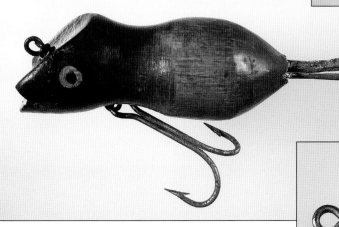

This ca. 1950s **Creek Chub "Mouse"** has a narrow waistline, wears a mask and incorporates a 'fixed', double-hook at the tail.

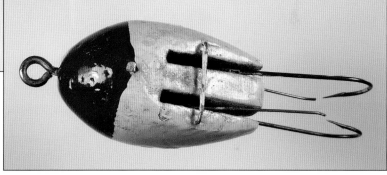

This **"Comstock Chunk,"** ca. 1920s, employs opposing weedless hooks and a wide, 'staple-type' pork rind attachment.

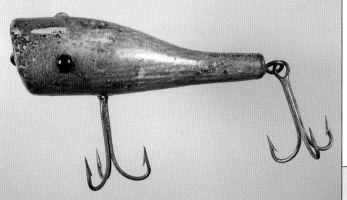

This dark glass eyed, super skinny **Creek Chub "Plunker"** ca. 1920s is very well made and may be a Pflueger factory-made prototype. It was found with a similarly painted frog (now in the Jack Looney collection) that is an exact match to a frog in Don Wheeler's book, *Frog Lures of Yesterday and Today – An Identification and Value Guide to Collectible Frog Lures,* 2008.

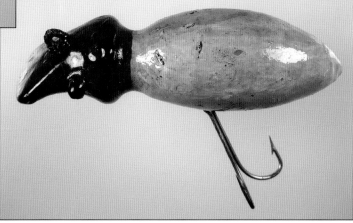

"Ladybug Wiggler," ca. 1910s–1920s. This is the only authentic, vintage copy I have run across. This one was made by Burt Errett of Bellefontaine, Ohio.

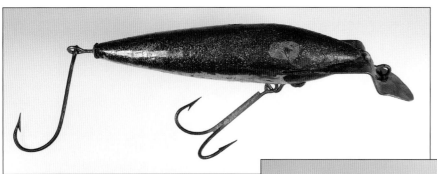

Creative two-hook variation of Creek Chub's famous **"Pikie Minnow,"** ca. 1920s, uses "Stump-Dodger" style belly hook hardware.

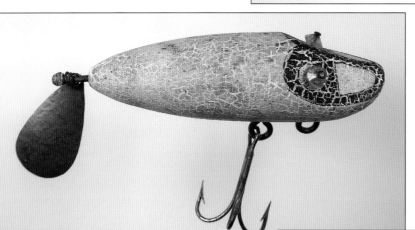

Amazing realism is evident in this hand-produced **Creek Chub "Baby Pikie Minnow,"** ca. 1930s.

With its hand hammered brass tail, faceted, glass bead eyes and a patina to die for, this **"Heddon Flaptail Jr.",** ca. 1930s, holds great appeal.

Much "fancier" than the original, the maker of this screw and washer eyed **Creek Chub "Spinnered Darter"** even added 'lip-stick' and bold gill strokes to his nicely painted facsimile.

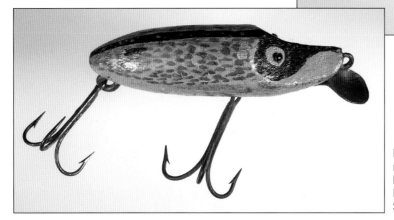

Later **Heddon "River Runt"** – Though made of wood, the form of this glass bead eyed 'masked' lure matches Heddon's classic, plastic "River Runt Spooks" ca. 1930s.

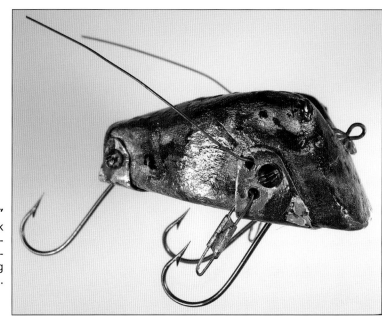

This handmade version of **Creek Chub's "Wee Dee,"** made by Bert Errett, Ohio, ca. 1930s, even adds pork rind clips on each side secured by the painted, wrap-around, full belly plate which also houses the weed-guards. Nail-attached, painted fancy metal bearing eyes. Scalloped bearing at line tie.

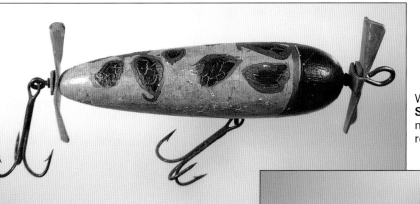

With clear influences from **Meyer's and Spellman** as well as **Keller's "Getz-Em"**, this nice surface bait features folded aluminum, reinforced props.

A handmade **"Hungry Jack,"** ca. 1930s, with genuine age is a rare find.

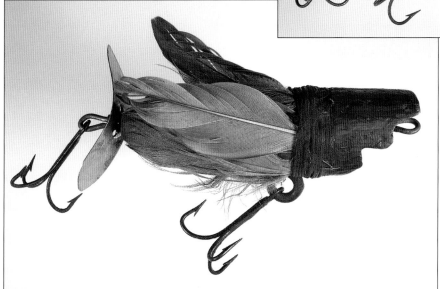

Wonderful character is expressed by this **"Weezel Sparrow,"** ca. 1940s.

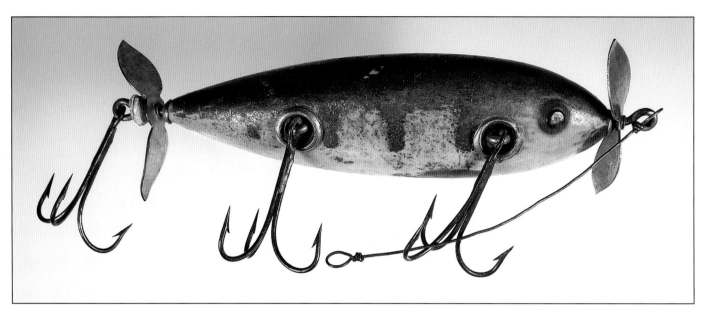

This **Creek Chub "Injured Minnow,"** ca. 1920s–1930s, from Muskegan, Michigan, is superbly made and painted and features hand poured glass eyes. It was made by the same maker as the Red Nose Jointed Diver (see page 78).

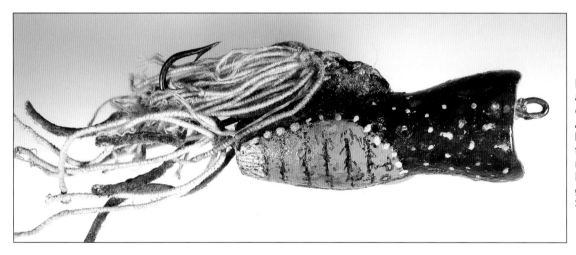

I have never seen a more interesting or folky rendition of **Arbogast's "Hula Popper,"** ca. 1940s, than this example marked "Potter" from Missouri. See more great Potter lures in Section 6.

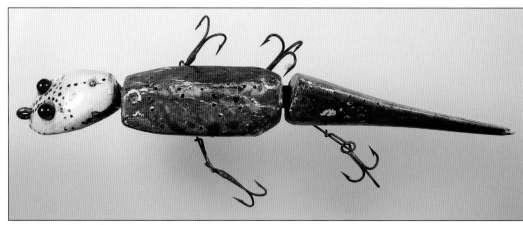

Intricate workmanship is evident in this **"Hinkle Lizard,"** ca. 1940s.

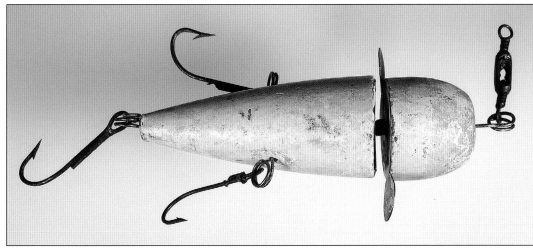

This ca. 1910s, creative, jersey-rigged **rotary-head** lure's wire-through construction turns upon itself forming integral split-rings at the line tie and all hook connections. Hook removal/replacement made easy – what a great idea.

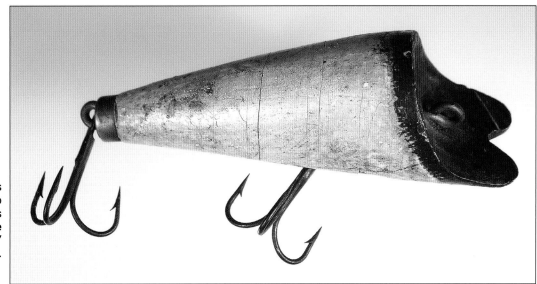

A brass rear tail cap punctuates this **Wise "Jim Dandy,"** ca. 1910s.

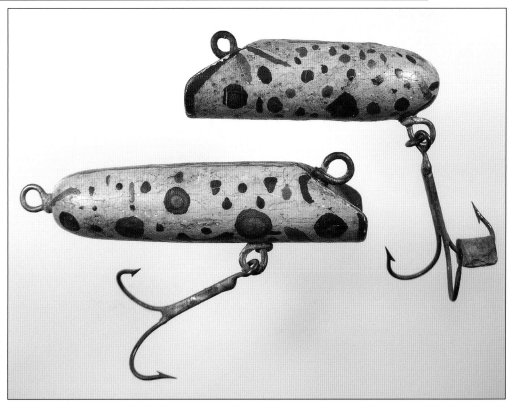

Wonderful paint and handmade hooks decorate this ca. 1920s **South Bend "Babe-Oreno"** (top) and **"Bass-Oreno"** (bottom) pair, clearly made by the same hand.

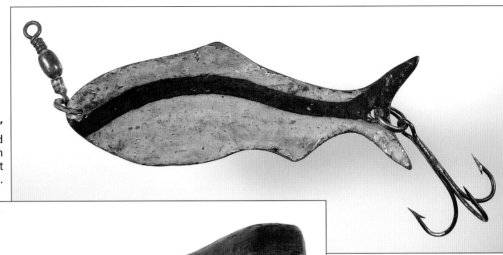

This **Frost "Del-Ray Wobbler,"** ca. 1920s, was hand-hammered out of copper, then painted on the 'inside' by folk artist Burt Errett, Ohio.

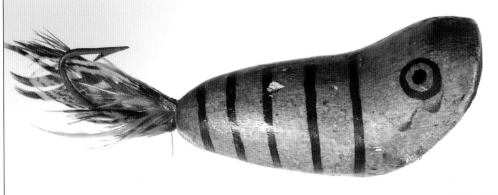

Simple yet very appealing is this prison-striped, **Heddon "Weedless Widow,"** ca. 1930s.

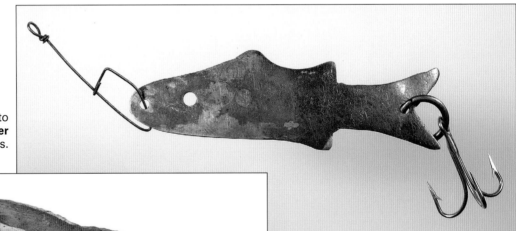

Sterling silver was used to fashion this **Kausch "Silver Soldier"** minnow, ca. 1920s.

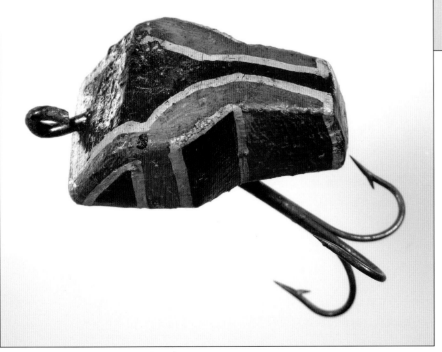

It was a shock to discover this handmade example of the obscure **"Leeper's Bass Bait,"** ca. 1920s.

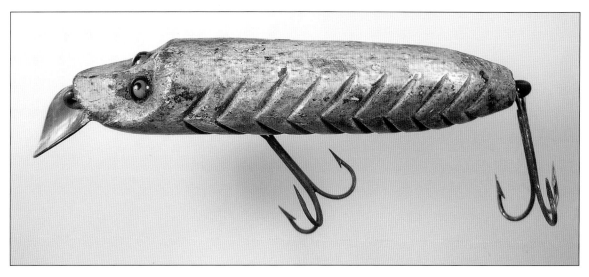

The maker of this classic **Heddon "Vamp,"** ca. 1920s, hand-cut the diving bill and deeply carved a V-pattern into the sides of the lure.

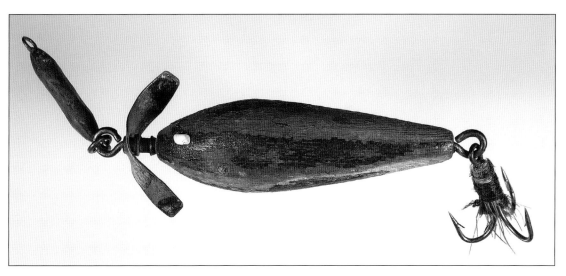

This ancient, bead-eyed, fore-weighted single hooker is a folky representation of **Heddon's "Artistic Minnow,"** ca. 1900s.

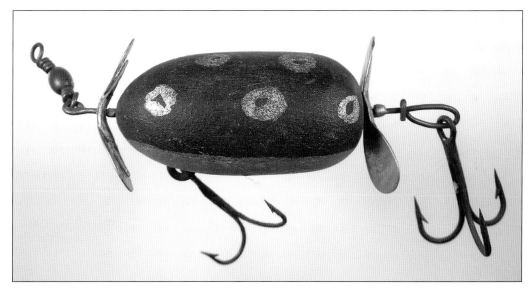

Simple and unique, this **Pflueger "Kent Frog,"** ca. 1910s–1920s, utilizes Pflueger "Bulldog" spinners.

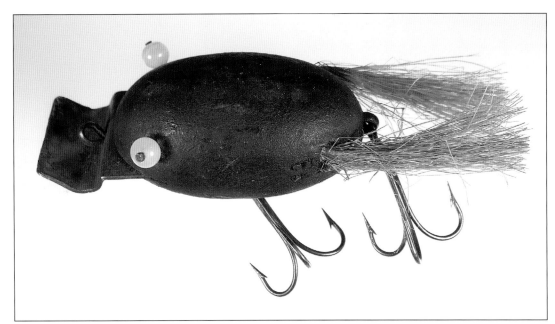

I dare say it would be hard to find a more folk-style **Creek Chub "Dingbat,"** ca. 1930s.

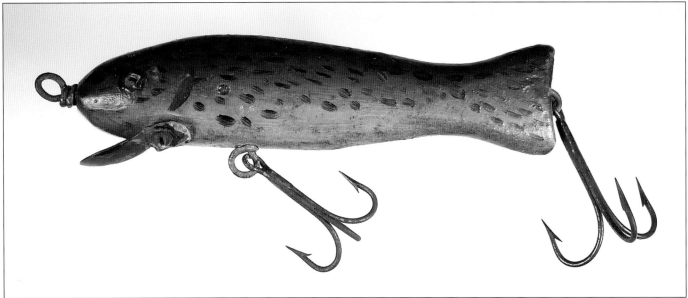

A nice folk art **Paw Paw "Caster" minnow**, ca. 1940s, is a real challenge to find. Made by the Pennsylvania maker presented in Section 4.

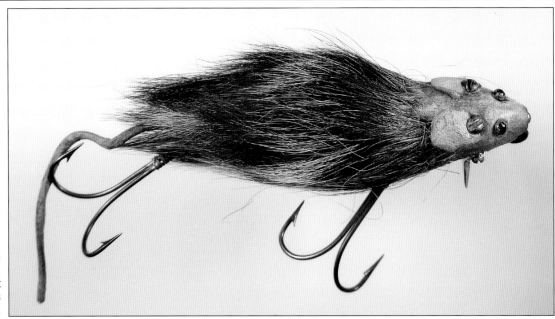

A hand-made **Heddon "Meadow Mouse,"** ca. 1930s, just doesn't get any better than this 'hairy' example.

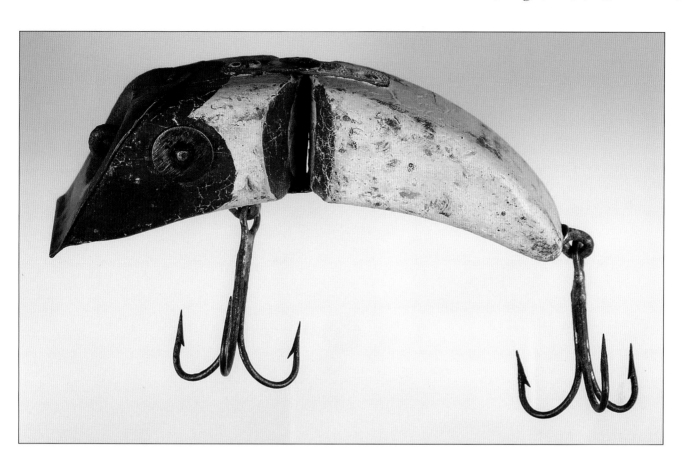

As a bonus for South Bend fans, I include this well-made and creative *jointed* **Tease – Oreno,** ca. 1930s.

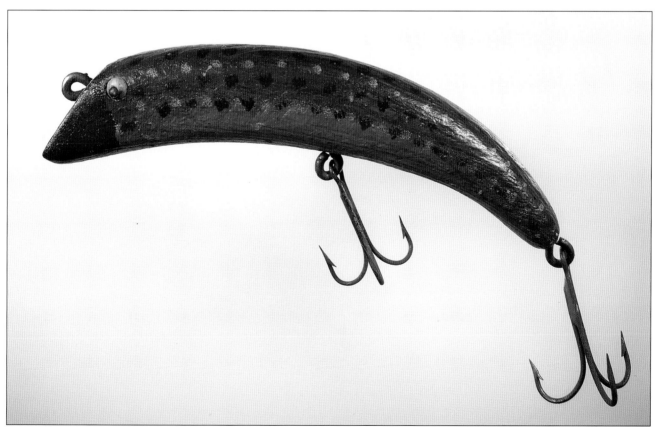

Made by the same hand as the South Bend Vacuum Bait (shown on page 126), this **South Bend "Tease-Oreno",** ca. 1930s, also has bone bead eyes.

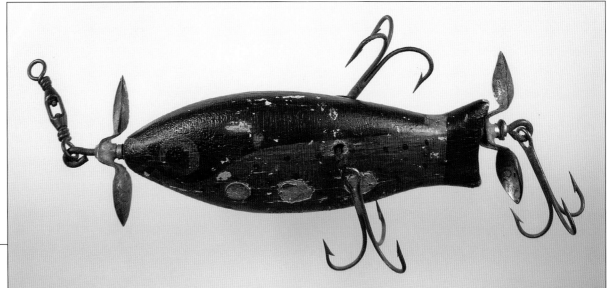

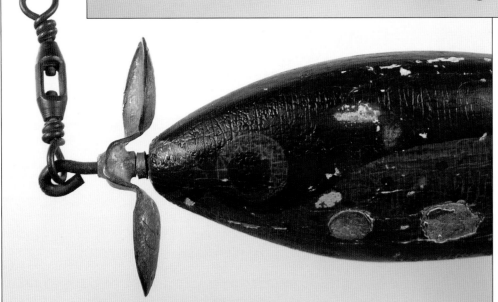

Pardee/Manco Type Underwater Minnow – 3-7/8" shaped, painted and varnished wood ca. 1900s. With string-tied side hooks and three horizontally-mounted belly weights, this old minnow is either arguably the finest 'copycat' bait out there or an extremely early, hand-fashioned prototype example. The hand-made, hat-shaped aluminum front and rear props are cupped and bear stampings which, among other things, imply their origin as an Ohio-based, carriage manufacturing company. Both the cupping of the props and the side mounted belly weights require substantially greater build efforts than the factory examples.

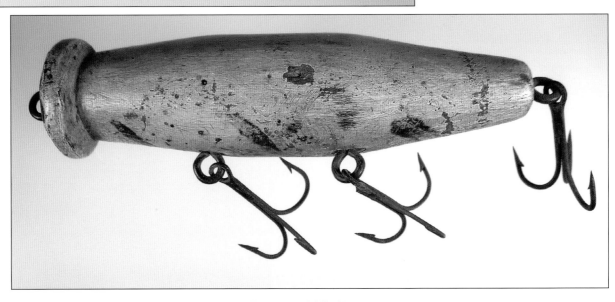

Boulton "Bass Hog," ca. 1910s – I never imagined I would find a handmade copy of a Bass Hog or Lehman's "White Wonder" bait, but this ancient, 4-1/4" fully chip-carved example with similar paint accents at the belly sure fits the bill.

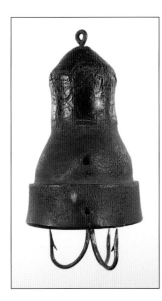

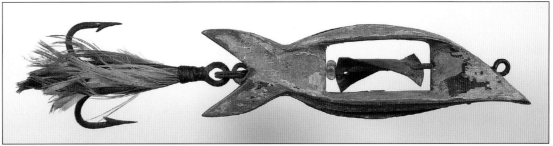

Fish-Tailed Chippewa – 3-1/2"
carved/shaped and painted
wood ca. 1910s. Striking and
well executed, this streamlined
rendition of the classic Chippewa
raises questions. Highly complex
in form, this mechanical/diving lure
should also wobble upon retrieve.
A single, formed and recessed wire
wraps the entire lure (at the belly

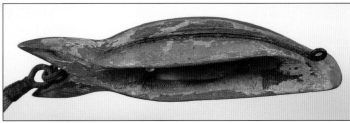

being set in a thin strip of lead acting as a keel). This continuous, reinforcing wire forms both the line tie and tail hook hangers. The tips of the wire are twisted and recessed into the body under the head area. A hand-cut and formed tin spinner, originally painted on one side, revolves around an embedded wire shaft located in the large central opening. This shaft contains a single glass bead bearing. How this wire was fixed into place at each end of the opening remains a mystery.

Moonlight "Fish Nipple"
(or **Shakespeare "Sure
Lure"**) ca. 1910s – This
wonderful 1-7/8" rubber,
(poured lead) weighted and
painted weedless facsimile
appears to have been
crafted from an antique
baby bottle cap/nipple. An
unusual and fortuitous find
for a copy-cat collector.

**Creek Chub Bait Co. Gar
Minnow**, ca. 1920s, 4-1/2",
utilizes painted, marked
Heddon props and has a
hand poured belly weight.

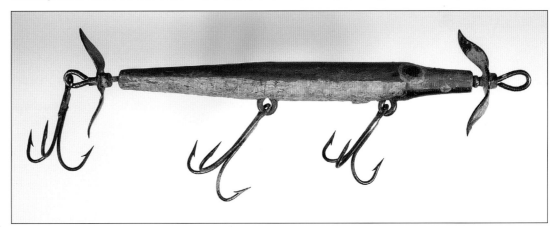

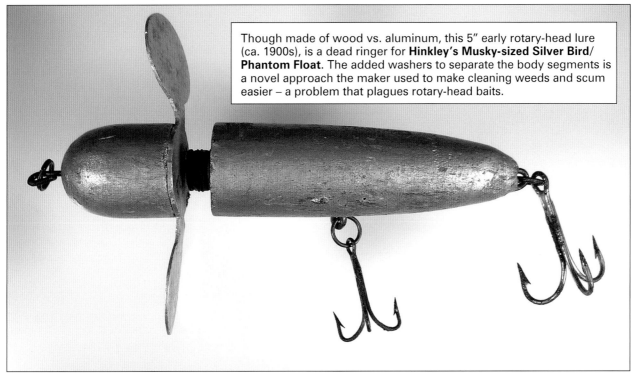

Though made of wood vs. aluminum, this 5" early rotary-head lure
(ca. 1900s), is a dead ringer for **Hinkley's Musky-sized Silver Bird/
Phantom Float**. The added washers to separate the body segments is
a novel approach the maker used to make cleaning weeds and scum
easier – a problem that plagues rotary-head baits.

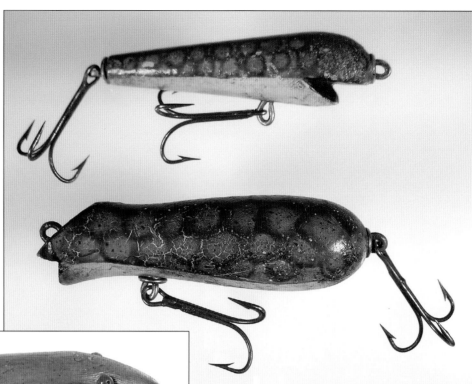

Pair of finely made, ca. 1920s lures in the form of a 3" **Baby Pflueger Surprise Minnow** (top) and a 3-1/2" **Shakespeare Swimming Mouse** (bottom). Through-body wire line tie and hook hanger construction is reinforced by two tiny cups on each lure. This pair, found in Canton, Ohio is fashioned by the same unknown maker as the pair shown on page 174.

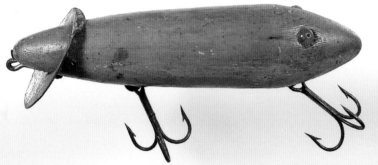

Heddon #1800 "Crab Wiggler," ca. 1920s. This 3-3/4" finely crafted example has great metal-work and opal-like glass eyes. The maker used Pflueger Never-Fail hook hardware.

Great scratch painting highlights this **Heddon "Crab Wiggler,"** ca. 1920s.

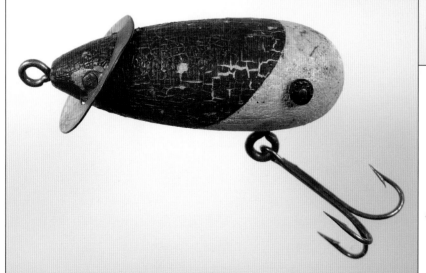

Surely this brass collared **Heddon "Deep-O-Diver,"** ca. 1920s, with hand-cut glass bead eyes is as old as the original.

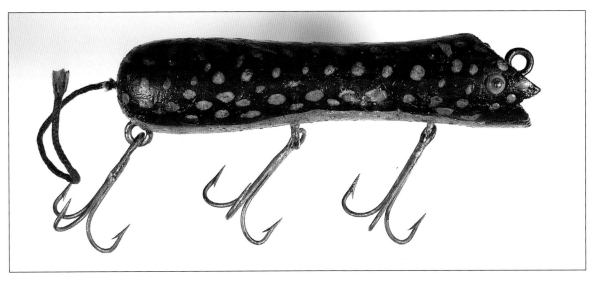

Shakespeare Swimming Mouse, ca. 1920s. An attractive elongated form, interesting paint scheme and ivory colored glass eyes lend warmth to this old 4-1/2" mouse.

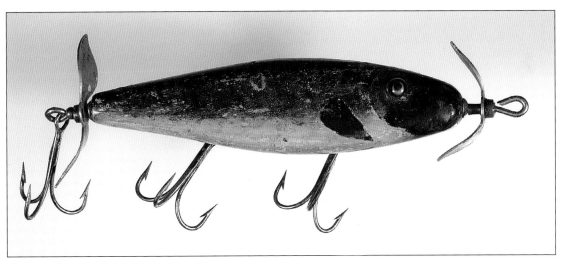

Here's something you just never find, a very well crafted and painted, 4" **Heddon "SOS"** (Swims-On-Side) Wounded Minnow No. 170, ca. late 1920s.

A finely made 4-3/4," side-hooked rendition of the famed **K & K Animated Minnow,** ca. 1910s, is a very nice find.

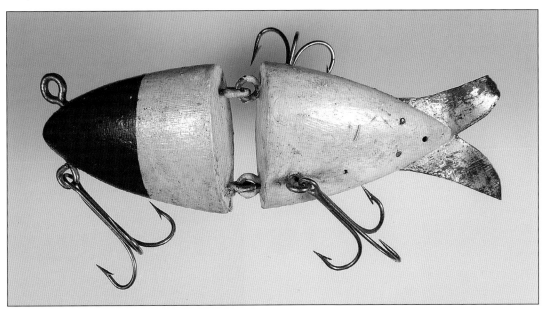

Pair Creek Chub Bait Co. "Beetles," ca. 1930s. Top: Simple paint, a slender waistline and glass bead eyes lend a distinguished look to this CCBC "Beetle." Bottom: Nice 2-1/2" Beetle rendition employs brass nail eyes and a nail-secured, hand-cut, galvanized diving lip.

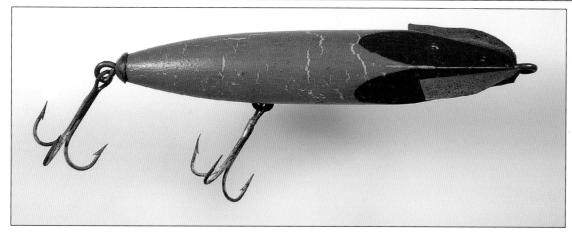

Heddon "Deep Diving Wiggler"- Beautifully executed crackle-back painted, 4-5/8", ca. 1910s. Continuous, folded tin nose "wing" is screw secured and serves to reinforce the line tie area.

Making these spring-loaded **"Captor's,"** ca. 1910s, couldn't have been easy. This old pair (made by different hands) are inspired variations of the original.

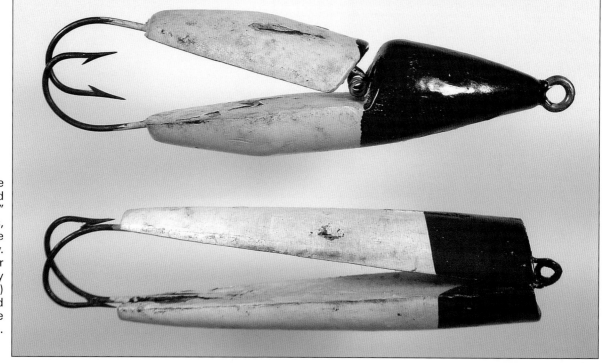

Siblings and Collections

In folk art one does not look for subtleties of composition and sophisticated organization, painterly qualities or masterly technique. But one may look for, and find, originality of concept, creativity of design, craftsmanly use of the medium, and flashes of inspiration, even genius. Folk art makes its appeal directly and intimately, even to people quite uninitiated into the mysteries of art... —Alice Winchester, *The Flowering of American Folk Art 1776–1876,* 1974

Due to the laws of nature (and fisherman), most vintage folk art lures live their lives separated for eternity from the hands that made them and, for that matter, from other lures those same hands made – their siblings. Its obvious when looking at a superbly crafted folk art lure that whoever made it surely didn't make just one. But where are all the others?

Once in a great while the law of averages intervenes and we have the opportunity at 'twins,' a brother and a sister, or close relatives from the same parent. Genetically related lures make great displays and conversation pieces. One validates the other(s). Like twins, the lures may be quite similar, yet being made by hand there are always subtle differences; like siblings, the lures may be quite different, yet when viewed together are clearly related. I think you will enjoy the relatives I have chosen to highlight in this section.

Rounding out this section are a few 'collections' of folk art lures: those organized by type or by a common (yet unknown) maker. My feeling is that with folk art lures, almost any thematic grouping is a magnet for attention. Whether the makers are known or unknown, a collection made by the same artisan, or a topical display with different examples produced by several makers, are always mesmerizing.

Pair handmade and tied **Burt Errett spinners**, one of brass, the other of aluminum. Both have oversized, hand-tied rear treble hooks and decorative glass bead and bearing accents.

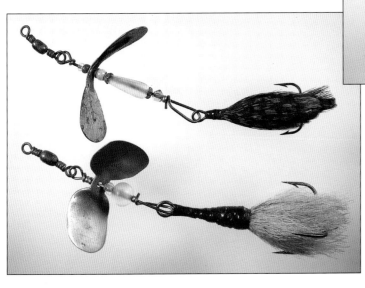

Spinner Pair by Burt Errett, Ohio – ca. 1920s, Top: Glass Bodied Spinner. Brass Hendryx blade painted on verso is mounted on a twisted handmade shaft housing a glass body and an assortment of glass beads and metal bearing caps. Hand tied rear feathered treble. Bottom: Vaseline Glass Spinner – Large, hand-cut/formed aluminum spinner mounted on a hand-twisted, wire shaft containing a large Vaseline glass bead and assorted other metal and glass beads. Unusual hand tied rear bucktail "hook-body".

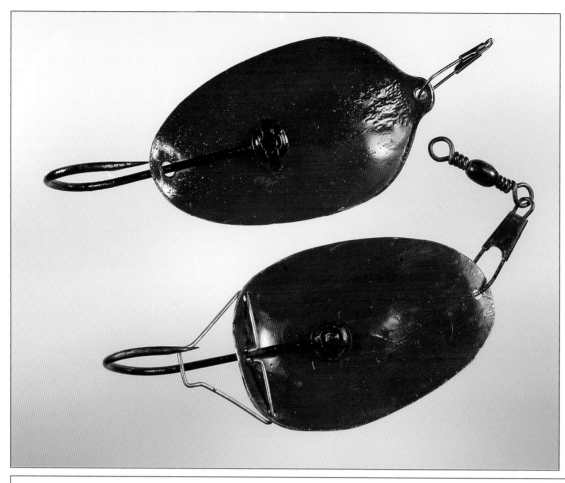

Large Silver Spoon Pair by Burt Errett, Ohio – ca. 1920s. Pair of modified, large sterling silver serving spoons 3" and 2-3/4", both having black japanned single hooks and snaps for line ties. Note the lead end of the spoons are oriented differently, top spoon line tie is at the base (of the spoon), whereas the bottom spoon's line tie is at the front tip. Top spoon anchors the hook via a riveted cotter-pin which passes through the hook line tie and formed washer. Bottom spoon employs a nut, bolt and washer as well as an unusual, adjustable (formed spring wire), pork rind/weed-guard at rear.

Musky Wiggler and Musky Revolving Minnow by Burt Errett, Ohio – ca. 1920s. Top: 6" polychromed, heavily varnished wood. Through-head, painted line tie/recessed rivet. Copper reinforcing washer at belly. Bottom: 4-1/4" hand-cut, polychrome painted and heavily varnished aluminum body with two folded, riveted, copper tail tab 'fins' finished similarly causing rotation. Integral twisted wire, metal leader. Formed wire clip at tail connects to large single hook.

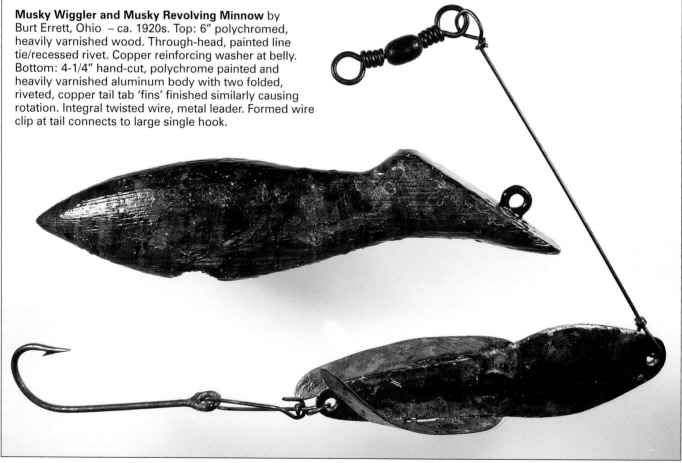

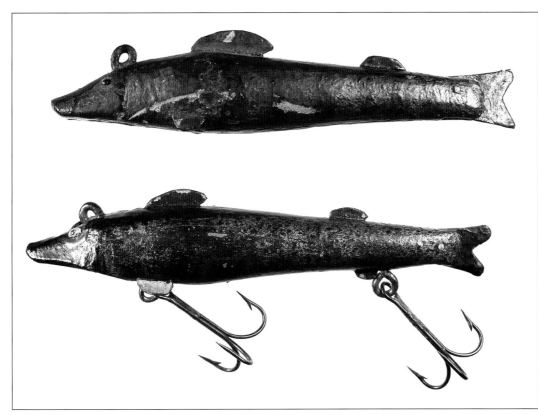

Unusual Hybrid Decoy-Lures – 4-3/8"ea. carved, painted and varnished wood ca. 1920s-1930s. Made like fish decoys but functioning as lures, this pair is unweighted and has multiple, inlet metal fins. Teeny tack eyes and carved mouth and gill details. Both have heavy wire line ties. Hooks have been removed from one of the examples.

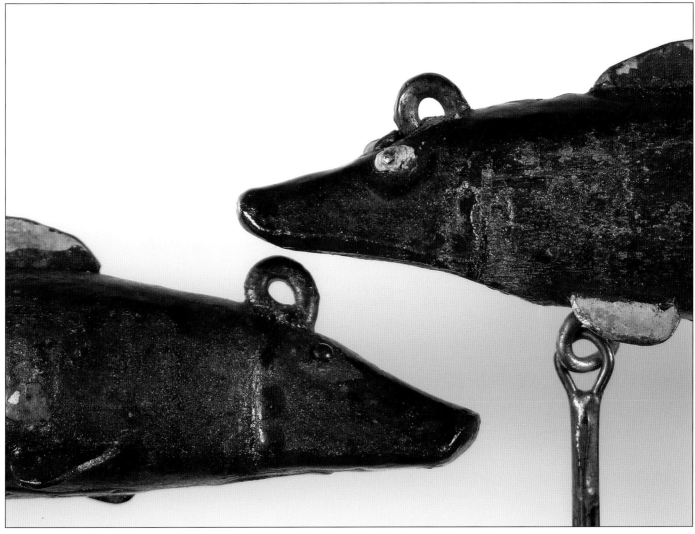

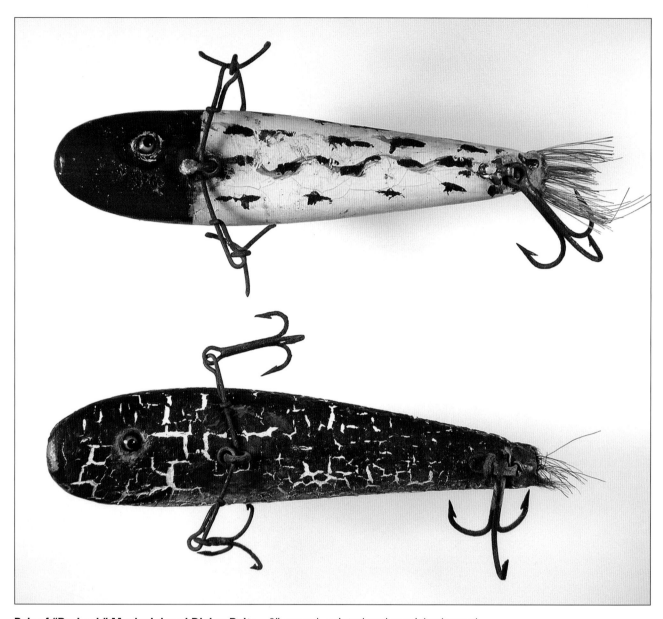

Pair of "Burbeck" Musky Injured Diving Baits – 6" carved, painted and varnished wood
ca. 1930s –1940s. Burbeck was a Wisconsin Musky guide. Photo is a shot of the pair from
the 'underside'. Curved (diving) body has only one glass eye mounted on the underside.
Flatfish-style belly hook hangers with integral hook retainer. Inlet fibrous or bucktail 'tail'.

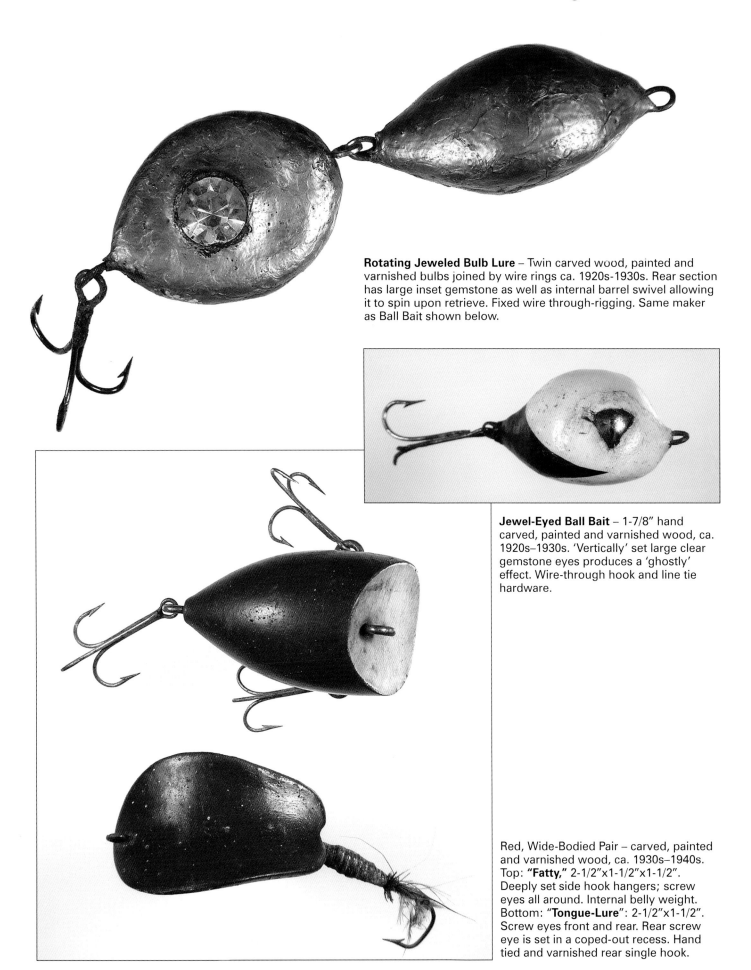

Rotating Jeweled Bulb Lure – Twin carved wood, painted and varnished bulbs joined by wire rings ca. 1920s-1930s. Rear section has large inset gemstone as well as internal barrel swivel allowing it to spin upon retrieve. Fixed wire through-rigging. Same maker as Ball Bait shown below.

Jewel-Eyed Ball Bait – 1-7/8" hand carved, painted and varnished wood, ca. 1920s–1930s. 'Vertically' set large clear gemstone eyes produces a 'ghostly' effect. Wire-through hook and line tie hardware.

Red, Wide-Bodied Pair – carved, painted and varnished wood, ca. 1930s–1940s. Top: **"Fatty,"** 2-1/2"x1-1/2"x1-1/2". Deeply set side hook hangers; screw eyes all around. Internal belly weight. Bottom: **"Tongue-Lure"**: 2-1/2"x1-1/2". Screw eyes front and rear. Rear screw eye is set in a coped-out recess. Hand tied and varnished rear single hook.

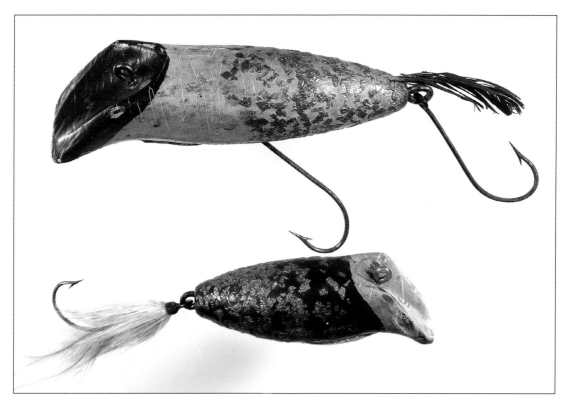

Primitive Bird Duo – hand carved, painted and varnished wood with flakes of lead used as glitter ca. 1920s-1930s. Top: 3-3/4", cup and screw belly hook hardware. Surface belly weight is screw attached and painted. Single rear tail feather. Wire front line and rear hook hanger with hand made cone washer line tie reinforcing. Single hook rigged.
Bottom: 1-1/2" with same construction details as top example except rear single hook is hand-tied.

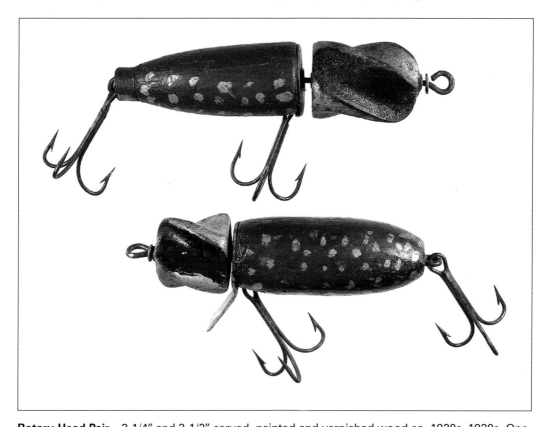

Rotary-Head Pair – 3-1/4" and 3-1/2" carved, painted and varnished wood ca. 1920s–1930s. One is rigged as a surface lure, the other, a diving lure. Heavy brass through-wire forms the line tie and rear hook hanger. Washer bearings behind line tie. The surface lure employs a metal tube, hook restrainer (painted) at the rear. Also employs a full back-plate and washer bearing at the joint. Deeply set wire hook hanger at belly. Backer plate at the joint on the diving example is simply extended to form the diving lip.

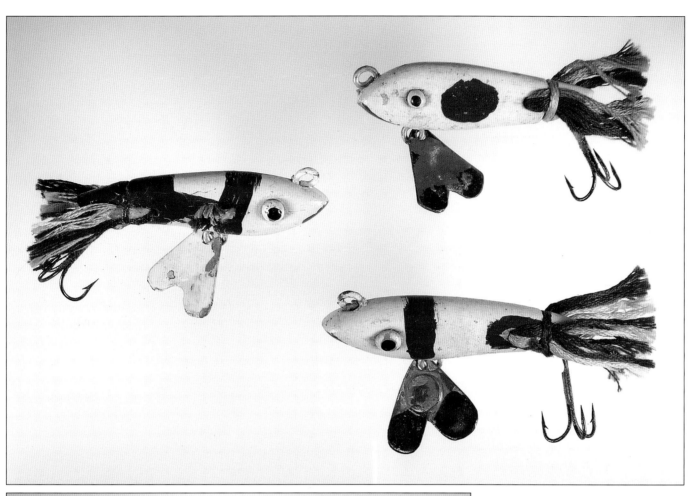

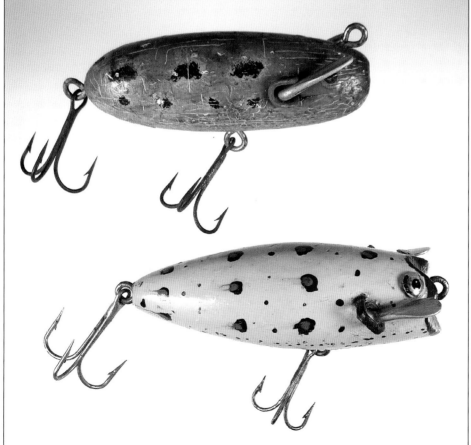

White Spinnered Darters (Michigan) – 2-1/2" carved, painted and varnished wood ca. 1940s–1950s. Found by Frank Baron, shown are three examples from a group of seven owned by the author. Painted metal tack eyes. Through-wire fixed line tie and rear hook hardware. Screw eye in belly holds a hand-cut metal spinner. Spinner examples range from weighted to un-weighted, natural metal to painted metal. Each darter has a colorful mixture of yarn/thread passing through the body near the rear of the minnow. Additional thread wrapping (secured in a carved groove at the tail), secures these accents at the rear of the minnow.

Flapper Plugs – 2-7/8" and 3" carved, painted and varnished wood ca. 1920s–1930s. Screw-eye line tie and tail hook hangers. Each has an internal lead belly weight, painted. One lure has painted eyes, the other painted tack eyes. Carved detailing differs on each at the nose. Each employs wire staples at each side of the head that restrains the movement of a through-body, U-shaped aluminum flapper mechanism. Each flapper is inserted with each end of same turned forward, then hammered (forged) into a paddle shape at each end.

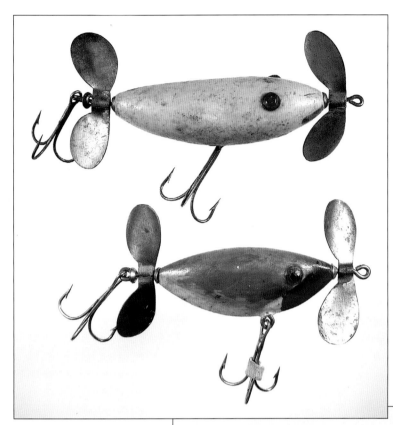

Pair Carved Bone Minnows (Grand Haven, Michigan) – 2-1/4" and 2-3/4" carved, painted and varnished bone ca. 1920s-1930s. Hand poured glass eyes. Large hand cut and formed Mickey-Mouse type props with front and rear dome bearings. White minnow has wire belly hook hanger inserted into brass tube connectors that are screwed into the belly – also has a poured lead belly weight. Green minnow is similar with a screw-eye belly hook hanger. It also sports a wrapped lead 'balance-weight' around belly hook.

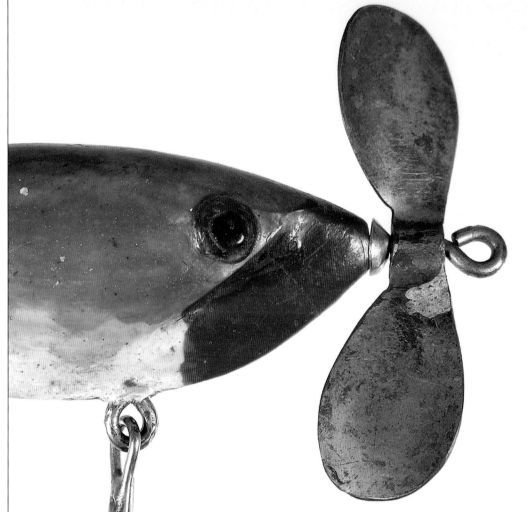

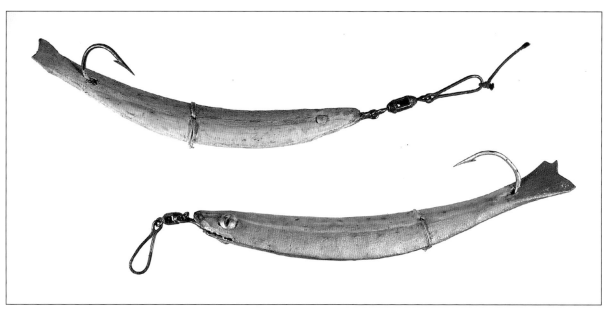

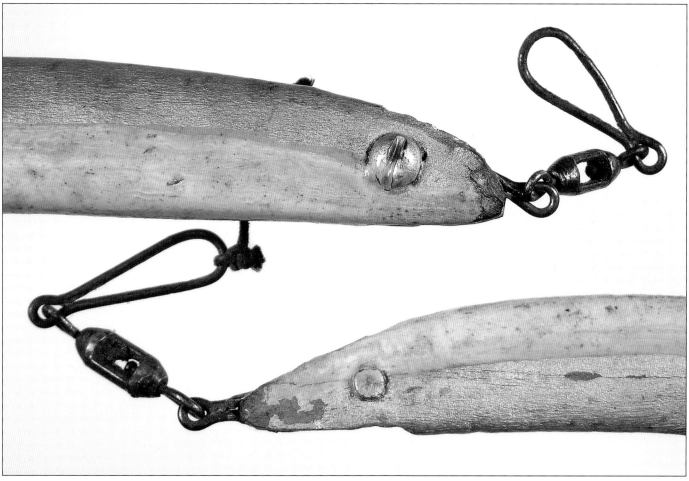

Crescent Darter Pair – 3-1/2" and 3 7/8" carved, painted and varnished wood ca. 1910s–1920s. Wire line tie is inserted into the nose/head of the minnow and wrapped around (on one minnow, a rivet doubling as eyes, and on the other minnow, a screw and nut assembly also functioning as eyes). Each lure has a formed single hook resting in a notch along its side which penetrates the minnow near the tail. The hooks are further secured at the lead end by wire wrapping which passes through the hook eye and a corresponding hole through the body of the minnow.

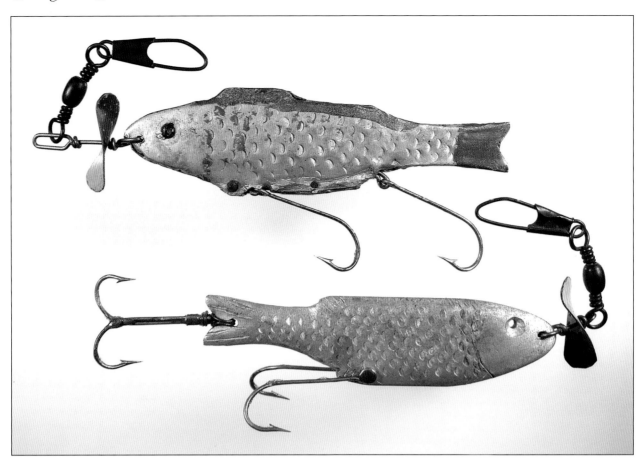

Folky Metal Fish Pair – 4" and 4-1/4" fish-shaped, aluminum-bodied lures with hammered scale, fin and gill accents ca. 1920s-1930s. The top fish has a soldered and crimped, 2-piece sandwiched body and paint accents. Rivet reinforcement forms the eyes and also appears twice at the belly. The belly rivets also serve to anchor a hand poured, internal lead belly weight. This fish has through-body wire hook hangers that wrap around the belly weight. Solid aluminum bottom fish features holes for eyes, a hand made, wire-tied fixed rear double hook and two single hooks attached by a brass nail at the belly. Both fish employ twisted wire leaders, each having a hand cut and twisted, painted metal spinner and integral snap-swivel.

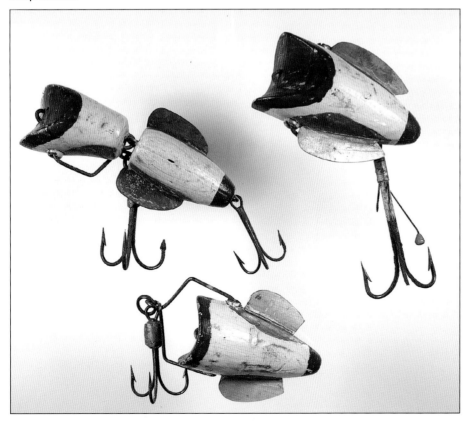

Finny Trio – 2-1/4" – 3-1/4" carved, painted and varnished wood ca. 1930s (one of these lures was found in Wisconsin). Each has embedded tin fins and a rotating, through-body wire harness which passes through cup-like hardware on each side of the head. Fixed, through-wire line tie and hook hardware. Hooks are attached via split rings to the external, wire trapeze-type harness. The wire frame can be rotated and used as an alternative line tie making the lure convertible into either a surface or diving bait.

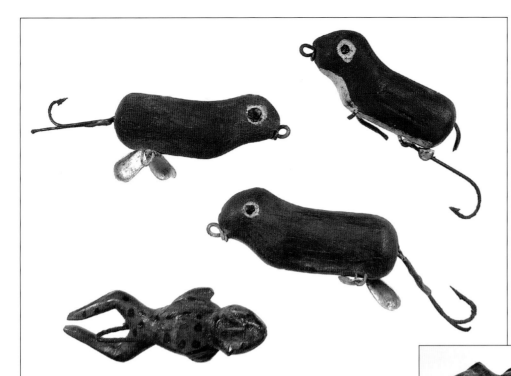

Hand Carved Miniature Rodent Grouping (Pittsburgh, Pennsylvania) 1-3/4" – 2-7/8" ea. chip-carved, painted and varnished wood, ca. 1920s-1930s. Frog – Single hook inserted through hole in the body then leaded-in with molten lead. Set of three mice, one is varnished, natural wood; two have carved and painted metal tack eyes, the other, carved and painted eyes. Wired-on, hand-cut aluminum flappers on two mice; the other mouse has a hand formed hook clip. Each mouse has a cast lead weight inserted into the rear tail area. One has inserted rubber legs and tail, the other pair of mice having their hooks function as a tail.

Maroon Fly-Rod Pair – (Pittsburgh, Pennsylvania) – 1-5/8" and 2-3/4", both are constructed from shaped, varnished and painted wood. Top – Bug: embedded, through-body single hook also forms line tie. Curved, hand cut brass wings are inlet into the body and secured. Bottom – Curved Bodied Darter: Through-wire line tie tail hook hanger passes through the body and supports a wire trapeze at the ends of which single hooks are attached.

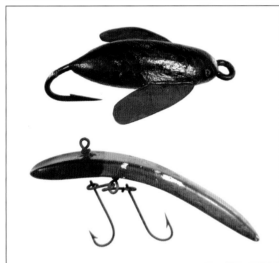

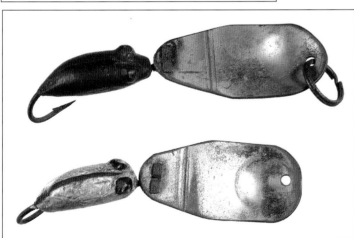

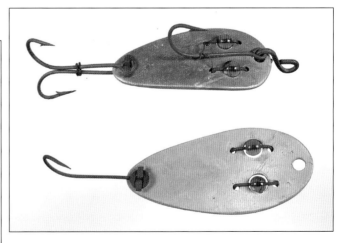

Aluminum Spoon Pair (Pittsburgh, Pennsylvania) – 2" and 2-3/8" cut aluminum spoons ca. 1930s. This pair of hand made spoons has glass bead eyes mounted via wire that (top example) in turn holds a single hook secured at the line tie by a formed wire. Rear hooks are secured by cotter pins. On the top example, two single trailing hooks are used which are wired together at mid-shank.

Giant Lipped Fly-Rod Lure Pair (Pittsburgh, Pennsylvania) - hand-carved, painted and varnished fly pair, ca. 1920s-1930s. Large formed steel plate (diving lip) attached by cotter pin to each lure. Each wood fly has a through-body hook and relief carved eyes.

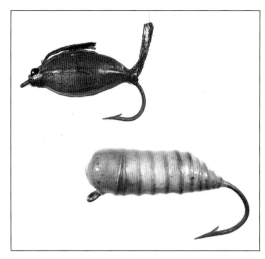

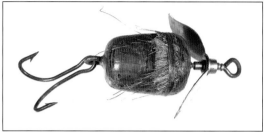

Translucent Fly Bait Pair – Top: 1" hollow-bodied fly minnow with thickened shellac pulled over an internal spring-wire frame. Varnished cording used for dorsal and tail fin accents. Teeny, painted brass tack eyes. Bottom: 1-1/2" spring grub consists of spring wire wrapped around a large single hook with thickened shellac pulled multiple times over the assembly.

Cork Spinner – 1", formed and varnished cork body mounted on a through-wire shaft with thrusted fore-spinner. Remnants of tied string-wrapped bucktail around the body.

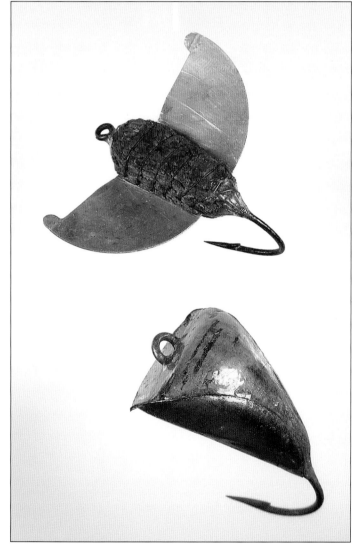

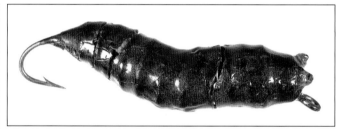

Large, Spring-Wire Grub – 2-3/4" amazing serpentine spring-wire body formed around a large, re-formed single hook. Very fragile body shows damage. It's formed by multiple dippings in thickened shellac which is drawn over the spring-wire. Hand-formed eyes with paint accents.

All the lures shown on this page were found as a group in northern Wisconsin near the Michigan border, ca. 1920s-1930s.

Carved, Varnished Cork Pair – Top, 1-1/4" Aluminum Winged Bug – Cut aluminum wings inserted through the body are further stabilized at the body by full body wire wrapping, each wire loop passing through tiny individual holes in the wings. Bottom, 2" Diving Triangle – Carved cork body is shrouded on 3 sides by formed and varnished tin body wrap open at the top. Tin forms a modest front diving lip. Large, through-body single hook completes the piece.

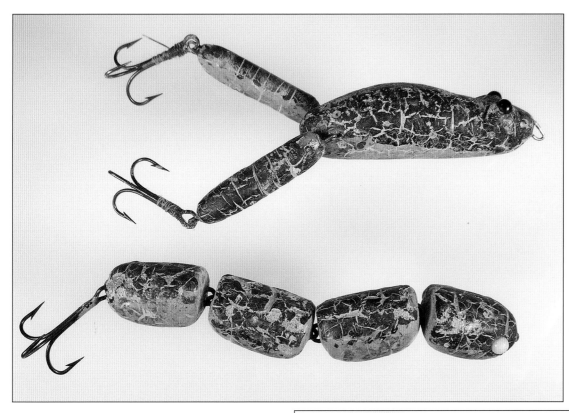

Incredible Cork Frog and Snake Pair (Missouri) – carved, articulated, painted and varnished cork frog 3-3/4", and snake 4-1/2", ca. 1910s-1920s. Construction technique is similar on both examples. Fully internal, fixed wire-through hardware forms the line tie, joints and hook hangers. Remnants of tied treble hooks remain on the frog.

Winged Hopper Pair – hand carved, painted and varnished wood bodies ca. 1930s. Top – 2-1/2" painted eyes. Embedded rear single hook with handmade wire weed guard secured by 2 nails. Raised screw on back acts as pork rind attachment. Embedded metal diving lip secured by two nails under the chin. Plated, screw-eye line tie with metal bead reinforcing. Through-body wire side hangers, each having a split ring and attached Hildebrandt copper spinner. Belly screw supports trailing spinner/swivel assembly. Wings and trailing spinner have been added. Bottom – 2", painted eyes and mouth. Embedded rear single hook likely secured by recessed pin at back. Embedded side 'pins' each house a factory spinner blade as wings.

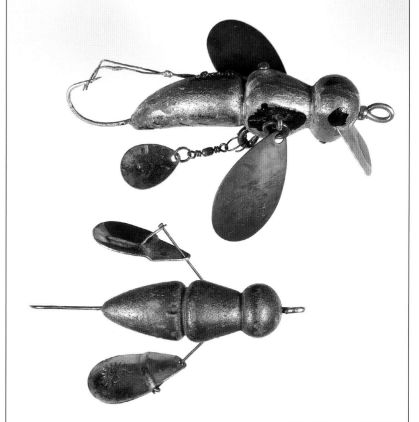

The lures shown on pages 168 and 169 were found in a partitioned Pflueger dealer box in the floor rafters of a basement in a house on the North side of Pittsburgh, Pennsylvania, that was scheduled for demolition. Several from this same maker are also featured in Section 3.

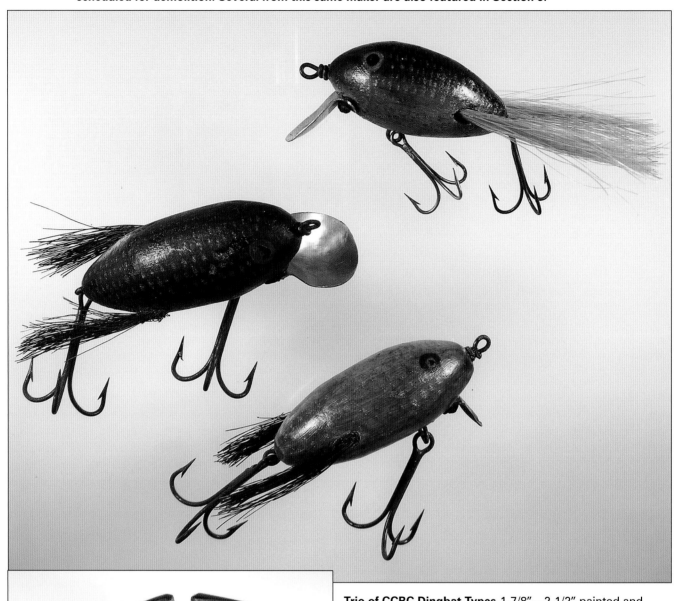

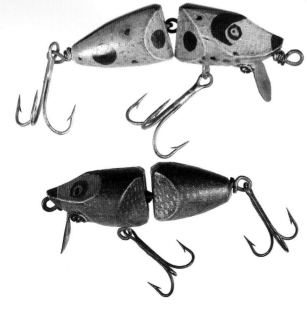

Trio of CCBC Dingbat Types-1-7/8" – 2-1/2" painted and varnished wood. Paint eyes. Screw attached, hand-cut front diving lips. Fully fixed wire-through in both directions.

Pair 1 – Jointed Vamp Style, 2-1/4" and 2-3/8"

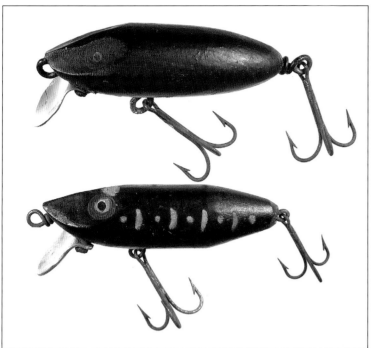

Pair 2 – Vamp Style, solid body, same construction technique, both 2-5/8"

The whole gang huddles-up. Also in the Pflueger dealer box made by the same maker was a collection of **10 Vamp and Jointed Vamp** types, both variations assembled similarly as follows: carved, painted and varnished wood. Fully fixed through-wire construction in both directions (including joints) forms the line tie and hook hangers. Painted eyes. Hand cut and formed aluminum or steel front diving lips, screw attached.

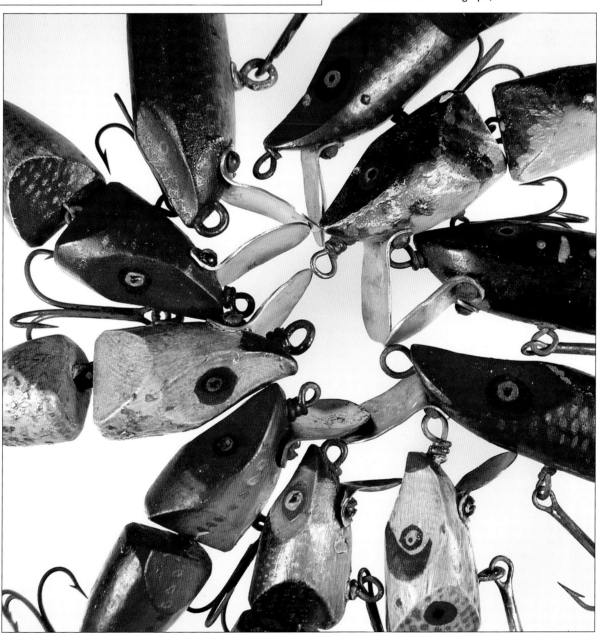

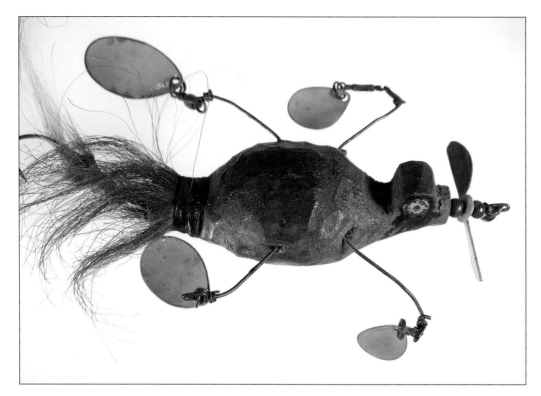

Primitive Cartoon Bird – 3"x1-1/4" chip-carved, painted and varnished wood ca. 1930s–1940s. Same maker as the Barber Pole Bait shown below. Horizontal through-body wire supports 4 swivels, each with a hand-cut and formed, painted spinner blade. Brass through-wire forms line tie and rear tail hook hanger. Hand cut formed and painted front prop with 2 glass bead bearings. Hand tied rear single hook. Remnants of a once bushy tail is attached by varnished cording. Hand poured lead belly weight.

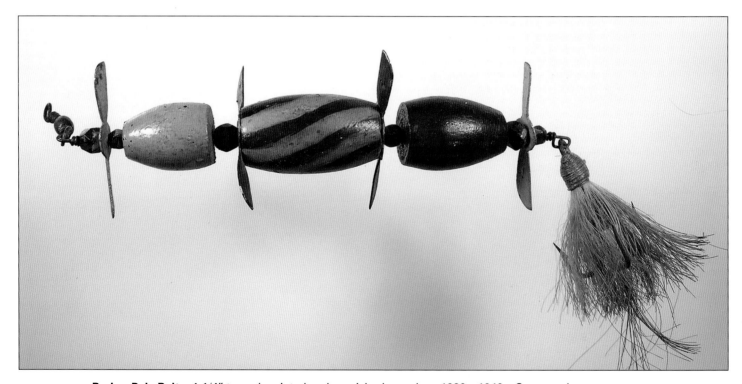

Barber Pole Bait – 4-1/4" turned, painted and varnished wood ca. 1930s–1940s. Same maker as the Primitive Cartoon Bird shown above. Triple-segmented wood body separated by glass bead bearings, also used at front and rear props. The props freely rotate at the front and rear, but are fixed via two nails at each end of the central (barber) section, causing the center section to rotate upon retrieve. Props are hand-cut, formed and painted tin. Hand-tied rear treble. Hand poured lead belly weights are located in both the front and rear sections.

V-Neck Chunk Bait – 2"x1-1/4" carved, painted and varnished wood ca. 1920s. Applied, surface mounted belly weight. Hook set in V-notched, recessed groove and secured by pork rind pin (nail). Made by the same maker as the adjacent "Dress Shirt" Bait.

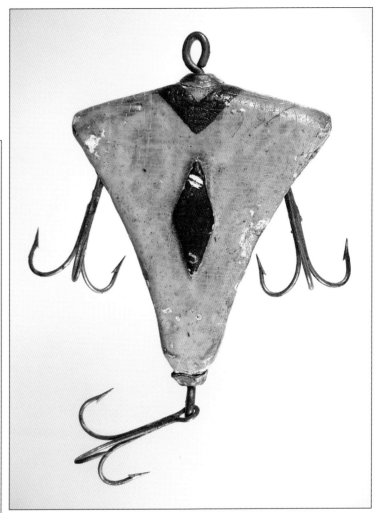

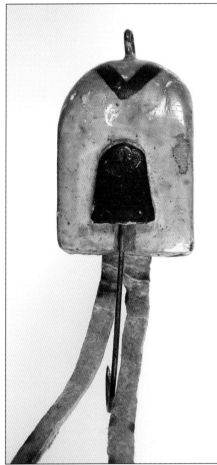

Dress Shirt Bait – 2-3/4"x2-3/8" carved, painted and varnished wood ca. 1920s. The form and paint suggests a collared dress shirt and tie. Deeply recessed sides hold screw eyes reinforced by hand cut and formed concave metal 'cones.' These same type cones (reversed) are used to reinforce the line tie and rear hook hangers. Made by same maker as the adjacent V-neck Chunk Bait.

Deerskin Mouse Pair, ca. 1930s – Top: 2-3/4" stitched deerskin over wood body with front (head) portion of carved, painted and varnished wood. Found at an estate sale in Grand Rapids, Michigan. Full through-body wire construction. Tiny, black glass bead eyes centered in paint decorated area. Deerskin is adhered at the collar with wrapped varnished, linen line. White, bucktail 'tail' accent. Bottom: 3-1/2" with generally same construction details as above, but with simple painted eyes vs. glass bead eyes.

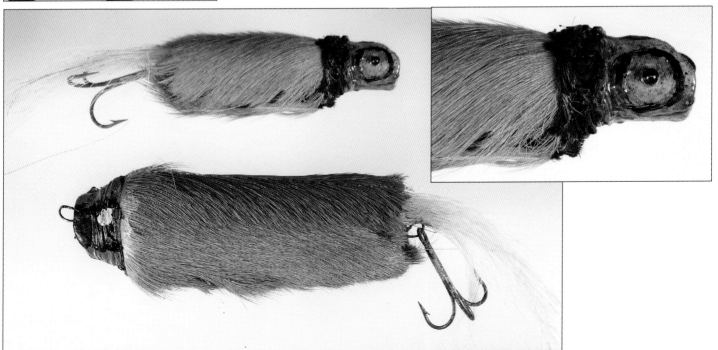

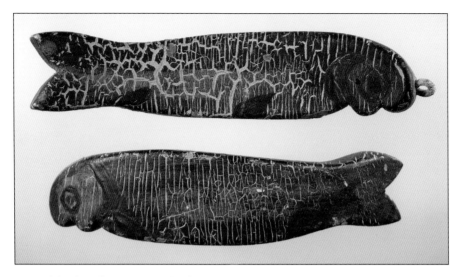

Carved Bodied Suckers – 4-1/4" fish-shaped, curved, carved, painted and varnished wood ca. 1930s–1940s. Remnants of previous hooks. One fish retains screw-eye line tie.

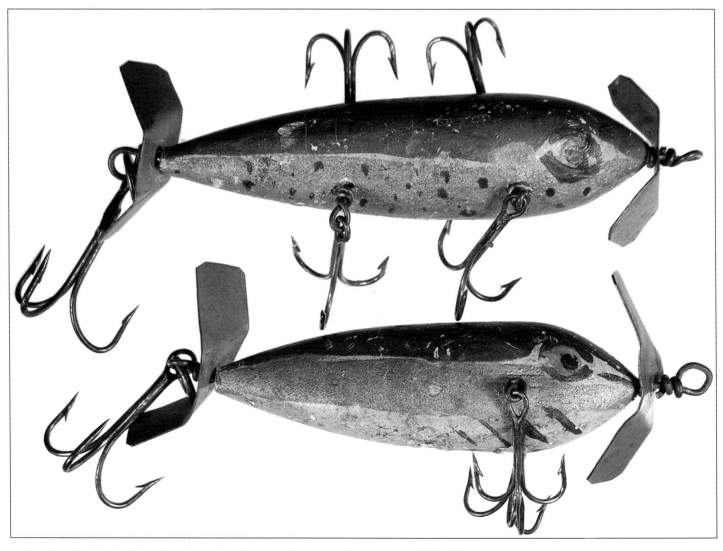

Classic pair of early, **three-hook and five-hook underwater minnows**, ca. 1910s. It's rare to find an early, 'matched' folk art underwater minnow set.

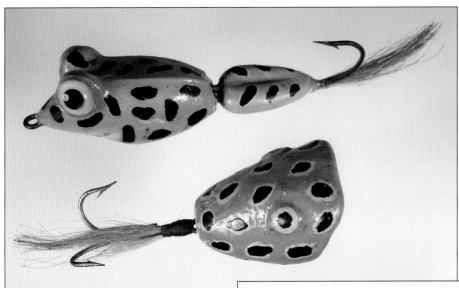

Fantastic Froggies – Hand carved, painted and varnished wood ca. 1930s. Top: Bug-Eyed Jointed Frog. 3" full, fixed, through-wire construction, including joint. Large glass eyes – inlet, rear 'hair' feet.
Bottom: Surface Chunk Frog – 1-5/8" carved, painted and varnished wood. Full, fixed through-wire forms line tie and (inlet) rear hook hanger. Painted tack eyes. Hand tied hair double-hook.

Mechanical Finned Duo (Wisconsin) – Siblings just don't get much more interesting than this amazing folk art pair measuring 2-3/8" and 2-1/4" respectively ca. 1930s–1940s. Similarly constructed, each features a freely turning painted brass fore-blade which causes the rotation of through-body side (pectoral) fin paddles. Hidden internal gears connect the fore-spinner and side-fin shafts. These internal works are hidden by a finely cut, formed and painted, multi-function surround harness which covers the body opening, while acting to secure the front spinner, three terminus ends of the line tie frame and both sides of the pectoral fin (paddles) shaft. The 2-piece, soldered and painted, external line tie frame is anchored by pins to the surround harness at the sides while passing through the harness at the belly. The wire belly hook hanger anchors the lower end of the surround harness. Conventional screw eye hangers hold the rear tail hooks.

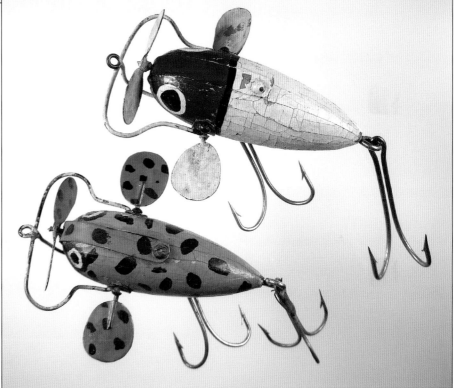

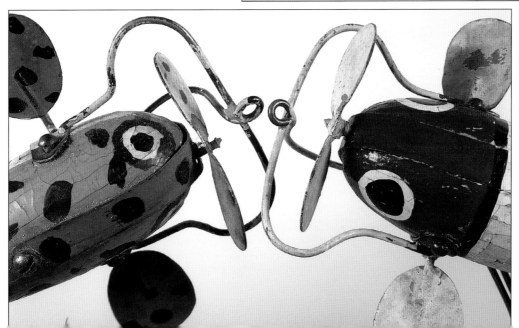

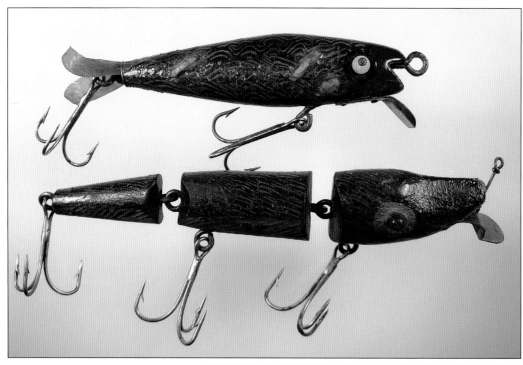

Scratch Painted Diving Duo ca. 1940s – Both constructed of shaped, scratch-painted and varnished wood. Top: 3-1/8" – this lure features adhered, painted wood side and crushed glass accents. Fixed, through-wire, line tie and hook hangers. Glass bead eyes, nail-secured. Wired-on, flexible, patterned, blue tail accent strips are likely fashioned from an old table-cloth. Bottom: 4-7/8" double-jointed lure features painted tack eyes. Hand-cut and formed metal diving lip with twisted wire line tie extension. The joints and hook hangers are believed to be through-wire.

Wisconsin Jointed Pike Pair – This pair is distinguished by great form, wonderful paint and the patina of age. 4-1/2" and 2-7/8" respectively ca. 1930s. Carved, painted and varnished wood. Larger example features unusual, small belly cups and painted dome tack eyes. Painted eyes on the small example. Deeply recessed screw eyes form the body joint and hook hangers. Hand cut and formed tin diving lip is soldered to the line tie on both examples. Note that the non-traditional lip design on the small, jointed example would cause erratic surface action.

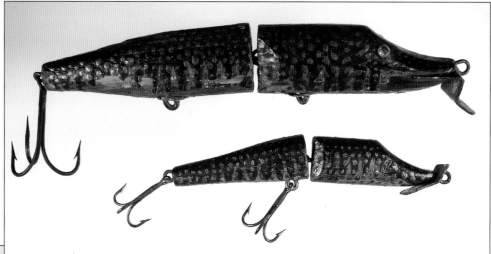

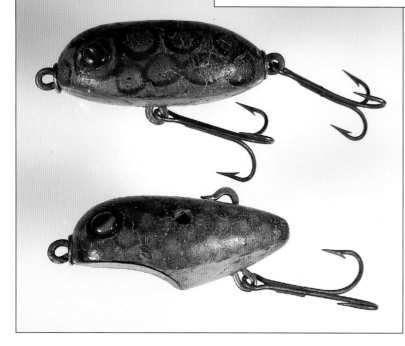

Folky Chunk Frog Pair (Canton, Ohio) – both 2-1/4" carved, painted and varnished wood. Through-body wire line tie and hook hangers. Each employs unique, small reinforcing cups. The unusual swirl glass bead eyes are inserted sideways (bead holes parallel to the lure) to achieve this special effect. On lower lure, hook hanger passes through back and is forged into a pork rind clip. With this detail and the unusual spotted paint, it is possible the maker was inspired by Bud Stewart's early work. This pair is fashioned by the same unknown maker as the pair shown on page 152.

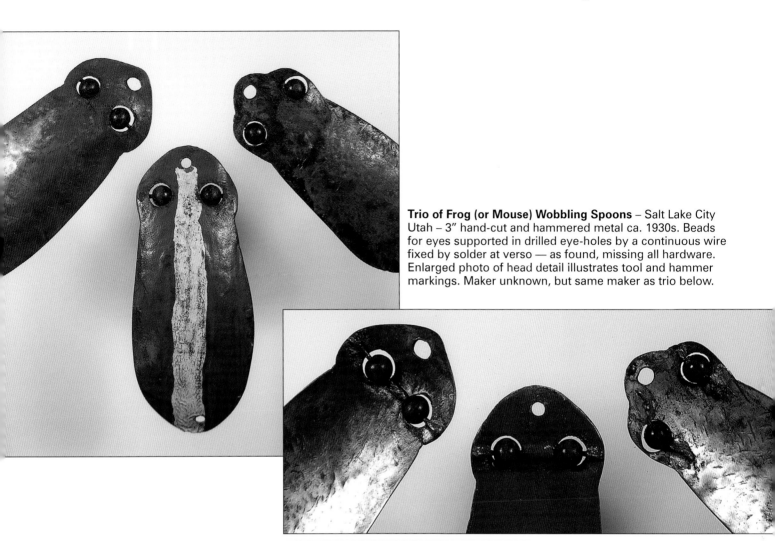

Trio of Frog (or Mouse) Wobbling Spoons – Salt Lake City Utah – 3" hand-cut and hammered metal ca. 1930s. Beads for eyes supported in drilled eye-holes by a continuous wire fixed by solder at verso — as found, missing all hardware. Enlarged photo of head detail illustrates tool and hammer markings. Maker unknown, but same maker as trio below.

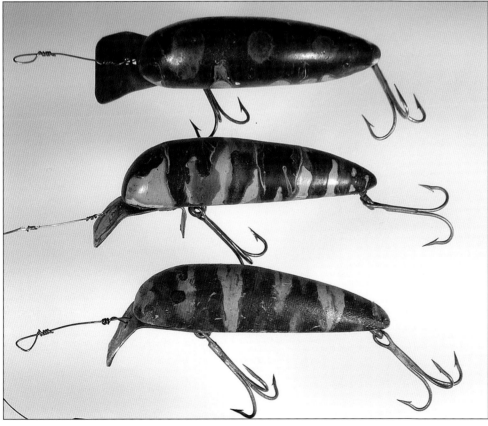

Swirl Wiggler Trio – Salt Lake City, Utah, ca. 1930s - 2-3/4" shaped, painted and varnished wood. Cut and formed metal diving lip secured by lead hook hanger eye and an additional screw. Short, hand-twisted wire leader attaches via two holes in the diving lip. Very unique, multi-color, swirl-type paint effects, perhaps inspired by Pflueger's famed paint pattern. Curiously, diving lips are painted black on the underside and each is paint marked with a number reference – from top to bottom, marked XXI, III and 37.

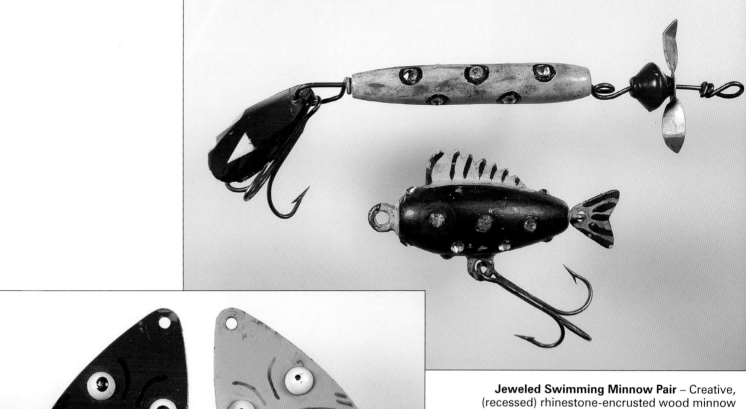

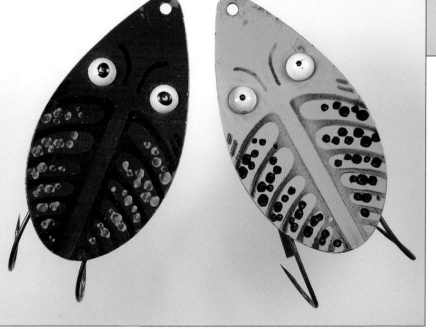

Jeweled Swimming Minnow Pair – Creative, (recessed) rhinestone-encrusted wood minnow pair by the same anonymous maker, ca. 1940s; body lengths of 2-5/8" (top) and 2" (bottom). Top: Twisted brass through-wire fixes the location of the painted and varnished wood body. The wire "loop" in front of the body doubles as the bearing for the fancy red, glass bead and the hand cut and twisted aluminum prop. The large, 1-3/8" red glass, teardrop-shaped attracter mounted at the rear was salvaged from an old chandelier. Bottom: A total of 15 rhinestones (including two for the eyes) decorate this unique minnow which also sports a painted metal dorsal fin and tail. Author believes the hardware is screw-eye; however, how the dorsal fin was attached remains a mystery.

This wonderful pair of 3" (weedless) metal lures hail from Wisconsin. Originally introduced in the 1940s, this particular style was made by H. M. Holling & Co. in the 1950s. They were called "**Sure-Lures**." Though technically "manufactured," these lures were entirely hand made and have a beautiful and very folky hand painted finish so are included here. The painted dome tack eyes are actually rivets that secure the weedless hooks.

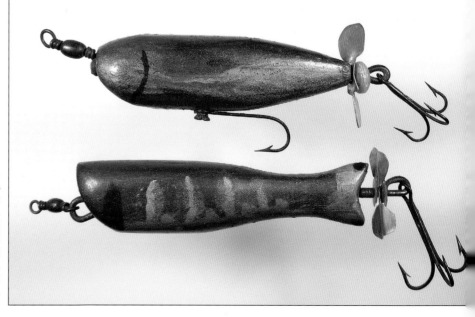

Pair Surface Minnow Poppers, ca. 1950s. Top: 2-7/8" carved, painted and varnished wood. A barrel swivel with one end turned down through which a screw is passed forms a unique line tie. Hand cut rear prop accentuated by glass bead bearing. Single, fixed belly hook is secured by screw. Bottom: 3-1/2" carved, painted and varnished wood. Fixed wire-through rigged. Celluloid and vintage spring bearings with hand cut rear tail prop.

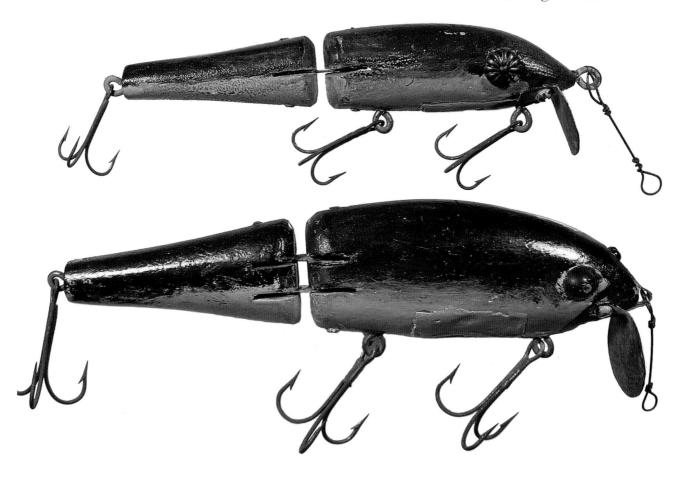

Musky Jointed Wiggler Pair – Nice pair of wedge-body lures made by the same hand ca. 1930s. Found in the Chautauqua, New York area in a tackle box containing an early Heddon 100 and Decker top-water rotary-head lure. They measure 5-1/2" top and 7" bottom; each is of shaped, painted and varnished wood with integral, "V-shaped" lead belly weight and hand cut and formed galvanized metal diving lips secured by screws. Screw eye hook hangers and integral hand-formed wire leaders. To add line tie reinforcement, the large example contains a separate, hand-formed metal strap – it's inset flush with the body and secured by screws under the head and on the forehead. This strap, soldered to the diving lip, forms the line tie. Cut metal "joint" straps (two being used on the large minnow), are inset into body segment cutouts and secured by through body metal pins. Nail secured large glass eyes on the large minnow and upholstery tack eyes on the small minnow.

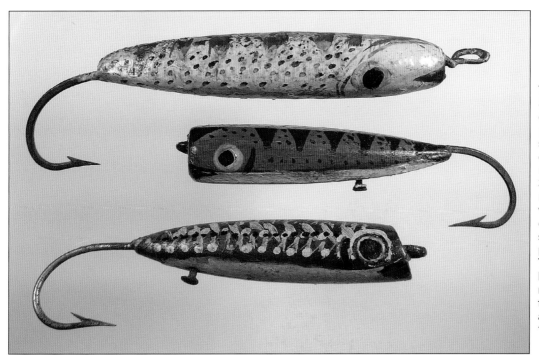

Trio of Weighted Saltwater Jigging Lures, ca. 1940s – Beautifully painted and varnished, shaped wood bodies over cast lead core. Length ranges from 2-3/4" – 3-3/4." Each is hand marked with its weight which ranges from 1-1/8 oz. to 2 oz. The large, single hooks are fixed into place by the cast lead. The two shorter examples have a belly mounted nail stud (anchored by the lead), for attaching a natural or artificial "trailer."

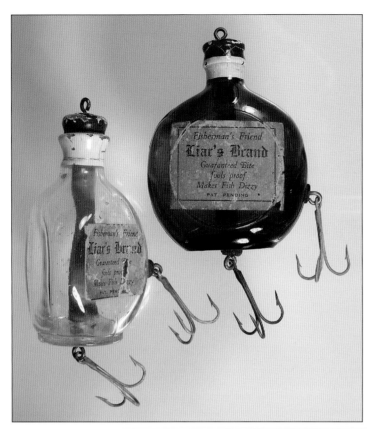

Vintage Bottle Lures – This creative, quality-made pair provides new life to what originally may have been small Whiskey bottles. The previous owner reported he purchased these unique "novelty" lures in this condition in the early 1970s – in used condition, their actual age is unknown. They are sturdily built and employ rubber seals to prevent water infiltration and stout wood backing for anchoring the line ties and hook hangers. I have no doubt they would work in practice. You saw them here first! The label on each bottle is marked:

> Fisherman's Friend
> **Liar's Brand**
> Guaranteed Bite
> fools proof
> Makes Fish Dizzy
>
> Pat. Pending

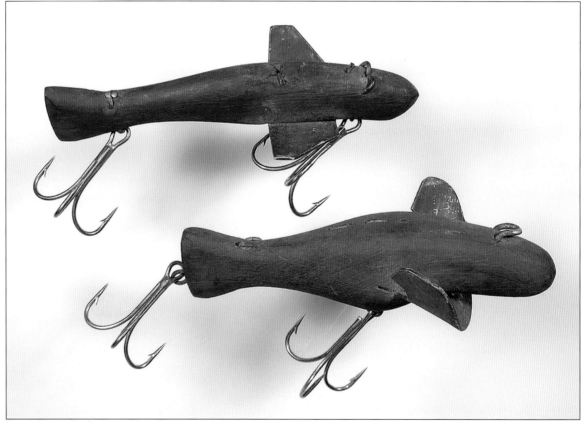

Fighter Plane Duo – these clever, patriotic ca. 1940s lures painted in army green were likely inspired by WWII fighter planes. Carved and painted wood 4" long. On top example (painted) aluminum wings are inset at the belly and staple attached – on bottom example wings are inlet into the body and secured by through wire which also forms the line tie and belly hook hanger. All other hooks on both pieces are retained by through-body cotter pins which are turned down at the back. *Gift to the author from Allan Weiss 7/09.*

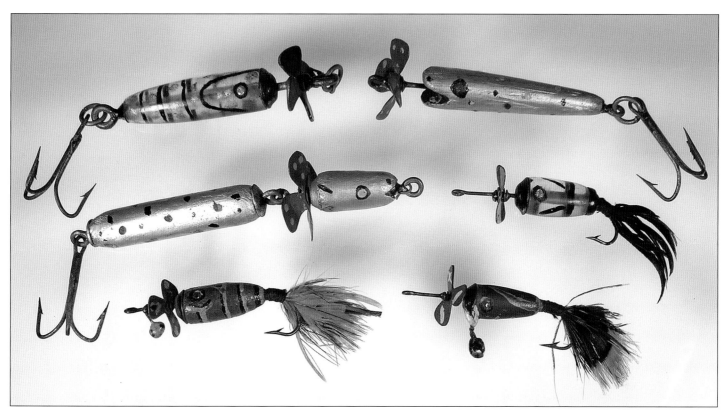

Bladed Wonders Collection – Creative and nicely made, this is an appealing group by the same maker ca. 1940s (possibly Detroit, Michigan origin). ½ dozen double, triple and quadruple bladed lures ranging in length from 1" – 4." Made of shaped and painted Lucite or carved, painted and varnished wood; gemstone or painted eyes; plain or feathered tail hooks; through body wire; hand cut and formed, paint-accented props; two with painted, drop wire (solder) weights; most feature painted metal grommet nose caps and multiple fixed/moveable bearings.

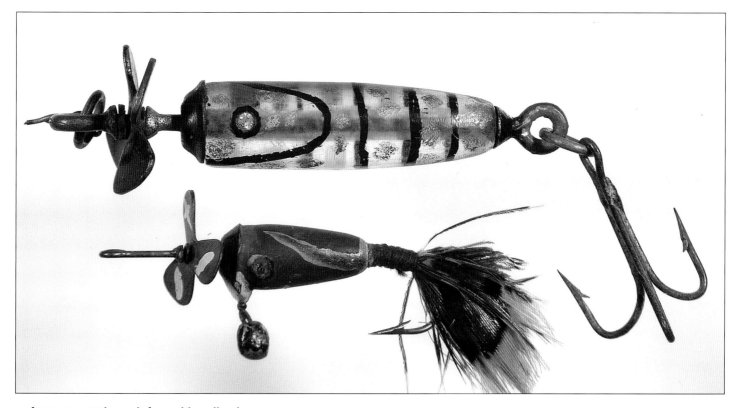

A representative pair from this collection.

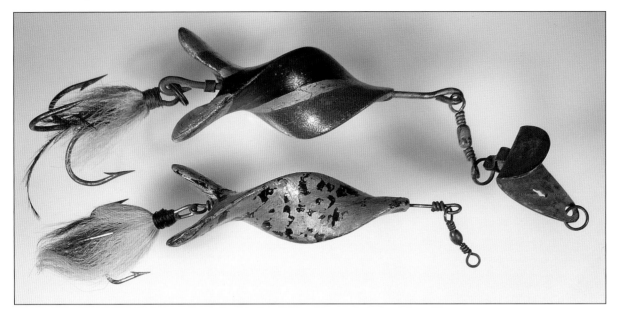

Pair of Musky Spinning Fish – Shaped, painted and varnished wood bodies ca. 1930s. Their form either at rest or in use suggests a swimming fish. These nicely fashioned and painted lures rotate around a central shaft upon retrieve. They are heavily rigged, particularly the striped example. It also features a leading, painted metal diving apparatus positioned *separately* from the lures body – a truly unusual detail. Length's are 4-3/8," 8" overall for the mottled lure, and 4," 12" overall for the striped example.

Pair of Musky Rotary Heads – 6" shaped, painted and varnished wood body's ca. 1940s–1950s found in Indiana. Wire tail hanger passes through body at belly and wraps around the belly wire hanger which in turn passes vertically through the back, is turned down flush with the body, and anchored by a heavy wire staple. On jointed model (top), line tie wire passes through the head and 2nd body segment – the wire is enlarged at the rear of this segment by a ball of solder which seats it flush with the back surface. The two through wires in the 2nd segment (which attach to the tail section) return along the face of this segment where they are turned down and set flush at the back and belly. This reinforced, heavy-duty, through body soldered wire construction technique would retain even a giant Musky without breakage.

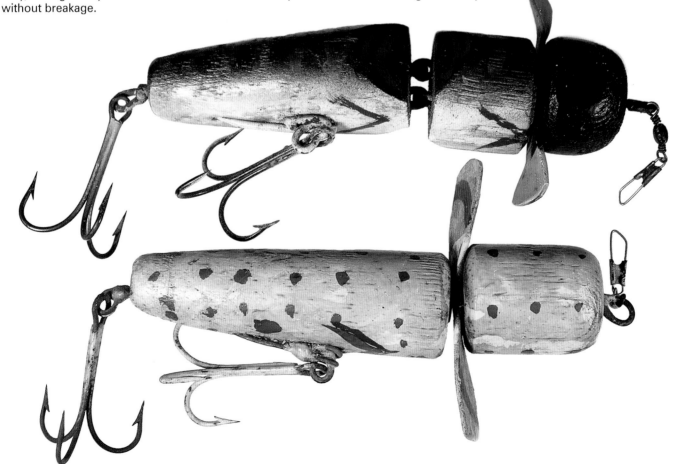

Good Things Come in Small Packages

If I were to write about the qualities that I find most compelling in any object, I would have to include words such as nobility, economy of means, power, grace, spirit, and unique vision of the artist...An element of ingeniousness is present in every piece.—Jane Katcher, *Expressions of Innocence and Eloquence – Selections from the Jane Katcher Collection of Americana.* 2006

Most readers will be familiar with hand-tied flies used to attract trout and also their much larger brethren, Bass-sized lures, Pike/Musky-sized lures, etc. Many people, though, may not be familiar with the smallish lures of around an inch or two made to be fished with a fly-rod (or later, light spinning tackle). Lures of this type were made in quantity by all major tackle makers and today are highly sought by collectors of vintage, fly-rod baits.

Fortunately for folk art lure collectors, the tiny sizes did not deter our fisherman forefathers from creating wonderful examples on their own. Nicely made ones that are imaginative are quite hard to find and make particularly interesting additions to a folk art lure collection. Amazingly, just as much creativity is possible with these teeny treasures as with the more conventional-sized lures.

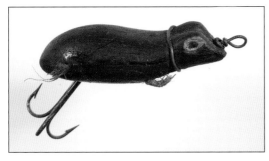

Headlock Frog – 2" carved, painted and varnished wood ca. 1940s. Relief carved eyes; remnants of inlet and glued bristle legs. Hook pivots longitudinally in a cut-out belly groove and is anchored by a horizontal, through body pin. A continuous, twisted wire forms the line tie, passes through the body, around the head and finally closes flush under the neck.

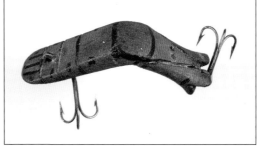

Turquoise Crawdad – 2", carved, painted and varnished wood, ca. 1950s. Recessed cut-lines. Tiny tack eyes. Internally wired line tie and belly hook hanger. Screw eye rear hanger.

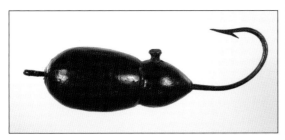

Bulbous Pork Rind Bait – 1-5/8" turned, painted and varnished wood, ca. 1920s-1930s. Embedded blued single hook. Pork rind stud (screw) mounted to rear bulb section.

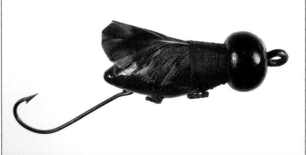

Fly Rod Winged Beetle – 1-3/4" turned, painted and varnished wood, ca.1930s. Thread wrapping secures feathered wing. Internal belly weight. Four applied cord legs inserted into the body. Fixed wire front line tie/rear hook hanger. Single black japanned hook.

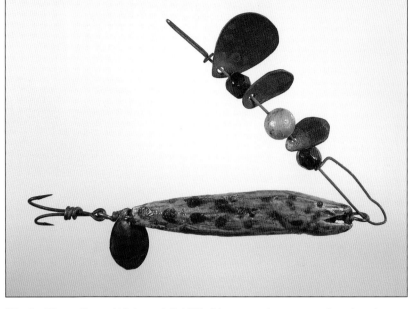

Fly Rod Surface Spinnered Minnow – 1-1/8"
turned, natural finish varnished wood,
ca. 1940s. Full wire-through hardware in both
directions. Glass bead bearings at front prop –
steel bead bearing at rear prop. Front and rear
props are hand-cut and varnished.

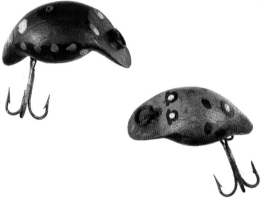

Musky Fingerling – (Alabama) 2-1/4" chip-carved, accent painted and
varnished wood ca. 1930s. Full fixed through-wire rigging. Rear double-
hook fashioned from two single hooks wired together. Includes a hand
formed wire, multi-blade and glass beaded fore-spinner and a hand-cut
and varnished rear tail spinner.

Pair Fly-Rod Tadpoles-1-3/8" carved, painted and
varnished wood, ca. 1940s. Through-wire fixed line tie
and belly hook hardware.

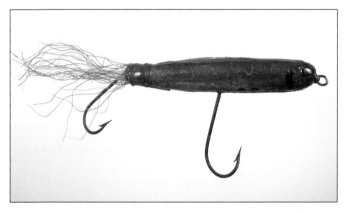

Green Darting Minnow – 2" carved, painted and varnished
wood ca. 1920s-1930s. Full fixed-wire through rigging
forming line tie and hook hangers. Rear string-tied, painted
and varnished hair tail.

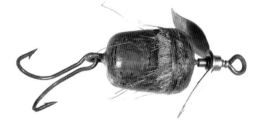

Cork Spinner – 1", formed and varnished cork body
mounted on a through-wire shaft with thrusted fore-
spinner. Remnants of tied string-wrapped bucktail
around the body.

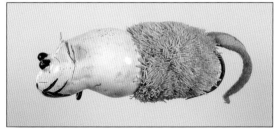

Super Mouse – 2" carved, painted and varnished
front with trimmed bucktail rear section
ca. 1930s. Single hook passes through the body
and returns under the chin forming the line tie.
Leather tail, glass pin eyes and painted, inlet
metal ears accent the mouse.

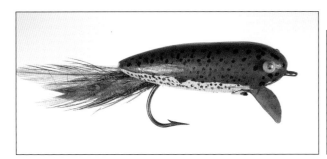

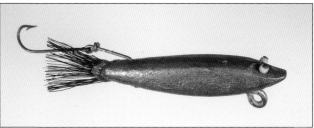

Green Feathered Diver – 1-3/4" carved, painted and varnished wood ca. 1930s. Homemade metal lip secured by nails under the chin. Teeny, painted glass bead eyes attached by nails. Single hook inset into the body with rear feathered tail inset into the same groove.

Lipless, Finned Darter – 2" carved, painted and varnished wood ca. 1930s-1940s. Teeny nail secured, glass bead eyes. Screw eye line tie. Through-body wire hook hanger returns at the belly. Rear bristle tail inlet and glued into the body.

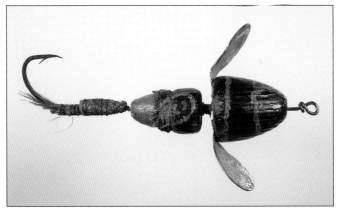

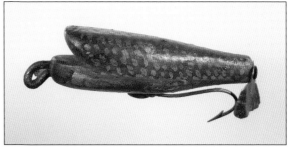

Mini Rotary-Head – 1-5/8" two-part, carved, painted and varnished wood body. Hand cut tin metal collar nail-attached to the head section. Full, loose through-wire rigged. Small grommet bearing and cut washer at joint. Served single hook is tied to through wire and (along with rear body section) shows remnants of being hand (string) tied.

Spotted "Whale" Darter – 2-1/4" hand carved, painted and varnished wood ca. 1930s–1940s. Nailed-on, hand cut and formed tail flasher. Heavy fixed through-wire line tie and belly hook hanger. Based upon how it is affixed and re-formed, belly hook follows the lower body contour.

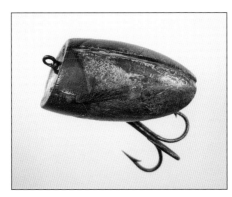

Diving "Chunk" Beetle – 1-5/8" carved, painted and varnished wood ca. 1930s. Hair (fin) accents pass through the body on each side forming "eyes" on the front face. Wire-through detail forms line tie and tail hook hanger. Upon retrieve, rear treble pivots on axis and rotates into a concave body cavity making the lure semi-weedless.

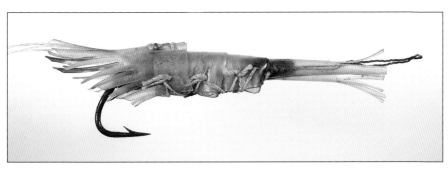

Celluloid Shrimp – 3-3/4" attractive, hand-cut formed and sewn, multi-segment celluloid body, built around a fibrous wrapped, served wire single hook ca. 1920s-1930s.

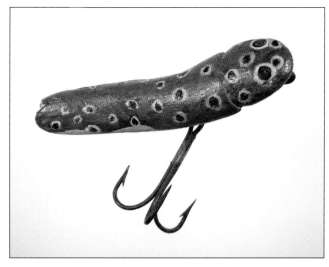

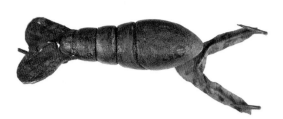

Brown Mini-Craw – 2" chip-carved, painted and varnished body ca. 1920s. Inlet, hand-cut and painted tin diving lip with through-wire line tie. Hand cut and painted tin V-frame with 2 soldered individual single hooks form the crawdad's arms and pincers.

Frog Darter – hand carved, painted and varnished wood, ca. 1920s–1930s. Screw eye hook and line tie hardware. Subtle belly and tail carving suggests legs in swimming motion.

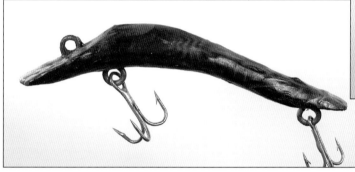

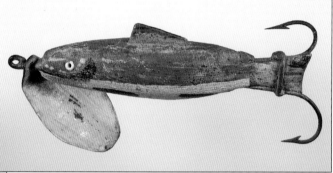

Green Spinnered Minnow – 2-7/8" hand carved, painted and varnished wood ca. 1920s. Inset glass bead eyes. Two rear single hooks wire wrapped around carved wood tail, and nail secured to the top and bottom of the minnow. Hand cut, formed and painted spinner. Internally fixed wire line tie. One hand-poured lead belly weight.

Feathered Diver – 3-1/2" varnished feathers adhered to hand carved body ca. 1930s–1940s. Through body fixed wire forms line tie and front hook hanger. Through body rear hook hanger penetrates back where it is turned down to the body.

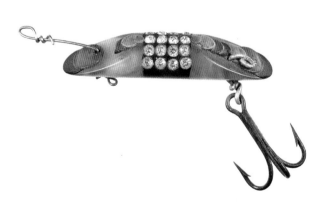

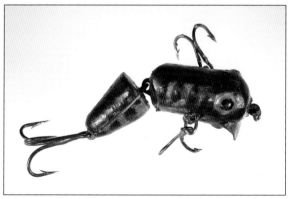

Bakelite Diver – 2-1/4" hand cut Bakelite body with paint accents ca. 1930s-1940s. Applied round Bakelite disks. Four rows of inset gemstones. Through-wire front line tie and rear hook hanger.

Mini Jointed Wiggler – 1-3/4" jointed, carved, painted and varnished wood ca. 1930s–1940s. Full internal fixed line tie, joint and hook hanger wire. Through-wire side hook rig. Hand cut and formed, painted and varnished front diving lip, nail secured. Painted metal tack eyes.

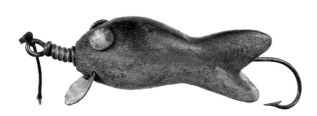

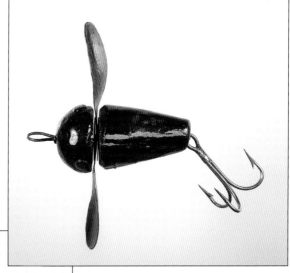

Nail-Eyed Fish Wiggler – 2" carved, painted and varnished wood ca. 1930s. Brass wire line tie passes through the body and returns at the front diving lip. Inlet diving lip is hand-cut, painted tin. Painted nail eyes. Internally secured, single tail hook.

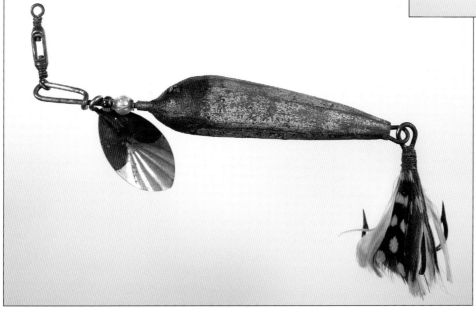

Two-Piece, Spinnered Bug – 1-1/2" turned, painted and varnished segmented wood body ca. 1930s. Full fixed through-wire line tie/rear hook hanger. Center mounted, hand-cut, formed and painted, freely revolving tin spinner. Painted tack eyes.

Chip-Carved Red & Silver Minnow – 2-1/2" painted and varnished, chip-carved wood ca. 1920s. Front brass shaft with fluted spinner and glass beads is secured by a lead belly weight, as is the rear, internally wired tail hook hanger. Teeny, inset, forward-looking glass bead eyes secured by nails.

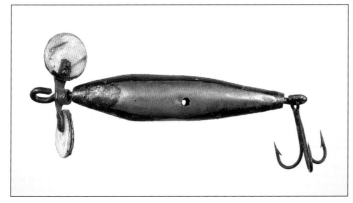

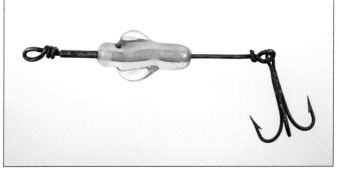

Early Aluminum Chambered Minnow – 2-1/4" hand made aluminum minnow with applied paint ca. 1900s-1910s. Through-body hole would allow water to enter, sinking the minnow. Loose, through-wire rigging forms line tie/rear hook hanger. Super hand made multi-part brass and pearl front spinner. Pearl spinner 'wings' attached via brass rivets.

Revolving Glass Minnow – 1" revolving, hand-poured glass bead mounted on a hand formed brass wire shaft ca. 1920s–1930s.

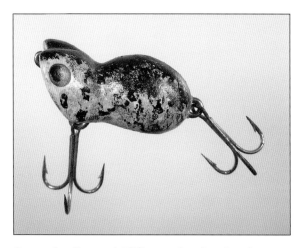

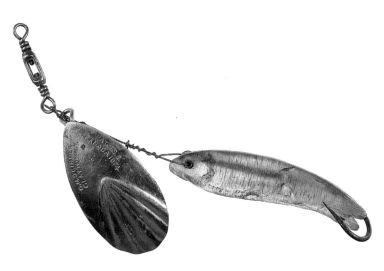

Spattering Frog – 1-5/8" carved, painted and varnished wood ca. 1940s. Painted eyes and screw-eye hardware. Gift from David Lindsay.

Carved Glass Fish Spinner – 2" hand carved and detailed glass body in the form of a fish ca. 1920s. Handmade wire leader passes through the fish in a trapeze form. Tiny grommet bearings on each side function as the fish's eyes, through which the wire trapeze passes. Wire leader has a no. 4 Skinner fluted blade attached. The aforementioned wire trapeze secures (on the concave side) the eye of a large single hook which is seated along the body and further secured by through-body string tied to the glass body down the shaft.

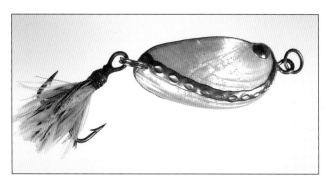

Silver Shell Spoon – 1-1/2" natural pearlescent shell with hand applied silver detailing ca. 1940s–1950s. Soldered wire line tie passes through the shell. Split ring passing through the shell retains the tied rear treble hook.

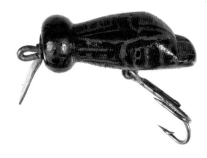

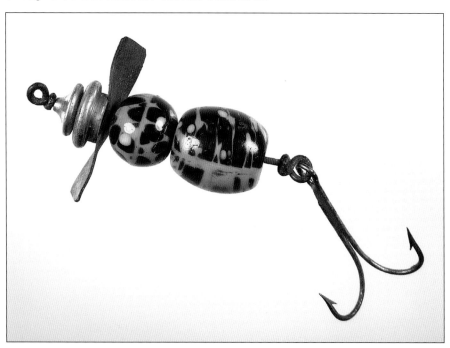

Clothespin Bug – 1-5/8" carved, painted and varnished clothespin ca. 1940s. Through-wire combination line tie/hook hanger. Re-cut, Diamond "P" Pflueger spinner diving blade attached via line tie. Paint pattern suggests maker was trying to capture a bugs natural luminescence.

Glass Bodied Bug – 1-5/8" glass bead 'bug' lure ca. 1930s-1940s. Heavy through-wire serves as line tie and tail hanger. Hand cut and formed brass spinner and 'found' turned aluminum part or fancy bead suggests a head.

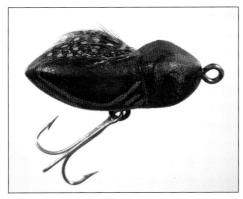

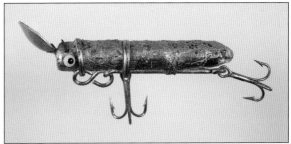

Maroon Bug – 1-7/8" hand carved, painted and varnished wood ca. 1940s. Applied feathers at back simulate wings. Painted eyes. Cup and screw hook hardware. Screw-eye line tie.

Fly Rod Spatter Bug – 1-7/8" hand-carved, painted and varnished wood with crushed glass glitter accents ca. 1940s-1950s. Reversed, cut aluminum (surface spattering) lip is inlet into the head and secured by through-body wire. Glass pin eyes. A cut-wire, hook shank connects to an S-shaped line clip which serves as the line tie. The hook shank/line clip assembly is attached to the body by two split rings (that wrap around the body) as well as line wrapping near the tail. This assembly serves to support the two small treble hooks.

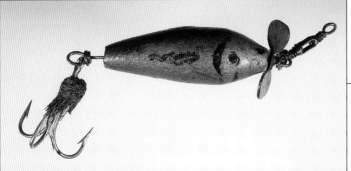

Early Spinnered Minnow – 1-3/4" shaped, painted and varnished wood ca. 1900s–1910s. Attractively painted, with tiny tack eyes. Loose brass through-wire forms line tie and rear hook hanger. Hand cut and formed aluminum prop.

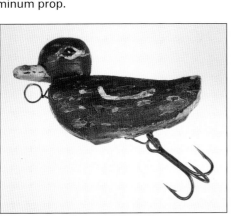

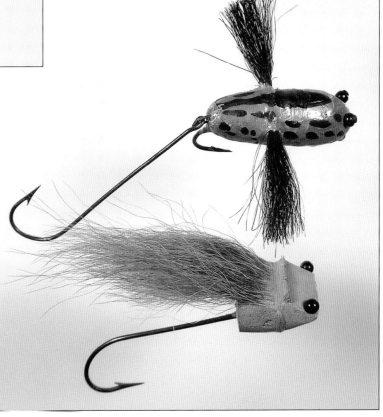

Teeny Weeny Duckling – Measures only 2" from tip of beak to tip of the tail ca. 1940s–1950s. Hand carved, painted and varnished wood. Head tilted left. Fine, fixed, twisted through-wire forms line tie and belly hook hanger. Two partially recessed, lead balance weights in belly are possibly fashioned from cut nails.

Bass Bug Lure Pair, ca. 1930s – Top: Chip-carved, painted and varnished 1-1/2" winged bug with nail-secured, glass bead eyes. Hair wings and the primary single hook are inlet into the body. A large, trailing stinger hook is attached via an embedded wire (which may be wrapped around the shank of the primary hook).
Bottom: This mustard colored bug has a dyed hair tail secured in a grooved channel at the top of lures head by hand-wound line. Glass pin eyes – the large, "blued" single hook who's eye forms the line tie, is inlet into the belly.

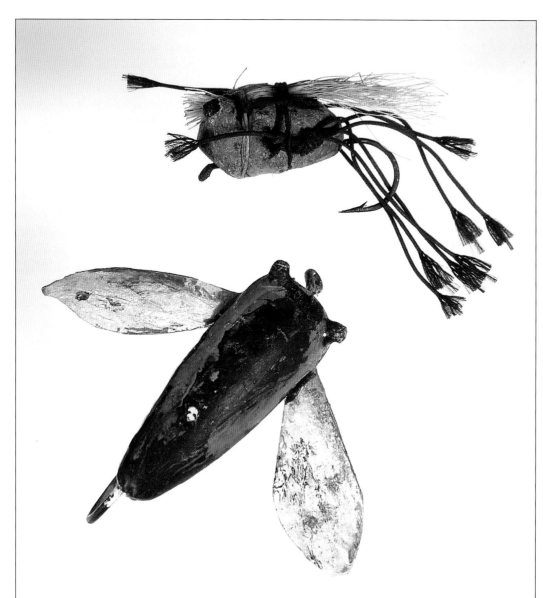

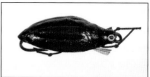

Fly Rod, "Floss" Beetle Lure – 1" hand carved, painted and varnished wood ca. 1950s. Reportedly made by a dentist, dyed dental floss is used for the legs. Tiny feather pieces inserted in the belly protrude near the head. Single belly hook is inlet into the body of the lure.

Hopper & Locust Pair, ca. 1930s – Top: Painted, hand carved cork body. Bucktail secured by thread and braided line wrapping. Painted eyes – inlet primary hook. Legs are suggested by creative wrapping, tying and placement of braided line. Bottom: 1-3/4" hand-carved, painted and varnished Locust with cut and shellacked cellophane wings; tack-secured glass bead eyes. Inlet primary hook. How can a maker spend this kind of time and risk total destruction of his creation as soon as he gets the first strike?

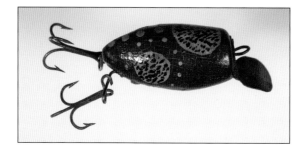

Folksy Spotted Bug – 1-3/8" carved, painted and varnished body ca. 1940s. Hand cut, formed and varnished metal diving lip secured at the head by 3 tacks. A single formed through body wire forms the line tie and both "clip-typed" rear hook hangers.

Folk Artists

Tell me whether the painting is good and I will not care who the painter is. — Maxim Karolik

Since by far the majority of folk art is anonymous, if the maker is known and can be documented, heightened interest often occurs which can enhance value, especially in the eyes of certain collectors who focus on collecting folk art from 'named' makers. This type of collecting is especially popular among duck and fish decoy collectors; with equivalent objects, the item crafted by a known maker may command a higher selling price.

One of the most revered 20th century American folk art lure makers is Bud Stewart (now deceased).

His early 1930s style fish decoys typically command $1,000 or more, however, many of his under-appreciated, highly unique, hand-crafted and superbly painted lures (also made by Stewart in the '30s) remain affordable. With free-flowing organic forms and his signature paint schemes, they can sometimes be acquired for less than another good folk art piece created by an unknown maker during the same period.

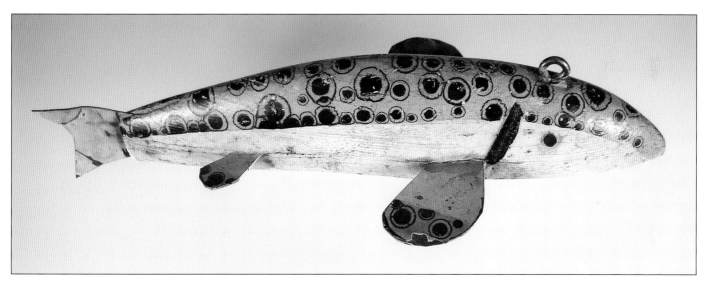

Early, ca. 1930s fish decoy by famed Michigan folk artist Bud Stewart.[1]

If faced with a choice between two comparably priced folk art lure pieces (one from an unknown maker, the other from a known maker), I will let my eyes decide and select the one whose overall visual appeal excites me the most given its form, paint and surface finish qualities. Of course, a provenance may be far richer than simply an awareness of the makers name. Collecting lures hand made by colorful characters with interesting life stories adds instant appeal.

Unlike manufactured lures, the history of individual folk art lures is usually long-lost to time. While wondering about or imagining a lures history is an intangible benefit of collecting folk art, whenever the who, when and where questions can be satisfied, one can draw even closer to the prize.

Bud Stewart (1912-1998)[2]

Inarguably one of Americas finest 20th century folk artists, Elman Garfield (Bud) Stewart was born February 3, 1912 in Vancouver, British Columbia. His family relocated to Flint, Michigan, when he was a young boy. Even as a kid Bud loved fishing. He carved lures for his own use as a teenager – they worked marvelously. By his later teens, he began carving fish-catching lures for others. Throughout the 1930s, he conceived, carved and painted an amazing variety of hand-made lures and fish decoys, many sporting his unique and appealing, signature' spotted paint finish. Collector interest in Buds early folk art pieces is high.

In 1940, in response to increasing demand, Stewart leased a building; for the next forty years he produced and marketed memorable lures and fish decoys – always a small operation, while he had assistance at some stages of production, Stewart himself continued to paint each and every lure and fish decoy sold. It was in the early 1940s that Stewart (also a trapper) conceived and began taking special orders for his amazing carved Musky Duck and Muskrat lures. See pages 193 and 194.

Subsequent to his wife's retirement in 1980, Stewart scaled down his operations and returned to his greatest love, fishing. However, after an exhibition of his work in the early 1980s, collector-demand skyrocketed, leading Stewart to create additional hand crafted treasures for the collector market. Pieces from his later years are always in high demand due to their variety, unique form, amazing paint and superior finish.

Stewart was inducted into the Fresh Water Fishing Hall of Fame in 1984, was honored in the winter of 1986 by the Smithsonian Institute and received Michigan's Heritage Award in 1987. A life-long fisherman and outdoor sportsman, Stewart passed away in 1998. To learn more about Bud Stewart and his work, see Baron and Carver's book.

[1] Published in the books *Bud Stewart – Michigan's Legendary Lure Maker*, by Frank R. Baron and Raymond L. Carver, 1990, page 44 and *Coykendall's Complete Guide to Sporting Collectibles* by Ralf Coykendall, Jr., 1996, page 282.

[2] *Bud Stewart – Michigan's Legendary Lure Maker*, by Frank R. Baron and Raymond L. Carver, 1990.

Bud Stewart fishing from his dock with a large, triple-jointed snake lure he crafted by hand. See a similar snake by Bud Stewart on page 195. *Photo courtesy of Frank Baron and Ray Carver*

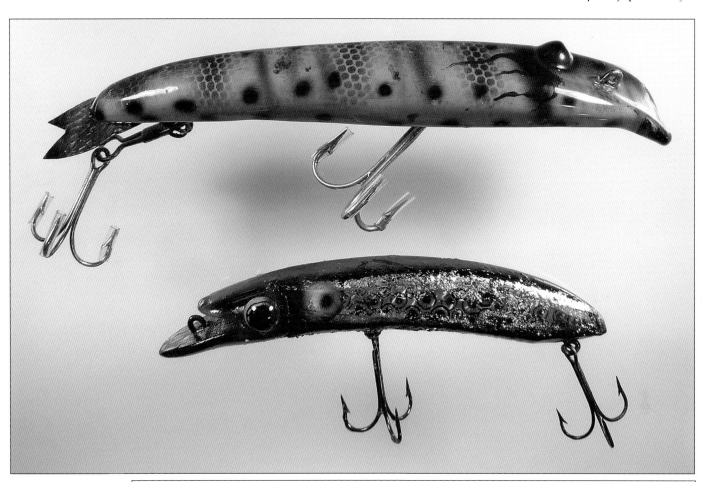

Bud Stewart Crippled Wiggler Pair – Top: 7-1/2" bloody-eyed Musky. Carved, painted and varnished wood. Painted dome tack eyes. Reinforced tail hook hanger. Cut metal tail. Bottom: 6" carved, painted and varnished wood. Signed by the maker. Painted dome tack eyes. Applied decals and glitter.

Bud Stewart Pair 2 – Pair of rare (injured) minnow variations, each with offset/eccentric line ties. Both of carved, painted and varnished wood. Top: 4-1/2" painted dome tack eyes. Integral belly weights. Attached spinner. Bottom: 5" with similar construction and detailing as above.

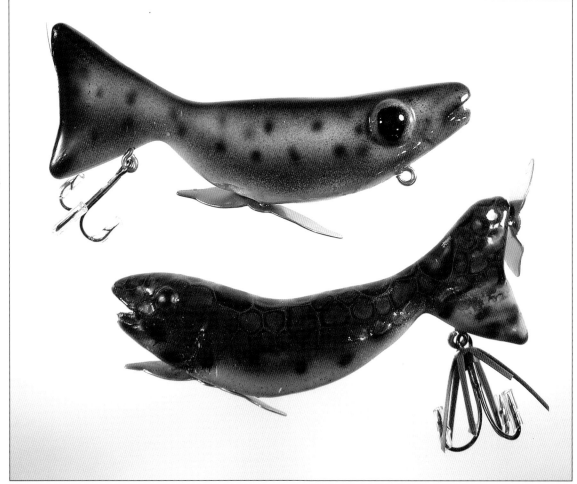

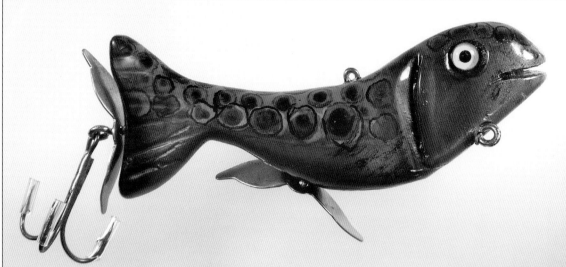

Bud Stewart Cheater Fish Decoy/Lure – 4-3/4" carved, painted and varnished wood. Signed by the maker. Glass eyes. Cut-Gills, two attached spinners. Double line ties-one for use as a fish decoy, the other, eccentrically set to fish the lure as an injured minnow. Integral belly weights.

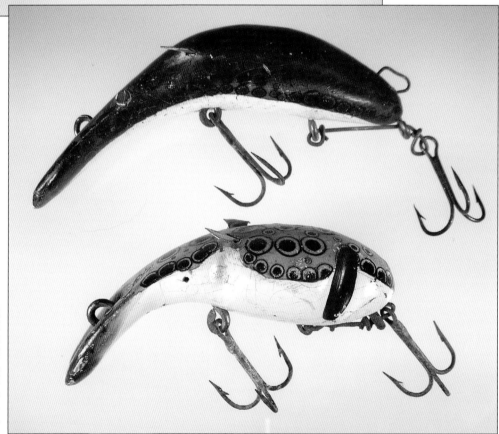

Pair Bud Stewart 1930s Crippled Wigglers – carved, painted and varnished wood. Each with Stewart's early signature spotted paint. Top: 4" painted tack eyes. Inlet metal 'ears'. Reinforced tail hardware. Pork rind clip at tail. Bottom: 3-1/4" inlet metal ears. Reinforced tail hardware.

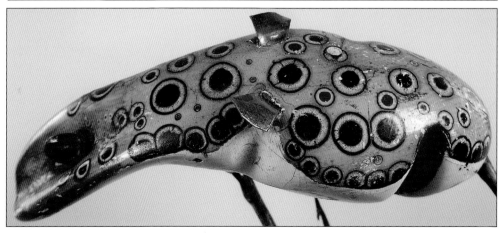

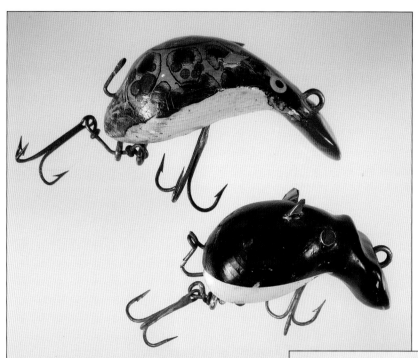

Pair Bud Stewart 1930s Pot Hole Mice – both of carved, painted and varnished wood. Top: 2-1/2", painted eyes, inlet metal ears, reinforced tail hardware, pork rind clip at tail. Deeply recessed belly hook hardware.
Bottom: 1-7/8" nails for eyes. Inlet metal ears. Reinforced tail hardware. Pork rind clip at tail. Deeply recessed belly hook. Belly weight. A painted number "3" appears on the belly.

Bud Stewart Musky Duck – 5" carved, painted and varnished wood ca. 1940s. 2-piece construction. Painted tack eyes. Reinforced belly treble hooks. Dual front spinner/line-tie combination. Pair of single weedless rear hooks.

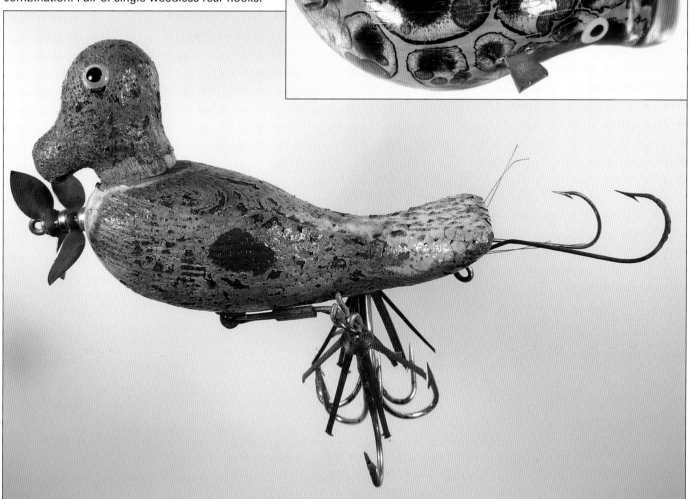

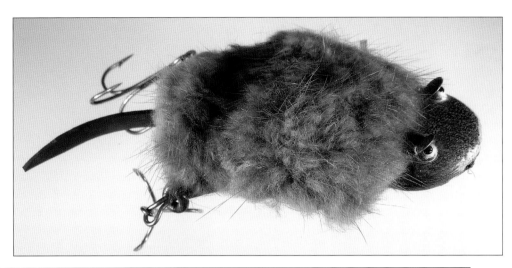

Bud Stewart Musky Muskrat –
4"x2-1/2" carved, painted and
varnished wood ca. 1940s – body
is covered with muskrat fur. Cut
rubber tail is inlet into the body.
Cup rig reinforced rear treble
hooks. Painted nail and domed
washer eyes. Inlet, cut metal
eyebrows.

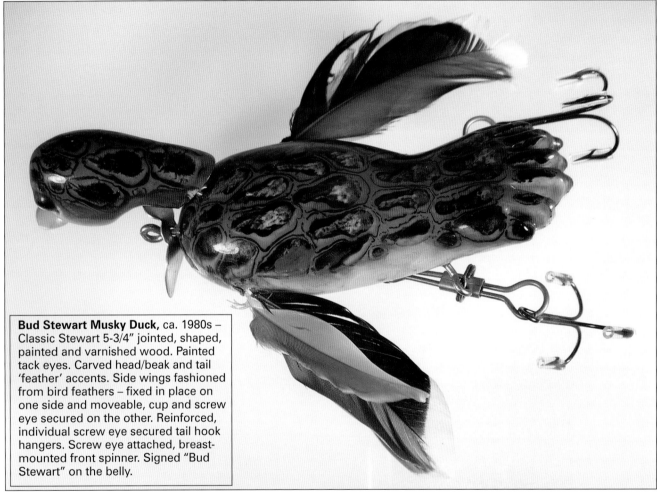

Bud Stewart Musky Duck, ca. 1980s –
Classic Stewart 5-3/4" jointed, shaped,
painted and varnished wood. Painted
tack eyes. Carved head/beak and tail
'feather' accents. Side wings fashioned
from bird feathers – fixed in place on
one side and moveable, cup and screw
eye secured on the other. Reinforced,
individual screw eye secured tail hook
hangers. Screw eye attached, breast-
mounted front spinner. Signed "Bud
Stewart" on the belly.

Quadruple-jointed Snake, 5-3/4" (8-1/2" overall) – crafted and signed by Bud
Stewart. Pin attached, inlet rubber tail, glass eyes and painted, formed metal
diving lip attached via shallow cups and screws. Stewart's remarkable painting
skills and signature spotted paint scheme highlight this great piece.

Burt Errett (1889-1952)

Burt Errett of Bellefontaine (Logan County), OH was one colorful character. Thanks to a threesome of Ohioans - Mark Donnan, a cabinetmaker and woodworker (who handled Errett's daughter's estate after her passing), and the father-son team of John and Jason Kleiber (long time members of the *National Fishing Lure Collectors Club*), the amazing legacy of prominent Ohio folk artist Burton M. ("Burt") Errett has not been lost to the ravages of time.

Born in 1889, Errett, a railroad fireman who started with Big Four Railroad in 1911, died in 1952 of a massive heart-attack at the train yard shortly before his retirement. Between birth and death however, one might say Errett truly <u>lived</u>. Often seen with a pipe, Burt, a true mans man and well known local outdoorsman, was the consummate inventor-tinkerer-craftsman. He was also a lifelong fresh and saltwater fisherman, hunter, traveler, artist, musician, marksman, noted gun collector, ball-player and 32nd degree Master Mason in the Masonic fraternity.

Errett, who led a vibrant life for the time, went on the lamb around 1910 traveling west and supporting himself by prospecting, day-hand ranching and selling his artwork. Some examples still survive, cowboys and Indians serving as his favored subject matter. So interesting were the letters he wrote while a young renegade that local school plays were written around them. How interesting could the letters be you ask? Heres a taste – a (partial) transcript of a letter Burt wrote to "Nell" (Nellie, his wife) on July 1st, 1911 from Los Angeles, California:

Dear Nell,

I thought I would write you a few lines and tell you just how things are out here. But remember girlie Don't Think for a minute you can wrangle or round me up for I'm merely a renigade (sic) – I have a very bright prospect in front of me, and if you will give me your word of honor that you will (Cut Out) that dam'd (sic) hen pecking & crossness (sic)…

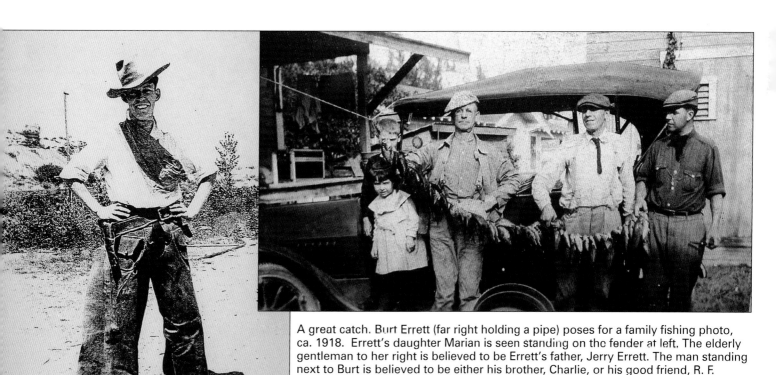

A great catch. Burt Errett (far right holding a pipe) poses for a family fishing photo, ca. 1918. Errett's daughter Marian is seen standing on the fender at left. The elderly gentleman to her right is believed to be Errett's father, Jerry Errett. The man standing next to Burt is believed to be either his brother, Charlie, or his good friend, R. F. Tremain, a local insurance agent. Notice the large tackle box seen on the porch to the left-rear. This exact box, hand-crafted by Mr. Errett, is illustrated on page 224.

Cowboy Burt in his early, renegade days

...I have made a better man out of myself that's all...I have been on a big Cattle Ranch for the past month – it was about as big as the State of Rhode Island. They had about twenty-two cow-punchers every meal. I...rode Bronks, drove cattle, Rangled them, and learned to rope. It was a fine experience and I gained about ten or fifteen pounds, had lots of good fishing & killed a Jack-Rabbit with a Beer Bottle. Duck, Grouse, Snakes, Blue-Winged Teal, Spike Tails, Prairie Chicken, Coyotes, Wolves, Deer & Bear are as thick as flies here in some places – I am making a business of Prospecting and Drawing & if you will <u>swear</u> you'll change your ways, I'll eat Christmas turkey with you all. Don't try to follow or trace me kid for I swear I never would come back by any means, only on my own free will – So just have patience and be good & nice & I...

Once, while fishing in Florida, the Kingfish he was battling was taken by a large shark. The next day he went shark fishing and landed a 12'-7" Hammerhead with his Kingfish inside! Later, in 1950, two years before his passing, he landed a trophy trout in Ohio's Mad River that was publicized widely.

Truly an inventive genius, Burt made everything from found objects; nothing was off limits. Burt used tableware, old hotel keys, dog-licenses, door hinges, bottle openers, file clasps, guitar pics, walnuts, arrow-heads, spark plug caps, brushes and more to make his creations. With seemingly limitless ingenuity evident in his own original lure designs, he nevertheless readily copied, altered, enhanced or improved on those by others. He was adept at working with various metals, wood, leather and glass. Errett used very heavy thick coats of marine grade varnish to protect his lures and floats (bobbers); over time, the varnish has aged to a still-shiny, yellowish-brown.

Errett left behind a mind-boggling array of goods: from cartoon-faced bass bugs to baseball- bat-shaped floats to superbly constructed tackle-boxes. Many examples of his work appear scattered throughout this book. Though Errett has become better known, further biographical research and documentation of his fishing-tackle treasures is warranted.

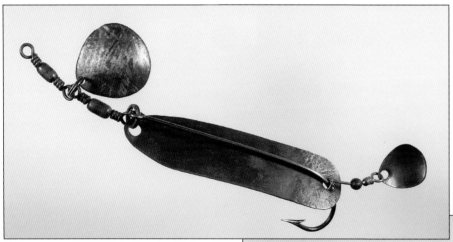

Brass Spinnered Spoon – Hand cut and formed brass spoon with a full length hook attached. This example includes an etched, hand-cut and formed front spinner coupled with a handmade, swivel-mounted rear drop spinner.

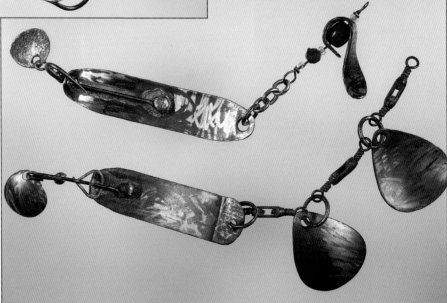

Pair, Hand-Made Burt Errett Spinnered Spoons – ca. 1930s. Top: Hand cut, formed, scratch-detailed and varnished patterned brass. Figure–4 type front spinner and steel body. Glass bead attractors. Screw/rivet attached hooks with homemade drop spinner assembly at tail. Bottom: Hand cut, hammered, formed, scratched and varnished copper body and blades. Screw/rivet attached hook with homemade drop spinner assembly at tail.

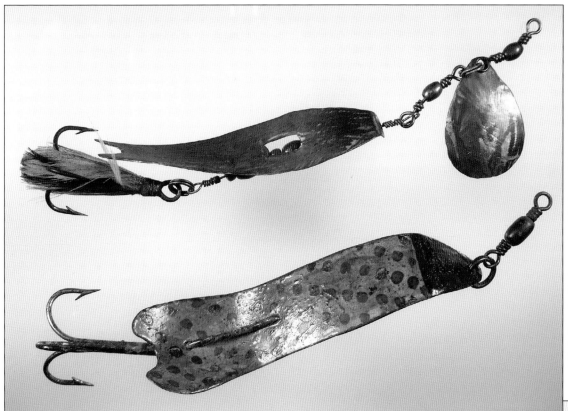

Cut-Out Spinner and Spotted Spoon by Burt Errett, – Ohio, ca. 1930s. Top: 3" hand-cut, formed, scored/scratch-effect, fish-shaped blade with cutout, revolves around a twisted wire, 10-beaded shaft. Feathered rear treble and hand applied scored/scratched fore-spinner completes the rig. Bottom: hand-cut formed, painted and varnished fish-shaped metal spoon. A fixed-mounted, painted factory snap penetrates the spoon's belly and secures the rear treble hook.

Red-Eyed Crawdad by Burt Errett, Ohio – ca. 1930s. 1-3/4" vintage, two-piece metal container (body) encompassing a single hook is pinned closed and painted after feathers at the back (representing claws) are cinched tight between the parts. Two solid red glass bead eyes and additional feathers are hand tied to the hook. A heart-shaped, cupped fore-spinner completes the rig.

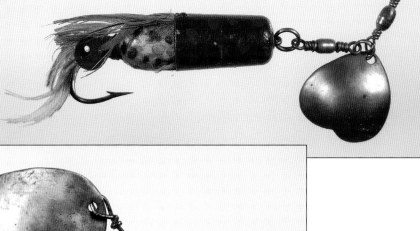

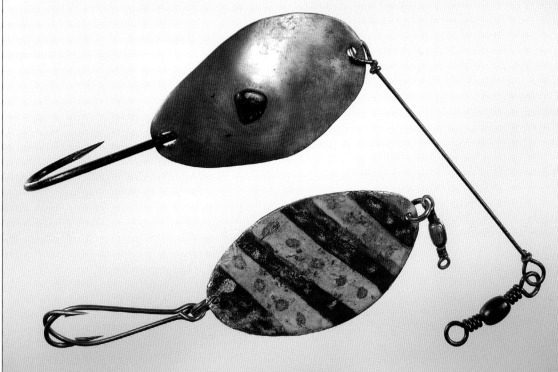

Pair Hand Hammered Spoons by Burt Errett, Ohio – ca. 1930s. Top: 2-3/8" hand-cut and hammered copper spoon with integral twisted wire handmade leader. Black japanned hook is screw and rivet attached. Bottom: 2-1/2" hand-cut and formed paint decorated spoon with glitter accents. Opposing rear single hooks render the spoon near weedless.

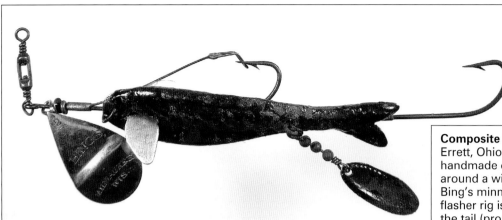

Composite Minnow Harness Rig by Burt Errett, Ohio – ca. 1910s–1920s. 3-1/4" handmade composite minnow formed around a wire frame is fitted to a weedless Bing's minnow harness rig. Hand cut drop flasher rig is wired through the minnow near the tail (properly positioning the rear of the minnow). A spinner's clevis passes through the minnow's eye, securing the front of the minnow to the rig. Separate, through-body aluminum phantom type wings pass through the minnow's head area.

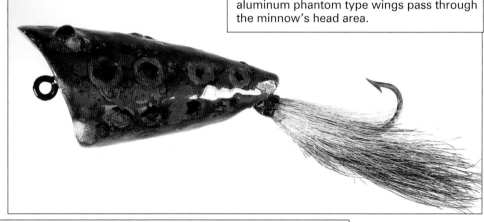

Frog Chunker by Burt Errett, Ohio – 2-3/4" carved, painted and heavily varnished wood ca. 1920s–1930s. Glass pin eyes, painted. Hand-tied, rear single hook is recessed into a body slot where it pivots around a through-body pin passing from the belly to the back. Line tie wire passes through the back and is fixed by a steel tack.

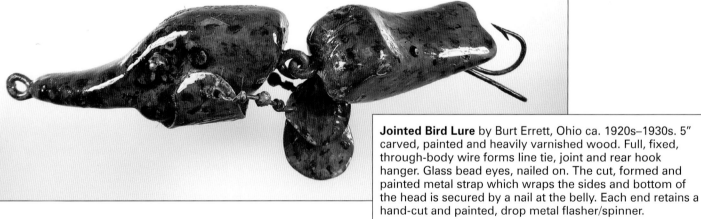

Jointed Bird Lure by Burt Errett, Ohio ca. 1920s–1930s. 5" carved, painted and heavily varnished wood. Full, fixed, through-body wire forms line tie, joint and rear hook hanger. Glass bead eyes, nailed on. The cut, formed and painted metal strap which wraps the sides and bottom of the head is secured by a nail at the belly. Each end retains a hand-cut and painted, drop metal flasher/spinner.

Bearded Chunk Bait by Burt Errett, Ohio – 1-3/4" chip-carved, painted and heavily varnished cork body with attached muskrat fur on the sides and belly ca. 1920s. Full, fixed wire-through construction. Hand-tied, feathered rear treble hook has a hand cut and formed copper flasher (painted on verso) attached near the hook eye.

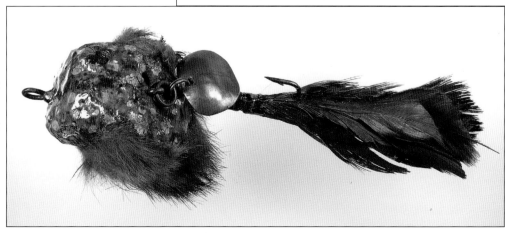

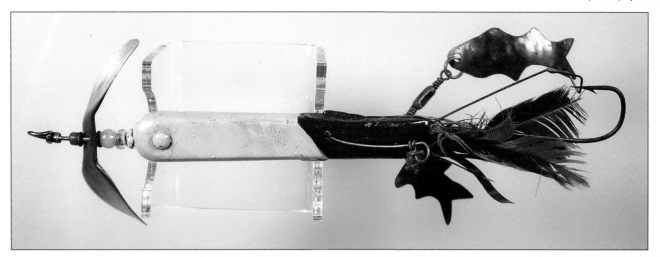

Fish Flasher by Burt Errett, Ohio – 3-1/8" hand formed and painted aluminum body ca. 1920–1930s. Painted rivet eyes. Large, hand-cut and formed copper front spinner is mounted to full, through-body fixed wire. Glass and metal bearings and beads at the front prop. Through-body wire side hangers hold hand-cut, formed and hammered brass, fish-shaped flashers. Pin-secured, soldered, twisted wire rig wraps around the rear weedless hooks shank to hold it in a fixed, weedless position. The hook itself is inserted into the tail and fixed into position by a belly rivet.

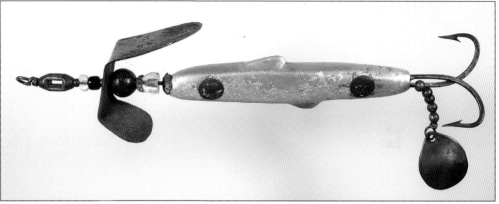

Aluminum Minnow by Burt Errett, Ohio – 2-3/4" carved and drilled aluminum minnow ca. 1920s. Copper rivets/washers at the front and rear secure the through-wire line tie, rear single hooks and a hand-cut and hammered drop flasher at tail. Eccentric, formed and hand-hammered large tin front prop with several colored and fancy glass and metal bearings.

Carved Cork Frog by Burt Errett, Ohio – 1-1/4" carved cork frog with inlet, hand-tied and paint decorated bristle legs ca. 1930s. Full, through-body twisted wire attached to eye of integral, embedded Bing's weedless hook subsequently passing through the body and terminating with a hand-cut, tin tail flasher. Front, hand-cut, formed aluminum spinner assembly with both glass bead and metal bearings is clipped to hook eye line tie. Eyes are nails passed through small hex-nuts and painted.

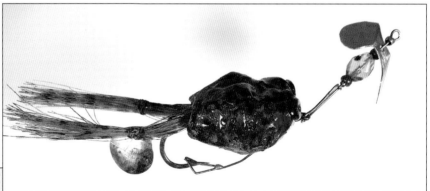

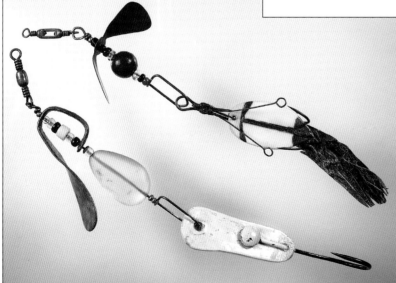

Incredible Spinner Pair by Burt Errett, Ohio, ca. 1920s-1930s – Top: handmade, twisted wire glass and metal beaded shaft with large handmade brass spinner blade and large, round painted red lead weight is clipped to a modified, ca. 1890s Mack hook. Attached to the Mack hook is a cut and paint decorated leather pork rind and a (painted and glued) wood strip decorated guitar pic. Both pork rind and guitar pic are clipped to an added, small single hook soldered to the top of the Mack hook. Bottom: Handmade, twisted-wire glass and metal beaded shaft with large, figure-4 type, paint decorated and varnished front spinner and a large 'flattish' translucent, oval shaped, carved glass bead. This assembly is clipped to a hand-formed and painted 2-1/4" aluminum 'body' with a large, single black-japanned hook riveted to it.

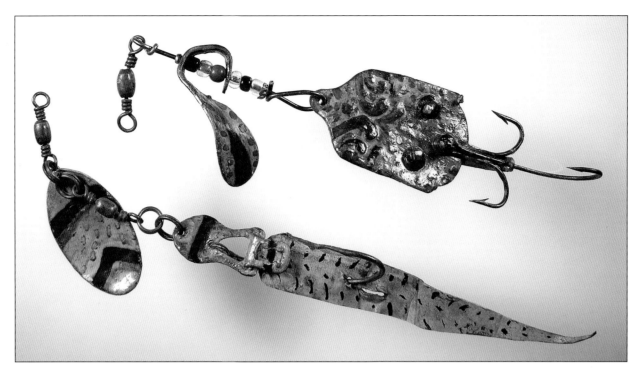

Amazing Metal Pair by Burt Errett, Ohio. ca. 1920s–1930s – Top: 1-7/8" re-formed, painted and varnished body made from an antique, fancy embossed spoon or ladle. Riveted copper pork rind studs/decoration. Rear 3 single hooks are attached via a handmade, cut metal strap and through-body rivet. Glass and metal beaded hand-made, twisted wire leader holds a large, paint decorated figure-4 type spinner made from the end of an ordinary spoon. Bottom: unique vintage metal suspender clip snap (which secures a long, paint decorated pork rind strip), is run through a hand-cut, painted and varnished "body." To the inside throat, a single hook is attached - it's end passes through the leather rind. Hand-cut and hammered front spinner assembly is paint decorated on both sides.

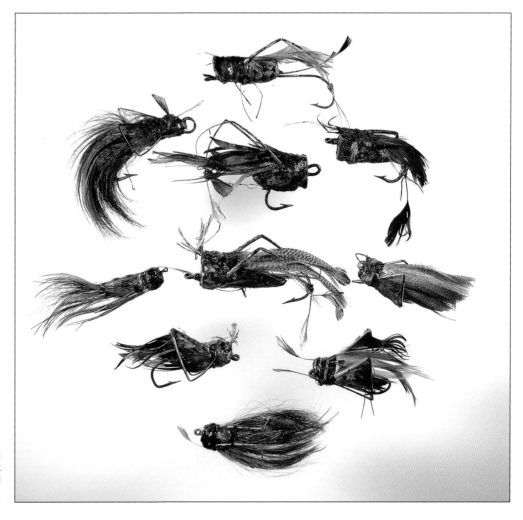

Errett was proficient at fly tying as well; here are ten great **folk art grasshoppers** he crafted ca. 1920s-1930s.

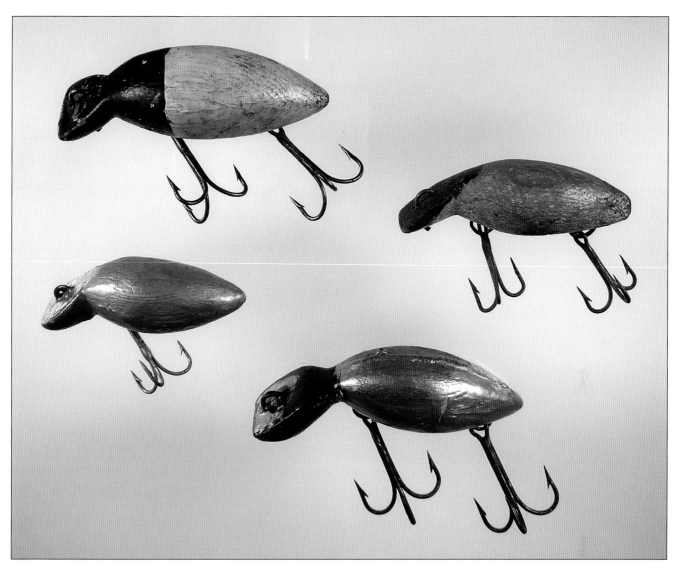

Wiggler Quartet – carved, painted and varnished wood ca. 1930s–1940s. Made by Sherill Denton of Sallisaw, Oklahoma, a shoe cobbler. Internally wired line tie and hook hangers. Called "Brushy – Mountain Wigglers," these lures were fished in Brushy and Sallisaw Creeks.

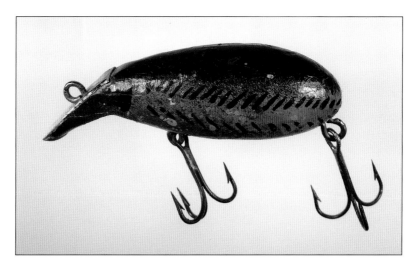

Ohio Wiggler – 3-1/8" carved, painted and varnished wood, ca. 1920s. Noted Ohio folk art collector Bob Vermillion has identified this lure as being made by Ray Clippenger of Alliance, Ohio. Recessed aluminum face plate.

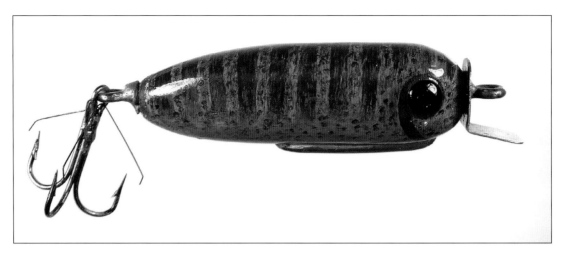

Ray Newell Colorful Shallow Diver – 3-1/2" shaped, painted and varnished wood, ca. 1930s. Newell was from Kenosha, Wisconsin. Heavy fixed through-wire line tie and rear hook hanger. Small L-shaped diving lip soldered to the line tie; rear tail hook hanger soldered closed. Hand made, rear weedless treble hook. Painted, dome-top tack eyes. Aluminum nail at belly used as a keel.

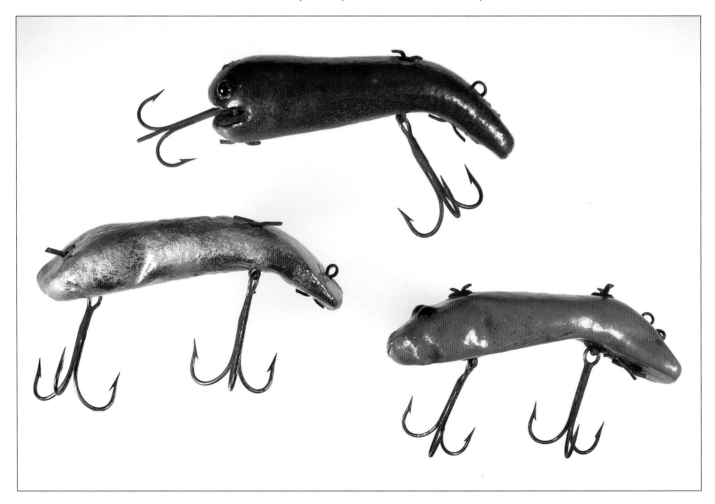

Ceramic Wigglers – Noted lure collector Dick Streater advises that these lures were crafted by George D. Horst, a sheet metal worker from Seattle, Washington, ca. 1930s. Each approximately 3-1/4" and made of formed, painted and varnished ceramic. Each employs through-body cotter-pin line ties and hook hangers. Mustard model has two line tie options. It also has brass cups top and bottom where the cotter pins enter and exit the body; also has painted, varnished, dome-tack metal eyes.

Crafted by George Osterhoudt Sr., Carthage, New York, ca. 1930s-1940s. Of the ten lures obtained by Walt Blue in November, 2004, at an auction of the maker's grandson's estate in Zepherhill, Florida, four are illustrated here:

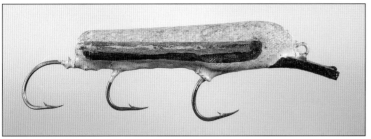

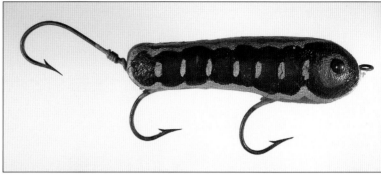

Bright, Striped lure – 2-3/4" carved, painted and varnished cork with inset, wired group of 3 single hooks. Wire-through hardware.

Pink-eyed Corker – 2-1/2" carved cork with pink glass eyes – same construction details.

Curved Cork pair – Top: 4-1/4" curved-bodied frog spot with glass pin eyes and 4-hook, single wire gang – this time reinforced with staples at the body where the hook passes through. Bottom: 3-3/4" carved, curved cork body with thickened head; same typical construction details as top lure.

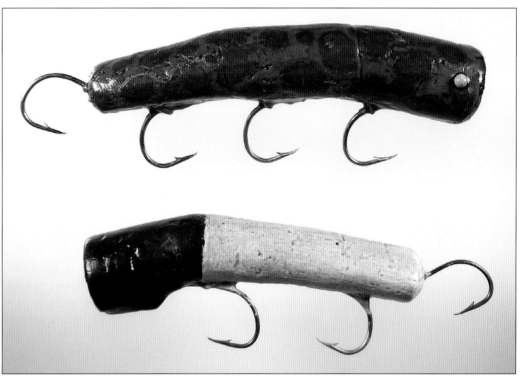

Master-Bait (Wisconsin) crafted by Pop Dean – 10" carved, double-jointed, painted and varnished wood ca. 1950s. Inset glass eyes. Full, heavy through-body wire passed through body slots. The 'widened' ends are punched to receive nail hinges at the joints.

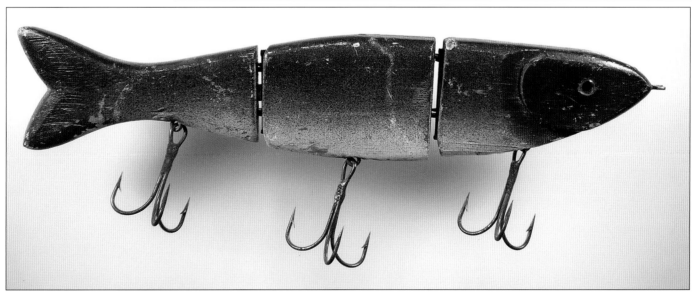

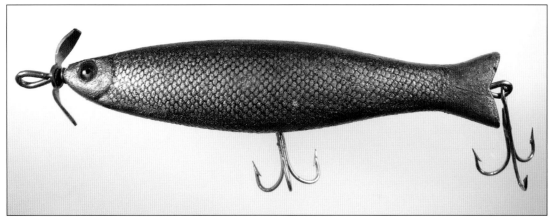

Injured Golden Shiner – 4-5/8" carved, painted and varnished wood with gill, tail bone and textured scale accents ca. 1920s–1930s. Made by Dr. Dale C. Beatty, an Osteopathic physician from St. Petersburg, Florida. Inset glass eyes. Shaved-down, marked Heddon prop. Heddon L-Rig belly hook hanger. Note: Dr.. Beatty also made the grand mahogany tackle box seen on page 229.

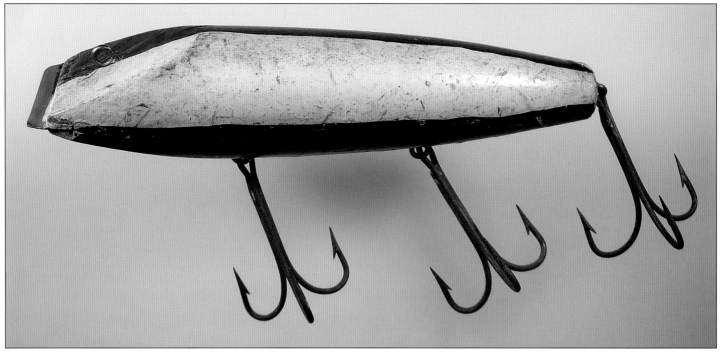

Simple alternating monolithic areas of black and white paint are the only adornment on this 6-1/2" cut-faced, Musky diving plug by famed Michigan guide Butch Schram ca. 1940s. Screw eye hardware all around. A barely protruding horizontally mounted inlet diving 'lip' protects the face. Butch, who hailed from the Lake St. Clair area, also carved waterfowl decoys; they too are highly collectible.

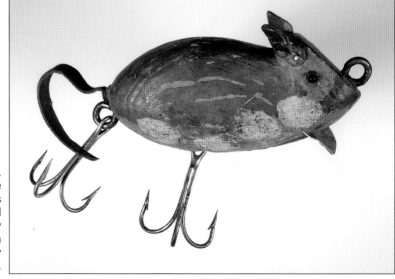

Gray Spotted Mouse – 2-3/4" chip-carved, painted and varnished wood, ca. 1930s. Made by Nick Beckus of Goodhue, Minnesota. This appealing lure features pin secured, pinched and painted leather ears, glass pin eyes, interior belly weight, an inlet, sheet tin diving lip and a pin secured leather tail. Recessed screw eye at belly prevents hook drags.

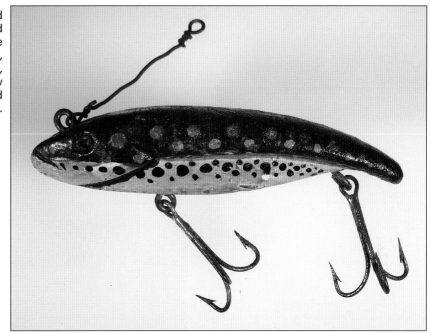

Pouty Droop-Tail – Great form, personality and paint are evident in this 4" carved, painted and varnished lure made by Leslie Blake from the Adirondack area of New York, ca. 1930s. Carved, eyes, mouth and gills with highly unique, decorated, cut-back body detail. Brass screw eye line tie and hook hangers. Integral twisted wire leader attached to line tie.

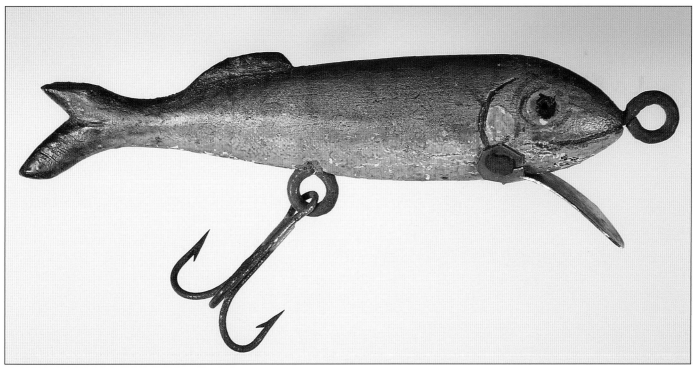

Diving Minnow by Tom Schroeder, Detroit, Michigan, (b.1885 – d.1979), ca. 1930s – Hand carved, painted and varnished, fish-shaped wood body. Tack applied, hand cut and formed aluminum diving lip. Screw eye line tie and belly hook hanger. According to Brad and Scott Kimball in their Book *The Fish Decoy* (volumes I and II), many consider Schroeder to be Michigan's finest duck decoy carver. The Kimball's reported he also made a dozen quality fish decoys. They stated his typical work was "very delicate and exquisite in detail." The overall appearance, quality and subtlety of paint and carving on this rare Schroeder fishing lure, certainly attest to his skills as an artist. Reportedly, one of three known Schroeder lures. Provenance – Former collections of Robert Burger and Tony Laws.

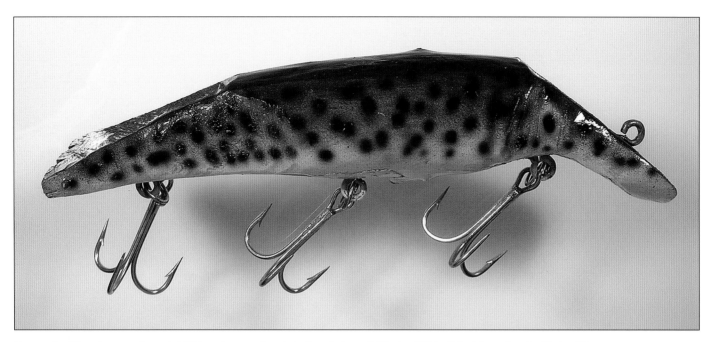

Homer Le Blanc's experimental 9" hand-carved, painted and signed **"Swim Whizz"** fashioned out of Lake St. Claire, Michigan driftwood, ca. 1939. Famed Musky guide and author Homer Le Blanc guided on Lake St. Clair, Michigan for over 50 years. In the late 1950s Le Blanc was "the highest paid guide in the world." Previously from the Steve Lumpkin collection, Lumpkin purchased this early "Trout" pattern example directly from Le Blanc at a Michigan lure show in 1988.

Le Blanc revolutionized Musky trolling techniques and, at age 84, was inducted into the National Freshwater Fishing Hall of Fame. His ever-popular Swim Whizz was *beyond classic* to generations of Musky fisherman. In addition to designing and manufacturing several lures, Le Blanc always considered himself an artist, producing a few paintings and creating a detailed fishing map of Lake St. Clair. Homer also authored the landmark book "Muskie Fishing – Fact and Fancy Lore and Lures" in 1957 (re-printed in the 1970s).

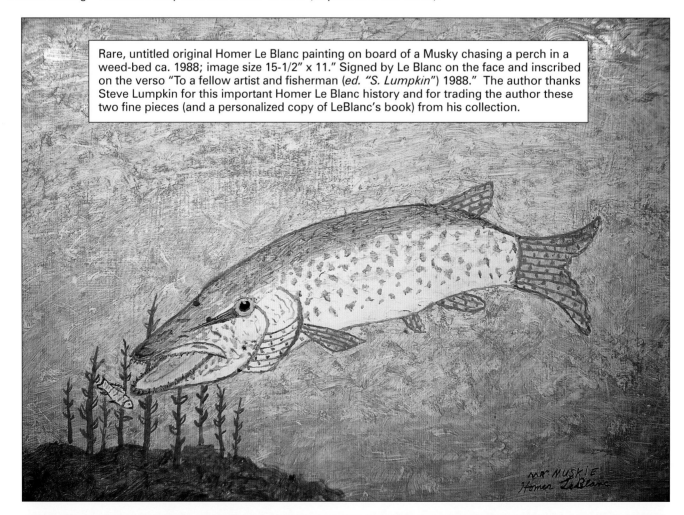

Rare, untitled original Homer Le Blanc painting on board of a Musky chasing a perch in a weed-bed ca. 1988; image size 15-1/2" x 11." Signed by Le Blanc on the face and inscribed on the verso "To a fellow artist and fisherman (*ed. "S. Lumpkin"*) 1988." The author thanks Steve Lumpkin for this important Homer Le Blanc history and for trading the author these two fine pieces (and a personalized copy of LeBlanc's book) from his collection.

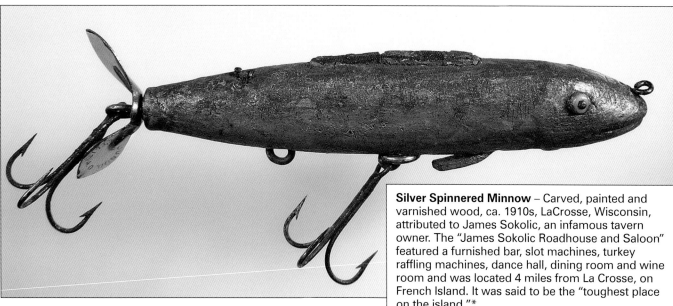

Silver Spinnered Minnow – Carved, painted and varnished wood, ca. 1910s, LaCrosse, Wisconsin, attributed to James Sokolic, an infamous tavern owner. The "James Sokolic Roadhouse and Saloon" featured a furnished bar, slot machines, turkey raffling machines, dance hall, dining room and wine room and was located 4 miles from La Crosse, on French Island. It was said to be the "toughest place on the island."*

Attractive, early, streamlined minnow, the salvaged Junod spinner at the tail is stamped "Dec. 29 '03". Tack secured glass bead eyes. Subtle, blended side paint coloration, mouth and gill carving. Tack applied, red painted leather strip at the back simulates a dorsal fin. A second leather strip inlet into the belly suggests secondary fins. Like some other classic early lures, a metal ring/"cap" provides additional reinforcement of the tail area. Two separate small tacks on the back near the tail suggest leather was once affixed to this area also.

* *Badger Bars & Tavern Tales – an Illustrated History of Wisconsin Saloons,* by Bill Moen and Doug Davis, 2003, page 19.

Collection of seven lures, crafted by Al Walker of Grindstone Lake, Minnesota, ca. 1940s–1950s. Walker owned a cabin on Grindstone Lake, located in east-central Minnesota. Walker is known to have made at least 150 different lures. Walker's signature swirling paint, expressive faces, unusual forms and applied decorations was beyond unique; each piece bears a sort of comical charm.

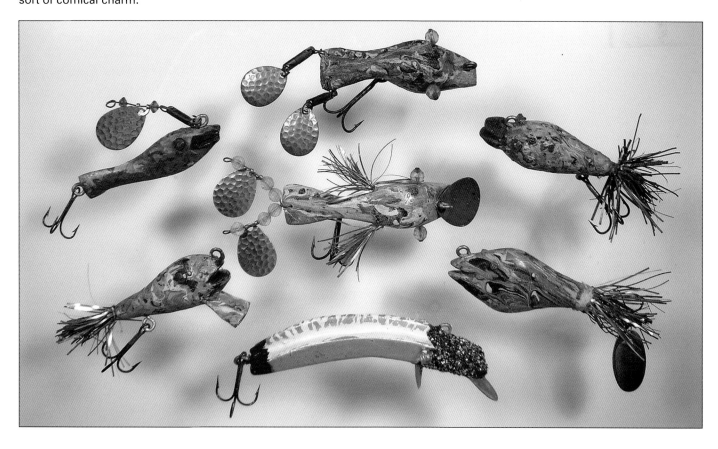

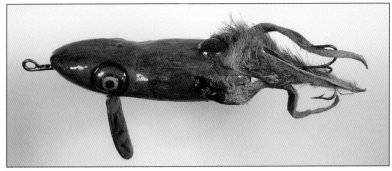

"Parkay" Frog – 3" carved, paint washed and varnished wood body with screw and thumb-tack attached animal skin 'legs' ca. 1940s. Relief carved and painted eyes. Through-body, fixed-wire forms line tie and is anchored to fixed rear treble hook (created by forming an oval solder weight, fixing three single hooks together). Painted and varnished, hand cut, galvanized metal diving lip is screw secured at belly with the word "EVE" painted on the verso. A vintage, glued and varnished Parkay (butter) logo adds color to the belly.

William Potts Giles (1893-1975)

William (Potter) Giles, a tinsmith by trade, was born September 4, 1893 and lived in Salisbury, MO. He operated out of the basement of a building located at Broadway and 3rd Street. After Giles' retirement in 1940 he crafted a case full of lures. Ultimately, these were passed along to his stepson, Gerald Mason, a dentist in Salisbury. [3]

Folk art lures just don't get more interesting and unique than Potters amazing creations – they appear to have been made by some sort of "mountain-man." For most, he used tails from squirrels and untanned pelts from other animals. Today, their unusual exaggerated forms, each possessing rich personality and character, stand as evidence of having been made by a gifted artisan. Often goofy or comical, even with little known about Giles the man, we can say with certainty that he had to have been a truly unique individual with a great sense of humor. Certainly a nature lover, in addition to preferring an earth-tone palette, many of his creations mimicked mice, rodents, snakes or other fantasy-creatures. Potter Giles was beyond creative; he neither copied nor was influenced by anyone – his active mind alone served as his inspiration.

Giles' lures have unusual form and are cleverly decorated – often he used not only novel paint patterns but pen (ink) and homemade, painted, multi-layered 'decals' for effect. Equally odd construction/ assembly techniques, wildly designed diving lips, and innovative hook-rigging schemes add loads of interest and appeal. While it seems that overall effect, image, and in-use presentation/action were his principle goals, Giles nevertheless spent extra time with fine details and flourishes such as engraving, small painted sketches, lettering, and heavy protective coats of varnish. Though each lure he crafted was unique, Potter cared enough about his creations to sign many of them, quite unusual in the 1940s. While I'd never consider fishing with one, I'm certain Potters lures would catch fish, perhaps the ultimate compliment to an imaginative and previously unheralded folk artist/fisherman.

Mr. Giles passed away November 3, 1975. As a folk art collector, I can only dream about there being more undiscovered Potter Giles' out there. The author thanks Missouri's own Dean Murphy for 'discovering' William Potts Giles and sharing his story.

[3] *Made in Missouri – Fishing Tackle; History and Identification* by Dean A. Murphy, 2003.

Potter Hairy Mouse – by Potter Giles, Missouri – 2-1/2" carved wood body wrapped in un-tanned animal skin ca. 1940s. Screw attached reformed belly hook is further secured at tail with wrapped gut to a full through-wire which passes through the nose forming the line tie. Formed, galvanized diving lip is secured by two nails. Metal tack eyes are both paint and decal decorated. Nail applied animal skin tail. Remnants of nail applied rear legs.

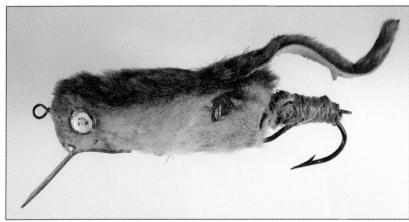

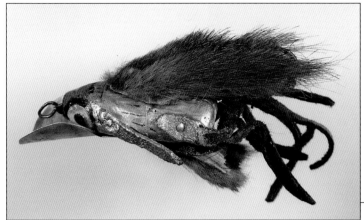

Squirrel Pelt Diver – by Potter Giles, Missouri - 2-1/2" hand carved and varnished wood with decal, paint and pen accents ca. 1940s. Adhered squirrel pelt at top and bottom. Tacked-on, painted leather front 'legs.' About one dozen, tacked-on, cut leather strips decorate the rear. Cut and formed aluminum diving lip attached with tacks. Cut, glued and varnished decal eyes over paint decoration.

Potter's Grinner – 3" hand carved and varnished natural wood with paint and decal accents ca. 1940s. Full through-body wire commencing as the line tie, passes through the head and is exposed at the belly, passing back through the rear section where it ultimately secures the rear treble. Animal skin hair tail is secured at the rear-top by a steel tack. Marked "Potter" on the belly.

Potter Cyclops Spoon – 2" chip-carved, painted and varnished wood with paint accented decals and surface applied foil. Full, through-body wire forms line tie, with the other end being wire wrapped and soldered to rear single hook. Belly is clearly marked "Potter."

Potter's Wobbler – 2-1/2" carved, painted and varnished wood with decal accents both on the top-side and the belly. Varnished decal eyes on underside of head – single belly mounted hook secures un-tanned leather animal skin/fur. Marked "Potter" on top of head.

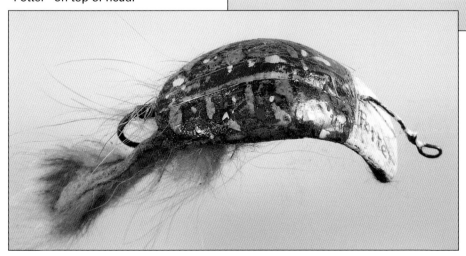

Wood-burned Diver – Made by Potter Giles, Missouri. 3-1/4" wood-burned natural wood, varnished with fin decal and paint accents. Fully through-wire forming line tie and rear hook hanger. Applied and wired-on squirrel 'tail' would impart additional in-use motion. Hand cut, formed and varnished aluminum diving lip secured by one screw and two tacks.

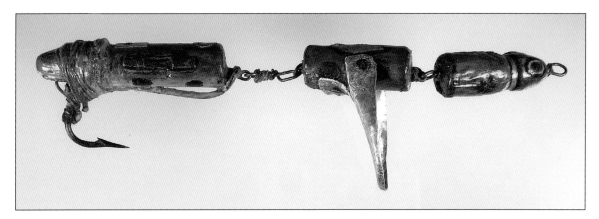

Double-Jointed, Diving Snake – Made by Potter Giles, Missouri. 5-1/2" double-jointed, carved, painted and varnished wood with paint and decal accents ca. 1940s. Highly unique form. Twisted, wire-through joint and line tie hardware. Oversized, hand cut and formed aluminum diving lip is secured by four tacks. Re-formed single hook in tail section is partially recessed and secured by both varnished wire and linen wrapping.

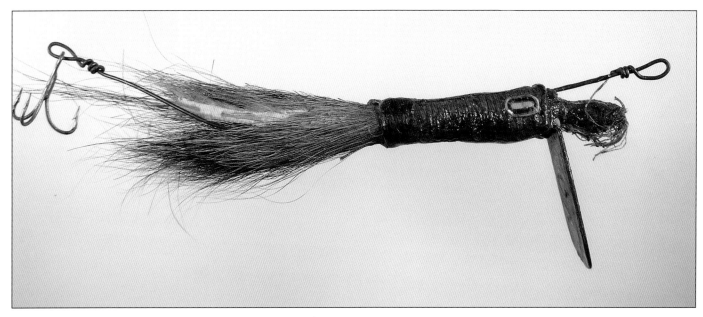

Foxtail Diver – Made by Potter Giles, Missouri - 3-1/4" varnished, fully cord-wrapped wood and bone body with applied eye and belly decals ca. 1940s. Hand wrapped and varnished fox-tail tail. Full fixed through-body wire forms line tie and tail hook hanger. Galvanized, varnished diving lip marked "Fox" on the verso. Lip is secured to the body by cord wrapping.

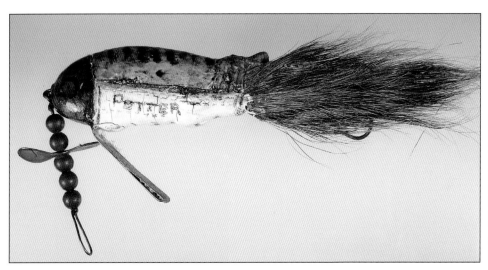

Squirrel-Tailed Minnow – Made by Potter Giles, Missouri - 2-3/8" hand-carved, wood-burned, painted and varnished wood. Painted eyes. Full, fixed wire-through forms front beaded wire spinner attachment and rear hook hanger. Folded, painted and varnished diving lip is marked "Potter". Squirrel tail 'tail' fully string-wrapped and varnished as well as metal tack secured.

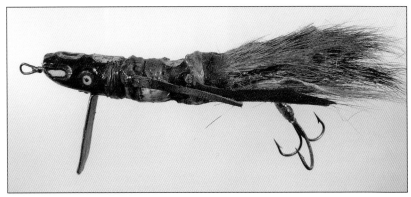

Native Wiggler - Made by Potter Giles, Missouri - 3" hand carved, painted and varnished wood with paint/pen accents as well as applied and varnished decals ca. 1940s. Full, fixed, twisted through-wire forms line tie and (soldered) rear hook hanger. Two pairs, wrapped and varnished leather legs. Unusually long and slender hand cut, folded and varnished diving lip is curiously marked "STICK." Signed "Potter" on the belly, with the signature accented by a sketch of a leaf. Wrapped and varnished squirrel or foxtail 'tail.'

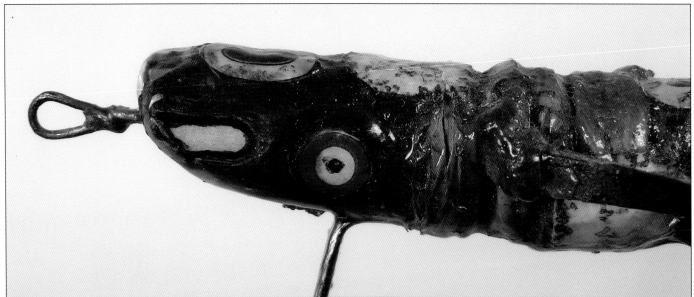

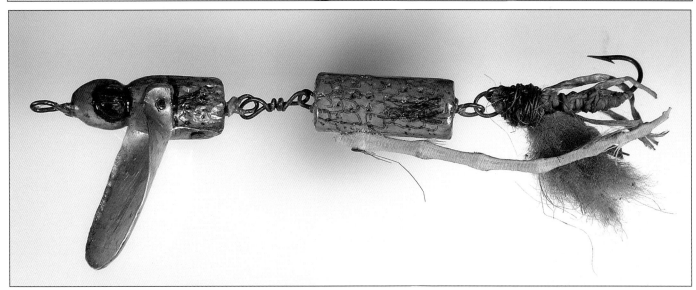

Jointed Potter Minnow – 3-1/4" hand carved, hand-impressed, paint decorated, varnished wood. Huge, hand cut, formed and varnished aluminum diving lip secured by 4 pins. Full wire-through construction with chain-link affect at joint. 3" squirrel tail bone attracter at bottom of rear body section. Fancy, wire tied, hand decorated rear hook features animal pelt, sinew and colored rubber-band accents.

Fisherman-modified Factory Lures

Springing from need or the desire to experiment, folk art lures are among the most colorful and unusual lures a collector can hope to find.— Dudley Murphy, *Antique Fishing Lures* (calendar), 2008

Imagine that its a beautiful spring evening in the 1940s and you (a tradesman by day) are out fishing your favorite hole with your best buddy. You're using a Creek Chub Bait Co. Darter and he's using an Arbogast Jitterbug. He's killing you and you haven't even been able to raise a fish. What do you do? You don't have a Jitterbug in your box, he doesn't have another and you can't afford another lure. It will cost you $1.00 that you just don't have.

What you do is level the playing field on your own; that same night you decapitate your Darter, hand-make a Jitterbug type lip, and paint the reassembled result in frog color just like your buddy's. Problem solved!

A fisherman alters a factory lure with the hope that his redesign will catch more fish. A Heddon 300 becomes a Pflueger Surprise, a South Bend Fish-Oreno becomes a CCBC Darter, a South Bend underwater minnow evolves into a pork-rind bait, a Heddon Tadpolly fished in the fall morphs into a fish decoy jigged in the winter. While illegal in most areas, a fish-spearing decoy becomes a fishing lure with the addition of some hooks.

While not created by hand from scratch, and technically not original folk art, fisherman-modified lures are fun and demonstrate how creative fishermen can be. "Frankenstein" baits can usually be obtained quite reasonably. Like the created from scratch, genuine article, they are one-of-a-kind and look great in a display case.

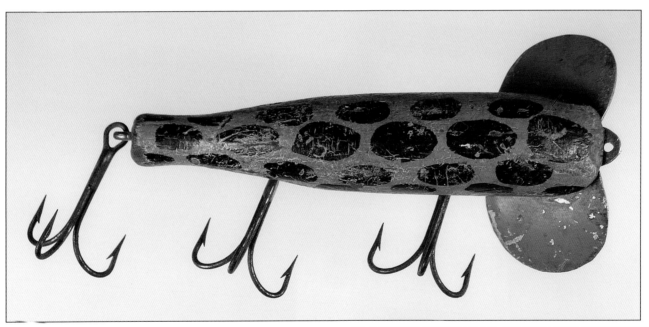

A factory-produced **Creek Chub Bait Co. "Darter,"** hand altered by a creative fisherman into an **Arbogast Jitterbug**.

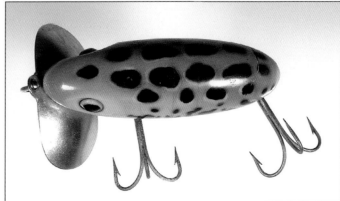

Actual, factory-produced **Jitterbug** by Arbogast Co., ca. 1940s.

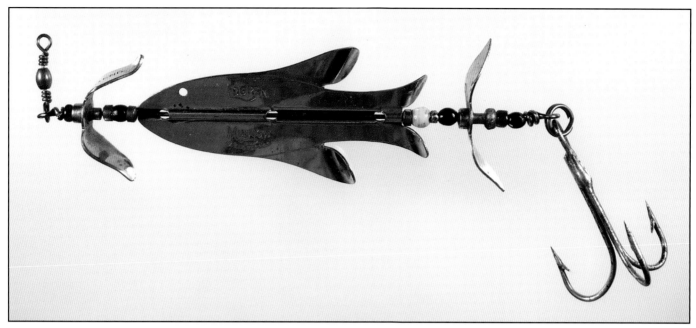

Modified Edgren Minnow by Burt Errett OH, replete with a fresh, twisted wire shaft containing added glass beads and props.

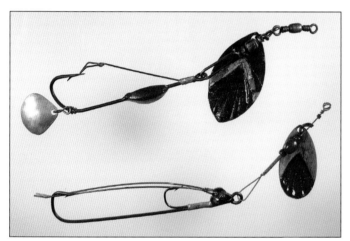

Converted Factory Pair – Burt Errett, Ohio. Top: Bing's weighted, weedless hook with an added homemade aluminum drop spinner and front glass beaded spinner assembly incorporating a (painted) Pflueger marked spoon. Bottom: Heddon frog harness with handmade front spinner assembly incorporating red glass beads and (painted) fluted spinner. Errett cut the factory leader's line tie tip to string the new blade and beads, then formed a new line tie.

Al Foss Little Egypt with added (actual) squirrel tail bone weedguard. Critter guard by Burt Errett, Ohio.

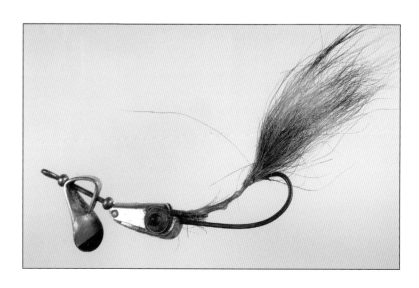

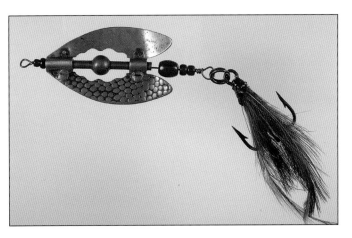

Re-wired, beaded and feather-tied **Pflueger American Spinner** by Burt Errett, Ohio.

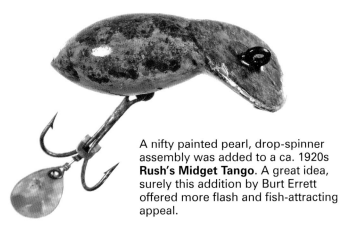

A nifty painted pearl, drop-spinner assembly was added to a ca. 1920s **Rush's Midget Tango**. A great idea, surely this addition by Burt Errett offered more flash and fish-attracting appeal.

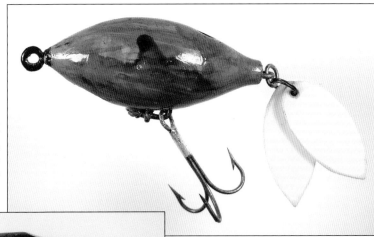

Modified Lockhart Pollywog by Burt Errett, Ohio – ca. 1910s. Repainted and heavily varnished including the line tie and ½ of the belly treble. Rear hook has been replaced with a metal ring, with attached pair of vintage, guitar-pic flashers.

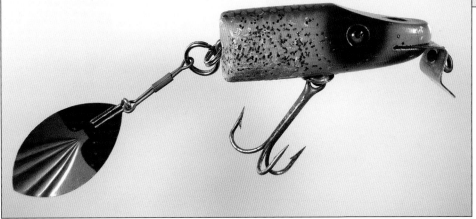

Modified Jointed Pikie Minnow – Rear portion of lure replaced with a fluted blade tail-spinner.

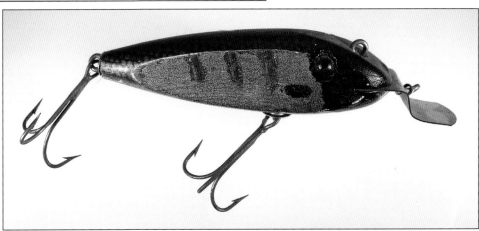

A "Shave-Sided" and paint accented **CCBC Wiggler**.

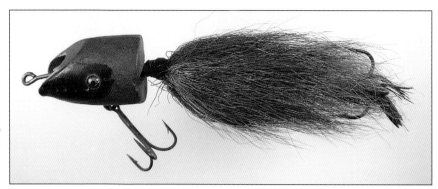

Front half of a **Moonlight 1900** body coupled to a large, hand-tied bucktail/feathered treble.

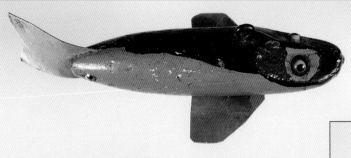

Sure Strike Minnow converted to a weighted fish decoy. Diving lip removed and pectoral/tail fins and poured lead belly weight added.

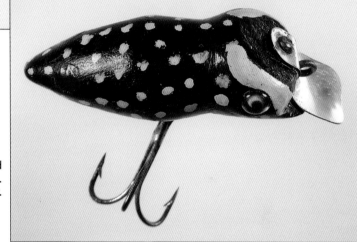

Shakespeare Mouse re-carved and painted to represent a Loon. Diving lip added by the maker.

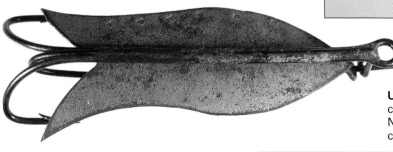

Unusual vintage spinner blade combined with an Eppinger's NoStealum bait harness by a creative fisherman.

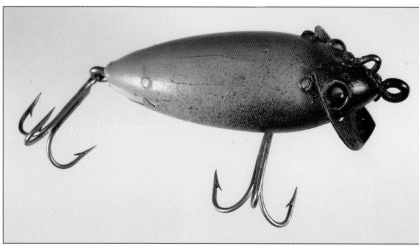

Heddon Crab Wiggler with its (re-cut) collar removed from one side and attached to the other end of the lure.

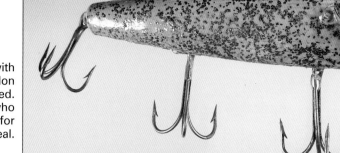

Heddon Near Surface Wiggler with its sides shaved and a re-cut Heddon Crab Wiggler diving lip added. Repainted by the fisherman who added flakes to the paint mix for added flash and appeal.

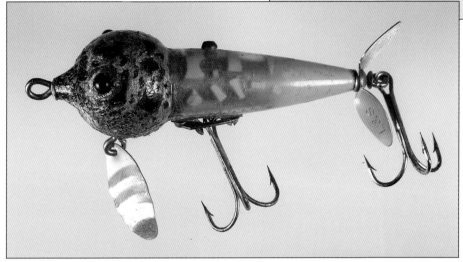

Heddon Dying Flutter rear body section mated to a **Garland Corkhead-**type head (New York). Glass bead eyes, Heddon 2-piece hardware and an attached flasher under the chin.

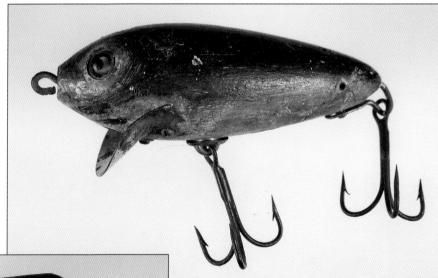

Heddon Crab Wiggler with its lip removed, re-cut and relocated to the other side of the lure.

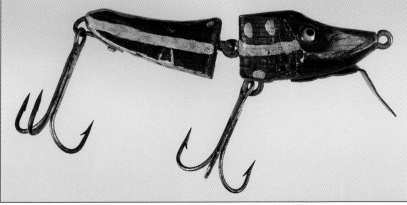

Recarved and deeply shaved **Heddon Jointed Vamp** including a new thinner, hand-fashioned metal diving lip. Painted in an unusual skunk pattern.

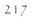

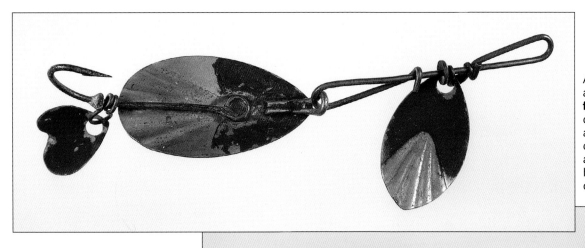

A pair of paint accented **Skinner fluted spinners** converted into a spinner/spoon combo with an added homemade, heart-shaped metal drop flasher as a tail.

Creatively made **CCBC Darter** converted into an elongated Arbogast Jitterbug.

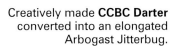

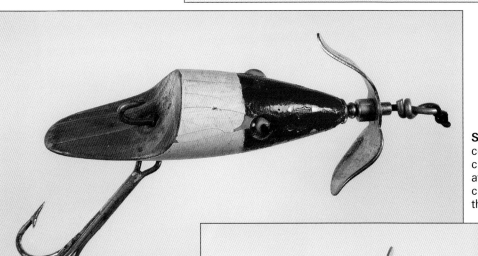

South Bend Underwater Minnow converted into a pork rind lure. The cut through wire is loose therefore, after the pork rind is attached, the clip will seat against the inside of the head as the lure is fished.

Pflueger Globe rotary-head lure accented with a multitude of inset, faceted gemstones.

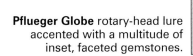

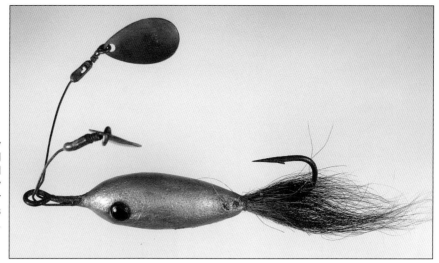

Shannon Twin Spinner mysteriously incorporates a painted and varnished wood body with a squirrel tail. Red glass bead eyes. Very professionally rendered – may be a Shannon or Jamison experimental lure. Author has no idea how it was done.

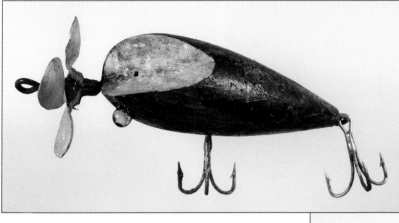

Found in Indiana, an unknown **surface plug** was reversed and converted into a diving lure. Glass eyes likely added by the maker. Very unusual hand cut and hammered 4-leaf clover aluminum prop.

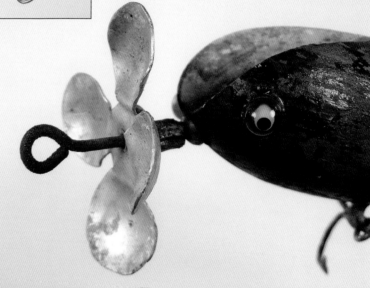

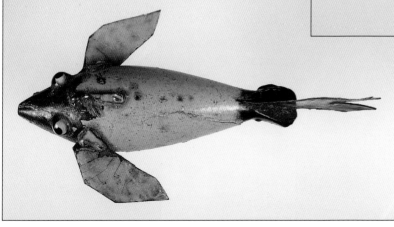

Interesting conversion of a **Heddon Tadpolly** into a weighted fish decoy. Note the added pectoral and tail fins as well as the usage of Heddon, two-piece hardware part as the line tie.

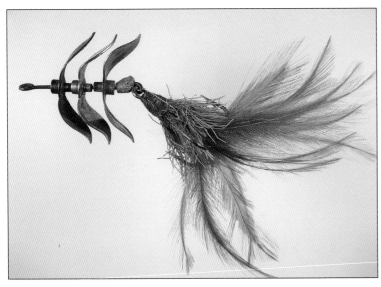

Bucktail and feather tied spinner employing three Heddon spinner blades on a hand-wired, weighted shaft.

South Bend Fish-Oreno with its metal head cut off and re-carved to resemble a CCBC Darter.

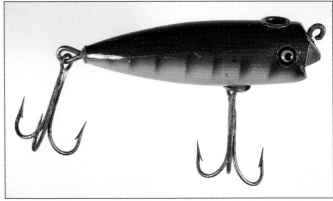

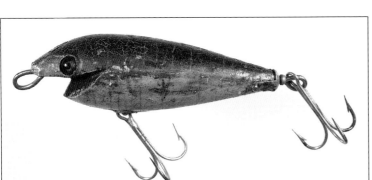

Oh my, this early **Heddon 300** was converted by a fisherman into a very happy Pflueger Surprise Minnow.

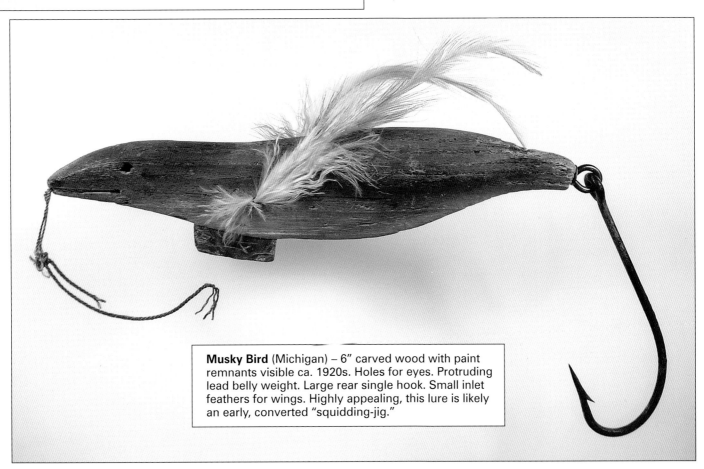

Musky Bird (Michigan) – 6" carved wood with paint remnants visible ca. 1920s. Holes for eyes. Protruding lead belly weight. Large rear single hook. Small inlet feathers for wings. Highly appealing, this lure is likely an early, converted "squidding-jig."

"Rambo" Pikie – Heavily modified CCBC "Husky Pikie" – Diving lip and top line tie removed. Big screw-eye hook hangers, anchors and large, heavy hooks added. Butt cut down, rear hook removed and swivel mounted hand cut brass tail spinner added, secured by a nail at the belly. Under chin line tie added. Attached hardware then heavily reinforced via wire wrapping around the body – ALL hardware connected together by this wrapping. A big fish would never be able to pull the hooks out of the body.

Musky Injured Minnow. 6-1/4", ca. 1940s–1950s – This lure tells a story about fisherman ingenuity. While a part of this section, unlike fisherman modified "factory lures," this lure started life as a folk art diving minnow and was later converted to a surface injured minnow. Remnants of belly hooks and a diving lip are evident. After its clever conversion, to enhance balance and action, additional weight was added both at the tail and to the through-body mounted side hook. This bonus lure proves fisherman tinkered with folk art lures just as they did with manufactured ones.

This South Bend Strike – Oreno (ca. 1920s) was converted into a weedless pork rind bait by the fisherman. Its feather-tail dressing was removed and a heavier, twin wire weed-guard added. Two snaps were added at the sides via screws to receive pork rind trailers. Additional line wrapping further secured both the weed-guard and side snaps.

Folk Art Tackle Collectibles[1]

Today, as reflected in this book, such diverse objects as factory-made cast iron doorstops, architectural fragments, and molded carnival chalkware are embraced as folk art. There is no reason to believe that the process of inclusion will be reversed. New items or categories (such as "wacky-wood") are continually being embraced; nothing once included is later rejected. This, too, is part of the American way. As the more traditional folk forms have been priced out of most collectors' range, taste makers and dealers have obligingly discovered new and less costly types or, as with 20th century folk art, a whole new century of material. All, in the belief, of course, that "art, like all else, should be open and available to everyone."—William C. Ketchum, Jr. – *American Folk Art,* 1995

While the emphasis of this book is vintage folk art lures, the folk art fishing "tackle" area is rich and diverse. Much has been studied and documented about the folk art fish decoy category. However, other folk art tackle categories such as rods and reels, tip-ups, hand-lines, line dryers, jigging sticks and an endless supply of tackle go-withs are ripe for the picking. I simply can't ignore such treasures in a book of this type. However, the scope of this work and the space provided doesn't allow me the liberty of including many examples. That will have to wait for another time.

Therefore, this section will highlight a cross section of folk art tackle collectibles from the authors collection – its my hope that the objects highlighted will whet your appetite for more. Naturally, just as I couldn't ignore folk art tackle collectibles at large, I just had to include some fish decoys and jigging sticks, most are anonymous.

Whether simple "his and hers" engraved fish scalers, colorful handmade floats, fishing reels, or a primitive fish (weight) balance scale, or conversely superbly crafted tackle boxes or amazing mechanical spring-hooks, these objects enrich the sporting collectibles field like icing on a cake.

[1] The folk art, Musky-shaped "Minnows and Boats" trade sign the author is shown holding on the front inside cover was once nailed to a tree outside a bait shop in Wisconsin.

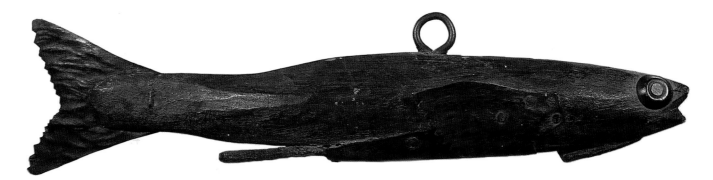

Fish Decoy – This superb 9-1/4" chip-carved decoy ca. 1900s was originally found in New York State (its probable place of origin) and collected by Tony Laws of Alabama. Acquired by the author in 2009, it is a fine example of fish decoy art. The exquisite, hand cut copper side and tail fins are highly original. A protective, copper belly plate covers the poured lead belly weight. Two thick belly-mounted leather strips simulate fins. Eye detail is provided by large, nail-secured brass grommets or caps.

Burt Errett's glass bead storage system. Large beads are strung on old fishing line with a button clasp. Small beads are stored in a hand made holder fashioned by cutting down a fancy kitchen knife handle for which he made a custom cork stopper (cap) fitted with a metal pin that slides and is friction fit into a cut notch in the knife handle – very creative!"

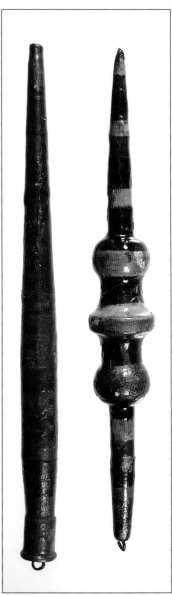

Great grouping of folk art bobbers ca. 1920s–1930s by Burt Errett. Note one of the pairs was inspired by baseball bats. Errett played baseball; the author has a ca. 1910s photo of Errett in a baseball uniform standing alongside his wife.

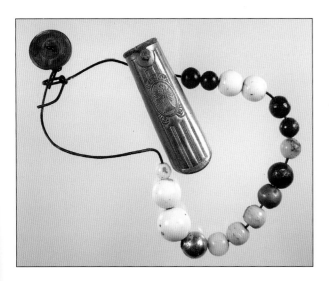

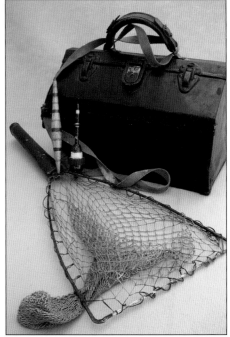

Hard to believe but this painted-metal, hip-roof tackle box with three removable trays was hand hammered and fashioned by Burt Errett, Ohio; it has a painted wood bottom. The net in the foreground is Errett's – he custom made the handle. The bobbers were also made by Errett. The separate red ring around the 'waist' of the painted cork bobber at right provides additional resistance – it is made from a vintage tape dispenser spool.

Superior craftsmanship evident in this ca. 1910s leather and wood tackle box made by Burt Errett. Brass locks, side belting anchors and corner reinforcing contrast boldly with the brass-tack secured, aluminum trim. Pullout drawers with recessed brass ring-pulls hide behind a leather-hinged, drop-front; a removable, wood and aluminum partitioned tray loads from the top. A pair of Errett-made folk art wood floats lean against the front. Burt's hand gaff can be seen at top. The superb aluminum framed, pen and water-color painted nameplate is attached to the inside lid using brass bolts and square nuts. This is the exact tackle-box that can be seen sitting on the porch in the family fishing photo (see page 195. Errett, at far right, is holding a pipe).

This enormous, 27"x10"x12-1/2", beautifully constructed, folk art, wood tackle box was conceived and built by Burt Errett, Ohio. The four lid hinges run longitudinally near the center of the top; the front face and top lifting together like a clamshell. Inside, three solid wood partitioned trays of differing size, slide in and out. A solid wood "bumper" base protects the sides from damage. The brass handle and full brass corner and edge trimming (secured by brass, dome-top nails) are gorgeous. Solid brass side loops suggest a design that could accommodate a leather shoulder harness.

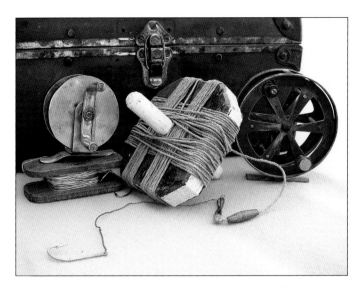

Pair of early, handmade brass fishing reels flank a Victorian, English **"Pike Troller"**, a type of early float. A live frog is attached to the wound line and the float (with the frog sitting on top) is set in the lake. After the frog leaves the float and is later gorged (swallowed) by a Pike, the fisherman retrieves the float and the Pike. The large center portion provides resistance to tire the fish once the frog is taken.

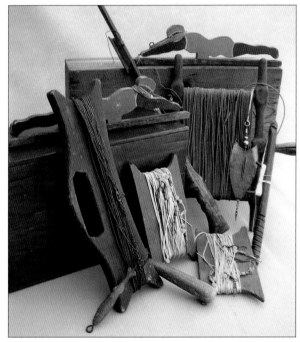

The great pair of ca. 1930s **"Diving-Bathing Beauty"** tip-ups found in Michigan, dive head-first into the ice-hole when you get a bite. Their legs sticking straight up indicate a fish is on! The large ca. 1920s maroon hand-line at left-center holds brass wire line with twisted brass leaders. The heavy lead weight drops multiple, large baited hooks or large trolling spoons deep as the boat is rowed. This device functions as both the rod and reel when trolling. Once a fish is hooked, the wire line is retrieved by hand. At its base, is a very early hand-cast lead cod hook from Canada. A pair of ca. 1930s folk art trot lines can be seen to the right of the hand-line. A larger, early hand-line/winder is seen to the right. The brass folk art Musky arrowhead spinner was made by Burt Errett, Ohio, ca. 1930s. The ca. 1950s two-piece jigging stick leaning left has a hand carved, wood 'pistol-grip.' The more contemporary dark, slender jig stick on the right has a carved head and glass eyes.

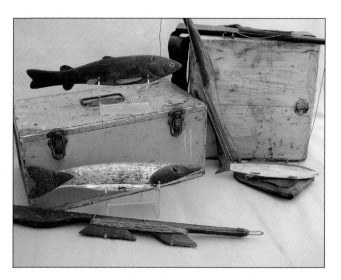

This group features two large fish decoys – in the foreground, a ca. 1940s 13-1/2" **Pike** found in northern Wisconsin. Displayed atop a ca. 1930s silver decoy box is a finely carved 12-1/2" wood-burned, natural finish decoy ca. 1910s. Three jigging sticks can be seen – the one in the foreground and the example leaning left are likely ca. 1920s-1930s. The 3rd example, ca. 1940s (resting on a silver tackle box made the by the author's grandfather) is mechanical, with action controlled by a trigger. It is attached to a ca. 1940s 9-1/2" silver Pike from Michigan.

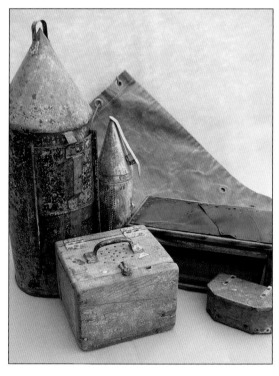

Collection of Folk Art Bait Containers – from left:
ca. 1920s-1930s large, cylindrical homemade minnow bucket with sliding lid is meant to be towed behind a boat as it is rowed.
At left-front, a depression era hinge-top square wood bait box uses a window pull and window latch on the lid – showing remnants of original silver paint, it could have been used for either worms or frogs. The nifty, perforated ca. 1930s handmade cylindrical container with funnel top is designed to be worn on a belt and serve as a cricket dispenser.
Rubber topped screen box at right holds frogs ca. 1940s.
At right front is a nicely made hinge-top worm can ca. 1930s.

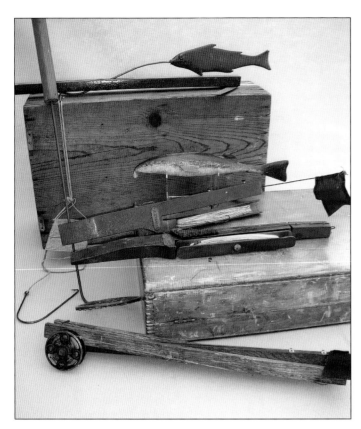

The exquisitely made, ca. 1910s–1920s, red, fish-shaped tip-up at the top and in the accompanying photo, is the finest tip-up the author has ever seen. The thin, removable carved red fish sports painted tack eyes. It rides on a formed, and forged copper tube. All metal pieces at the pivot-point are hand made. It features nail reinforcing at the fin 'tips' to prevent damage. The wood base includes retractable brass supports to stabilize it on the ice. Great form on the 12", ca. 1930s Black Sucker seen in the center. Brass name-plates reading "M. Cresci" decorate the unusually designed folk art tip ups (center) ca. 1920s. The ca. 1920s tip-up in the foreground employs an antique typewriter ribbon (as the reel/line-holder) and 'made' hardware. A brass plate indicates it was owned by a "Mr. Lewis Buchner" of "Amsterdam, New York." A green-handled, homemade ice-skimming tool can be seen at the left.

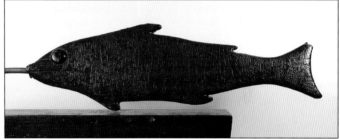

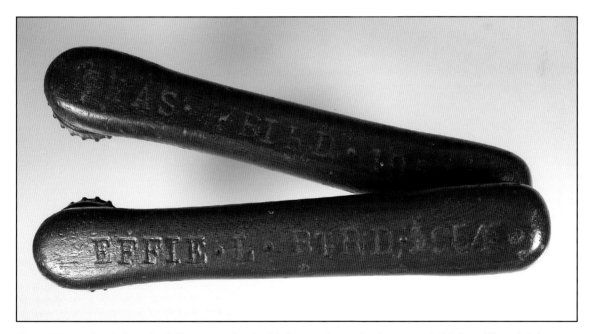

One of the author's favorite folk art goodies is this interesting pair of engraved "his" and "hers" fish scalers, marked "Chas. W. Bird" & "Effie L. Bird," each dated 1954. Simple carved, painted and varnished wood, each has a vintage bottle-cap nailed to the end (which acts as the scaler). I'll bet Effie was a good fisherman. A fish scaler is such a utilitarian device, yet Mr. Bird chose to hand-craft and engrave a matched pair for use by he and his wife. It's hard to imagine any husband/wife team that would repeat Bird's effort in 2011 – one of the reasons folk art collecting is so enjoyable.

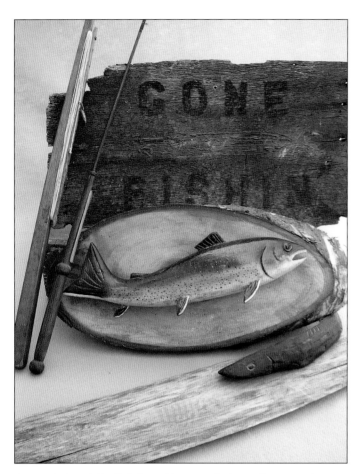

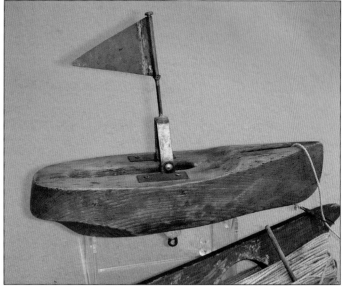

A ca. 1940s-1950s **Rainbow Trout** wall plaque leans against an authentic, early "Gone Fishin" sign. To the left are a fine pair of folk art rods – an oak ice fishing stick and a delicate turned wood and cane rod surely meant for nothing larger than pan-fish; two nails hold the line. An old, wood-burned fish carving swims in the foreground.

'Boat-Shaped" Mechanical Float for "Jug-Fishing" ca. 1920s. This super piece of folk art came from the estate of Mr. A. L. Fulmer of East Syracuse, New York and was used by Mr. Fulmer on Oneida and Onondaga Lakes. A sliding weight balances the baited hook in the 'flag-down' position (brass flag folds down into a recessed groove in the hull). When a fish strikes, the flag is raised via leverage and the hook set, in part due to the resistance of the boat's hull against the water surface. This float may have been used any number of ways:
—For still fishing either from a boat or from shore as an extra line (as-rigged)
—Jug fished. Dropped (loose) into the lake as one of many, then picked up after a fish gets hooked
—Towed behind the boat as one rows
—Ice fishing tip-up – Doubtful unless fishing only for small fish. A larger fish could pull the entire affair under the ice

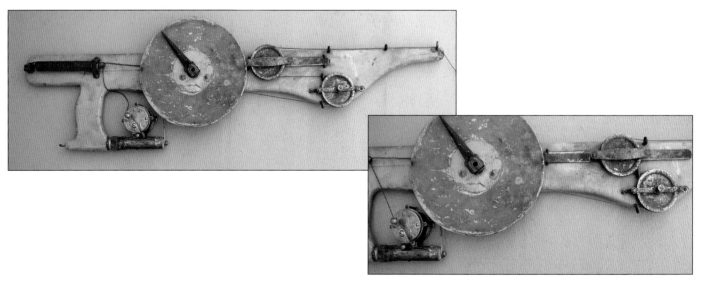

Folk Art "Tommy-Gun" Rod/Reel Combo – This incredible, ca. 1920s, rod/reel gizmo was made by an individual with a good sense of humor and time on his hands. It actually works and, due to its length, was likely used for ice fishing. At the base of the pistol-grip, a vintage reel seat holds an ancient, raised-pillar reel. A long coil spring acts as the drag – the line passes around an old grocery scale and through a pair of pulleys, one of which slides forward on a rail when a fish bites – the 'pointer' on the scale either was a strike indicator or measured depth. Purchased from the Don Ludy collection, Arlan Carter had this contraption on display for years at his North Land Fishing Museum in Wisconsin. Folk art tackle ingenuity doesn't get any better than this.

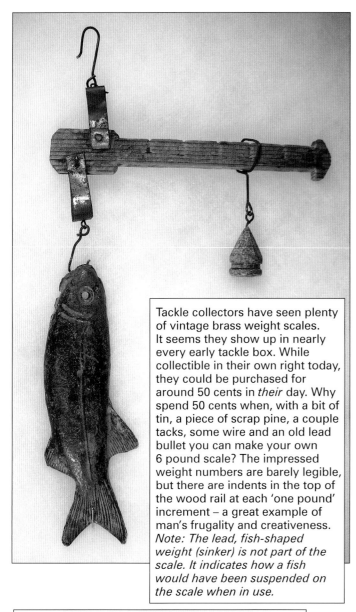

Tackle collectors have seen plenty of vintage brass weight scales. It seems they show up in nearly every early tackle box. While collectible in their own right today, they could be purchased for around 50 cents in *their* day. Why spend 50 cents when, with a bit of tin, a piece of scrap pine, a couple tacks, some wire and an old lead bullet you can make your own 6 pound scale? The impressed weight numbers are barely legible, but there are indents in the top of the wood rail at each 'one pound' increment – a great example of man's frugality and creativeness. *Note: The lead, fish-shaped weight (sinker) is not part of the scale. It indicates how a fish would have been suspended on the scale when in use.*

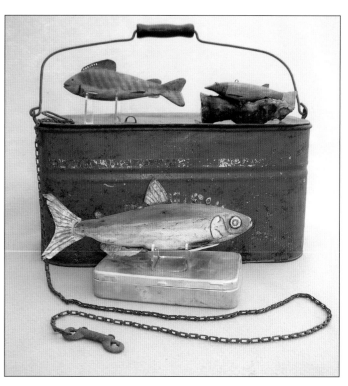

A large, painted **"Kingfisher" Minnow Bucket** serves as the backdrop for 3 interesting fish decoys fashioned by unknown carvers in the 1930s-1940s. In the foreground is an 11-1/2" MI fish with nicely blended paint and interesting carving and metalwork. At top left is a finely made 7-1/2" perch from East Tawas, Michigan. To its right, a 5-1/2" folky sucker with relief-carved eyes hailing from Grand Rapids, Minnesota.

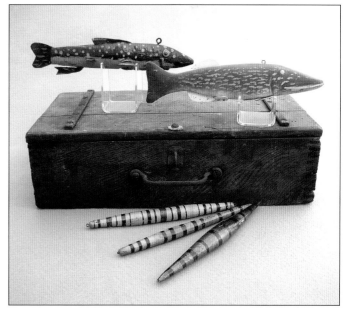

An appealing pair of ca. 1930s–1940s **Northern Pike decoys** of around 8-1/2" ea. swim atop an ancient fish decoy box. The 3 colorful, carved wood bobbers in the foreground were made by Burt Errett, Ohio.

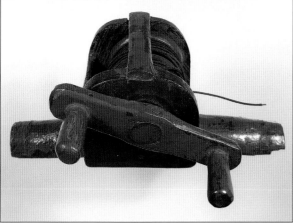

Completely fashioned from hand carved, painted and varnished wood, this primitive, **folk art *bait-casting* style reel** is truly a rare find. Even the line spool is hand carved. Expending the time to create from scratch a useable fishing tool in an era when an inexpensive factory reel could be had for less than 50 cents tells us much about both its creator and the times.

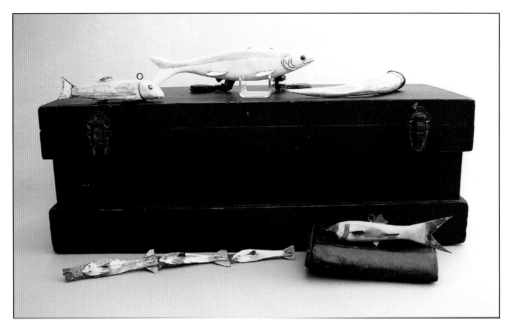

A bevy of lighter colored fish decoys surround a dark mahogany tackle box, handmade in the 1920s–1930s by Dr. Dale C. Beatty, an Osteopathic physician from St. Petersburg, Florida. It is a large box measuring 24-1/2"x9-1/4"x9". The box is unique in that it has no larger storage compartment in the bottom – rather, like the two removable top trays, it too is partitioned to hold lures. Dr. Beatty also made the superb minnow seen on page 204. The attractive ca. 1940s Sucker in the top-left was made by Richard Dulac of Rogers City, Michigan. Noted fish decoy collector Frank Baron has attributed the gorgeous 10" fish (top-center) to the Lake St. Clair/Mount Clemens area school, believing it to be made by either Andy Trombley or Chub Buchman. At the lower left is an old, 12" tandem, decoy rig, used in river fishing; the 'joints' between each fish are heavy canvas. At the lower right is a fun, ca. 1950s decoy from an unknown carver clearly inspired by a rocket-ship, a popular symbol of the times.

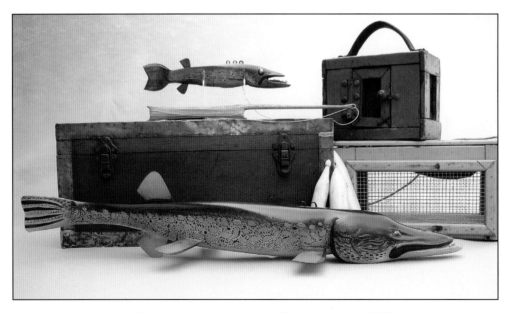

A mix of old and new bridge the generations. A 12" copper-toothed Pike by contemporary master decoy maker C.B. Lewis swims atop a beautiful, copper-trimmed folk art tackle box found in Indianapolis, Indiana. ca. 1920s – an ingenious fold down cover inside the box's lid neatly houses the fisherman's four-piece metal casting rod. In the foreground is Lewis' amazing 28" weighted and balanced serpentine Pike decoy featuring carved bone teeth. The folk art jigging stick hails from the estate of famous sportswriter Charles F. Waterman. Renowned fisherman and author of numerous sporting books, Waterman also wrote for such notable publications as Gray's Journal, Sports Afield and Florida Fisherman. To the right is an interesting pair of wood folk art frog carriers ca. 1930s-1940s. Leaning against them are three luminous, chip-carved handmade bobbers ca. 1920s.

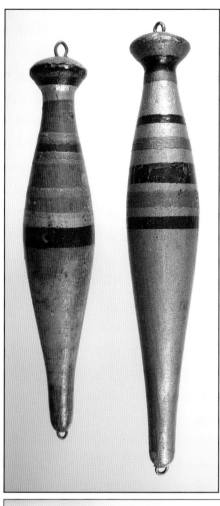

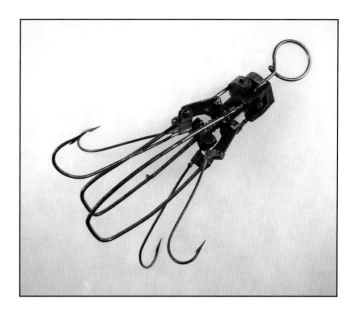

Large Hand-made Springhook
ca. 1900s–1910s. One of the author's favorite hand-made hooks is this fantastic, folk art, weedless springhook. Whoever conceived and crafted it was a mechanical genius.

Appealing form, nice paint and a mellow patina is evident in this pair of folk art floats from Wisconsin, ca. 1930s.

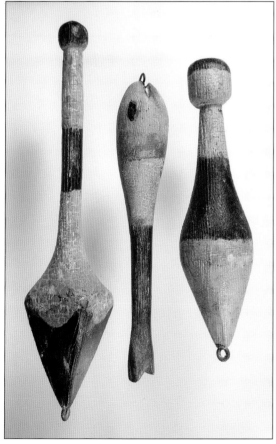

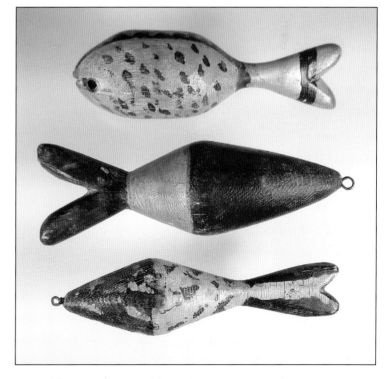

Nice age plus creativity galore are conveyed by these folk art bobbers made by an unknown fisherman from Cincinnati, OH ca. 1930s. Though primitive, the fish forms, child-like paint and patriotic colors appeal to one's basic senses.

Contemporary Artists

Still other objects represent the modern continuation or revival of the folk tradition.— Gerald W. R. Ward, *Art for the Nation: American Folk Art and the Museum of Fine Arts, Boston,* 2001

The central theme of this book is vintage folk art fishing lures, yet it would be remiss to forego mentioning the work being fashioned by contemporary artisan/craftsmen, many of whom possess extraordinary talent. Because they are at the top of their trade, certainly many of their creations will survive our lifetimes and be treasured by future generations of collectors.

Bob Baird
Utah – *Diamond Baird Lure Co*.

An avid fisherman and fly reel collector, Bob Baird fashions exquisitely made, jewelry-quality custom lures, reels, knives and creels. His pallet of exotic raw materials includes an array of precious stones, gold, sterling silver, nickel-silver, brass, pearl, nickel, and the highest quality tanned, tooling leather – he's even used woolly mammoth for reel side plates and mastodon ivory for reel handles. He makes each glass bead by hand, he painstakingly makes every single part used to construct a fine fly reel to excruciatingly exacting standards. All hooks are hand forged and tempered; his "Shepherds Hooks" are art unto themselves. Custom crafted presentation boxes house each of his creations. Samples of Baird's work may be viewed at his website http://www.diamondbairdlureco.com/ Prepare to be shocked and amazed by his treasures. Bob can be contacted through his website or via e-mail at diamond@diamondbairdlureco.com.

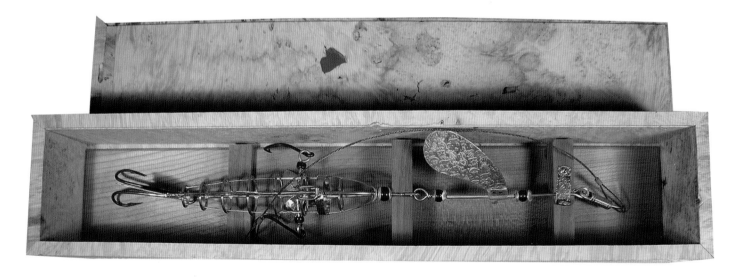

The "MusKieny" is a musky-sized live bait trolling lure – the authors "dream-lure." Entirely hand made, including hand forged, hardened and tempered steel shepherd-hooks' and hand poured glass beads, this German silver bait cage takes on the profile of a fish. Its dorsal, pectoral and tail fins are sterling silver. The large fore-blade is laminated – the outside surface made of sterling and the inside copper, both sides stamped using Bairds trademarked, hieroglyphics pattern. The head of the cage can be unclipped and swings downward, leaving a fish-shaped chamber into which a live minnow is inserted tail first. After re-clamping the cages 'head.' the rig is ready to be cast or trolled. The cage is balanced, runs true and has been tank-tested by Baird. Author does not envision further field-testing.

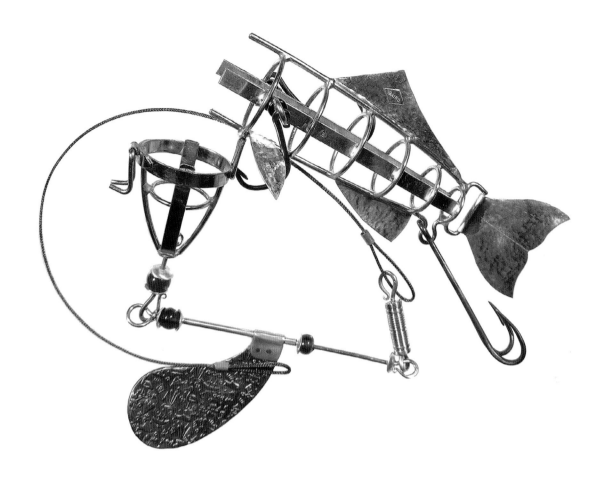

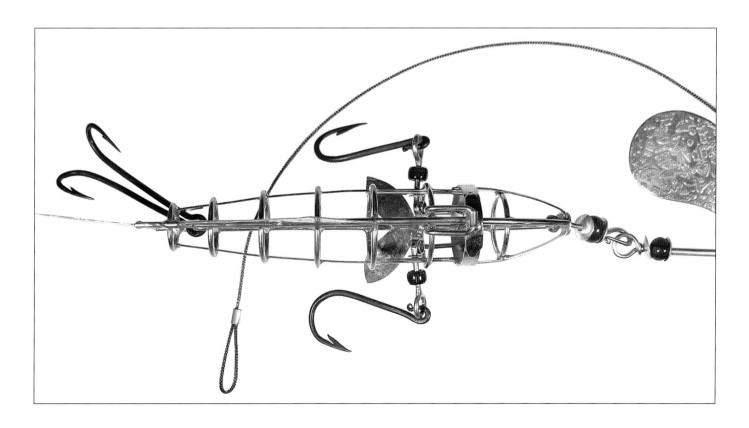

Aage Bjerring
New York

In addition to custom crafting fishing lures and decoys, Aage (pronounced O-Wah), a Danish-American artist residing in Long Island, sells his paintings commercially. His work has been featured in art exhibitions and galleries. His highly collectible fish decoys are included in the well known reference book *The Fish Decoy* by Art, Brad and Scott Kimball as well as *Fishing Lure Collectibles – An Encyclopedia of the Modern Era, 1940 to Present* by Dudley and Deanie Murphy, 2006. Appealing, simplified forms and a colorful, signature painting style are his hallmarks. When holding or viewing a Bjerring creation, there is no doubt it came from the hand of an artist. His lures and decoys always exhibit a unique, folky interpretation of his subject. Sometimes shocking, wild or bold, each is highly imaginative. Through simple paint effects, even his more 'traditional' fish have great character. Aage can be reached via e-mail at aageone@optonline.net .

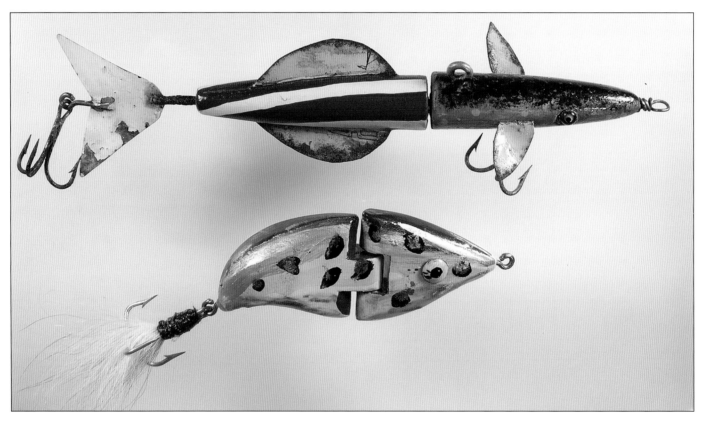

Aage Bjerring Pair – 7-3/4" and 3-3/4". Top: Combination fish decoy/lure - shaped, painted and varnished wood. Segmented, revolving tail. Six belly weights, glass eyes, tin fins and tail.
Bottom: Jointed lure – carved, painted and varnished wood. Painted dome tack eyes. Tied rear treble.

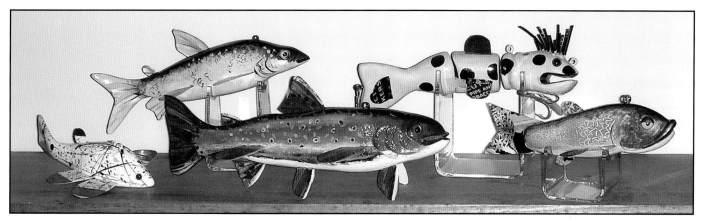

Noted New York City-based artist Aage Bjerring creates colorful and unique fish decoys that excite the eyes and stir the imagination. Highly creative, Bjerring has abundant painting talent.

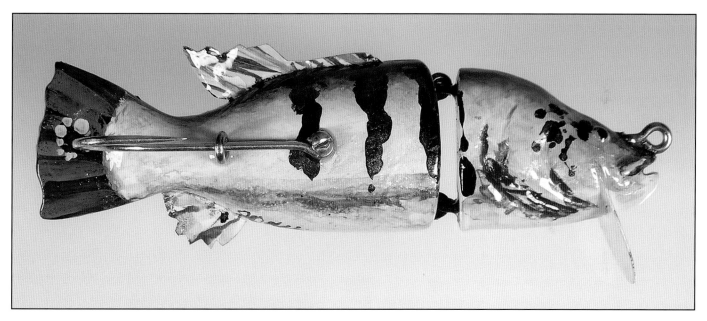

Jointed Peacock Bass, 4-3/4", demonstrates Aage Bjerring's ample carving and brush painting skills. Aage missed a Striper and caught two Bluefish on this lure before selling it to the author.

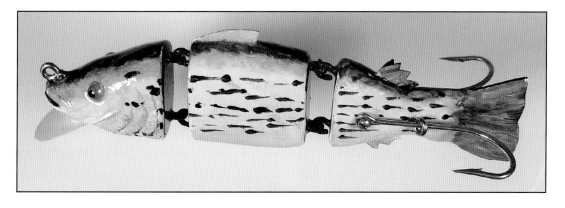

Double-Jointed Striper – This colorful, hand carved rendition of a baby Striper would both dive and wiggle upon retrieve. Aage's creative detailing and pasty painting style is immediately recognizable.

Bill Grossman
Virginia – *Swift Creek Lures, "Art With A Hook"*

Bill Grossman, a retired art teacher and lifetime fisherman with a master's degree in Fine Arts, was featured in the January 2008 edition of *Bass Master* Magazine for his displays at the National Folk Festival in Richmond, Virginia. Also in January 2008, a feature article on Grossman appeared in *Virginia Wildlife Magazine*. His work has been highlighted in the *NFLCC Magazine* and in *Fishing Lure Collectibles – An Encyclopedia of the Modern Era, 1940 to Present* by Dudley and Deanie Murphy, 2006. Why all this attention? His work is original, creative and visually striking. Each lure or fish decoy is hand carved of walnut, cherry, mahogany or maple. All pieces are brush painted, never air-brushed. Grossman's unusual forms and lustrous, shimmering paint separate him from the crowd. Bill can be reached via e-mail at artwithahook@comcast.net More of Bill's lures can be seen at his website http://www.swiftcreeklures.com/index.htm

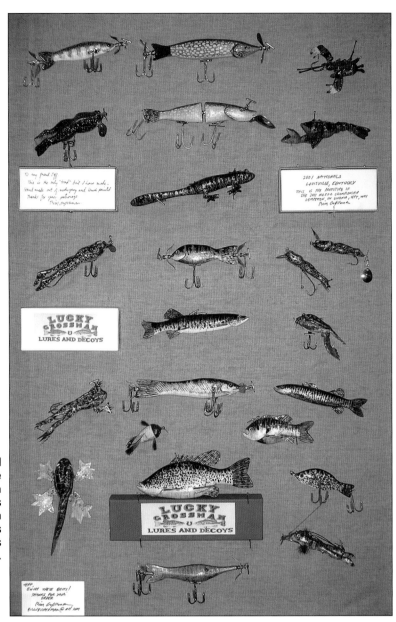

Fish decoys, fishing lures and sundry critters and frogs handmade by Bill Grossman fill this large case. Grossman individually hand carves each using selected hardwood. As many as twenty coats of paint and clear-coat meld to create an illusion of depth that must be seen to be believed. Colors change as a piece is moved or eye position is adjusted. Grossman hand signs each of his pieces.

Close-up of three Grossman decoys. The large Pike's white side-markings were applied with luminous paint so this fish shines brightly in the dark. Both the Bullhead and swimming Salamander exhibit superb form with great surface complexity and depth.

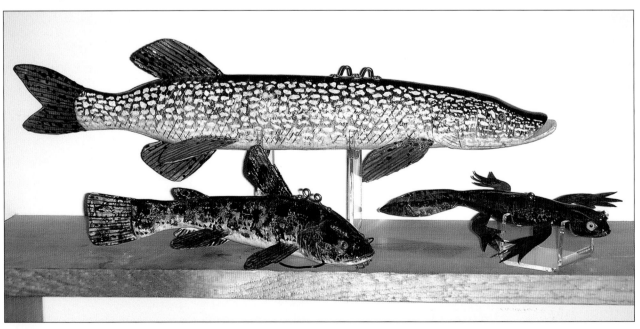

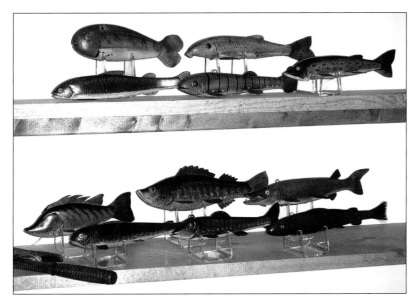

A school of eleven fine fish decoys made by Bruce Lewis swim in unison. The richness and character of his creations is in ample evidence. His exceptional paint and surface finish technique suggest they have lived in a smoke-filled bar for the last 80 years. Each is identified as a Lewis original by hand stamping the metalwork with 1930s era tool and die stamps.

C.B. "Bruce" Lewis
Pennsylvania – *Golden Age Fish Decoys*

Lewis' creations challenge the senses and evoke times past. With a Lewis fish one realizes he is holding a modern work of art; yet its classic form, folky paint, mellow patina and wonderful character harken back to a simpler time – the 1900s through the 1930s, the "Golden-Age" of fish decoys. Lewis utilizes antique and vintage salvaged wood, brass and copper flat stock, glass, bone, tacks, nails, silver wire, and leather. Salvage sources include old barn beams, old-growth pine porch posts and flooring, antique chairs, vintage toilet tank liners and early US postal mailbags.

Each Lewis fish has a warm, rich, settled patina. Through his proprietary, finely finished and hand-rubbed surface, one feels as though you are stroking a fine antique piece of furniture. Lewis was the subject of a feature article "CB Lewis – Master Fish Decoy Maker" by the author, published in the November-December 2007 issue of *Hunting and Fishing Collectibles Magazine*. Examples of his work are also illustrated in *Fishing Lure Collectibles – An Encyclopedia of the Modern Era, 1940 to Present* by Dudley and Deanie Murphy © 2006. C.B. Lewis may be contacted via e-mail at goldenagedecoys@yahoo.com or his website: www.goldeneyedeoys.com.

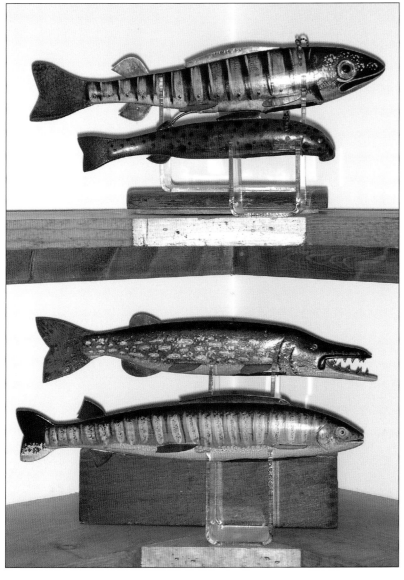

Two Perch (top and bottom), a spotted Sucker and a copper-toothed Pike by Bruce Lewis compete for attention. While each conjures up scenes and influences from the past, each also breathes the incomparable Lewis style and signature touch.

C.E. ("Charlie") Wilson
Nebraska – *The Minno Company*

Charlie Wilson formed the Minno Co. in 1996. Each lure is an original Wilson design and carved of the finest white cedar. All propellers, diving lips and spinners are individually cut, soldered and polished by hand. Each eye and nose bead is hand made from glass – each eye being custom colored, made one at a time and hand fitted to the lure. Bottom line: Wilson makes everything but the hooks. To produce fine surface finishes (in addition to clear coat sealing), a minimum of 8 layers of acrylic enamel is used. Paint schemes are appealing and wide-ranging. Wilson's lures beg to be touched. Beautiful two piece cardboard or custom made wood (hinged or slide-top) boxes accompany each lure. Notably, each lure is balanced and field tested.

C.E. Wilson was profiled in a feature article by the author published in the March-April 2009 issue of *Hunting & Fishing Collectibles Magazine*. His work has also been highlighted in the *Lincoln Journal Star*, the June 2001 *NFLCC Magazine* and in *Fishing Lure Collectibles, Volume Two, The Modern Era,* 2003 by Dudley and Deannie Murphy. Wilson's art is regularly seen at area art shows and is displayed at Willow Point (Art) Gallery Ashland, Nebraska. Wilson refuses to introduce a lure unless it catches fish. Charlie be contacted via e-mail at customlure@aol.com.

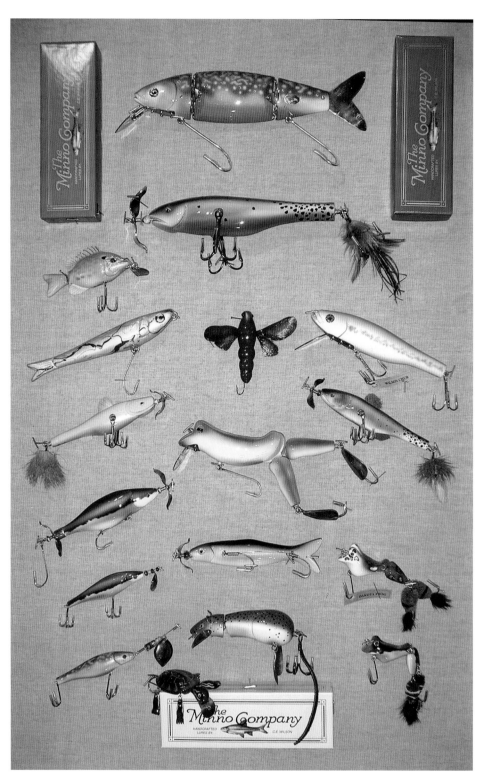

It is quite easy to appreciate this case of C. E. (Charlie) Wilson's treasures, which include several very special pieces.

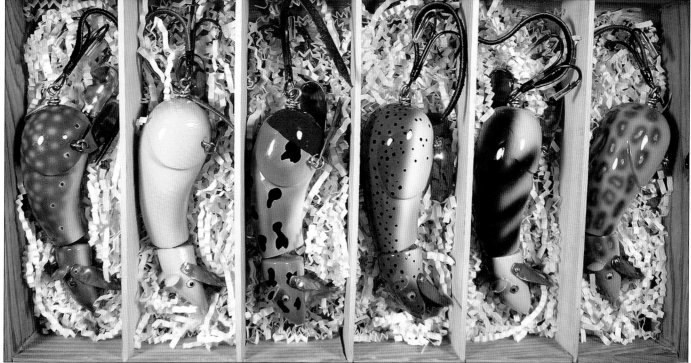

At the author's request, Charlie Wilson custom made a "six-pack" box for half a dozen of his jointed Musky Rats. He created an original lithograph that decorates the box top; it features three of his lure styles offered at the time. Made in May of 2000, the box is signed and labeled as No. 001, the <u>first</u> six-pack box crafted by Wilson. Each of the Musky Rats has hand poured glass eyes as well as hand made, formed and polished metal ears, diving lips and side flasher spoons. The spotted rainbow trout colored example was the first Wilson lure the author purchased in 1998. How could I resist a jointed, Musky Rat painted as a Rainbow Trout?

Bibliography

Folk Art

American Folk – Folk Art from the Collection of the Museum of Fine Arts, Boston. Boston: Museum of Fine Arts, 2001.

Bishop, Dr. Robert, Curator. *American Folk Art: Expressions of a New Spirit*, New York: Museum of American Folk Art, 1982.

Bishop, Robert and Jacqueline M. Atkins. *Folk Art in American Life*. 1995.

Cahill, Holger. *American Folk Art – The Art of the Common Man in America 1750–1900*. 1970.

Fendelman, Helaine and Susan Kleckner, *Collecting American Folk Art,* 2004.

Folk Art: Imaginative Works From American Hands. New York: Time–Life Books, 1990.

Katcher, Jane; David A. Schorsch and Ruth Wolfe, editors. *Expressions of Innocence and Eloquence – Selections from the Jane Katcher Collection of Americana*. New Haven: Yale University Press, 2006.

Ketchum, William C., Jr. *American Folk Art,* 1995.

Lipman, Jean; Elizabeth B. Warren and Robert Bishop. *Young America – A Folk-Art History,* New York: Museum of American Folk Art, 1986.

Lipman, Jean and Alice Winchester, *The Flowering of American Folk Art 1776–1876.* New York: Whitney Museum of American Art, 1974.

Pennington, Samuel, Guest Curator. "April Fool– Folk Art Fakes and Forgeries," Folk Exhibition Catalogue. *Maine Antique Digest*. The Museum of American Folk Art and Hirschl & Adler, 1988.

Treasures of American Folk Art from the Abby Aldrich Rockefeller Folk Art Center. Williamsburg: The Colonial Williamsburg Foundation, 1989.

Colonial Revival Movement

Axelrod, Allan. *The Colonial Revival in America.* New York: Norton Publishing, 1985.

Ivankovich, Michael and Susan. *Early Twentieth Century Hand-Painted Photography – Identification & Values* Collector Books/Schroeder Publishing, 2005.

Rhoads, William B. *The Colonial Revival.* New York: Garland Publishing, 1977.

Wikipedia, the free encyclopedia http://en.wikipedia.org/wiki/Colonial_Revival_Movement

Index